The Palace Museum's Essential Collections
CHINESE TREASURES

The Commercial Press

CHINESE TREASURES

Chief Editors	Chen Lihua 陳麗華，Liu Yue 劉岳
Deputy Chief Editor	Qin Fengjing 秦鳳京
Editorial Board	Guan Xueling 關雪玲，Zhang Rong 張榮，Wang Shuo 王碩，Zhao Lihong 趙麗紅，Wu Chunyan 吳春燕
Photographers	Hu Chui 胡錘，Liu Zhigang 劉志崗，Zhao Shan 趙山，Feng Hui 馮輝，Yu Ningchuan 余寧川
Translators	Tang Hoi-chiu 鄧海超，Veronica Ng Ho-yi 吳可怡
Editorial Consultant	Hang Kan 杭侃
Project Editors	Xu Xinyu 徐昕宇，Qiu Yinqing 仇茵晴
Cover Design	Zhang Yi 張毅
Published by	The Commercial Press (Hong Kong) Ltd. 8/F., Eastern Central Plaza, 3 Yiu Hing Rd, Shau Kei Wan, Hong Kong http://www.commercialpress.com.hk
Printed by	C & C Offset Printing Co., Ltd. C & C Building, 36 Ting Lai Road, Tai Po, N.T., Hong Kong
Edition	First Edition in November 2016

ISBN 978 962 07 5682 5

Printed in Hong Kong

Introducing the Palace Museum to the World

SHAN JIXIANG

Built in 1925, the Palace Museum is a comprehensive collection of treasures from the Ming and Qing dynasties and the world's largest treasury of ancient Chinese art. To illustrate ancient Chinese art for people home and abroad, the Palace Museum and The Commercial Press (Hong Kong) Ltd. jointly published *The Complete Collection of Treasures of the Palace Museum*. The series contains 60 books, covering the rarest treasures of the Museum's collection. Having taken 14 years to complete, the series has been under the limelight among Sinologists. It has also been cherished by museum and art experts.

After publishing *The Complete Collection of Treasures of the Palace Museum*, it is understood that westerners, when learning about Chinese traditional art and culture, are particularly fond of calligraphy, paintings, ceramics, bronze ware, jade ware, furniture, and handicrafts. That is why The Commercial Press (Hong Kong) Ltd. has discussed with the Palace Museum to further co-operate and publish a new series, *The Palace Museum's Essential Collections*, in English, hoping to overcome language barriers and help more readers to know about traditional Chinese culture. Both parties regard the publishing of the series as an indispensable mission for Chinese history with significance in the following aspects:

First, with more than 3,000 pictures, the series has become the largest picture books ever in the publishing industry in China. The explanations show the very best knowledge from four generations of scholars spanning 90 years since the construction of the Museum.

Second, the English version helps overcome language and cultural barriers between the east and the west, facilitating the general public's knowledge of Chinese culture. By doing so, traditional Chinese art will be given a fresher image, becoming more approachable among international art circles.

Third, the series is going to further people's knowledge about the Palace Museum. According to the latest statistics, the Palace Museum holds more than 1.8 million pieces of artefacts (among which 228,771 pieces have been donated by the general public and purchased or transferred by the government since 1949). The series selects nearly 3,000 pieces of the rare treasures, together with more than 12,000 pieces from *The Complete Collection of Treasures of the Palace Museum*. It is believed that the series will give readers a more comprehensive view of the Palace Museum.

Just as *The Palace Museum's Essential Collections* is going to be published, I cannot help but think of Professor Qi Gong from Beijing Normal University; famous scholars and researchers of the Palace Museum Mr. Xu Bangda, Mr. Zhu Jiajin, and Mr. Liu Jiu'an; and well-known intellectuals Mr. Wu Kong (Deputy Director of Central Research Institute of Culture and History) and Mr. Xu Qixian (Director of Research Office of the Palace Museum). Their knowledge and relentless efforts are much appreciated for showing the treasures of the Palace Museum to the world.

Looking at History through Art

YANG XIN

The Palace Museum boasts a comprehensive collection of the treasures of the Ming and Qing dynasties. It is also the largest museum of traditional art and culture in China. Located in the urban centre of Beijing, this treasury of ancient Chinese culture covers 720,000 square metres and holds nearly 2 million pieces of artefacts.

In the fourth year of the reign of Yongle (1406 A.D.), Emperor Chengzu of Ming, named Zhu Di, ordered to upgrade the city of Beiping to Beijing. His move led to the relocation of the capital of the country. In the following year, a grand new palace started to be built at the site of the old palace in Dadu of the Yuan Dynasty. In the 18th year of Yongle (1420 A.D.), the palace was completed and named as the Forbidden City. Since then the capital of the Ming Dynasty moved from Nanjing to Beijing. In 1644 A.D., the Qing Dynasty superceded the Ming empire and continued using Beijing as the capital and the Forbidden City as the palace.

In accordance with the traditional ritual system, the Forbidden City is divided into the front part and the rear part. The front consists of three main halls, namely Hall of Supreme Harmony, Hall of Central Harmony, and Hall of Preserving Harmony, with two auxiliary halls, Hall of Literary Flourishing and Hall of Martial Valour. The rear part comprises three main halls, namely Hall of Heavenly Purity, Hall of Union, Hall of Earthly Tranquillity, and a cluster of six halls divided into the Eastern and Western Palaces, collectively called the Inner Court. From Emperor Chengzu of Ming to Emperor Puyi, the last emperor of Qing, 24 emperors together with their queens and concubines lived in the palace. The Xinhai Revolution in 1911 overthrew the Qing Dynasty and more than 2,000 years of feudal governance came to an end. However, members of the court such as Emperor Puyi were allowed to stay in the rear part of the Forbidden City. In 1914, Beiyang government of the Republic of China transferred some of the objects from the Imperial Palace in Shenyang and the Summer Palace in Chengde to form the Institute for Exhibiting Antiquities, located in the front part of the Forbidden City. In 1924, Puyi was expelled from the Inner Court. In 1925, the rear part of the Forbidden City was transformed into the Palace Museum.

Emperors across dynasties called themselves "sons of heaven", thinking that "all under the heaven are the emperor's land; all within the border of the seashore are the emperor's servants" ("Decade of Northern Hills, Minor Elegance", *Book of Poetry*). From an emperor's point of view, he owned all people and land within the empire. Therefore, delicate creations of historic and artistic value and bizarre treasures were offered to the palace from all over the country. The palace also gathered the best artists and craftsmen to create novel art pieces exclusively for the court. Although changing of rulers and years of wars caused damage to the country and unimaginable loss of the court collection, art objects to the palace were soon gathered again, thanks to the vastness and long history of the country, and the innovativeness of the people. During the reign of Emperor Qianlong of the Qing Dynasty (1736 A.D. – 1796 A.D.), the scale of court collection reached its peak. In the final years of the Qing Dynasty, however, the invasion of Anglo-French Alliance and the Eight-Nation Alliance into Beijing led to the loss and damage of many art objects. When Puyi abdicated from his throne, he took away plenty of the objects from the palace under the name of giving them out as presents or entitling them to others. His servants followed suit. Up till 1923, the keepers of treasures of Palace of Established Happiness in the Inner Court actually stole the objects, set fire on them, and caused serious dam-

age to the Qing Court collection. Numerous art objects were lost within a little more than 60 years. In spite of all these losses, there was still a handsome amount of collection in the Qing Court. During the preparation of construction of the Palace Museum, the "Qing Rehabilitation Committee" checked that there were around 1.17 million items and the Committee published the results in the *Palace Items Auditing Report*, comprising 28 volumes in 6 editions.

During the Sino-Japanese War, there were 13,427 boxes and 64 packages of treasures, including calligraphy and paintings, picture books, and files, transferred to Shanghai and Nanjing in five batches for fear of damage and loot. Some of them were scattered to other provinces such as Sichuan and Guizhou. The art objects were returned to Nanjing after the Sino-Japanese War. Owing to the changing political situation, 2,972 pieces of treasures temporarily stored in Nanjing were transferred to Taiwan from 1948 to 1949. In the 1950s, most of the antiques were returned to Beijing, leaving only 2,211 boxes of them still in the storage room in Nanjing built by the Palace Museum.

Since the establishment of the People's Republic of China, the organization of the Palace Museum has been changed. In line with the requirement of the top management, part of the Qing Court books were transferred to the National Library of China in Beijing. As to files and essays in the Palace Museum, they were gathered and preserved in another unit called "The First Historical Archives of China".

In the 1950s and 1960s, the Palace Museum made a new inventory list for objects kept in the museum in Beijing. Under the new categorization system, objects which were previously labelled as "vessels", such as calligraphy and paintings, were grouped under the name of "*gu* treasures". Among them, 711,388 pieces which belonged to old Qing collection were labelled as "old", of which more than 1,200 pieces were discovered from artefacts labelled as "objects" which were not registered before. As China's largest national museum, the Palace Museum has taken the responsibility of protecting and collecting scattered treasures in the society. Since 1949, the Museum has been enriching its collection through such methods as purchase, transfer, and acceptance of donation. New objects were given the label "new". At the end of 1994, there were 222,920 pieces of new items. After 2000, the Museum re-organized its collection. This time ancient books were also included in the category of calligraphy. In August 2014, there were a total of 1,823,981 pieces of objects in the museum's collection. Among them, 890,729 pieces were "old", 228,771 pieces were "new", 563,990 were "books", and 140,491 pieces were ordinary objects and specimens.

The collection of nearly two million pieces of objects is an important historical resource of traditional Chinese art, spanning 5,000 years of history from the primeval period to the dynasties of Shang, Zhou, Qin, Han, Wei, and Jin, Northern and Southern Dynasties, dynasties of Sui, Tang, Northern Song, Southern Song, Yuan, Ming, Qing, and the contemporary period. The best art ware of each of the periods has been included in the collection without disconnection. The collection covers a comprehensive set of categories, including bronze ware, jade ware, ceramics, inscribed tablets and sculptures, calligraphy and famous paintings, seals, lacquer ware, enamel ware, embroidery, carvings on bamboo, wood, ivory and horn, golden and silvery vessels, tools of the study, clocks and watches, pearl and jadeite jewellery, and furniture among others. Each of these categories has developed into its own system. It can be said that the collection itself is a huge treasury of oriental art and culture. It illustrates the development path of Chinese culture, strengthens the spirit of the Chinese people as a whole, and forms an indispensable part of human civilization.

The Palace Museum's Essential Collections series features around 3,000 pieces of the most anticipated artefacts with nearly 4,000 pictures covering eight categories, namely ceramics, jade ware, bronze ware, furniture, embroidery, calligraphy, paintings and rare treasures. The Commercial Press (Hong Kong) Ltd. has invited the most qualified translators and academics to translate the series, striving for the ultimate goal of achieving faithfulness, expressiveness, and elegance in the translation.

We hope that our efforts can help the development of the culture industry in China, the spread of the sparkling culture of the Chinese people, and the facilitation of the cultural interchange between China and the world.

Again, we are grateful to The Commercial Press (Hong Kong) Ltd. for the sincerity and faithfulness in their co-operation. We appreciate everyone who has given us support and encouragement within the culture industry. Thanks also go to all Chinese culture lovers home and abroad.

Yang Xin former Deputy Director of the Palace Museum, Research Fellow of the Palace Museum, Connoisseur of ancient calligraphy and paintings.

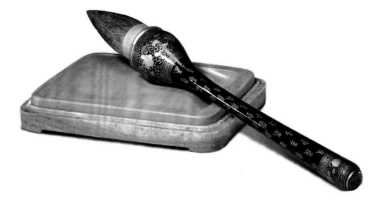

Contents

List of Chinese Treasures

GOLD AND SILVER WARE, JEWELLERY, JADE, PRECIOUS STONES, AND OTHERS

1 **Silver raft-cup**

2 **Gold seal**
with a knob in the shape of intertwining dragons and the seal mark "*fengtian zhibao*"

3 **A set of gold chime bells**
(sixteen bells)

4 **Gold cup**
with the inscription "*jinouyong-gu*" (gold cup that lasts forever) and inlaid with pearls and precious stones

5 **Gold celestial globe**

6 **Gold stupa**
with gold filigree designs and inlaid with pearls and precious stones

7 **Gold stupa**
for containing hair

8 **Gold statue of Sakyamuni Buddha**

9 **Gold *ruyi* scepter perfume-holder**
with engraved designs

10 **Silver lobed vase**
with silver filigree designs

11 **Lobed gold ewer**
engraved with designs of dragons amidst clouds

12 **Perfume-sachet**
with gold filigree designs

13 **Gold basin**
with engraved designs of eight auspicious symbols and two phoenixes

14 **Gold cup and plate**
with engraved designs and inlaid with pearls

15 **Gold censers**
in the shape of cranes (a pair)

16 **Gold shrine**
in the shape of a tower-pavilion inlaid with pearls and turquoises

17 **Gold statue of Maitreya Buddha**
inlaid with pearls

18 **Gold Mandala (*tancheng* or altar-city)**
with gold filigree and engraved designs inlaid with turquoises

19 **Eight auspicious symbols**
with gold filigrees and inlaid with precious stones

20 **Seven Buddhist treasures**
with gold filigrees and inlaid with precious stones

21 **Gold dragon and phoenix coronet**
inlaid with pearls, precious stones, and kingfisher feathers

22 **Green jade imperial seal**

23 **Jaspar seal**
with the seal mark "*huangdi fengtian zhibao*"

24 **White jade bowl**
with two ears and designs inlaid with gold wires and precious stones

25 **White jade bowl**
with a gold cover and a stand and engraved with Tibetan scripts

26 **Jasper water-dropper for an inkstone**
in the shape of a sacrificial animal

27 **A set of jasper snuff bottles**
with animal-shaped ears

28 **Weasel-hair brush**
with a celadon jade holder-tube and a cloisonné enamel holder with designs of dragons in relief

29 **Celadon jade miniature landscape**
with designs of narcissuses

30 **Sabre**
with a white jade hilt inlaid with precious stones and a peach-wood scabbard coated with gold and inscribed "*hanying*"

31 **Celadon jade dagger**
with a hilt inlaid with precious stones and a scabbard decorated with copper leaves

32 **Jadeite *qing* chime**
with a design of an elephant bringing peace

33 **Red and white agate flower receptade**
in the shape of two carps

34 **Aventurine boulder**
with designs of three rams bringing prosperity in the beginning of a New Year

35 **Glass snuff bottle**
with painted designs of flowers of wealth in colour enamels

36 **Glass snuff bottle**
with painted designs of *kui*-dragons in colour enamels

37 **Glass snuff bottle**
with painted designs of western ladies in colour enamels

38 **Red overlay white glass snuff bottle**
with designs of a dragon and a phoenix

39 **Mixed colour aventurine gourd-shaped glass snuff bottle**

Treasures of Dynastic China in the Collection of the Palace Museum

LIU YUE

In the collection of the Palace Museum, there are over one million and eighty thousand cultural relics covering various periods from the primitive society to the Ming and Qing dynasties. These relics represent all types of materials and crafts with most of them coming from the court collection of the Qing Dynasty. With the passage of time, these cultural relics are testimonies of Chinese history and her splendid culture embodying cultural essence and spirit of humanity. Various artefacts were produced by prominent masters, made with valuable materials, or created with skilful designs, reflecting the highest technical accomplishments of their respective periods. They also reveal the changes of aesthetic pursuit in designated periods and are acclaimed as treasures of the Chinese dynastic history.

DEFINITION OF THE TERM "TREASURES" AND THE EDITORIAL PRINCIPLES OF THIS VOLUME

"Treasures" can be defined in a broad sense and a narrow sense. Broadly speaking, "treasures" refer to those artefacts produced with precious materials with high value and wide coverage, whereas "treasures" in a narrow sense refer to those artefacts made with gold, silver, pearl, jade, and other jewellery. These artefacts can be further divided into two groups. One group is confined to inorganic materials such as gold, silver, and others, jade and stones, such as nephrite, jadeite, lapis lazuli, turquoise, and malachite, mineral precious stones, such as diamond, ruby, sapphire, emerald, tourmaline, zircon, crystal, olivine, garnet, etc. Another group is confined to organic materials such as ivory, rhinoceros horns, coral, cloudy amber, pearls, etc. It is to be pointed out that categorization of "treasures" does not remain the same at all times, but subject to changes with historical evolvement. For example, bronze, copper, and isinglass, which were quite rare in the past, had been removed from the categories of "treasures" in later times.

In the compilation of this volume, the term "treasures" is defined in between its broad and narrow senses. The term "treasures" in its narrow sense becomes the core of selection with reference to their values, but the selection criterion has also been extended by taking reference to the historical significance as well as the cultural and aesthetic characteristics of the artefacts. Such a criterion is based on a pre-requisite: the current volume is one of a series of collection catalogues. The volume on "treasures" is conceptually in parallel and consistent with the other volumes on calligraphy and painting, bronzes, ceramics, jade carvings, embroidery, furniture, and others.

This volume has included 229 pieces (sets) of cultural artefacts that can be categorized as treasures,

and which were divided into three major groups. The first group covers gold, silver, and jewellery, which is further sub-divided into categories of gold and silver ware, ware decorated with pearls, precious stones and jade, organic precious stones, and ancient inkstones. The second group covers lacquer, wooden, and other carved ware, including ancient *qin* zithers, lacquer ware, bamboo and wood carvings, and ancient inksticks and ink cakes. The third group covers metallic ware in enamels. In terms of materials, these artifacts include gold and silver, jade and precious stones, glass, ivory, rhinoceros horns, lacquer, bamboo, wood, and enamel ware. In terms of usage and function, these artefacts cover ritual, religious, military, decorative ware, costumes, and scholar's objects. They reveal the principles and typical characteristics of the Qing court collections, production and usage of such ware, and scope of preservation of other artefacts, in addition to calligraphy and painting, bronzes, ceramics, jade and stone carvings, and embroidery with outstanding representativeness and paragon of such ware.

THE CULTURAL SIGNIFICANCE OF TREASURES

The coverage of treasures is wide and these treasures have sophisticated social, political, economic, and geographical backgrounds with each category and each piece of them showing deep historical and cultural significance. The pursuing paragraphs give a general analysis.

Long history and continuous development

The production of most treasures has a long and continuous tradition as indicated by a great number of archeological finds. Decorative objects made with precious stones had been produced as early as the late Neolithic period. For example, at the site of Beiyinyangying (4000 – 3000 B.C.) at Nanjing, Jiangsu, decorative accessories made with jade, quartz, agate, and other materials were found at the chest of the deceased. At the tomb sites of the late Longshan culture (2500 – 2000 B.C.) at Xizhufeng, Linqu, Shangdong, the lady buried there had turquoise earrings on her ears and jade tubes as decorative pendants on the chest. At the tomb sites of the Xia and Shang kingdoms at Xiajiadian, Chefeng, Inner Mongolia, a significant quantity of turquoise, white stones, jade, agate, and other beads and tubes were unearthed, exemplifying that the use of precious stones was already popular at the time.

Owing to their nature and distinctive qualities, gold and silver were probably the earliest metals used by human kind. Gold would not easily become a chemical compound with other elements and often keeps its nature as a mineral. It is also a rare material with charming colours which would not easily change and is not hard but rather plastic to facilitate modeling, thus it has been appreciated and used since the pre-historic times. The reserve of silver on earth is more abundant than that of gold; however, its surface will become easily oxidized, and is less treasured in terms of its aesthetic value and rarity. In spite of this, it is also used as a precious material for producing objects. On the pottery shards unearthed at the site of the Longshan culture at Tangyin, Henan, it was found they had been mixed with gold sands, showing that people at the time utilized gold intentionally for decorative purposes. At the site of Huoshaogou, Yumen, Gansu, which was dated to the Xia Kingdom, the earliest gold and silver ornaments including gold and silver bracelets were unearthed. Subsequently in the dynasties to follow, gold and silver were used more and more frequently for producing high quality ware and objects, and had also become a medium as currencies for transaction. As a result, these materials had become symbols of wealth and high status.

Comparatively speaking, if the history of producing gold and silver ware in China could not surpass that of West Asia, lacquer ware was no doubt an ingenious Chinese innovation. The chapter *Shiguopian* in the classic *Hanfeizi* of the Warring States period recorded that "In producing food vessels, King Yu and Shun had chopped woods in mountains and carved them for layering with lacquer and ink…in

making sacrificial vessels, King Yu layered the exterior of the ware with black and the interior with cinnabar lacquer". Such record reveals that as early as in the periods of King Yu and Shun, which was dated four to five thousand years ago, food and sacrificial ware was layered with lacquer. In the classic *Hanfeizi*, it was further elaborated that "such a practice of King Shun had been regarded as too extravagant by the lords, and thirteen kingdoms did not follow such a practice". This record reflects that lacquered ware was regarded as luxury objects at the time, and was used as ritual objects during sacrificial ceremonies. Archaeological finds also show that lacquer ware with wooden bodies was unearthed at the sites of Hemudu, Yuyao, Zhejiang, which was dated six to seven thousand years ago. From such finds, it is known that lacquer ware was produced in parallel with stone and pottery ware since the Neolithic period for several thousand years before the coming of the Bronze Age.

The history of bamboo, wooden, ivory, and rhinoceros horn ware could also be traced to the Neolithic period or even earlier. It was because these materials were available in the natural environment and could be easily obtained. Probably they were utilized for making objects even earlier than bronzes and ceramics which were artificially produced. They were also probably be used for making utensils and tools for daily usage. The Chinese characters in ancient China for describing these tools and utensils often carried writing structures of "*mu*" (wood) and "*zhu*" (bamboo) and archaeological finds also provided proof to this point.

More important was that the sustainable development of Chinese history had facilitated the progressive development of these crafts with the evolution of economy, technology, and culture, and more works were produced with period characteristics in the subsequent dynasties. Such ware highly nourished people's life. Although in historical development, the production of the ware might not be always stable at all times, and might prosper or decline at various times, these crafts had maintained continuous development in general with cross influences among each other, marking a cradle of production and collection as revealed in the court collections of the Qing Dynasty.

Ritual significance and symbols of rank and status

Among the treasures collected in this volume, objects related to the court number the most and also represent the best quality. One of the distinctive features is that these objects carry ritual significance and are symbols of rank and status. For example, there were stringent regulations on the use of materials, such as the shape of knobs and sizes in the production and use of imperial seals. The Emperor was the highest ruler of the country and his imperial seals numbered the most, indicating the highest rank. In the Qianlong period, it was ordered that the Emperor should have twenty-five imperial seals made with gold, jade, sandalwood, and others. For example, the jasper seal with a seal mark "*huangdi fengtian zhibao*" (plate 23) was made in the period of Emperor Taizong of the Qing Dynasty before the Manchus conquered China. The principle laid down that the Emperor ruled the nation with the order from heaven. There were another ten imperial seals which were kept at the Fenghuang Tower at Shenjing (present day Shenyang). Among them, the gold seal with a knob in the shape of intertwining dragons and the seal mark "*fengtian zhibao*" (plate 2) was one of the earliest imperial seals made in the early Qing period, and it represented the supreme sovereignty of the Emperor. The set of gold chime bells (plate 3) with altogether sixteen pieces was casted for the 80th birthday of Emperor Gaozong (Qianlong) in the 55th year of the Qianlong period (1790 A.D.) with consumption of 11,439 taels of gold. These bells were rare and valuable musical instruments for performing the music *zhongheshaoyue* (*shao* virtuous and peaceful music performance) during sacrificial ceremonies and court ceremonies when the Emperor ascended the throne with a significant ritual attribute. This set is one of the two extant sets of gold bells with the other casted in the Kangxi period of the Qing Dynasty, reflecting the power of China and the whole system of rites in the Kangxi and Qianlong periods. Groups of treasures were also used in the processions of Emperors and Empresses. One of the most representative objects was a set of eight pieces of gold ware known as the "eight gold pieces". According to chapter 77 of the *Qing Collected Statues*, during the procession ceremony

of the Emperor, eight types of gold ware would be used, including two pieces of gold incense burners with overhead handles, one large and one small vases (jars), one piece of gold basin (washer or basin for washing face), one piece of water pot (spittoon), and two perfume-containers. The size, form, decoration, and usage of each of them have stringent regulations, and they must be made with "high quality gold with hammered designs of dragons amidst clouds, flames, auspicious plants, and set and inlaid with red coral, lapis lazuli, and turquoise". These eight types of ware were "displayed on an octagonal cinnabar lacquer tray with designs of dragons in gold" and supported by a "square cinnabar lacquer stool with designs of dragons in gold and a floral mat". This complete set of gold objects fully demonstrated the high status of the user with ritual attributes. The "eight gold pieces" were also used in the processions of the Empress Dowager and Empress, but with different decorations, as represented by a gold basin with engraved designs of eight auspicious symbols and two phoenixes (plate 13). The rim is decorated with designs of auspicious symbols produced by the hammering technique and set and inlaid with red coral and turquoise beads, while the interior base is decorated with molded designs of lotuses, phoenixes, and foliage scrolls. Obviously such ware was not for functional use, but symbols of imperial sovereignty and ranking status.

The present volume also illustrates a special object, a gold cup with the inscription "*jinouyonggu*" (gold cup that lasts forever) and inlaid with pearls and precious stones (plate 4), which was a ritual object used by the Emperor in the first writing ceremony held at the Chinese Lunar New Year. The body of the cup is in kingfisher green colour and engraved with floral designs set and inlaid with eleven east pearls, nine rubies, twelve sapphires, and four tourmalines. At the *zi* hour (23:00 hour – 01:00 hour) of every Lunar New Year, the ceremony would be held at the Dongnuan Studio of the Yangxin Palace. At the time, the Emperor would change his dress and light a candle on a candle-stand known as "jade candle burns for a long time" with this gold cup put beside, pour *tusu* wine into the gold cup, and hold a brush to write auspicious inscriptions for blessing the nation to

last forever and its people to enjoy peace, wealth, and prosperity.

Costumes were also artefacts that revealed ranking and status. On a gold dragon and phoenix coronet inlaid with pearls, precious stones, and kingfisher feathers used by Empress Xiaoduan, wife of Emperor Shenzong of the Ming Dynasty, which was unearthed at the Ding Mausoleum (plate 21), over one hundred rubies, sapphires, and five thousand pearls in different sizes were used with woven gold wire designs to decorate this coronet with a splendid colour scheme and extravagance. It represented the status of the "Mother of the Nation" of the deceased Empress. Another work, which was a winter imperial mink court hat decorated with gold phoenixes worn by the Empress (plate 51), was made from mink with red embroidered wrappings, and inlaid and set with numerous east pearls, pearls, corals, cat's eye stones, and other precious stones. This hat was not only decorated in an elegant and luxurious manner, but also provided valid reference to the rules of dressing as recorded in the manual *Qing Collected Statues*.

On the other hand, rulers in dynastic China had already given order for the exclusive use of certain materials with stringent regulations on their usage. For example, in the Qing Dynasty, the pearls from the Songhua River regions in Northeast China were named "east pearls" as the Manchus arose to power from this region. The court had paid much attention to the use of these pearls and commissioned special labour to obtain these pearls, which must be sent to the court for the exclusive use of the Emperor, Empress, concubines, and members of the imperial family. According to their size and lustrous quality, these pearls were classified into five grades for designation to different ranks for use. The use of first-grade pearls was only confined to the Emperor and Empress, whereas the use of pearls from grade two and below was confined to concubines and other members of the imperial family.

A splendid assembly of crafts

At the beginning of this introduction, the definition of "treasures" was elaborated. Other than the materials, special attention is given to

"techniques". Other than extending the criterion for selecting objects for inclusion, objects are also selected with the criterion to represent the highest technical accomplishments in terms of the respective crafts in their designated periods of production. Some of the objects even show a consummate assimilation of different types of techniques and materials, revealing a splendid assembly of different crafts.

With gold and silver ware as examples, the production of gold and silver ware in the Qing Dynasty often blended techniques of casting, hammering, engraving, gold filigree designs, as well as set and inlay on the same object. A gold stupa for containing hair (plate 7) was produced in the 42nd year of the Qianlong period (1777 A.D.) with the order of Emperor Gaozong (Qianlong) to pay homage to his mother Empress Dowager Xiaozhengxian by keeping her hair inside. In producing this work, a total of over 3,000 taels of gold were used with utilization of casting, carving, engraving, and incising techniques, and it was further inlaid and set with pearls, rubies, sapphires, turquoises, and other precious stones. It is the highest and heaviest stupa with the most refined designs of the Qing court extant. On a gold Mandala (*tancheng* or altar-city) with gold filigree and engraved designs inlaid with turquoises (plate 18), marvellous and sophisticated designs were rendered skilfully on the mandala with a diameter of only less than 20 cm. This piece reflects the superb technical production of gold and silver ware in the Qing Dynasty. In addition, a peach-shaped gold box with carved coral designs of dragons amidst clouds, bats, and character "*shou*" (longevity) (plate 82) has a gold body and is coated with red coral on the exterior. These two materials were utilized perfectly in brilliant matching gold and red colours with elegance of the Qing court style. A jadeite miniature landscape with designs of bamboos (plate 46) and other miniature landscapes inlaid and set with precious stones utilized various precious stones for decorations to resemble naturalistic landscapes and were refined decorative objects. Ornaments such as *bianfang* hair crosspieces, hairpins, and bracelets were made with gold and silver, and further decorated with kingfisher feather designs and inlaid and set with precious stones with a touch of extravagance and elegance, reflecting the fashion favoured by court ladies in the Qing Dynasty.

As an essential category of the splendid assembly of crafts, ancient *qin* zithers must be included. To produce a *qin* zither, various processes in the selection of the materials, carving and production, lacquer layering, inlaid of *hui*-markers, and fastening of strings were required. In the selection of materials, wood with soft and loose textures would be used, such as parasol and Chinese catalpa. In ancient China, there were strict steps to follow in the treatment of textures, width, hardness, scars, storage conditions, and the final touch-ups of *qin* zithers. In the production process, design, drafting of diagrams, production of the top surface (including sound absorbers and releasing holes) and base (including the dragon pond and phoenix pool), fixing of parts, and final drying were essential steps, and then ko-hemp cloth would be mounted on the *qin* zither with the application of an ash biscuit glued by mixing raw lacquer and antler powder or glued by the so-called eight precious ashes which were a mixture of powdered gold, silver, mother-of-pearl, turquoise, and other precious materials, and coated with many layers of lacquer. After the *qin* zither was grinded flat, the surface of the zither would be further polished and lacquered again. Finally *hui*-markers, pegs, and strings made from various precious materials would be added to complete the production process. Mostly, mother-of-pearl, gold, jadeite, and jade were used to produce the *hui*-markers, and the legs and pegs were often made with hard wood such as red sandalwood, redwood, and occasionally with jade or horn. The strings were made with silk. Therefore, in the production of a *qin* zither, various crafting techniques had to be utilized at the same time. The *qin* zither "*Jiuxiao Huanpei*" (Celestial Tinkle) (plate 98) and the *qin* zither "*Dasheng Yiyin*" (Sages' Voice) (plate 99) illustrated in this volume were produced by the *Lei* family which was a reputed production workshop for *qin* zithers in the Tang Dynasty, whereas the *qin* zither "*Qinglai*" (Pristine Lilt) (plate 100) was dated to the Southern Song Dynasty and had survived over a thousand years. It is extremely treasurable that these *qin* zithers were preserved in perfect conditions and could still be played, and they were valuable artefacts of great historical value.

The paragon of period styles

Chinese treasures are not only representative objects with historical, cultural, and technical significance, their forms, decorative motifs, and aesthetic appeal also reflect the stylistic developments in various dynasties and periods.

A silver raft-cup (plate 1) was a representative and refined piece of work made by Zhu Bishan, a reputed silversmith of the Yuan Dynasty. The form of this raft-cup was derived from the legend of Yan Junping, a Daoist priest of the Han Dynasty, who rode on a raft upstream to reach the origin of the river and finally arrived at the heavenly river. This piece was creatively modeled with a classical and romantic essence. The figure was depicted with graceful facial expressions. Considering the foreign rule of Mongols in the Yuan Dynasty, the short span of their rule, and the social upheavals at the time, this piece might be a symbol of upholding the lofty attitude of the literati class in an era of turmoil, and the message it carried had been highly regarded. Zhu was an esteemed silversmith in the Yuan Dynasty, who enjoyed the fame that could not be surpassed by other silversmiths in the Chinese dynastic history. The form of this cup had been copied and modeled by other craftsmen in later times, and a rhinoceros horn cup in the form of an immortal riding on a raft (plate 62) of the late Ming Dynasty should have been made by following the work created by Zhu Bishan.

In order to understand the distinctive features of the crafts in the Yuan Dynasty, lacquer ware provided typical examples. There were four major types of Yuan lacquer ware, including carved cinnabar lacquer ware, ware with designs inlaid with mother-of-pearl, plain monochrome lacquer ware, and engraved gold (*qiangjin*) lacquer ware. Extant carved lacquer ware, including carved cinnabar, carved black, and striated carved (*tixi*) lacquer ware, numbered the most and showed marvelous technical accomplishments. Various noted masters such as Zhang Cheng, Yang Mao, Zhang Minde, and others were recorded, and their common stylistic characteristics included the use of good quality and thickly layered lacquer, fluent carving techniques, and lustrous and rounded decorations. They also borrowed the art of Chinese painting for incorporation into lacquer art, and this was related to the artistic trend and practice at the time. An octagonal cinnabar lacquer tray with carved designs of pavilions and figures (plate 101), a cinnabar *zun* spittoon with carved floral designs (plate 102), a round cinnabar lacquer dish with carved designs of gardenias (plate 103), and a round cinnabar lacquer box with carved designs of a mansion-pavilion and figures (plate 104) made by these artists revealed their accomplishments in rendering decorative themes and distinctive styles in the mastery of the art of lacquer craft. Although the artist who made the round lacquer dish with striated carved lacquer (*tixi*) designs of cloud patterns (plate 108) was not known, the work still revealed the distinctive period style of carved lacquer ware of the Yuan Dynasty with its spontaneous and heroic vigour in artistic rendering.

The art of carved lacquer ware had profound influence on the lacquer art of the Ming Dynasty. The carved lacquer ware of the Yongle period of the early Ming Dynasty was characterized by thick layers of lacquer, rounded and lustrous carving, as well as fine polishing and increasing decorative motifs, showing the progressive developments with legacy of Yuan lacquer art. Various ware extant reflects the flourishing industry of lacquer at the time, as represented by typical works such as a round cinnabar lacquer dish with carved designs of peonies and peacocks (plate 110) and others. The Xuande period of the Ming Dynasty marked a transitional stage of lacquer art with new creative ware such as a round multi-colour lacquer carrying box with carved designs of two orioles and an apple tree (plate 116), which is characterized by luxuriant colours of lacquer layers and exquisite carved and polished designs. Another example is a round cinnabar lacquer box with carved designs of nine dragons (plate 117) with its form and decorations similar to Yongle ware, but the colour of lacquer is brilliant and the designs were rendered with sharp and angular carving without the lustrous charm of the ware in the preceding dynasty. From the Zhengtong to the Zhengde periods (1436 – 1521 A.D.) of the mid Ming period, the production of imperial lacquer ware had nearly suspended, and the style of lacquer art became more meticulous and delicate instead of the simple and precise style

in vogue previously. In the Jiajing and Wanli periods, the transformation of the styles in lacquer art had materialized, and the carving style turned into sharp and clear artistic rendering. In addition to the typical decorative motif, such as "designs of the character '*chun*' (spring) and auspicious symbols of longevity" (plate 124) with eminent auspicious attributes of Daoism, increasing auspicious themes with popular appeal appeared, revealing the stylistic characteristics in the mid and late Ming periods. The cinnabar lacquer ewer with carved designs of landscapes and figures (plate 128) was a piece with a purpleclay body in the form of a teapot made by Shi Dabin, a well-known master who excelled in producing purpleclay ware, and this was the only work of Shi extant, thus highly treasurable. On the other hand, a rectangular black lacquer box with designs of dragons amidst clouds inlaid with mother-of-pearl (plate 129) was a representative piece of ware made by Jiang Qianli, an artist prolific in producing ware with set and inlaid designs, which revealed the high standard in the production of lacquer ware inlaid with thin mother-of-pearl designs in the late Ming period.

After the turmoil in the late Ming period, less lacquer ware was produced as lacquer art was still in an initial period of revival in the early Qing period. In the mid Qing period, lacquer art had attained a golden period of development with stylistic characteristics of refined and extravagant aesthetic appeal and precise and delicate rendering. Ware produced in the Qianlong period, such as a cinnabar lacquer box with carved designs of a scene of literary gathering (plate 138) and a cinnabar lacquer box in the shape of a maple leaf with carved designs of autumn insects (plate 142), was rendered with brighter colours, sharp carving techniques, and a touch of sophistication and extravagance, reflecting court taste. A cinnabar lacquer plate in the shape of chrysanthemum petals (plate 147) was made with a very thin silk body less than 1 mm in thickness and layered with cinnabar lacquer in a colour simulating red coral with a shiny and delicate charm, revealing the highly progressive development of lacquer art in the period. A diaper-shaped black lacquer tray with gold painted designs of landscapes (plate 144) and others had borrowed the decorative style of Japanese lacquer ware in pursuit of new artistic innovations at the time. A multi-colour lacquer box in the shape of a caltrop flower with engraved gold (*qiangjin*) designs of phoenixes (plate 136) showed the consummate blending of techniques of painted lacquer, filled-in multi-colour lacquer, and engraved gold lacquer (*qiangjin*) on the same object, materializing an innovative artistic creation after lacquer art had entered its full stage of maturity. Since the Daoguang period, with the decline of imperial power, lacquer art began to decline as well. The craftsman Lu Kuisheng was one of the few reputed artists at the time, and his extant work, which is a sandy lacquer inkstone box with designs of three cocks inlaid with *baibao* (a hundred precious) stones (plate 149), still maintained a refined standard of producing lacquer ware in the late Qing period.

Another category of crafts with eminent period styles was enamel ware with metallic bodies, and such ware could be further sub-divided into cloisonné enamel ware, champlevé enamel ware, and painted enamel ware. Historical records showed that the art of cloisonné enamel was imported from West Asia into China in the Yuan Dynasty, but there were few pieces of cloisonné enamel ware of the Yuan Dynasty extant and they were not dated. Various ware with Yuan dates was actually produced in the Ming Dynasty. However, with a close examination on the cloisonné enamel ware with marks of the Ming Dynasty, it was found that some of them were not produced in the Ming Dynasty, such as a cloisonné censer with elephant-shaped handles and designs of lotus scrolls (plate 193) and a cloisonné enamel *zun* vase with designs of three animal heads holding rings and lotus scrolls (plate 194). The colours of enamels on various parts of them varied. The enamels on the principal parts of the ware were thick with pure, brilliant, and translucent colours, and the objects were mostly decorated with floral scrolls depicting large flowers; yet the areas near the feet were bordered with lotus lappets or banana leaf patterns. This style of artistic rendering was rather similar to the decorative styles on nasish textiles and gold embroidery with influences from Persia and the decorations on Yuan ceramics. Therefore some experts opine that these pieces should have been produced in the Yuan Dynasty but modified later.

Most of the enamel ware of the Ming Dynasty was produced in the Xuande, Jingtai, Jiajing, and Wanli periods of the Ming Dynasty, and extant ware often carries reign marks of their respective periods. Xuande ware was often layered with light blue enamel as the ground, and decorated with designs in a lustrous and pure colour scheme with red, yellow, green, and white enamels. Decorations were mostly flowers defined in a precise manner. Most of the ware carrying the mark of the Jingtai period was fakes, and with reference to historical documents and compared to related crafts, cloisonné enamel ware (which was known as "Jingtai blue" ware in later times) had greatly flourished at the time. Large ware with a height as a man was produced, and there were innovations in terms of enamel colours. The ware produced in the Jiajing and Wanli periods was inferior if compared to the ware produced in preceding periods. However, enamels in white, green, brown, or with a combination of two to three colours were utilized as the ground in addition to blue, exuding a refreshing charm with a brilliant colour scheme.

Other than imitating the styles of Jingtai ware and western ware in the Kangxi and Qianlong periods of the Qing Dynasty, there was a significant quantity of enamel ware with decorative styles of the court produced, with type forms and production skills surpassing those of the preceding periods. At the time, new minerals from Boshan, Shangdong were utilized and the colours became different. A cloisonné enamel Lama stupa with a gold statue of Buddha now on display at the Fanhua Tower, Forbidden City (plate 212) had consumed over several ten thousands of silver taels and was a representative piece of the period. Owing to the aesthetic favour of Emperor Gaozong (Qianlong), crafts of the court in the Qinglong period were in pursuit of archaism. A cloisonné enamel *yan* boiler with designs of animal masks (plate 209) and a cloisonné enamel chicken *zun* vase (plate 211) were produced with a touch of archaism, yet they were also creative in the sense that they blended the forms and decorations of various crafts for re-shaping into new styles that showed the distinctive period style of the time.

The outlook of champlevé enamel ware was quite similar to that of cloisonné enamel ware, but the technical production was different in that the designs were not in relief outlines by utilizing the welding technique, but were directly applied on the ware with casting, engraving, champlevé, and erosion techniques. In the Qing Dynasty, Guangzhou (Canton) had become an important port for foreign trade, and champlevé enamel ware with western decorative designs greatly flourished. Many huge decorative objects and furniture for use by the imperial court and in imperial gardens were produced there. The technique of painted enamel was probably introduced into the court by way of Guangzhou as early as the Kangxi period and flourished in the Qianlong period. Foreign missionaries such as Giuseppe Castiglione, Matteo Ripa, and the French craftsman who adopted the Chinese name Chen Zhongxin had served at the Inner Court to paint enamel ware. As a result, Chinese painted enamel ware had experienced a transformation, and the ware with western style also became a vital part of traditional enamel art. We may quote examples such as a painted enamel vase with designs of peaches and bats (plate 215), a painted enamel flower basket in the shape of a begonia and decorated with designs of peonies of the Kangxi period (plate 216), a painted enamel teapot with designs of flowers and butterflies of the Yongzheng period (plate 219), an eight lobed painted enamel teapot with an overhead handle and designs of landscapes, flowers, and birds in panels (plate 223), and a set of painted enamel gold cup and saucer with designs of western young ladies (plate 225) of the Qianlong period for comparison, and the stylistic changes in their respective periods could be obviously defined.

Since the Song Dynasty, the literati class had become the leaders of fashionable tastes in their periods. The development of art and crafts had to suit their literati and aesthetic pursuits in order to fulfill their spiritual and material aspirations. As a result, decorative themes with historical stories, legends, and literati attributes had increased. Aesthetically, lyricism and archaism were more favoured than merely skilful rendering. Inscriptions, colophons, or even long essays were composed to explain the background of various objects and enrich them with cultural significance. Therefore, various objects such as brushes, ink, inkstones, and others, which were closely

associated with literati pursuit, had become dominant pieces of art and crafts. It was said that "when fine brushes and ink were obtained, the greatest pleasure in life would be achieved", and this statement truly explained the significance and meaning of stationery to the literati class. For example, the production, appreciation, display, and collection of inkstones were much favoured by the men-of-letters. Since the Song Dynasty, inkstones used or inscribed by reputed masters had become valuable collectors' objects, such as the inkstones of Su Shi and Mi Fu, and they were often copied or imitated in later periods. Xiang Yuanbian, a great connoisseur of the Ming Dynasty, had collected various famous inkstones. Jin Nong, a well-known calligrapher, painter, and one of the "Eight Eccentrics of the Yangzhou School of Painting" had a rich collection of inkstones, and he named himself "a wealthy man who possesses one hundred and twenty famous inkstones". Huang Ren, a noted connoisseur of inkstones in the Kangxi and Qianlong periods, had collected ten refined inkstones, and named his studio "Studio of Ten Inkstones" with a pseudonym "Master of Ten Inkstones". Two *duan* inkstones collected by Huang (plates 91, 92) are included in this volume for appreciation by our readers.

Inkstones are essentially associated with ink. Xie Shaopeng, a calligrapher and literati of the Song Dynasty, had written a letter to Zhao Lingrang (*zi* Danian), a member of the imperial family, to borrow two famous pieces of inksticks made by Li Chengyan and Zhang Yu, who were reputed masters for ink production, for personal appreciation. He promised that if the inksticks made by Li Chengyan were authentic, he would exchange them with an acclaimed calligraphic work *Yiretie Manuscript* written by Wang Xizhi from his collection. This letter was later known as the *Danian Manuscript* (now in the collection of Palace Museum), which was not only a masterpiece of calligraphy in cursive script, but also provided significant reference for the making of ink in the Five Dynasties period and connoisseurship in the Northern Song Dynasty. In the Ming and Qing dynasties, renowned masters for producing ink, such as Cheng Junfang and Fang Yulu of the late Ming period, and Cai Sugong, Wang Jishang, Wang Jie'an,

and Wu Kaiwen, who were collectively known as the Four Masters for producing ink in the Qing Dynasty, were closely associated with the literati class, and their works were highly acclaimed by men-of-letters. With the increasing interest in collecting and appreciating ink, a kind of "assorted inksticks and ink cakes" came into being in the Qing Dynasty, which was for appreciation rather than for practical use. This kind of "assorted inksticks and ink cakes" required high technical competence for production and should possess high qualities, revealing the impact of aesthetic tastes of designated periods on the production of ink.

In addition to brushes, ink, and inkstones, the culture for establishing an ideal studio space for the literati had also matured, and various objects for decoration or for use in a studio were produced in increasing numbers. For example, ink-droppers, water-pots, perfume-holders, flower-pots, miniature landscapes, and boulders all belonged to this group of scholar's objects. A lacquer treasure box with painted designs of fans in gold tracery over a gold-sprinkled ground (plate 160) was a special box for storing stationery objects used by the court, which was known as "(a box) for keeping a hundred assorted collectibles". In a box with moderate size and creative designs, there are sets of boxes in which are drawers and compartments with each compartment storing one object. Small boxes might store several objects or over ten objects, and large boxes might store up to several hundred objects. In terms of categories, these objects include calligraphy, painting, jade ware, ceramics, enamel ware, lacquer ware, bamboo and wood carvings, and others. In terms of forms, these objects include bowls, plates, vases, boxes, water-pots, water-droppers, wrist-rests and other stationery items, and accessories such as rings, fan pendants, and others. The time and locality for producing these objects spanned from the ancient to the present, and from the west to China. These treasure boxes reflected the maturity of connoisseurship with consideration to both decorative and appreciative merits, and a major focus in design was that these boxes should be easy for storing objects and for carrying.

Most of the bamboo and wood carvings included in this volume are scholar's objects, in particular bamboo carvings. With the pronouncement,

patronage, or even direct participation of the literati class, bamboo carvings had caught much attention with their artistic appeal enhanced. Subsequently, artistic bamboo carvings were produced in addition to bamboo ware for daily use, and had become a special repertoire of art that flourished in Jiading (present day Shanghai), Jinling (present day Nanjing), and adjacent areas, reflecting distinctive regional characters. A bamboo brush-holder with carved designs of ladies (plate 162), a small bamboo vase carved in the shape of a pine tree (plate 163), and a boxwood brush-holder carved with the scene of announcing victory at Dongshan (plate 167) exude a strong sense of literati aesthetics and have high artistic merits that could match other antiques and scholar's objects.

Other than literati aesthetics, various items of crafts carried mundane tastes in terms of artistic rendering, in particular in the choice of auspicious decorative motifs. This was closely related to the ingenious nature of the materials used for production, and there was no conflict between "literati" and "mundane" aesthetics in decorating objects. For example, a gold *ruyi* scepter perfume-holder with engraved designs (plate 9) has adopted a form symbolic of auspicious blessings, and the decorations are also assembled with auspicious motifs. The design of "three abundances", including citrons, peaches, and pomegranates, on a red sandalwood box in the shape of a bookcase and with carved designs of three abundances inlaid with a hundred precious stones (plate 173) is suggestive of the blessing of fortune, longevity, and fertility. A miniature landscape with a gilt copper basin with gold filigree designs and set with precious stones and pearls, and with designs for blessing ten thousand years of longevity (plate 48) and a jadeite *qing* chime with a design of an elephant bringing peace (plate 32) are also decorated with prominent auspicious designs. Common auspicious decorations include gourds which are a symbol of prosperous family life, *lingzhi* fungi which are a symbol of long life, peonies which are a symbol of wealth, and persimmons and *lingzhi* fungi which are homonyms that symbolize "good wishes for everything to come". On some objects, even auspicious Chinese characters such as "*fu*" (fortune), "*shou*" (longevity), "*xi*" (double

happiness), and others were directly adopted as decorative designs. In the Ming and Qing dynasties, it was a popular practice that "decorative designs should carry meanings, and meanings must carry auspicious blessings" in rendering decorations. Skilful craftsmen could also cleverly enable viewers to appreciate and understand the auspicious blessing imbued in the decoration without over-exaggeration.

Inclusive cultural character and identity

The rich contents of treasures as cultural artefacts are formulated by multi-cultural elements, which include the interaction of the court and regional characters, the inter-relationship between Chinese and aboriginal civilizations, and the meeting and assimilation of Chinese and foreign cultures.

Most of the objects selected for this volume were collected by the Qing court, and various objects had been directly produced by the Imperial Workshops in accordance with imperial orders from Emperors. It is obvious that the court styles were based on the foundation of regional crafts: they were closely associated with each other in terms of choice of materials, technical production, creative forms, and decorative motifs, and were cross-influenced. A typical example was the bamboo skin veneered (*zhuhuang*) ware. *Zhuhuang* (bamboo skin veneered carving) was also described as "*tiehuang*" (applied bamboo skin), "turned-over bamboo skin", or "*wenzhu*" (veneered bamboo) as recorded by the Qing court. The production technique was to carve out yellow bamboo skin with a thickness of around 3 mm from the inside of bamboo stems. Then the bamboo skin would be steamed until it became soft, turned over for compressing into flat strips, and glued to the wooden biscuits for further polishing and carving with designs. Such a technique not only marked a breakthrough from the constraint of bamboo as a kind of material, but attained a refined quality and unique aesthetic appeal described as "the quality is like ivory but even plainer, it is as plain as boxwood and even harder and more lustrous". Such a production technique was first introduced in Shangkeng, Fujian in the late Ming period and was popular in the region. During the procession of Emperor Gaozong (Qianlong) to South China in the 16th year of the Qianlong period (1751

A.D.), such material and technique were brought to the court during the preparation of the procession. In the 36th year of the Qianlong period (1771 A.D.) when the Ningshou Palace was constructed, the court had extensively used such materials and techniques for decorating the Juanqin Studio, marking a landmark in the development of this special technique. It could be attributed that the progressive development of bamboo skin veneered ware was pronounced by the court. In the book *Miscellaneous Notes of the Qing Dynasty* compiled by Xu Ke, he described, "objects with turned over bamboo (designs) include stools, beds, screens, and partitions with more and more wonderful forms. Such a decorative style originated from the procession to South China by Emperor Qianlong." With such a background, this type of technique from Shangkeng was spread to other regions, starting from Shaoyang, Hunan and then Jian'an, Sichuan since the Daoguang period, and subsequently adopted in the Jiading district where bamboo carving was very popular. However, as the bamboo skin was very thin, it was only suitable for carving designs in shallow relief. With its popularity, traditional techniques such as carving in the round, carving in openwork, carving in high relief, and engraving declined. Bamboo craftsmen were then more focused on the production of the bamboo skin veneered ware which was easier to handle and could be produced in larger numbers, instead of producing bamboo ware that required sophisticated technical competence. Finally, such ware had gradually replaced the traditional bamboo carvings and marked a drastic change in the art of bamboo carvings since the mid Qing period.

In addition to bamboo carving, the interaction of ivory carving in Guangdong and the court styles provides another good example. Around the Qianlong period, the previous so-called ivory ware with "Suzhou style, Guangzhou craftsmanship" was gradually replaced by "Guangzhou style, Guangzhou craftsmanship" instead. The ivory ware produced in Guangzhou had got away from the influence of other regions and developed its own identity, which spread nationwide. We may take a statistic survey on the number of craftsmen summoned to work for the Imperial Workshops in order to get a glimpse of such a phenomenon. According to extant records, there were altogether thirty-two ivory craftsmen who worked at the Imperial Workshops in the Kangxi, Yongzheng, Qianlong, and Jiaqing periods with five of them coming from the North and the others coming from the South. The latter group of craftsmen could be further split into two origins of localities. One group with around fourteen craftsmen came from the Jiangnan regions while another group of around thirteen craftsmen came from Guangdong. At the beginning, it was those Jiangnan craftsmen who dominated the ivory workshop. Yet around the fifth year of the Qianlong period (1740 A.D.), the proportion of Guangdong craftsmen gradually increased, and after the 10th year of the Qianlong period (1745 A.D.), all the ivory craftsmen were natives of Guangdong, ranging from two to six at any one time, who served at the Imperial Workshops and had become a dominant group which contributed significantly to shape the court style of ivory carving. In the Yongzheng period, the Jiangnan style was still the mainstream in the court. In the second year of the Qianlong period (1737 A.D.), Huang Zhenxiao, a Guangdong craftsman, was called upon to serve at the Inner Court. He completed production of an ivory brush-holder with carved designs of a scene of fishermen's families in amusement in relief (plate 66) in the next year, which still carried the stylistic legacy of crafts of the Jiangnan region. In the sixth year of the Qianlong period (1741 A.D.), the Guangdong craftsman Chen Zuchang was appointed the head, who led other craftsmen including Xiao Hanzhen, Chen Guanchuan, Gu Pengnian, who was a craftman from Jiangning, and an inner court craftsman Chang Cun to produce a set of ivory albums carved with scenes of monthly leisure resorts (plate 80) based on a painting by Chen Mei, a court painter at the time. On this piece, regional stylistic features diminished and were replaced by the court style which assembled the essence of various crafts. However, since the mid Qianlong period, the style of ivory carving showed a strong regional style of Guangzhou ivory art with meticulously and delicately rendered designs, as represented by a small rectangular ivory box set with carved designs of *ruyi* cloud patterns in openwork made by Li Juelu (plate 67) and an ivory flower-perfume holder with carved designs of double

happiness and great fortune in openwork (plate 76)

The interaction between court crafts and regional crafts, the appointment and discharge of craftsmen, the acceptance and rejection of tributary ware, and other related actions facilitated the pronouncement of decorative styles favoured by the court. In such a way, regional crafts had experienced a stylistic filtering and were transformed in simulation of the progressive development of court crafts.

China is a unified country with multi-races. Crafts of the minorities had also attained high accomplishments and asserted considerable influence on the traditional crafts in China. In the Qing Dynasty, the ruling class had much favour for Lamaism and thus the crafts from Mongolia and Tibet had frequent opportunities of exchanges with the arts in Central China. An example was that on the 13th day of the eighth month of the 45th year of the Qianlong period (1780 A.D.), which was the 70th birthday of Emperor Qianlong, the sixth Panchen Lama Lobsang Palden Yeshe came to Rehe (present day Chengde in Hebei) and Beijing to celebrate the Emperor's birthday and present tributes which included a cloisonné green enamel silver bowl set and inlaid with precious stones. This bowl has a silver body and layered with green enamel, and the body is decorated with designs set with rubies by blending various kinds of techniques including hammering, carving, set and inlaid enamel layering, and gilt with a touch of extravagance and elegance that fully reveal high artistic merits of Tibetan crafts. Emperor Qianlong appreciated this ware very much and commissioned the Imperial Workshops to produce a cloisonné enamel gold bowl set and inlaid with precious stones (plate 213) in imitation of the original ware. These two pieces reveal the interactive influence and inspirations between aboriginal crafts and court crafts.

The cultural exchanges between China and overseas countries were also testified by the inclusive identity of treasures as cultural relics. Glass ware was a typical example. Traditional glass in China was confined to those low-temperature fired glass with contents of lead and barium, which was very different from the glass with contents of potassium and calcium in the West in terms of the nature of the materials and production techniques, and thus posed a cultural melting point when the two materials met. For instance, we can quote an example with the production of aventurine sprinkled glass. The method in the production of aventurine sprinkled glass was to utilize some metallic elements, which would saturate and release during melting and temperature reduction in the course of firing glass, and become sprinkling crystallized particles that gave glass a deep tea-dust or reddish-brown metallic colour, with numerous gold sprinkles looking like stars with charming visual effects. The successful production of this type of glass was achieved with the participation and guidance of western missionaries including Gabriel-Leonard de Brossard and Pierre d' Incarville. After repeated tests and modifications of the original European formula, aventurine sprinkled glass in the court style was finally produced successfully in the sixth year of the Qianlong period (1741 A.D.). An aventurine boulder with designs of three rams bringing prosperity in the beginning of a New Year (plate 34) illustrated in this volume is a representative piece of glass ware of this type.

On the other hand, the enamel ware mentioned above, including cloisonné enamel ware, champlevé enamel ware, and painted enamel ware, was also introduced from overseas. In particular in the Kangxi period of the Qing Dynasty, painted enamel ware brought by western ambassadors, missionaries, and merchants had got special attention from the Emperor, and was regarded as new crafts from the west for introducing into the Imperial Workshops. With the promotional efforts from Emperors Kangxi and Yongzheng, these new crafts developed rapidly and were assimilated with Chinese art, which formulated distinctive features of these new art forms. In the production of painted enamel ware in the Kangxi period, techniques of Chinese ceramics and western glass production were borrowed and blended, and subsequently painted enamel ware with metallic, glass, and ceramic bodies were successfully produced in the late Kangxi period. Another distinctive feature of the painted enamel ware of the Kangxi and Yongzheng periods was that such ware showed strong Chinese elements. The techniques were introduced from the west, yet the forms, decorative designs, and colours were derived from genuine Chinese repertoires without much western influence, which was very

different from the Qianlong counterparts that were marked with western styles. Such a phenomenon revealed that to produce enamel ware with Chinese styles was a mutual understanding in the Kangxi and Yongzheng periods. It did not just come from aesthetic consideration, but there were other reasons. Painted enamel ware of these two periods was not only used by the imperial court, but was also bestowed as gifts to foreign ambassadors to show that the imperial court had successfully mastered these new production techniques. At the same time, the production of painted enamel ware by the Imperial Workshops had also significant impact on the prosperous development of producing export enamel ware in Guangdong and the emergence of ceramic ware painted with colour enamels in Jingdezhen.

Comparatively speaking, some crafts show eminent features of foreign cultures. A white jade bowl with two ears and designs inlaid with gold wires and precious stones (plate 24) is a typical example. The treatment of the biscuit, decorative designs, and technical features reveal the style of Hindustan or Islamic jade ware. Hindustan was located in the northern part of India, including various regions in Kashmir and West Pakistan. Jade ware produced there was noted for thin and light bodies set and inlaid with floral designs in gold, silver, and precious stones. The special favour of Emperor Qianlong for such ware had created profound influence on the production of imperial jade ware. The gold celestial globe (plate 5) was not only a decorative object, but also a functional piece of ware. This instrument could be used for observing and showing the motion of constellations, and at the same time serving as a clock which could make a sound to indicate time. The globe could also play music four times at noon, the twelfth hour in the midnight, and the sixth hour in the morning and evening. Such a sophisticated and multi-functional instrument could not be produced without the spread of western astrology and consummate command of the production of clocks and watches at the court. We may say that it was an object showing the introduction of knowledge and technology from the west to China since the late Ming and early Qing periods. An Ivory concentric sphere with carved designs of characters "*fu*" (fortune), "*shou*" (longevity), and *baoxiang* floral rosettes (plate 78) was known as "ghost work ball" in the past, which was made with high technical competence and regarded as a typical type of ivory carvings in Guangdong. However, researches in recent years revealed that these spheres were closely associated with the lathe turnery ivory craft which was popular in the Holy Roman Empire from the 16th to the 17th century.

THE SOURCES AND PRODUCTION OF COURT TREASURES IN THE QING DYNASTY

A majority of treasures included in this volume had been collected by the Qing court and were made in respective periods. Some ancient works were inherited from the courts of the former dynasties with others collected elsewhere in the Kangxi, Yongzheng, and Qianlong periods. The Imperial Workshops of the Department of Imperial Household and the three weaving offices at Suzhou, Nanjing (Jiangning), and Hangzhou were responsible offices for producing such ware. The Imperial Workshops were put under the Department of Imperial Household and was one of the offices responsible for various affairs of the inner court and production of imperial ware including gold, jade, wood, lacquer, bronze and copper, ivory, inkstone, enamel, glass, and other ware, covering nearly all types of court crafts. The three weaving offices were also under the Department of Imperial Household, which were responsible for producing textiles, clothes, and dresses for court use. In addition, there were also custom houses with the Jiangning Weaving Office in charge of the Longjiang Custom House, Suzhou Weaving Office in charge of Hushu Custom House, and the Hangzhou Weaving Office in charge of Beixin Custom House. These offices, together with other assessment offices and offices of salt industry, were not under the supervision of the Ministries of Revenue and Works. With the establishment of these offices, the Department of

Imperial Household was able to collect taxes and revenues from salt industry, and control money on its own. It also had a duty to collect high quality luxury objects for sending as tributes to the court. In the high Qing period, these three offices, together with the Salt Industry Office at Changlu, Salt Industry Offices at the two Huai regions, Jiujiang Custom House, Fengyang Custom House, and others, were also assigned with the duty in producing ware and objects for court use. For example, on the fourth day of the first month of the 42nd year of the Qianlong period (1776 A.D.), the court ordered withdrawal of forty-eight pairs of miniature landscapes set and inlaid with precious stones and had them sent to the above eight offices, each office with six pairs, for restoration and touching-up and to be included in the list of annual tributary objects.

The Qing Emperors had laid down rigid regulations to guide the production of various crafts. Firstly, careful considerations should be given to develop the main themes of type forms and decorations with drafts and drawings prepared. Then graphic drawings and three-dimensional samples including wax, wood, and composite samples would be produced, with hand drawings most common. With the approval of the Emperor, production would start, and if modifications were required, the work would be sent back to the Imperial Workshops for re-touching to the satisfaction of the Emperor.

In general, the materials required for producing imperial daily objects would be drawn from respective warehouses of the Imperial Warehouse Department. For example, the silver warehouse kept stocks of gold, silver, and precious stones, the leather warehouse kept stocks of furs, leathers, ivory, rhinoceros horns, etc. In *Chunmingmenglu*, a historical document of the late Qing period, the stocks of the silver warehouse was recorded in detail, "In the capital there are ten warehouses…in addition to the Inner warehouse and three warehouses of the Ministry of Revenue, there are other six warehouses under the Department of Imperial Household. Among the six warehouses, the silver warehouse was located at the Hongyi Chamber. There are two chambers at the Taihe Palace, namely Tiren Chamber in the East and Hongyi Chamber in the West. To avoid the use of the character "*hong*",

which was one of the characters of the name of Emperor Gaozong (Qianlong), the post of Grand Secretary of this Chamber was suspended and this Chamber is seldom known. The most precious objects in the silver warehouse include sapphires with size of two fingers and weight of three Chinese catties, and two packages of diamonds with a large size similar to a seed. Others include gold, jade, and lots of brilliant precious stones." If the Inner Warehouse had enough stocks, then with imperial approval, these stocks could be drawn for use. For example, on the 19th day of the double sixth month of the fifth year of the Qianlong period (1740 A.D.), the Imperial Workshop sought the Emperor's consent for drawing various materials to produce "gold phoenixes mounted with birch skin and kingfisher feathers" and these materials include "three rows of gold phoenixes with characters "*shou*" (longevity), with each row containing nine phoenixes and eight auspicious symbols made with jade. Each row should be mounted with three hundred and seventy pearls, nineteen rubies, and eleven sapphires. For these rows, a total number of one thousand and one hundred pearls, fifty-seven rubies, and thirty-three sapphires are required". Emperor Qianlong granted approval with the order that "It is approved to use the jewellery in the stock of the Inner Court for this purpose". If the Inner Warehouse did not get enough stock, then the materials would be drawn from the stocks of the three weaving offices, the Guangdong Custom House, and other offices. For example, a list of required materials including jewellery and precious stones for producing two gold stupas was submitted on the 23rd day of the third month of the 11th year of the Qianlong period (1746 A.D.), and the Emperor ordered that "ask the Guangdong Custom House for the lapis luzuli and coral mat in accordance with the number listed, ask the Suzhou Weaving Office for the four white jade pieces, ask the Inner Warehouse for the beads to make the chains, use the turquoises in the stock of the imperial warehouse to make the turquoise mat and after selection, have them to be produced in the capital, and chose those beads and east pearls from the silver warehouse. Submit a report after these had been done".

Since all jewellery and precious stones were in the warehouses of the Department of Imperial

Household, an annual stock-taking had to be conducted with a report submitted to the Emperor. There were various records on these exercises in the Qing court archive, such as a record that "On the first day of the 12th month of the third year of the Daoguang period (1823), eunuchs Wang Changqing and Liu Jinli submitted a report of jewellery in the stocks of warehouses: seventeen cat's eye stones, six bead pendants, six hundred and thirty-seven diamonds, one piece of diamond flower, five hundred and sixty-nine rubies, one hundred and ninety-seven sapphires, seven topazes, four emeralds, one thousand one hundred and eleven tourmalines, two packages of large coral beads with a total of six hundred chains, and one package of small coral beads with a total of two hundred and ninety chains".

In addition to the Department of Imperial Household, the Ministries of Revenue and Works as well as other Ministries also played their roles in the production of treasures. For instance, the production of imperial seals with ritual attributes was supervised by the Ministry of Rites which drew the required materials for casting from the Ministries of Revenue and Works, and the actual casting was carried out by the Mint and the Department of Imperial Household with the process directed by the Emperor.

The treasures of the Qing court also came from the tributes submitted by provincial officials during festive occasions, or were acquired from the market. Others included gifts obtained through diplomatic events. In order to please the Emperor and got his recognition, officials in the capital and the provinces assiduously acquired very valuable and precious treasures from different sources and sent them to the Emperor as tributary objects so that they might get promotion. Occasions were many with tributes to be sent on annual basis, to celebrate birthdays and to celebrate festive events. There were some extreme cases in sending tributes. For example, Zhengrui, the Director of Salt Industry at Changlu, had sent tributes fifteen times; Wu Lana, Viceroy of Fujian and Zhejiang, sent tributes eleven times; Pu Lin, the Governor of Fujian, sent tributes nine times in the same 59th year of the Qianlong period (1794); and as such, tributes were sent to the court nearly every month or even more. In general, no matter the quality of tributes, whether they were gold, silver, refined or not, they would be accepted if they were authentic objects, considering their high values. If the forms or styles of these objects were not pleasing enough, they would be designed again and redone. From the Qing court archive, it was known that the Imperial Workshops had melt down various gold and silver ware, or even had those inferior objects gathered and sent to the Monetary Office at Chongwenmen for exchange of money. Acquisition of crafts from the market was more popular in the late Qing period, and most objects acquired were jewellery and accessories which might carry the marks of brand names or shops, as shown by the mark "pure gold from Dehua" at the interior of the ruby ring set in K-white gold (plate 57). Diplomatic gifts obtained also occupied a considerable portion of Qing court treasures. According to Chapter 93 in the *Guides in the Imperial Qing Collected Statutes*, in order to celebrate being elected as the Pope, Papa Benedictus XIII (the Pope from 1724 to 1730 A.D.) had sent his ambassadors to China to present over six types of tributes, including green glass vases with designs of phoenixes, various glass snuff bottles, cloudy amber cups, miniature boats with woven silver wire designs, models of steam boats, vases, flower-shaped trays in various sizes, and small flower vases. He was born from the Orsini family and elected as the Pope when he was in his seventies, and his gifts to Emperor Yongzheng reflected the accomplishments of crafts and popular artistic styles in Europe at the time. It was not known whether these tributes had any inspiration on Emperor Yongzheng for the production of court treasures during his time.

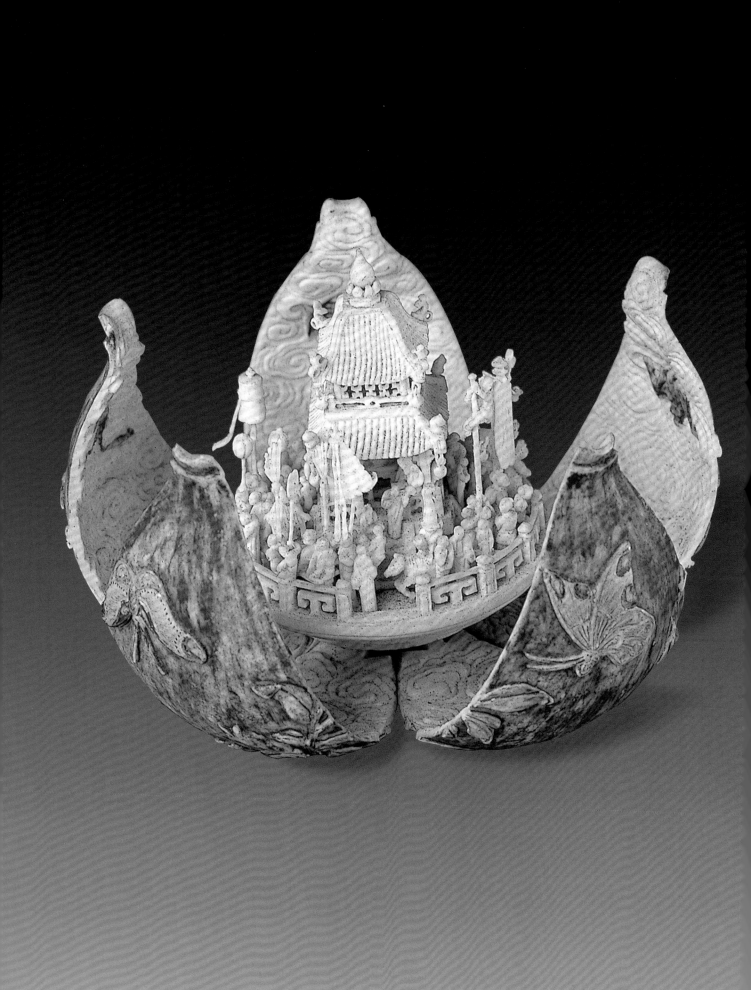

GOLD AND SILVER WARE, JEWELLERY, JADE, PRECIOUS STONES, AND OTHERS

Gold and Silver Ware

Jewellery, Jade, and Precious Stone Ware

Organic Precious Stones
(Rhinoceros Horns, Ivory, Coral, and Cloudy Amber)

Ancient Inkstones

1

Silver raft-cup

Zhu Bishan

Yuan Dynasty

Height 18 cm Length 20 cm
Qing court collection

The silver raft-cup is in the shape of an old tree with warts, and the body is modeled with textures of Chinese cypresses and junipers. On one side is a hollow belly, and the other side is modeled in the form of a withered tree trunk curling up. A Daoist priest, who wears a Daoist crown and cloud-shaped boots, is leaning on the raft. His left hand is lying on the raft while his right hand is holding a book scroll for reading. Underneath the mouth of the raft-cup is an inscription written by Du Ben, a scholar of the Yuan Dynasty, which literally describes that "jade liquid (wine) is stored for self-amusement, ride on a raft and travel in the Milky Way". Under the belly of the cup is an inscribed poem which literally describes, "The unrestrained poet Li Bai drank hundred cups of wine, and the old master Liu Ling was fond of getting drunk. Both fully appreciated the enjoyment of getting drunk, and their names were reputed as drunken celebrities in history." The front side of the cup's tail is inscribed "*longcha*"

(dragon raft), and on the rear side is an inscription which literally describes, "in the *yiyou* year of the Zhizheng period, Zhu Bishan from Weitang made this work in the Changchun Studio at Dongwu and wished that it would be treasured and permanently kept by my posterity" with a seal mark "*huayu*" in seal script. The *yiyou* year of the Zhizheng period corresponded to 1345 A.D.

This ware is both a wine vessel and a decorative object. The form has been derived from the legend of Yan Junping, a Daoist priest of the Han Dynasty, who rode on a raft upstream to reach the origin of the heavenly river. The production technique of this ware is to cast the form first and to carve decorations later, then fix it with the completed parts of head, hands, and cloud-shaped shoes by welding with traces of welding barely visible. This piece marks the high quality of production and artistic merit of casted silver ware of the Yuan Dynasty, and also has significant value for the study of the history of arts of the Yuan Dynasty.

Zhu Huayu, *zi* Bishan, was a native of Jiaxing, Zhejing, and dates of his birth and death were unknown. He was a well-known silversmith of the Yuan Dynasty and most renowned for producing silver ware. This raft-cup represents a new creative type form created by Zhu and is highly esteemed among his works.

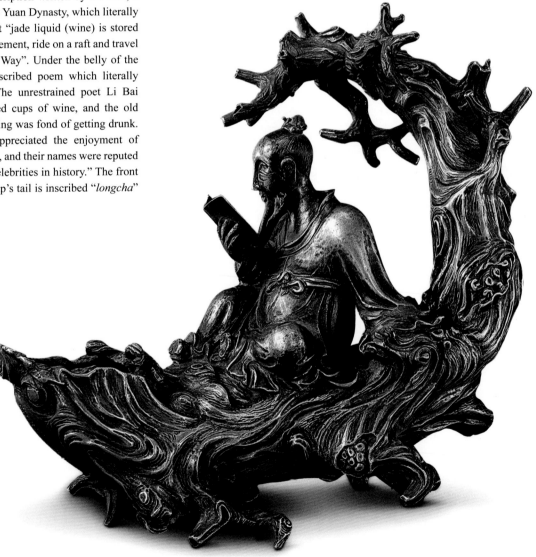

2

Gold seal
with a knob in the shape of intertwining dragons
and the seal mark "*fengtian zhibao*"

Early Qing period

Overall Height 9.7 cm Diameter of Seal Face 12.8 cm
Qing court collection

The imperial seal is square in shape and has a knob in the shape of intertwining dragons. It is casted with a seal mark "*fengtian zhibao*" in Manchurian script in relief. The seal is also fastened with yellow tassels and an ivory chip on which are Manchurian and Chinese inscriptions "*fengtian zhibao kui*" (box for the seal "*fengtian zhibao*") on the two sides respectively.

This imperial seal was listed as the fifth seal in the seal series "Ten Imperial Seals of Shengjing (Shenyang)", and in the Qianlong period, it was kept in the Fenghuang Tower in Shengjing (Shenyang). According to the document *Manchurian Archive of the Palace Historiographic Academy*, this imperial seal was in use as early as the Chongde period (1636 – 1643 A.D.) of Emperor Taizong, Qing Dynasty before the Manchus conquered China. The seal mark on this seal was a kind of Manchurian seal script by combining the original Manchurian script and the Chinese seal script. It was similar to the seal mark on the imperial seal "*huangdi zhibao*" (imperial seal of the Emperor) used by Emperor Taizong, proving that it was produced before the Manchus conquered China. It was one of the imperial seals produced and used in the early Qing Dynasty.

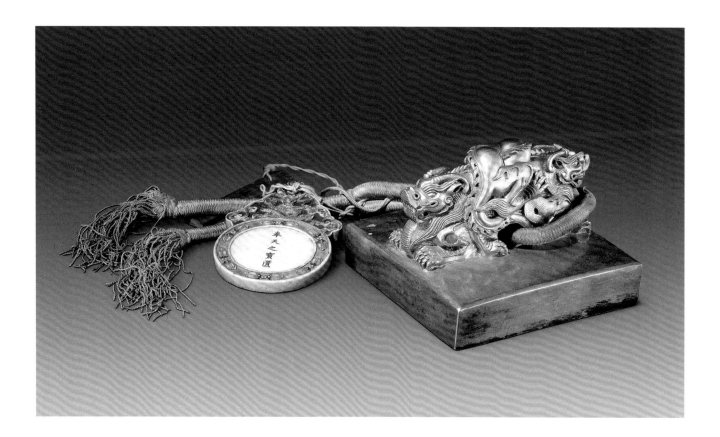

3

A set of gold chime bells
(sixteen bells)

Qing Dynasty Qianlong period

Height 27 cm
Diameter of Mouth 20.6 cm
Qing court collection

The shape and size of each bell in this chime of sixteen bells are identical. Each of the bells has a crown in the shape of intertwining dragons, an oval body, and a hollow interior. The exterior of each bell is decorated with various designs in relief, with the upper part ornamented with *ruyi* cloud patterns and the middle with dragons in pursuit of a pearl. The front and back panels of each bell have the tone of the bell cast in regular script in relief and the mark "made in the 55th year of the Qianlong period". Near the mouth are eight relief tone nipples for hitting musical tones, and in between the nipples are symmetrical cloud decorations on the upper and lower side. When the bells were used, they would have been suspended on two frames, an upper and a lower, arranged according to pitch. The pitch of a bell is determined by the thickness of its body, with thinner bells making lower-pitch sounds. The tuning of the bells corresponds to the system of twelve temperaments and four augmented temperaments.

In the Qing Dynasty, chime bells were used in the highest class of court music performances known as *zhongheshaoyue* (*shao* virtuous and peaceful music performance). Such performances often accompanied sacrificial ceremonies in temples or occasions when the emperor and empress ascended their thrones during court ceremonies. This set of chime bells were produced by the Imperial Workshops of the Qing court in the 55th year of the Qianlong period (1790 A.D.) using over 13,600 taels of gold. This set is one of only two complete sets of gold musical instruments from the Qing court, the other being from the Kangxi period.

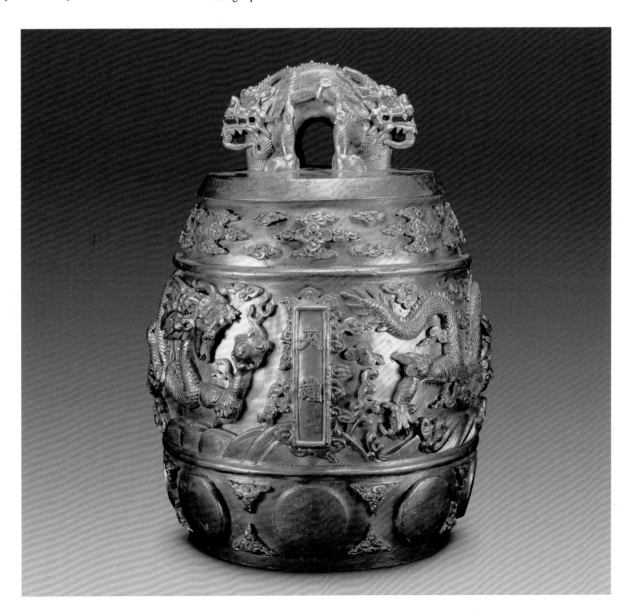

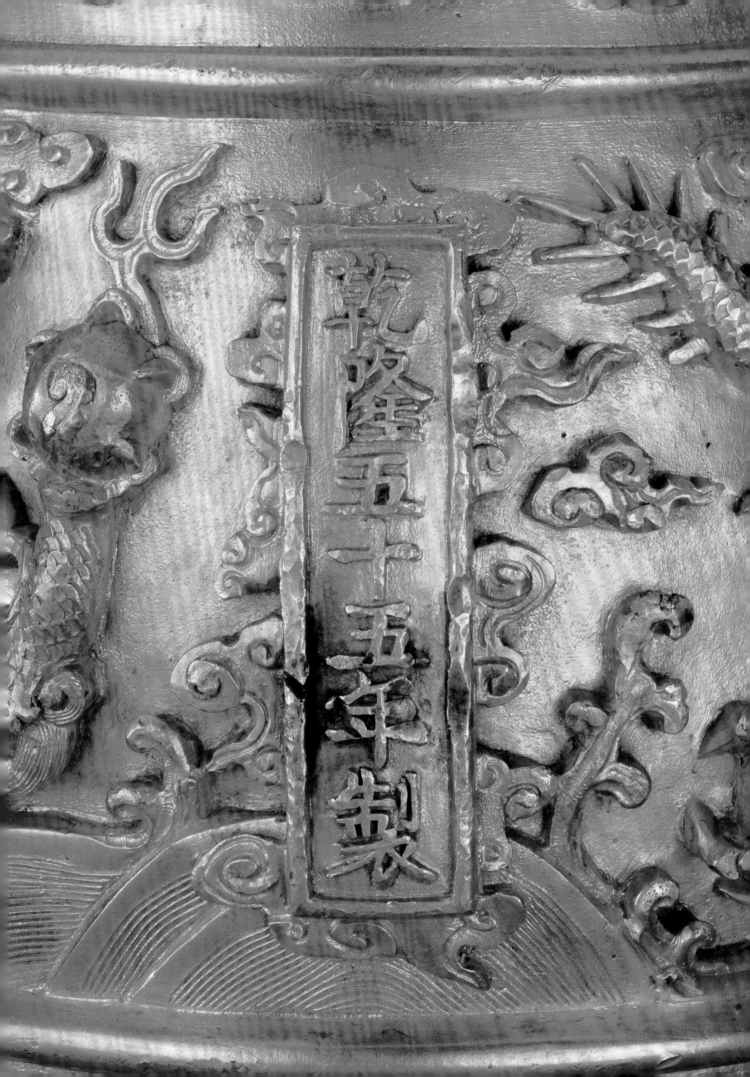

4

Gold cup
with the inscription
"jinouyonggu"
(gold cup that lasts forever)
and inlaid with pearls and
precious stones

Qing Dynasty Qianlong period

Height 12.5 cm
Diameter of Mouth 8 cm
Qing court collection

The cup has an upright mouth, a deeply curved belly, and three legs in the shape of elephant heads beneath. An east pearl and a ruby are inlaid at the forehead and in between the eyes of the elephants respectively. On the two sides of the mouth are ears in the shape of *kui*-dragons with an east pearl on the head of each of them. The body of the cup is in kingfisher green colour and engraved with lotus scrolls, *baoxiang* floral rosettes, and other floral designs. The stamens of the flowers are inlaid with eleven east pearls, nine rubies, twelve sapphires, and four tourmalines. The mouth rim of the cup is decorated with key-fret patterns with two panels in which are engraved inscriptions *"jinouyonggu"* (gold cup that lasts forever) and *"Qianlongnian zhi"* (made in the Qianlong period) in seal script in relief.

According to the Qing court archive, this cup was made in the second year of the Jiaqing period (1797 A.D.) by the Imperial Workshops of the Qing court. Although Emperor Qianlong had abdicated in favour of his son at that time, the court still adopted his reign mark on imperial ware.

"Ou" actually refers to ware such as cups or basins. In the past, *jinou* was a symbol of sovereignty of the state, and the phase *"jinouyonggu"* carried the blessing for the power of the state to last forever. Such type of cups was used in the first writing ceremony hosted by the Emperor, which started in the Yongzheng period and continued into the Qianlong period. At the *zi* hour (23:00 hour – 01:00 hour) of every Lunar New Year, the ceremony would be held at the Dongnuan Studio of the Yangxin Palace. At the time, the Emperor would light a candle on a candle-stand known as "jade candle burns for a long time", pour *tusu* wine into the gold cup, hold a brush inscribed *"wannianzhi"* (a branch lasting for ten thousand years) on the brush-tube and *"wannianqing"* (green lasting for ten thousand years) on the brush-tube's end, and dip the brush first with cinnabar lacquer and later with ink to write auspicious inscriptions for blessing the nation to last forever and its people to enjoy peace, wealth, and prosperity.

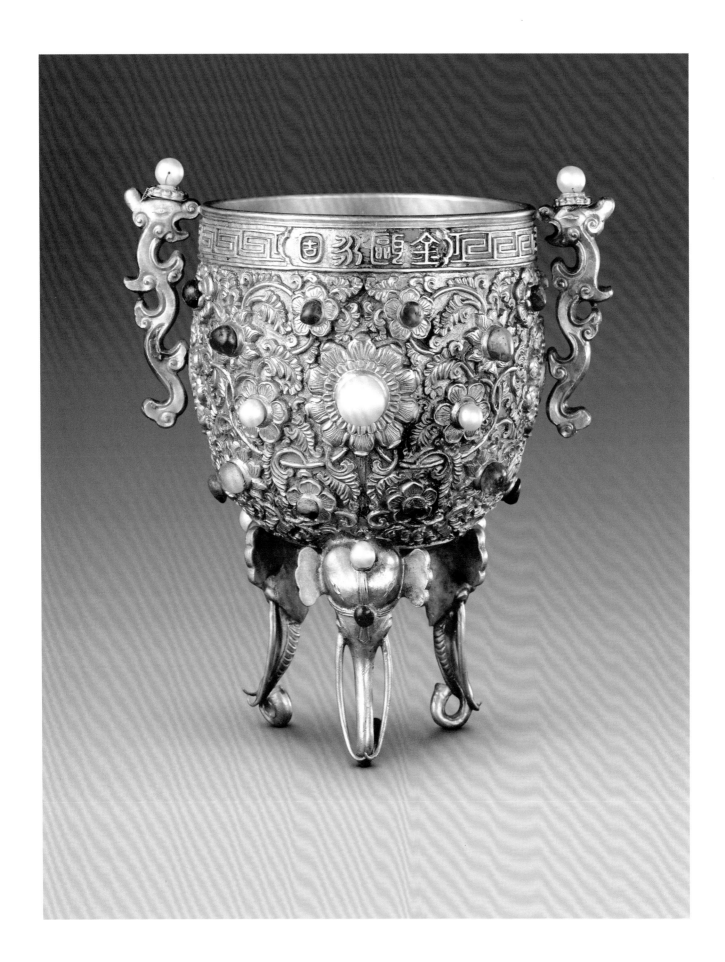

5

Gold celestial globe

Qing Dynasty Qianlong period

Overall Height 82 cm
Diameter of Globe 30 cm
Diameter of Base 43.5 cm
Qing court collection

The celestial globe comprises of three parts: a globe, a supporting frame, and a stand. The stand is a round cloisonné plate with a gold body, which has four animal-head shaped legs. The surface of the stand is decorated with cresting waves in relief, and in the middle is a round plate with a compass inside. On top of the stand base is a supporting frame in the form of nine curling dragons with their eyes set with sapphires, and on which is the celestial globe. The surface of the globe is incised with diagrams of the three enclosures, twenty-eight lunar mansions, three hundred and sixty-eight constellations, and also with three thousand two hundred and forty-two stars set and inlaid with pearls. Surrounding the globe are a gold celestial horizon, a cloisonné celestial meridian, and a clock at the North Pole for indicating time. Three mechanisms of clock, alarm, and music playing are installed inside the globe, which can be turned on or off at three string holes near the South Pole.

The celestial globe was also known as the armillary sphere or the celestial instrument, an instrument for observing and showing the motion of constellations in ancient China. This celestial globe has both the functions of observing motion of constellations and serving as a clock which will make a sound to indicate time. At the former part and the latter part of a Chinese hour, the clock would make an announcement sound. The globe could also play music four times at noon, the twelfth hour in the midnight, and the sixth hour in the morning and in the evening. From the late Ming to the early Qing Dynasty, western studies had been introduced into China, and the knowledge of western astronomy had become more popular in the Qing court, thus facilitated the Imperial Workshops to produce this type of multi-functional celestial globes.

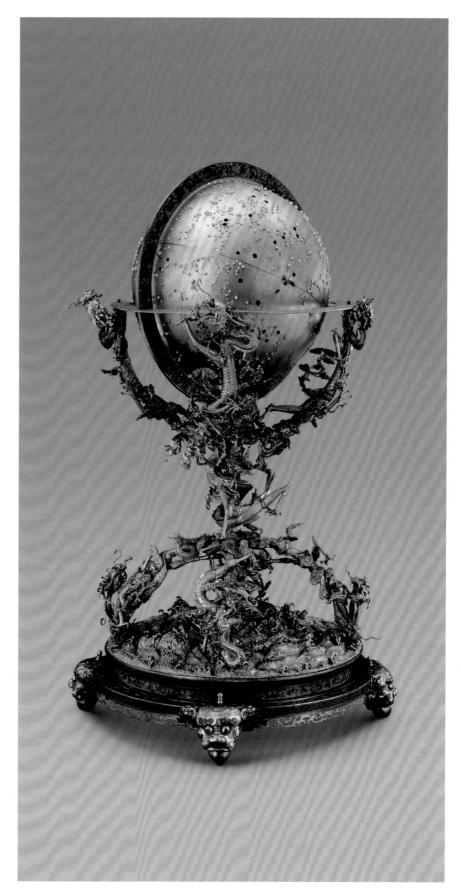

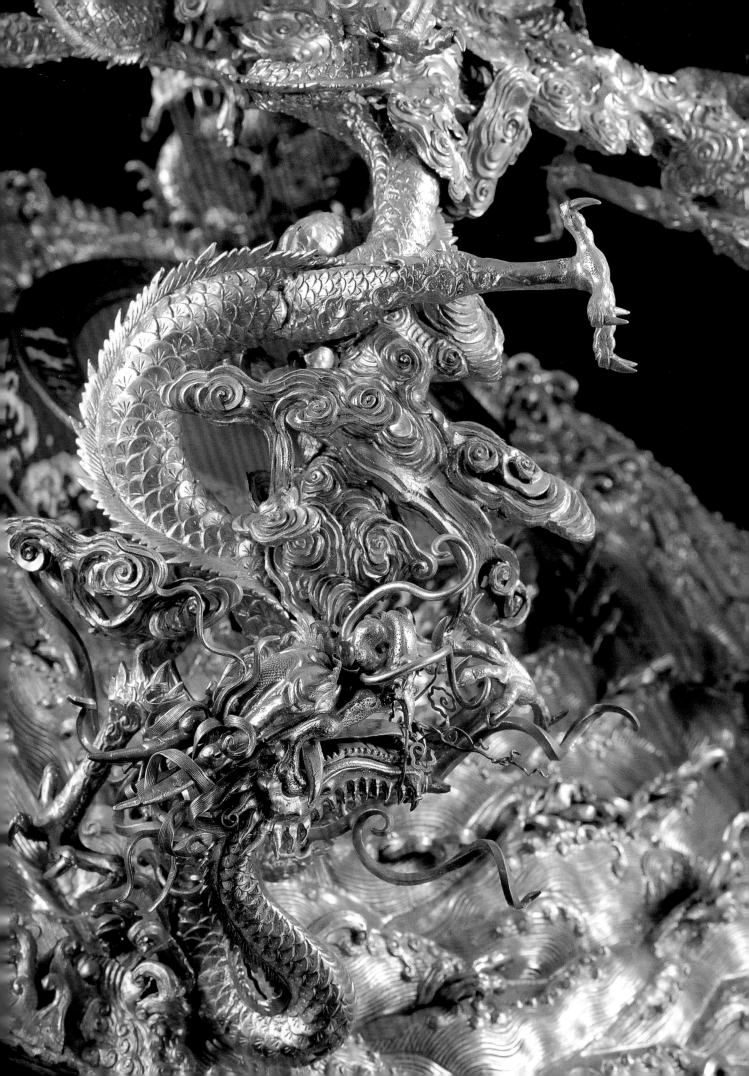

6

Gold stupa
with gold filigree designs and inlaid with pearls and precious stones

Qing Dynasty Qianlong period

Overall Height 71 cm
Length of Stand Base 38 cm
Qing court collection

The stupa comprises of three parts: the platform, the stupa, and the spire. The stupa is decorated with gold filigree designs and inlaid with various precious stones. At the lower part of the stupa's platform is a Buddha's throne in the shape of Mount Sumeru, decorated with key-fret patterns, lotus scrolls, and lotus petals inlaid with turquoises, lapis lazuli, and red corals, and interspersed by one hundred and twenty crystals. The waist is inlaid with seventeen rubies, as well as tourmalines and other precious stones. On the surface of the platform are gold railings inlaid with turquoises and watching pillars inlaid with twelve pearls. The upper part of the platform is modeled in the form of a terrace platform and decorated with lapis lazuli lotus petals inlaid with turquoises and sixty rubies, sapphires, tourmalines, and cat's eye stones. The surface of the stupa is decorated with lozenge patterns bordered with small rubies, and inside the lozenges are decorations of swastikas (卍), shou (longevity) medallions, and bats inlaid with lapis lazuli and turquoises, which are symbols of fortune and longevity. The shoulder of the stupa is decorated with animal-mask patterns in turquoise. At the front of the stupa is a shrine, in which a lapis lazuli statue of Amitayus Buddha is stood. The gate of the shrine is inlaid with eleven rubies, sapphires, and tourmalines. On top of the gate is a white jade tablet with an imperial inscription "Eulogy to Amitayus Buddha" by Emperor Qianlong. The spire of the stupa has thirteen tiers and is inlaid with rubies, sapphires, turquoises, and lapis lazuli. The canopy of the stupa is inlaid with large rubies to represent the sun, and ten other precious stones to decorate the moon. The top of the stupa is crowned with a large pearl.

This stupa weighs 17,700 grammes and is modeled with marvillous craftsmanship. It is a refined piece with a touch of extravagance, representatng the high quality of gold and silver ware in the Qing Dynasty. Amitayus Buddha is also known as Amitabha Buddha, who is one of Buddhas of the Five Directions, and the lord of the Western Paradise of Endless Happiness. He and his two companion bodhisattvas, Avalokitesvara and Vajrapani, are collectively known as the Three Lords of the Western Paradise. He, Sakyamuni Buddha, and Bhaisajyaguru Buddha are known as the "Three Sacred Buddhas". It is believed that when a disciple chants his name, the disciple will be reborn in the Western Paradise of Endless Happiness, and thus Amitayus Buddha is very commonly worshipped.

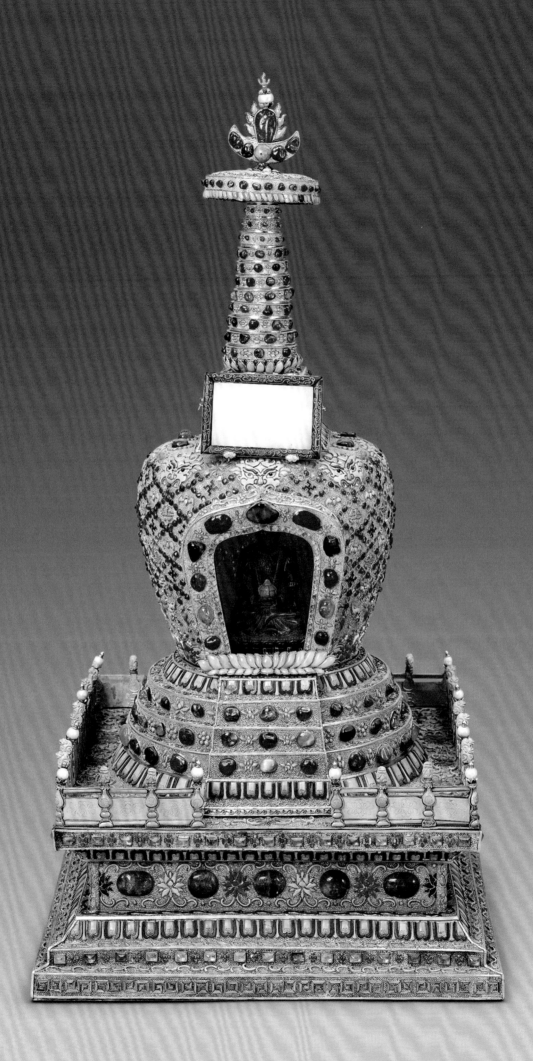

7

Gold stupa
for containing hair

Qing Dynasty Qianlong period

Height 147 cm
Length of Platform Side 70 cm
Qing court collection

The stupa comprises of three parts: the platform, the stupa, and the spire, and at the lower part of stupa's platform is Buddha's throne in the shape of Mount Sumeru. The waist is engraved with dancing lion designs. On top of the platform is a terrace platform which is fully engraved with various designs and inlaid with precious stones. At the front side of the stupa is a shrine in which is a gold statue of Amitayus Buddha, and the hair of the Empress Dowager are also kept inside. Surrounding the gate of the shrine are engraved designs inlaid with rubies, sapphires, and turquoises. The shoulder of the pagoda is engraved with the design of animal-mask holding bead chains spreading downwards. The spire of the stupa has thirteen tiers fully inscribed with Sanskrit. Bead chains inlaid with pearls, rubies, sapphires, and turquoises spread underneath the canopy. The top of the stupa is decorated with the sun, moon, and pearl set with precious stones, jade, and turquoises. A red sandalwood Buddha's throne serves a stand for the stupa.

This stupa weighs 107,500 grammes which is the largest, heaviest, and most refined piece of extant gold stupas. In the 42nd year of the Qianlong period (1777 A.D.), Empress Dowager Xiaoshengxian, mother of Emperor Qianlong, passed away. To show homage to his mother, the Emperor ordered to cast a stupa to keep the hair dropped by the Empress Dowager when she was still alive inside. However, the Warehouse of the Department of Imperial Household did not get enough gold to cast the stupa. Therefore various gold ware such as basins, spoons, chopsticks, snuff bottles, and others were melted down, and over three thousand taels of gold were then obtained to produce this stupa which was put inside the Shoukang Palace where the Empress Dowager once lived.

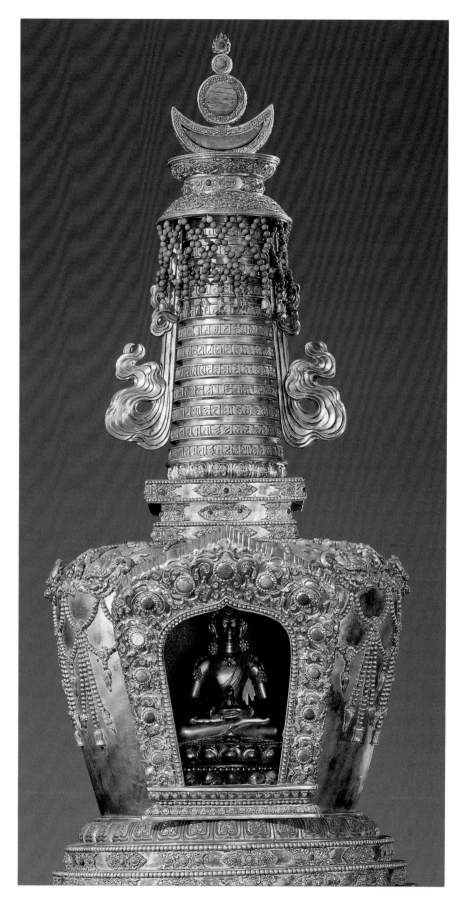

乾隆十三年十二月二十日奉

特旨赤金成造供佛利益穆加年尼佛畨福少加圖巴清福釋加穆

尼佛齊希業古稱齊達齊布爾漢

9

Gold *ruyi* scepter perfume-holder
with engraved designs

Qing Dynasty Qianlong period

Height 15 cm
Length 56 cm
Qing court collection

The perfume-holder is in the shape of a *ruyi* scepter with an openwork body engraved with designs of peonies, chrysanthemums, and other flowers and leaves. The centre of the head, middle part, and tail are decorated with peonies, with flower leaves set and inlaid with jadeite, flowers set and inlaid with tourmalines, and stamens set and inlaid with pearls. The exterior and the flanking sides of the body are set and inlaid with jadeite, tourmalines, rubies, sapphires, and others to form conjoined bead chains. At the end of the tail is a yellow silk tassel with a knot fastened in the shape of character "*shou*" (longevity).

The head, middle part, and tail of this perfume holder have moveable lids and are hollow for putting perfume inside. This highly decorative piece with creative designs could be used both as a decorative *ruyi* scepter or a functional perfume-holder.

10

Silver lobed vase
with silver filigree designs

Qing Dynasty Qianlong period

Height 17 cm
Diameter of Mouth 10.5 cm
Diameter of Foot 11 cm
Qing court collection

The vase has a slightly flared mouth, a contracted neck, a hanging belly, and a ring foot. Its form is similar to a pear-shaped vase. Vertical ridges on the body divide the vase into twelve lobes. The body is made with thick silver wires and decorated with thin silver wire foliage scroll designs welded on the body. The foliage scrolls are also made with thick silver wires as veins and thin silver wires as texture of leaves to create a sense of naturalism, perspective, and dimensionality.

The vase is produced by using three kinds of silver wires with different thickness. The designs are rendered in openwork with exotic aesthetic appeal, revealing the decorative style of the arts of the Baroque period in Europe, and represents a distinctive style of decorative arts of the Qing Dynasty.

Filigree designs are also known as "*huazuo*" or "*huawen*" (both terms literally mean floral designs) and refer to a kind of traditional decorative techniques in producing metal ware. Metals such as gold, silver, and others are pulled into wires and woven into strips or net eye patterns, and then welded on ware. It is most difficult to produce three-dimensional ware with such a technique, and the artistic merit of such ware is the most exquisite. From the seventeenth to the eighteenth century, Baroque art was widely popular in Europe, and characterized by its luxuriant, sophisticated, and dynamic decorative rendering. With the coming of missionaries to the East, such an artistic style was also introduced into China, and had produced considerable imfluence on Chinese art in the period.

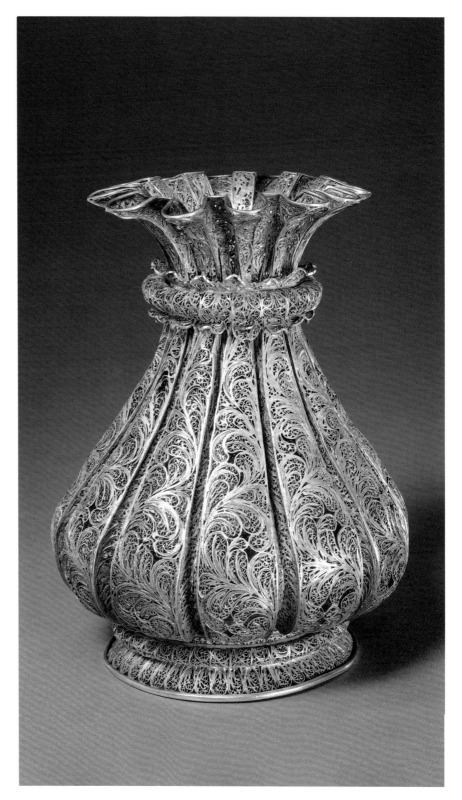

11

Lobed gold ewer
engraved with designs of dragons amidst clouds

Mid Qing period

Height 31.5 cm
Diameter of Belly 16 cm
Diameter of Foot 10 cm
Qing court collection

The ewer has a flared moth, a slim neck, a globular belly, and a trumpet-shaped ring foot. On the two sides of the ewer are a long narrow curved spout and a curved handle, and in between the handle and the neck is a gold chain. The ewer has a pagoda-shaped lid on which is a round knob. Vertical borders define the body into lobes which are decorated with engraved dragons amidst clouds. The base foot is decorated with engraved running dragons, cresting waves, and flames. The lid is divided into four tiers by three borders, and each tier is engraved with two dragons in pursuit of a pearl. The handle and spout are plain with the mouth of the spout decorated with engraved designs and the base of the spout with engraved animal-mask patterns.

This ewer with a delicate and graceful form and exquisite decorative designs is an imperial wine vessel of the Qing court, representing the typical style of metal ware of the mid Qing period.

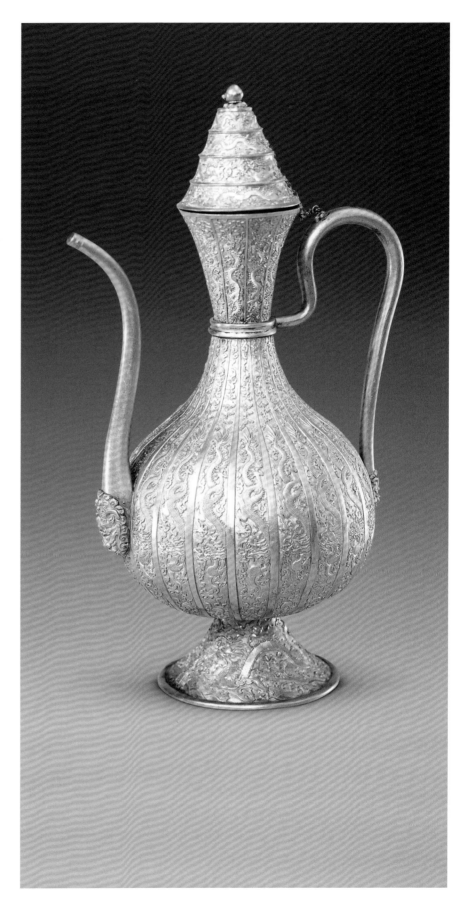

12

Perfume-sachet
with gold filigree designs

Qing Dynasty　Tongzhi period

Height 1.6 cm
Diameter 5 cm
Qing court collection

The round sachet comprises of two parts: the body and the lid with the interior hollow, which can be opened and closed. The body is decorated with gold filigree brocade patterns as the ground. The two sides are decorated with flowers and leaves in *diancui* kingfisher-feather green. At the two ends of the perfume-sachet are two moveable loops with yellow silk tassels fastened with six sets of carved coral beads representing fortune and longevity and small pearls. It has a yellow slip with ink inscriptions on each of the two sides, which literally describes, "received on the 14th day of the 2nd month of the 1st year of the Tongzhi period and submitted by Shen Kui", and "two pieces of gilt and silver perfume-sachets. Each is fastened with two coral beans". The 1st year of the Tongzhi period corresponded to 1862 A.D.

Perfume-sachets were also known as perfume-pockets, floral-sachets, etc. They were originally a kind of small cloth pockets for containing perfume and to be carried on the body to give fragrant smell. Such perfume-sachets were a kind of decorative objects in the Qing court, which could be carried on the body or hung on bed curtains, and various materials had been used for making them. *Diancui* is a traditional decorative technique which inlays kingfisher feathers on gold, silver, and other metal ware.

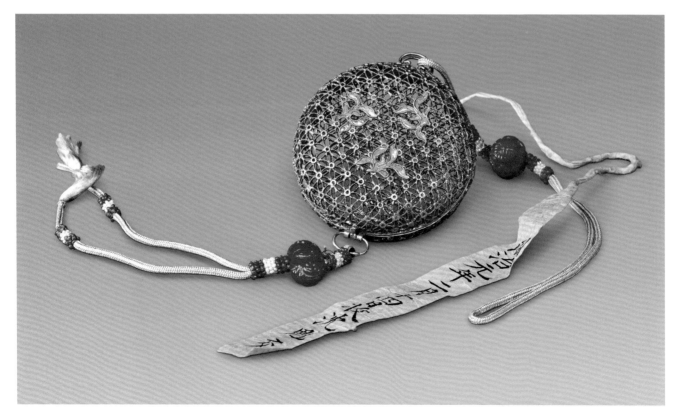

13

Gold basin
with engraved designs of
eight auspicious symbols and
two phoenixes

Qing Dynasty

Height 9 cm Diameter 95.5 cm
Qing court collection

The basin has a round mouth, a folded rim, a deep belly, and a flat base. At the rim are decorations of double-coins, wheels of the dharma wheels, treasure vases, and other auspicious symbols in relief produced by the hammering technique. Red corals and small turquoise beads are inlaid amidst the designs with scrolls of string patterns which are suggestive of auspicious blessings lasting forever. The interior and exterior walls are plain. The interior base is decorated with molded and compressed designs of lotuses, phoenixes, and foliage scrolls with three protruding lotuses along the central axis. On each of the right and left side of the lotus at the centre is a pair of phoenixes in flight, and the heads of the phoenixes are carved in the round.

This basin was one of the eight types of gold ware used in the procession ceremony of the Empresses in the Qing Dynasty. According to the book *Qing Collected Statues* and other records, during the procession ceremony of the Emperor, father and mother of the Emperor, the Empress Dowager, the Empress, eight types of gold ware would be used, which included two pieces of incense burners with overhead handles, two pieces of vases (jars), one piece of basin (washer or basin for washing face), one piece of water pot (spittoon) and two perfume-containers. They were collectively known as "eight gold pieces" as named later.

Hammering was a kind of traditional decorative technique in ancient China. Considering the elasticity of gold, silver, and other metals, craftsmen would use a hammer to hit these metals into flakes and strips, and use them for producing various types of vessels or decorations. In general, ware or embossed decorations in relief were often produced by this technique.

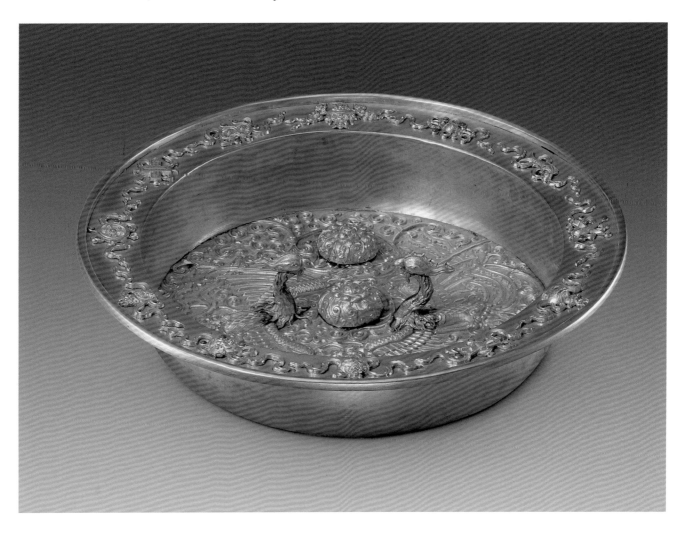

14

Gold cup and plate
with engraved designs and inlaid with pearls

Qing Dynasty

Overall Height 8 cm
Diameter of Cup 7 cm
Diameter of Plate 20 cm
Qing court collection

The cup has a wide mouth, a tapering belly, and a ring foot. On the two sides are two ears in openwork with inscriptions *wanshou* (longevity lasting for ten thousand years) and *wujiang* (without end) in seal script. Under the inscriptions are decorations of *lingzhi* fungi. On top of each ear is a lotus-shaped support inlaid with a pearl. The exterior wall is engraved with dragon designs and interspersed by *baoxiang* floral rosettes and cresting waves. The supporting plate has a wide mouth and everted rim on which are engraved designs of *baoxiang* floral rosettes and inlaid with four pearls. The surface of the plate is engraved with designs of clouds, lotuses, and also inlaid with four pearls. At the centre of the plate is a ring for holding the cup, which is engraved with dragons amidst clouds. The interior and exterior walls of the plate are plain.

This set of cup and plate was for the imperial use of the Emperor during celebration ceremony of his birthday. The ears of this cup are creatively designed, and the production technique of this set of gold ware represents the superb craftsmanship of the time.

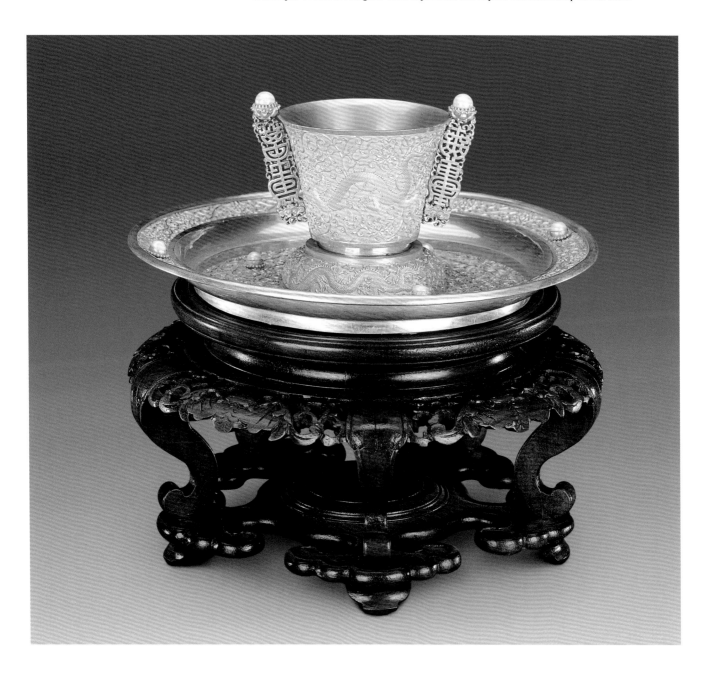

15

Gold censers
in the shape of cranes
(a pair)

Qing Dynasty

Overall Height 95 cm
Qing court collection

This pair of gold censers is in the shape of cranes raising their heads and crying, and is casted in the round. The bodies of the cranes are engraved with feathers, and the tails are made with gold flakes. The belly of each censer is hollow for placing perfume inside. The back of each bird has an opening and a lid in the shape of feathered wings. When perfume is burnt, the smoke and fragrance would be released through the bird's beak. The stands of these censers are produced with lead and modeled in the shape of rocks for insertion of the mortise-tenon joints at the feet of the cranes.

Censers in the shape of cranes were often placed at the two sides of the imperial throne in the palace. They were both decorative and functional objects used for burning perfume.

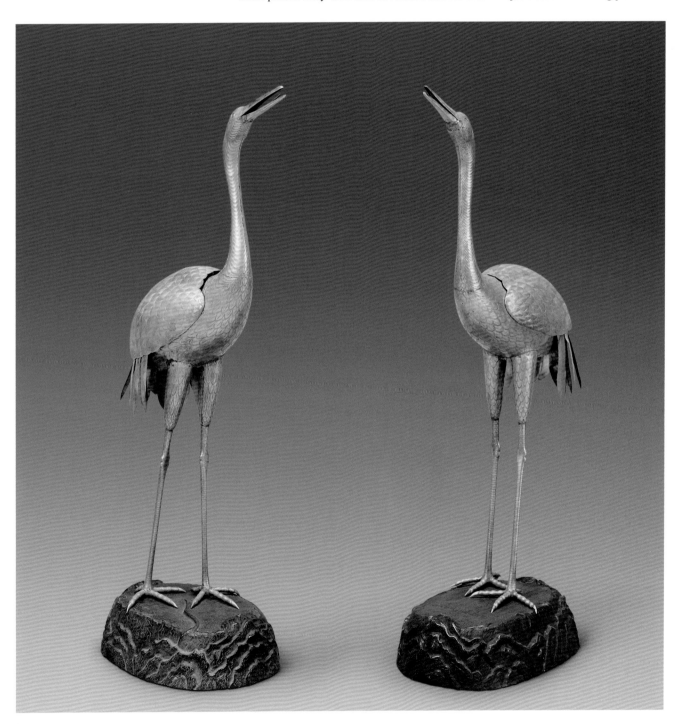

16

Gold shrine
in the shape of a tower-pavilion inlaid with pearls and turquoises

Qing Dynasty

Height 65 cm
Length 51 cm
Width 22 cm
Qing court collection

The shrine is in the shape of a two-tiered tower-pavilion supported by a Buddhist throne engraved with inverted lotus petals. The contracted waist is decorated with vajras, foliage scrolls, and *baoxiang* floral rosettes in low relief. At the front of each of the two tiers of the tower-pavilion are three Buddhist niches, in which statues of the Buddhas are placed. The niche door is bordered and inlaid with pearls. The wall surface of the tower-pavilion is decorated with cloisonné foliage scrolls as the ground, on which are eight auspicious symbols inlaid with turquoises. The eaves of the tower-pavilion are also inlaid with a border of turquoises. At the centre of the roof-ridge is a treasure vase set with turquoises.

A shrine is used for placing statues of Buddhist figures, deities, or ancestors for worship. This shrine weighs 35,750 grammes and is finely and precisely modeled after Chinese architecture, representing a rare piece of its type.

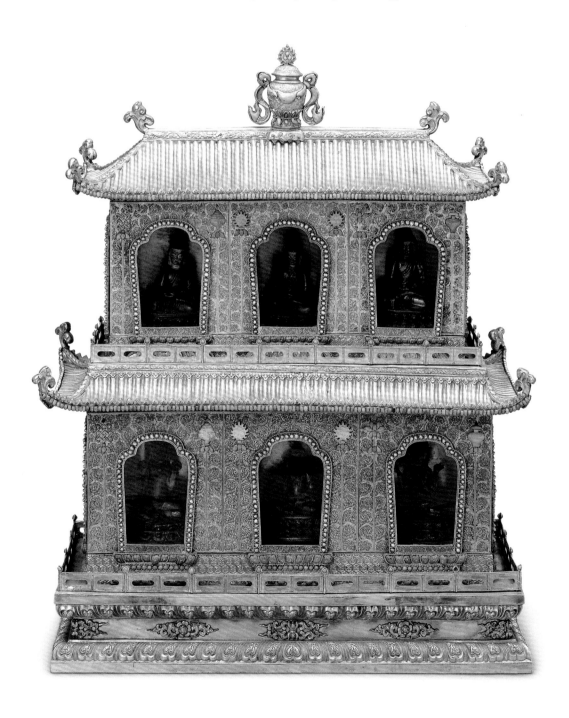

17

Gold statue of Maitreya Buddha
inlaid with pearls

Qing Dynasty

Overall Height 54 cm
Qing court collection

The Maitreya Buddha is wearing a crown with his two eyes half open to look at people in the world with mercy. He is wearing a hanging skirt with bead chains and ribbons spreading over the body. While his left hand is holding a ribbon, his right hand is holding the mudra of comfort. He stands on a throne in the shape of an inverted lotus. Surrounding him are lotus stems with the wheel of the dharma on one side and the treasure vase on the other side.

This is a statue of Maitreya Buddha of Tibetan Buddhism with a weight of around 19,030 grammes and inlaid with one hundred and eighty-three pearls. The statue is exquistiely modeled with a delightful form and in brilliant gold colour, representing a refined piece of gold Buddhist statues of the Qing Dynasty.

Maitreya Buddha was originally a disciple of the Buddha, who entered nirvana earlier than the Buddha, and it was predicted that he would become the Buddha of the Future. Therefore Maitreya had two forms: Bodhidsattva (a status prior to the Buddha) and Buddha. Buddhist sutras recorded that his disciples would be transmigrated to the Maitreya's Pure Land, and therefore the belief and worship of Maitreya Buddha was very popular among various Buddhist Sects and Tibetan Buddhism.

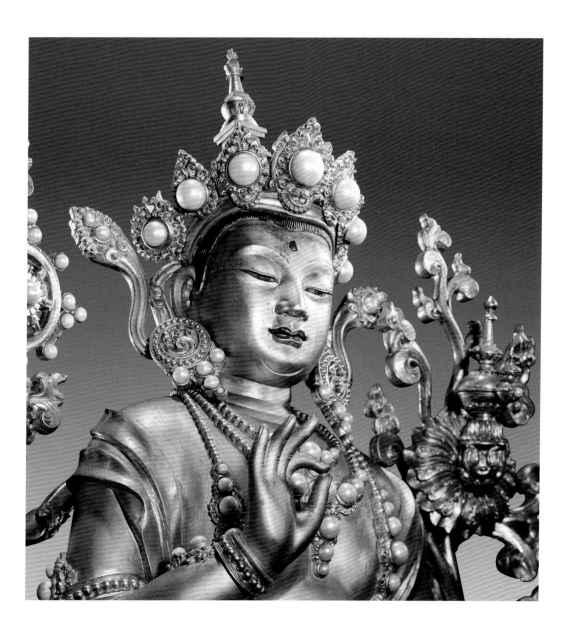

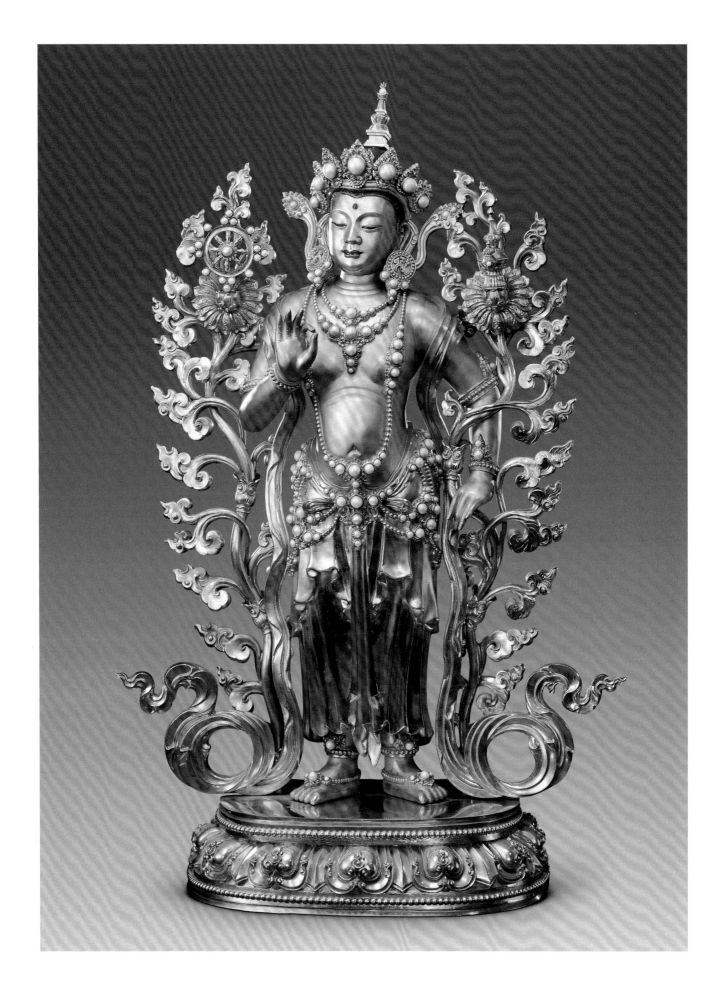

18

Gold Mandala
(*tancheng* or altar-city)
with gold filigree and engraved designs inlaid with turquoises

Qing Dynasty

Height 35 cm
Diameter 17 cm
Qing court collection

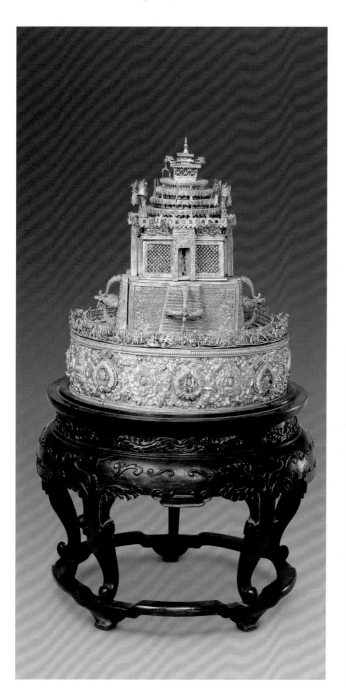

The lower part of this mandala is in the shape of a round altar, and on its sides are engraved *baoxiang* floral rosettes interspersed by eight auspicious symbols made with gold filigree peach-shaped patterns inlaid with turquoises. The exterior side of the altar's top is bordered with cloisonné figures, beasts, trees, clouds, flames, and filigree walls of eight sitanvanas (graveyard). In the altar is a city with a square platform, and on each of its sides is a gold filigree staircase decorated with vajras. In the centre of the city is a gate in which Yamantaka and his subordinates are placed for worship. On top of the city is a four-tier round spire, and on its top is a two-tier tower with eaves. The mandala is supported by a red sandalwood stand decorated with foliage scrolls.

This mandala was originally placed in a Buddhist Hall in the Qing Palace. Decorated with gold filigree, engraved, and inlaid designs, it weighs around 18,000 grammes. It is skilfully modeled with a touch of extravagance, representing a very valuable piece of work of its type.

The "*tancheng* or altar-city" refers to the Mandala in Sanskrit, which is used to enshrine statues of Buddhas and avalokitesvaras for cultivating Tibetan Buddhism or for use in ritual ceremonies. Yamantaka is the angry transformation of Manjusri who is one of the five supreme Vajras of the Anuttrayoga Tantra of Tibetan Buddhism, and also one of the three supreme Vajras of Gelug Sect of Tibetan Buddhism.

19

Eight auspicious symbols
with gold filigrees and
inlaid with precious stones

Qing Dynasty

Height 48 cm Diameter of Base 15 x 12 cm
Qing court collection

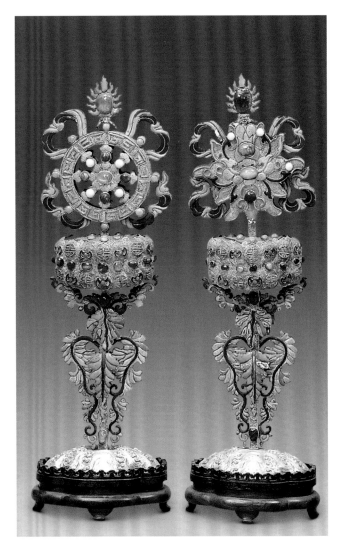

The eight auspicious symbols have red sandalwood stands in the shape of begonias. The surface of each stand is decorated with cresting waves on its gold body. Each stand has a vertical column either inlaid with two rubies, two sapphires, or two cat's eye stones respectively, and on the two sides are decorations of foliage scrolls inlaid with turquoises. On top of the column is an inverted lotus pedestal with a contracted waist woven with gold wires. On the ground of lotus petal designs are decorations of corals, bats in flight inlaid with lapis lazuli, and *shou* (longevity) medallions inlaid with turquoises. The contracted waist is inlaid with a border of rubies, sapphires, cat's eye stones, and tourmalines. On each of the lotus pedestals is a square stand supporting one sacred emblem, and on top is a flame design inlaid with precious stones and turquoises.

The eight auspicious symbols are also known as the eight sacred emblems, which refer to the wheel of the dharma, conch shell, victory banner, parasol, lotus flower, fish pair, treasure vase, and the endless knot, and which are used as Buddhist ritual instruments. These eight auspicious symbols were also popular decorative Buddhist designs in the Qing Dynasty, which carried the blessing of "eight auspicious symbols to bring brightness".

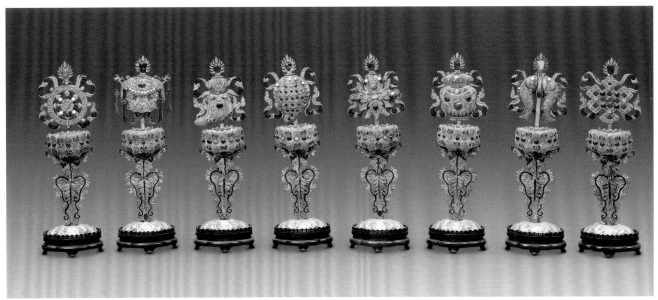

20

Seven Buddhist treasures
with gold filigrees
and inlaid with precious stones

Qing Dynasty

Height 43 cm
Diameter of Base 16 x 11.5 cm
Qing court collection

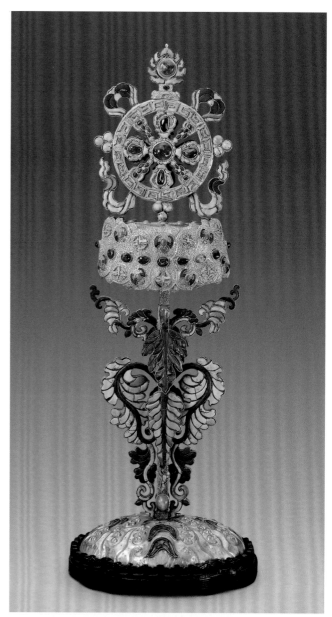

The seven treasures have red sandalwood stands in the shape of begonias. The surface of each stand is decorated with cresting waves on its gold body. Each stand has a vertical column either inlaid with rubies, sapphires, or cat's eye stones, and on the two sides are decorations of foliage scrolls inlaid with turquoises. On top of each column is an inverted lotus pedestal with a contracted waist and gold filigree designs. On the ground of lotus petal designs are decorations of bats in flight and *shou* (longevity) medallions inlaid with red corals, lapis lazuli, and turquoises. The contracted waist is inlaid with a border of rubies, sapphires, cat's eye stones, and tourmalines. On each of the lotus pedestals is a gold filigree stand supporting one type of the seven Buddhist treasures, and on top is a flame design inlaid with precious stones and turquoises.

The seven treasures are also known as seven precious emblems, which refer to the wheel of the dharma, the pearl, the diva, the loyal official, the white elephant, the horse of wonder, and the general. They represent the treasures brought about by the blessing of the King of the Wheel of Law in Hindu mythology. Later these symbols are adopted for use in Buddhism, and serve as objects to pay tribute to the Buddha.

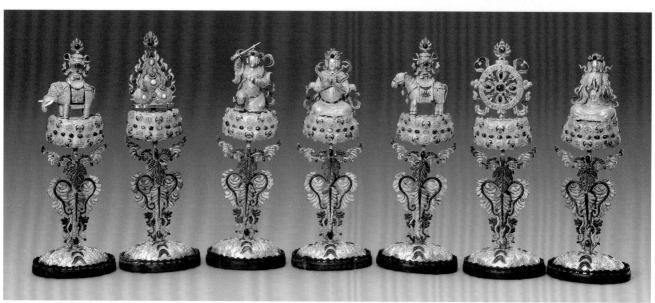

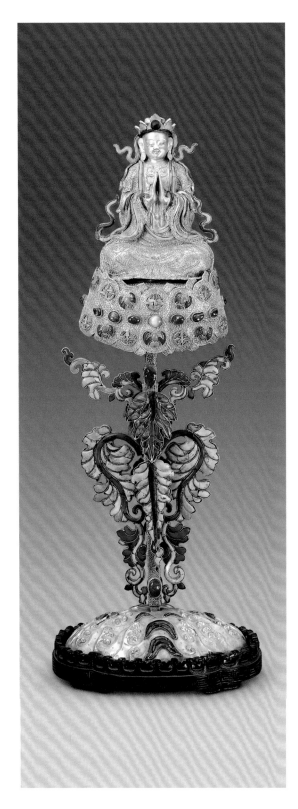

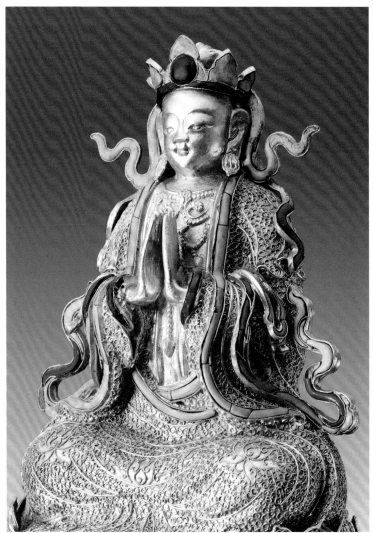

21

Gold dragon and phoenix coronet
inlaid with pearls, precious stones, and kingfisher feathers

Ming Dynasty Wanli period

Height 26.5 cm
Diameter of Mouth 23 cm
Unearthed at the Ding Mausoleum of the Ming Dynasty, Beijing, in 1958

The coronet is made with slim bamboo strips and layered with lacquer. On the coronet are decorations of kingfisher feather flakes in the shape of *ruyi* cloud patterns and eighteen plum blossoms inlaid with precious stones and pearls. The front side of the coronet is decorated with a pair of phoenixes made with kingfisher feathers, and the top of the coronet is decorated with three dragons woven with gold wires in equal distances, with two dragons on the left and right side of the coronet holding tassels of pearls and precious stones in the mouths. The back side of the coronet is decorated with two braids made with six strip-chains of pearls and precious stones spreading to the left and right sides in the shape of a fan. On the rim of the coronet is a border of flowers set with rubies.

Altogether over one hundred rubies, sapphires, and five thousand pearls in different sizes were used to decorate this coronet with a splendid colour scheme and extravagence. It was the ritual coronet worn by Empress Xiaoduan at grand ceremonies of the court. Empress Xiaoduan was the wife of Emperor Shenzong (Zhu Yijun) who had become Crown Empress in the sixth year of the Wanli period (1578 A.D.). She passed away in the 48th year of the Wanli period (1620 A.D.) and was conferred the posthumous title Xiaoduan. She was buried together with Emperor Shenzong at the Ding Mausoleum.

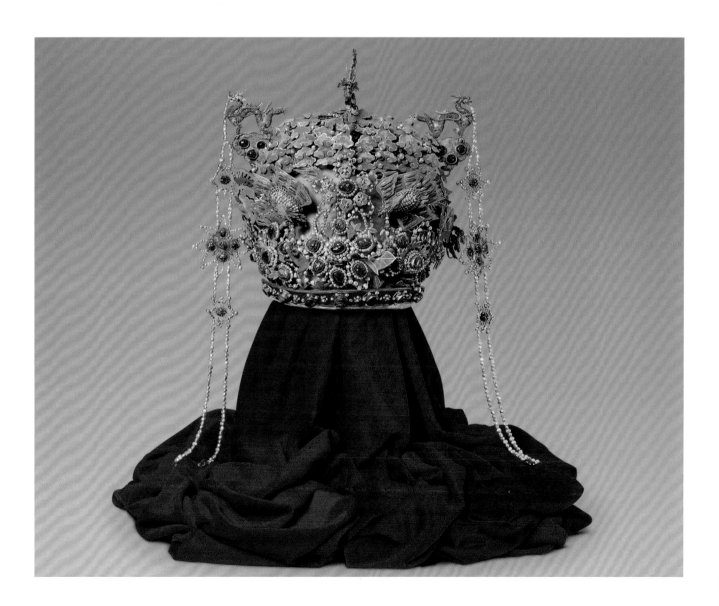

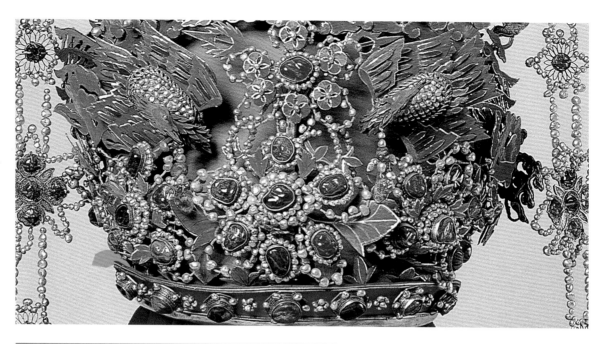

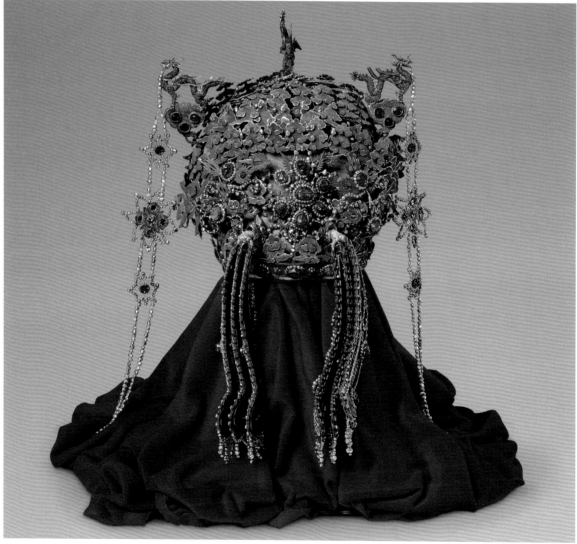

22

Green jade imperial seal

Ming Dynasty　Chongzhen period

Overall Height 11 cm
Length of Sides 11 x 9 cm

The seal is square in shape and has a knob in the shape of a recumbent dragon. The seal script is engraved with the written signature mark "*Youjian*", the name of Emperor Chongzhen of the Ming Dynasty. It is authenticated as the Emperor's seal as proved by the same seal mark found on the existing imperial writings of Emperor Chongzhen.

The knob of seal is carved with a touch of gracefulness and vigour, and the signature mark is engraved in a fluent and swift manner. Imperial seals of the emperors of the Ming Dynasty are no longer extant with this seal as the only exception, which is extremely valuable.

Zhu Youjian, the last emperor of the Ming Dynasty, ascended the throne in 1627 A.D. and changed his reign's name to Chongzhen in 1628 A.D. In 1644 A.D., the revolutionary leader Li Zicheng led his peasant army to conquer Beijing. The emperor fled to Jingshan and committed suicide, signifying the downfall of the rule of the Ming Empire.

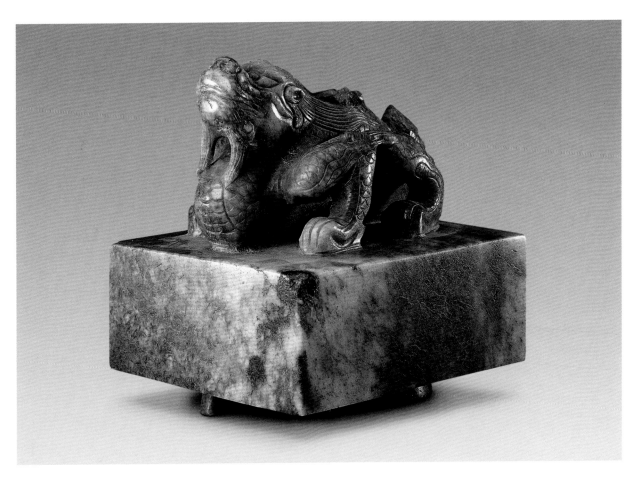

23

Jaspar seal
with the seal mark *"huangdi fengtian zhibao"*

Early Qing period

Overall Height 15.2 cm Length of Side 14 cm
Qing court collection

The seal is square in shape and has a knob in the shape of a curling dragon. The seal mark is carved in *yuzhu* seal script in relief, with Manchurian script on the left and Chinese script on the right.

The imperial seal was one of the twenty-five imperial seals, which signified the imperial rule of the Qing Empire, and was produced in the period of Huang Taiji, Emperor Taizong before he took over China. The imperial mechanism laid down the principle that "the imperial rule was bestowed from heaven", and emperors of the Ming and Qing dynasties ruled the nation with the order from heaven. In the early Qing Dynasty, the mechanism in using imperial seals was quite confused without designated regulations. In view of this, Emperor Qianlong had selected twenty-five seals of high quality from the imperial inventory and re-carved the twenty-five imperial seals for designation as official imperial seals. This set of "twenty-five imperial seals" is the only extant set of seals that represent the supreme power of the emperors in the Chinese dynastic history, and thus has great historic significance.

Yuzhu is also known as jade chopstick seal script. It is one of the styles of ancient seal scripts with strokes elegantly and roundly rendered, resembling the quality and slimness of jade chopsticks, and thus was so named.

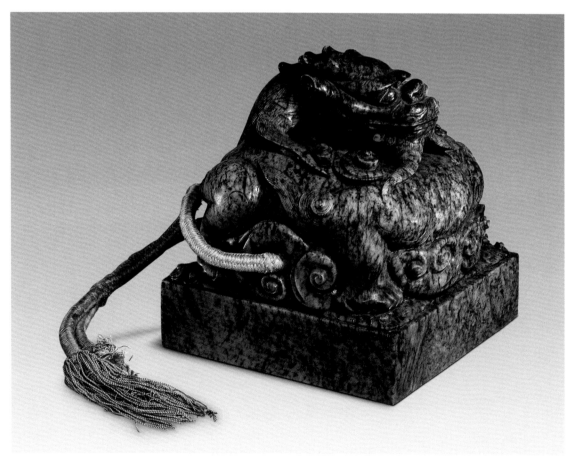

24

White jade bowl
with two ears and designs inlaid with gold wires and precious stones

Qing Dynasty Qianlong period

Height 4.8 cm
Diameter of Mouth 14.1 cm
Diameter of Foot 7 cm
Qing court collection

The bowl has a flared mouth, a slanting belly, a ring foot in the shape of flower petals, and two ears in the shape of peaches. The mouth rim is plain, and the exterior wall of the belly is decorated with foliage scrolls and flowers inlaid with gold wires. The red flowers are further set and inlaid with one hundred and eight precious stones. The exterior base is decorated with foliage scrolls inlaid with gold wires. The interior wall of the belly is engraved with an imperial poem by Emperor Qianlong in regular script and marks which literally describes "imperial inscribed in the first month of the year *bingwu* of the Qianlong period" and a seal mark "*bide*". The centre of the interior base is inscribed "*Qianlong yuyong*" (for the imperial use of Emperor Qianlong) in clerical script. The year *bingwu* corresponded to the 51st year of the Qianlong period (1786 A.D.)

This bowl shows the typical decorative features of Hindustan jade ware. Hindustan was located in the northern part of India, including various regions in Kashmir and Pakistan. In the Qing Dynasty, jade ware produced in India, Turkey, and Central Asia was collectively grouped as Hindustan jade ware. Such ware had the distinctive features of thin bodies and delicate and exquisite carved designs, most of which was decorated with designs inlaid with gold, silver flowers, and precious stones in a skilful and exquisite manner.

Designs inlaid with gold and silver are also known as gold and silver inlaid designs, or vice versa, which is a traditional technique for decorating arts and crafts by using gold or silver wires to inlay decorative designs or scripts on the ware with three processes including carving grooves, set and inlay of designs, and final polishing.

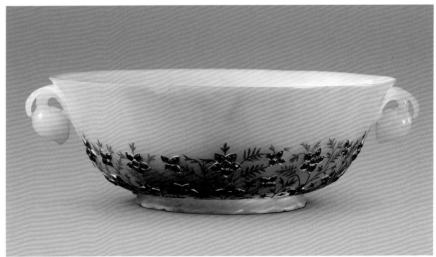

25

White jade bowl
with a gold cover and a
stand and engraved with
Tibetan scripts

Qing Dynasty Qianlong period

Overall Height 26 cm
Diameter of Mouth 14.5 cm
Qing court collection

The ware comprises of three parts: the jade bowl, the gold cover, and the gold stand. The round white jade bowl has a flared mouth, and the exterior wall is plain. The interior mouth rim is engraved with a border of Tibetan scripts. The base is inscribed with a four-character mark of Qianlong (Qianlongnian *zhi*). It has a fitting cover and a stand made with 90% gold. On top of the cover is a pearl-shaped knob. The surface of the cover is decorated with three layers of lotus petals and six groups of foliage scrolls in low relief, and in each of the groups is a flower inlaid with turquoises. The stand is divided into three tiers. The upper tier is a drum-shaped bowl stand carved with foliage scrolls in low relief and decorated with plum flowers and cloud patterns inlaid with turquoises. Under the stand is a plate on which are carved designs of foliage scrolls and flowers inlaid with turquoises. Under the plate is a high stem carved with foliage scrolls, cloud patterns, and *ruyi* clouds, and it is inlaid with turquoises in different shapes.

This bowl is made by utilizing gold and jade, and inlaid with forty-six turquoises in different sizes and shapes perfectly. The form and the decorative style show a blending of Mongolian and Tibetan aborginal crafts, and at the same time reveal the typical decorative style of Qing court ware.

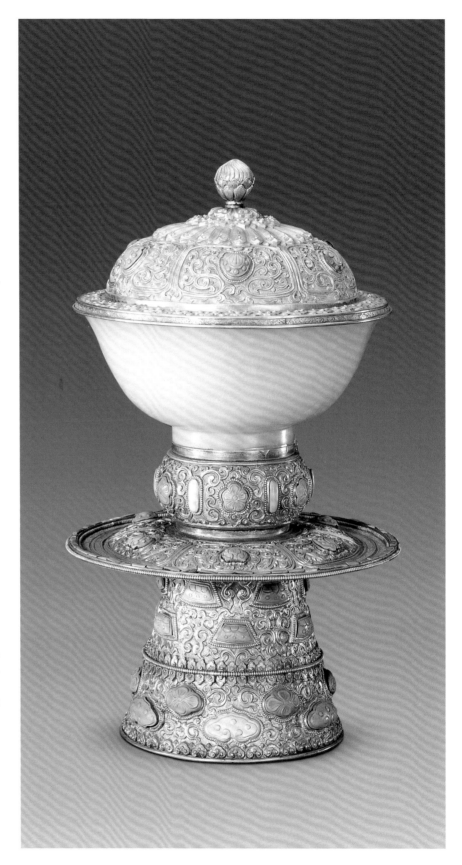

26

Jasper water-dropper for an inkstone
in the shape of a sacrificial animal

Qing Dynasty Qianlong period

Height 11 cm
Diameter of Mouth 1.5 cm
Qing court collection

The water-dropper for an inkstone is carved in the shape of a sacrificial animal in the round, and the interior is hollow for storing water. At the back is a round hole in which a spout is inserted. Underneath is a four-character mark of Qianlong (Qianlongnian *zhi*) in seal script.

Water-droppers for an inkstone were a kind of stationery in ancient China, which were used for storing water for pouring into an inkstone to grind ink.

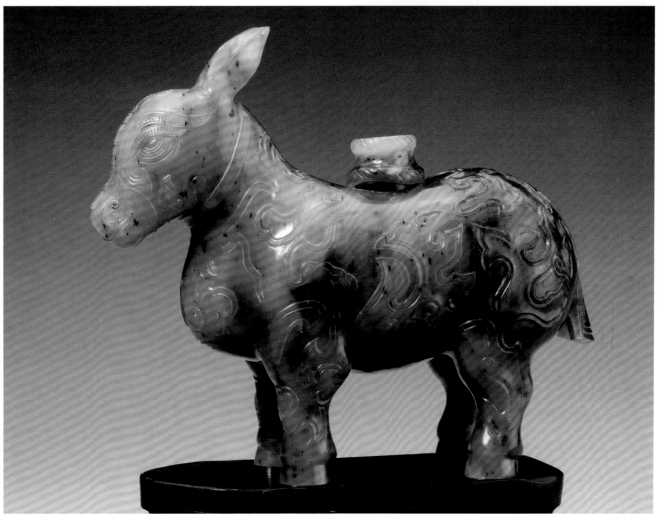

27

A set of jasper snuff bottles
with animal-shaped ears

Qing Dynasty Qianlong period

Overall Height 5.9 cm
Diameter of Belly 4.3 cm
Qing court collection

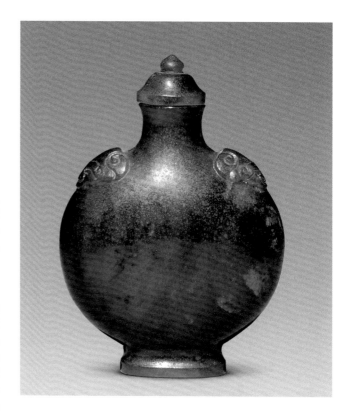

Each of the snuff bottles is in the shape of an ovoid flask with an oval ring foot. The body is plain with the two symmetrical sides of the shoulder decorated with animal-shaped ears. The base is incised with a four-character mark of Qianlong (Qianlongnian *zhi*) in seal script. Each bottle has a small round jasper stopper with an ivory spoon.

This set of eight jasper snuff bottles are stored in a red sandalwood box with carved decorations in relief and designs inlaid with jade. The surface of the box cover is decorated with swastikas (卍) and bat designs inlaid with jade, which carry the auspicious blessing of ten thousand fortunes. The production of jaspar snuff bottles was rather limited, and they were often modeled with archaic forms in a delightful and refined manner, with most of them produced by the Imperial Workshops of the Qing court.

Snuff bottles are used for containing snuff which is produced by drying good quality tobacco leaves, mixing them with high quality herbs, and grounding the mixture into powder for putting inside a concealed container. After a considerable period of storage, the tobacco powder could be directly smelled. Snuff was imported from the west into China around the early Qing period.

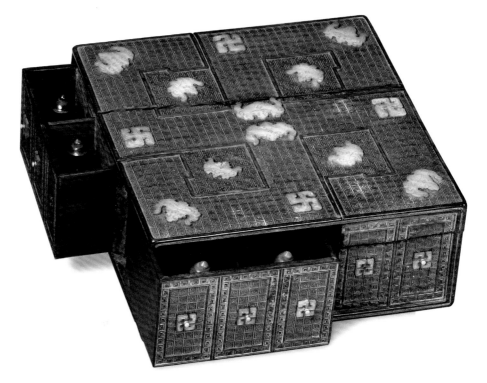

28

Weasel-hair brush
with a celadon jade holder-tube
and a cloisonné enamel holder
with designs of dragons in relief

Qing Dynasty Qianlong period

Length of Holder-tube 24.6 cm Diameter of Holder-tube 1.8 cm
Length of Holder 2.9 cm Diameter of Holder 3.8 cm
Qing court collection

The holder-tube of the brush is carved with dragon designs in relief, and the two ends are decorated with lotus designs and key-fret patterns. The top of holder-tube is decorated with reclining *chi*-dragons. The cloisonné enamel holder is decorated with lotus designs, which holds the brush tip made with weasel hair in the shape of a flower bud.

This brush, made with both jade carving and cloisonné enamel decorative techniques, is a very rare and extant piece of work of its type. The jade is of a refined quality and skilfully decorated with the cloisonné enamel designs rendered fluently and spread evenly with graceful and shiny colours, representing the most refined type of Chinese brushes.

Chinese brush, belonging to one of the four treasures of the scholar's table, is a traditional tool for writing and painting in China and is often made with hair of animals. According to the materials used, Chinese brush can be divided into several types, such as "hard hair brush" (made with hair of rabbits, wolves, and mouses), "mixed hair brush", and "soft hair brush" (made with hair of goats or sheep). Wolf hair often refers to hair of the tail of weasels used for making brushes.

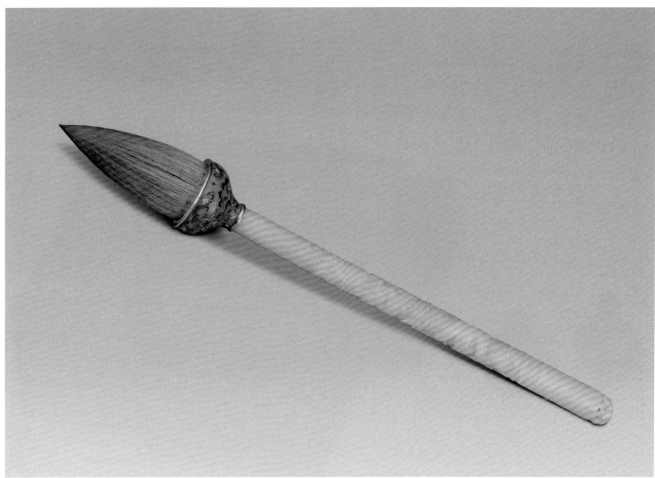

29

Celadon jade miniature landscape
with designs of narcissuses

Qing Dynasty Qianlong period

Overall Height 30 cm
Length of Pot 18 cm
Width of Pot 13 cm
Qing court collection

This miniature landscape comprises of two parts: the basin and the miniature landscape. The basin is made with celadon jade in the shape of chrysanthemum petals, and the wall is thinly carved with a semi-translucent quality. Each of the four corners is decorated with an ear in the shape of a flower with two leaves in openwork, and each flower is inlaid with twelve rubies as petals and green glass as stamens. The lower part of the basin is carved with leaf patterns inlaid with green glass and gold wires. The miniature landscape in the pot comprises of five stems of narcissuses and a rock made with lapis lazuli. The narcissuses are set with ivory as the roots, painted ivory as leaves, white jade as flowers, and yellow jade as stamens with a touch of naturalism.

The decorations at the basin of this miniature landscape are similar to the decorative style of Hindustan jade ware. The colour scheme of the basin and the miniature landscape match harmoniously with a touch of lyricism, and this ware is a refined decorative object for display during the Chinese Lunar New Year. According to the *List of Tributary Objects to the Court*, it is recorded that "On the 27th day of the 10th month of the 56th year of the Qianlong period (1791 A.D.), Fu Kang'an came to the capital and sent a pair of celadon jade miniature landscapes with designs of narcissuses as tributary gifts (to the court)". This piece should have been one of this pair.

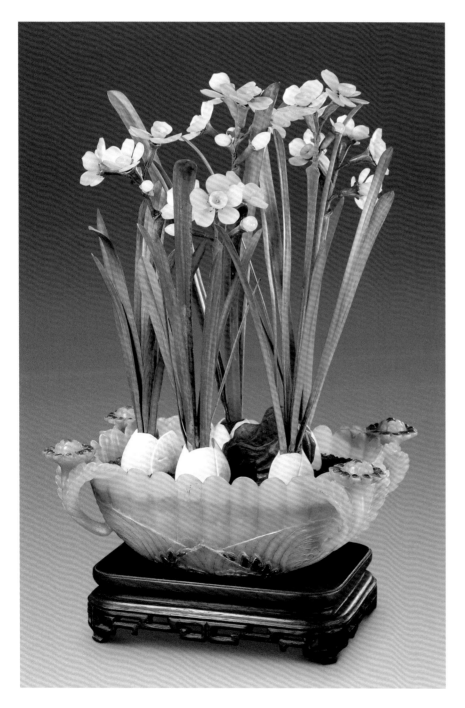

30

Sabre
with a white jade hilt inlaid with precious stones and a peach-wood scabbard coated with gold and inscribed *"hanying"*

Qing Dynasty Qianlong period

Overall Length 94 cm
Length of Blade 72 cm
Length of Handle 20 cm
Qing court collection

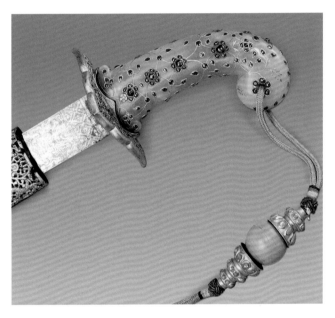

The sabre has a white jade hilt with a curved head, on which are decorations bordered with gold wires and inlaid with over one hundred rubies and emeralds. The top of the hilt is fastened with a yellow silk tassel with a pendant inlaid with turquoises on a gilt lotus pedestal. It has a lozenge-shaped guard and steel blade. Near the hole for installing the blade are interspersed patterns inlaid with gold, silver, and copper wires. On one side is an inscription *"tianzi ershijiu hao"* (no. 29 of the Heaven category) and the name of the sabre *"hanying"* (elite) in clerical script, and on the other side is a four-character mark of Qianlong (Qianlongnian *zhi*). Under the mark are decorations of figures matching the attributes of elites. The scabbard is covered with peachwood bark coated with gold, which suggests the blessing of peachwood would wipe off evils. The upper and lower ends of the scabbard are engraved with inlaid openwork gold decorations on iron. The body of the scabbard are decorated with two borders with inlaid gold designs of *panchi*-dragons in relief and fastened with a yellow silk tassel for carrying.

From the 13th year (1748 A.D.) to the 60th year (1795 A.D.) of the Qianlong period, the Imperial Workshops had produced three categories of sabres, namely *"tian"* (heaven), *"di"* (earth), and *"ren"* (man). Each category had thirty sabres, and altogether ninety pieces were produced, with this one belonging to one of them.

Decorations on this sabre show a special decorative technique of metal art by utilizing gold or silver inlay on incised or carved designs. The production method is to incise line borders by holding a knife from a slanting angle, and then inlay thin gold or silver flakes or wires on the metal body. Afterwards the inlaid gold or silver designs would be hammered to fit into the incised line borders tightly and flatly, and then polished into shiny gold or silver inlaid designs.

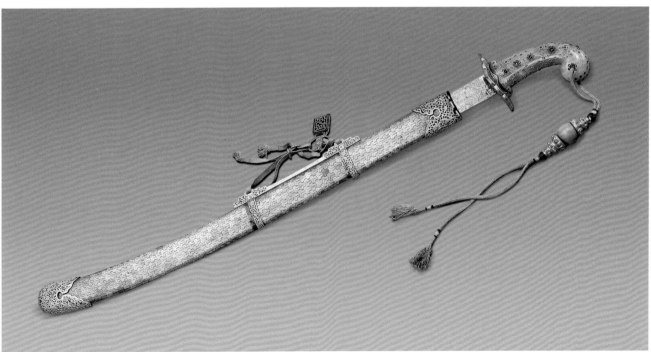

31

Celadon jade dagger
with a hilt inlaid with
precious stones and a
scabbard decorated with
copper leaves

Qing Dynasty Qianlong period

Overall Length 41 cm
Length of Blade 27.5 cm
Length of Handle 13.5 cm
Qing court collection

The celadon jade dagger has a curled
hilt and floral decorations inlaid with over
one hundred rubies, emeralds, sapphires,
and other precious stones bordered with
gold wires. The steel blade is sharp at the
front and thick at the rear. It has a wooden
scabbard coated with gilt copper leaves
carved with lozenge-shaped floral patterns.

The dagger was for imperial use by
Emperor Qianlong.

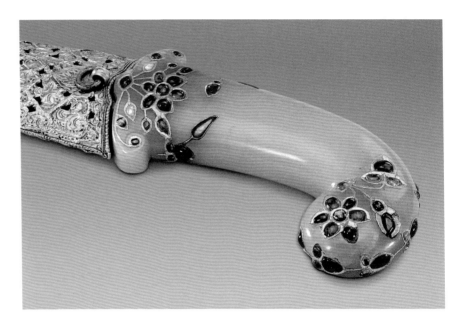

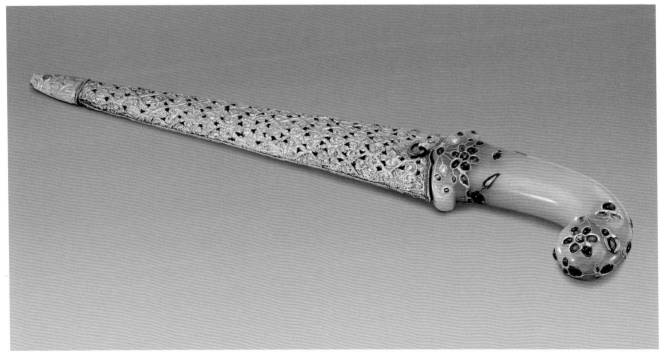

32

Jadeite *qing* chime
with a design of an elephant
bringing peace

Qing Dynasty Qianlong period

Overall Height 56 cm
Height of Chime 26 cm
Width 25 cm

One side of the chime is carved with a design of an elephant turning its head backwards in low relief, and another side is carved with a design of *ruyi* cloud patterns in relief. The round panel in the middle is inscribed with four characters "*taiping youxiang*" (elephant bringing peace) in seal script. The upper side of the chime is decorated with pine needle balls, and the ball at the centre is pierced and fastened with a copper ring and hanger linking to the small gilt copper chime on top. The large chime is supported by a wooden stand decorated with variegated clouds and bats. The small chime is hung on a red sandalwood frame carved with *ruyi* cloud patterns and designs of flowers and leaves in openwork.

Jadeite is also known as "hard jade" and Burma jade.

"Elephant bringing peace" was a very popular auspicious motif on the decorative objects of the imperial Qing court, which carried the blessing of peace for the nation and abundant harvest. *Qing* (chime) is a homonym for *qing* (happiness) while *fu* is a homonym for fortune; with decoration of *ruyi* clouds, the combination of these motifs has the auspicious meaning of "good fortune and happiness will come, and wishes would come true".

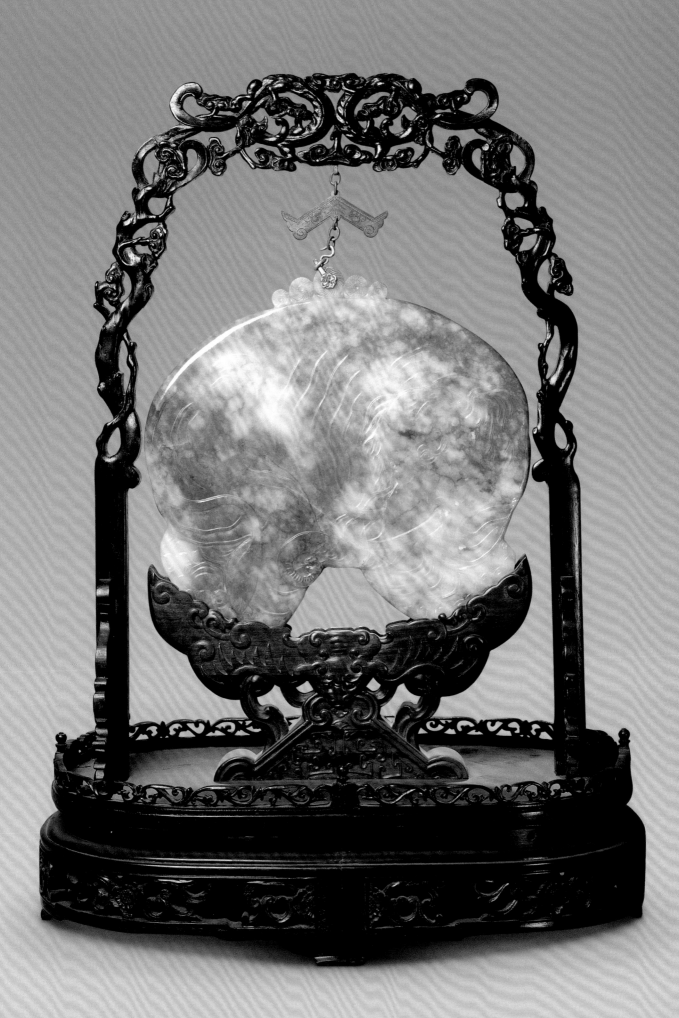

33

Red and white agate flower receptade
in the shape of two carps

Qing Dynasty Qianlong period

Height 23 cm
Width 12.5 cm
Qing court collection

With carving techniques in openwork and relief, this flower receptade is carved in the shape of two carps by utilizing the ingenious colours of red and white of agate. The two carps in red and white open their mouths with their tails and bodies conjoined and rendered in a leaping posture. They have wings on the bodies, and outside their mouths are flaming pearls, suggesting that the fish are transformed into dragons. The tails spread to the two sides to form the legs. The bodies are carved with designs of *lingzhi* fungi. The receptade is supported on a red sandalwood stand carved with crested waves and two conch shells on top of the waves in relief. The interior side of the tail of the red fish is engraved with a four-character mark of Qianlong (Qianlongnian *zhi*) in seal script.

Agate is a kind of chalcedony with luxuriant colours which exudes a sense of dimension, and it is often used to produce accessories or decorative objects. As agate has various textures and colours, craftsmen often utilize its ingenious colours to carve different decorations that fit perfectly with the colours naturalistically in a distinctive manner.

The motif of carps transforming into dragons and carps leaping the Gate of Dragon is a traditional auspicious decorative motif. It is said that once a carp successfully leaps over the Gate of Dragon, it would become a dragon, and this decorative motif carries the blessing of success in official career.

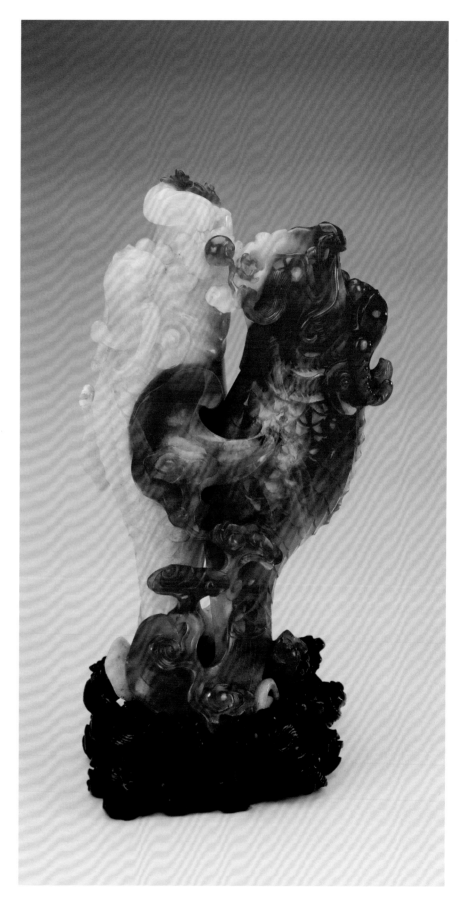

34

Aventurine boulder
with designs of three rams
bringing prosperity in the
beginning of a New Year

Qing Dynasty Qianlong period

Overall Height 15 cm
Length 21.6 cm
Width 13.6 cm
Qing court collection

The landscape boulder is in the shape of rocks, amidst which are three rams in different postures, carved in relief and in the round. A bigger recumbent ram is at the hillside, with its head looking up at the peak. The other two rams are smaller, with one looking for food in the hill and another sitting on the peak turning its head back. The base of the boulder is engraved with a four-character mark of Qianlong (Qianlongnian *zhi*) in seal script. It has a fitting boxwood stand carved with rocks and crested waves in relief.

Aventurine was a new type of glass first produced in the Qianlong period. Such a kind of glass was mixed with copper or other crystallized particles to produce a gold-sprinkled appearance. Its production was closely associated with the introduction of new production technology from the west at the time.

Boulder is a kind of three-dimensional sculptural objects in simulation of natural landscape or garden rockery. It was popular in the Ming and Qing dynasties, and decorative boulders were made with bamboo, wood, ivory, stones, jade, and other materials. This piece is the only extant aventurine ware of the Qianlong period that carries the reign mark and is very valuable. The motif of three rams bringing prosperity at the beginning of a New Year is derived from the description of the Eight Trigrams in the classic *Book of Changes*, which elaborates that the first month of the Chinese Lunar New Year belongs to the *tai* trigram which has three horizontal strokes on the bottom, representing the spring comes after winter, brightness replaces the dark, and everything blooms again to bring prosperity. The character "*yang*" (ram) is a homonym for "*yang*" (prosperity), and hence the motif of three goats is often employed as an auspicious symbol of a peaceful nation and prosperous society.

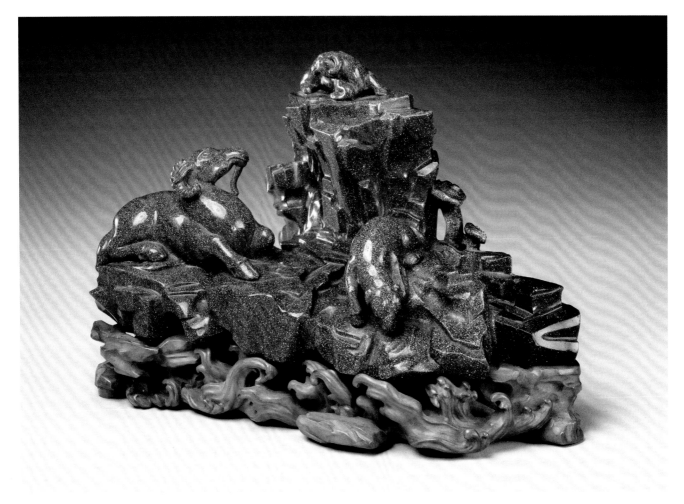

35

Glass snuff bottle
with painted designs of flowers of wealth in colour enamels

Qing Dynasty Qianlong period

Overall Height 5.4 cm Diameter of Belly 4 cm
Qing court collection

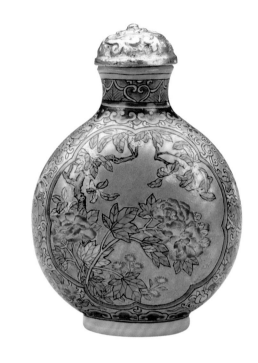

The ovoid snuff bottle has an oval ring foot. On the opaque glass body are designs in painted colour enamels on a gold ground. The two sides of the bottle are decorated with floral-shaped panels. One panel is decorated with hibiscuses and osmanthuses, and the other panel is decorated with plum blossoms and camellias, which carry the auspicious blessing of wealth and prosperity. Outside the panels are decorations of floral scrolls. The base is engraved with a four-character mark of Qianlong (Qianlongnian *zhi*) in seal script. The snuff bottle has a gilt bronze stopper with carved designs and an ivory spoon.

The snuff bottle was produced by the Glass Factory of the Imperial Workshops of the court. It is coated with a gilt ground, representing the luxuriant decorative style of imperial ware. The Palace Museum only collects three snuff bottles with the same design and high production quality, which are rare and unusual.

36

Glass snuff bottle
with painted designs of *kui*-dragons in colour enamels

Qing Dynasty Qianlong period

Overall Height 4.8 cm Diameter of Belly 4 cm
Qing court collection

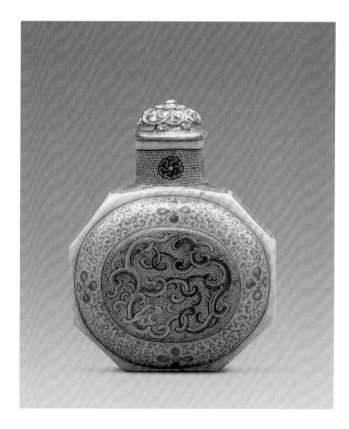

The ovoid flat octagonal snuff bottle has a flat base. On the opaque white glass body are designs painted in pink enamel. The front and rear sides of the bottle have two panels in low relief, in which are decorations of two intertwining *kui*-dragons painted in blue and green enamels, and surrounded by floral scrolls painted in blue enamel. The base is engraved with a four-character mark of Qianlong (Qianlongnian *zhi*) in imitation Song script style. The snuff bottle has a gilt bronze stopper with carved designs and an ivory spoon.

The snuff bottle has a delicate and graceful form with clearly layered decorative designs painted with a subtle and harmonious colour scheme, representing a refined piece of work produced by the Glass Workshop of the Imperial Workshops of the court.

37

Glass snuff bottle
with painted designs of western ladies in colour enamels

Qing Dynasty Qianlong period

Overall Height 4 cm Diameter of Belly 2.8 cm
Qing court collection

The snuff bottle is in the shape of a small vase and has an upright mouth and a ring foot. On the opaque glass body are designs painted in colour enamels. The snuff bottles have panels on its four sides. The front and rear panels are decorated with western ladies in colour enamels, and the left and right sides are painted with designs of western buildings in rouge red enamel. The base is engraved with a four-character mark of Qianlong (Qianlongnian *zhi*) in imitation Song script style. The snuff bottle has a gilt bronze stopper with carved designs and an ivory spoon.

The western ladies on this snuff bottle are rendered with elegant features of foreign ladies, which should have been painted by court painters of the Qianlong period.

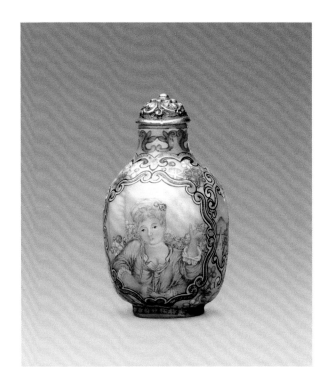

38

Red overlay white glass snuff bottle
with designs of a dragon and a phoenix

Qing Dynasty Qianlong period

Overall Height 4.8 cm Diameter of Belly 3.2 cm
Qing court collection

The flat snuff bottle has an oval ring foot. This white glass snuff bottle is overlayed with pinkish-red glass with one side of which decorated with a *kui*-dragon and the other side decorated with a *kui*-phoenix. The decorative motifs have the auspicious blessing of "dragons and phoenixes bringing prosperity and harmony". The base is engraved with a four-character mark of Qianlong (Qianlongnian *zhi*). The snuff bottle has a gilt bronze stopper with carved designs and an ivory spoon.

This flat and round snuff bottle is modeled with a graceful form, showing the typical decorative style of the Qing court. It was produced by the Glass Workshop of the Imperial Workshops of the court for imperial use.

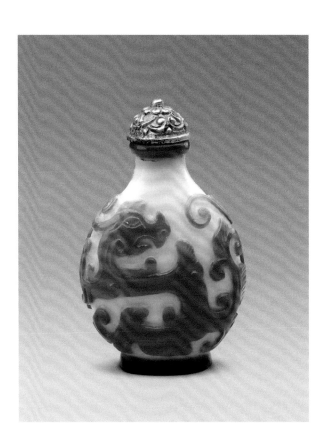

39

Mixed colour aventurine gourd-shaped glass snuff bottle

Mid Qing period

Overall Height 5.3 cm Diameter of Belly 4.2 cm
Qing court collection

The gourd-shaped snuff bottle has a contracted waist and a flat base. The body is modeled by mixing various glass materials in blue, deep red, red, light green, light yellow, brown, and other colours to form different colour striations, and further highlighted by sprinkled aventurine with a touch of elegance and extravagence. The snuff bottle has a gilt bronze stopper with carved designs and an ivory spoon.

This snuff bottle is exquisitely modeled with mixed colour glasses, representing one of the finest pieces of aventurine glass snuff bottles. Such a production technique was originated in the west with craftsmen mixing glass materials in different colours for firing so that variegated effects of colour striations and mottles would appear naturally. When copper element is added for firing, aventurine sprinkles would appear, and the decorative style is known as aventurine sprinkled decorations.

40

Glass snuff bottle
with inside painting of a scene of a boat returning home amidst the storm

Zhou Leyuan

Late Qing period

Overall Height 4.1 cm Diameter of Belly 2.3 cm
Qing court collection

The snuff bottle is in the shape of a small jar with an upright mouth, a wide shoulder, and a ring foot. The interior of the bottle is decorated with a panoramic scene of a boat returning home amidst wind and rain. In the painting, a fisherman wearing a raincoat and riding a boat is on his way to the shore with landscape setting of pine trees, water pavilions, and large trees being blown by strong wind. The base is written with a mark *"renchen furi, Zhou Leyuan zuo"* (Painted by Zhou Leyuan on a summer day in the year *renchen*). The year *renchen* corresponded to the 18th year of the Guangxu period (1892 A.D.).

Zhou Leyuan was a master excelled in inside painting of snuff bottles in the late Qing period. He was prolific in painting landscapes, figures, flowers, birds, and insects. He also mastered the style of Hua Yan, a renowned painter of the Qing Dynasty, and adopted Hua's style for his inside paintings of snuff bottles, as represented by this piece.

Crystal snuff bottle
with inside painting of a portrait

Ma Shaoxuan

Late Qing period

Overall Height 9.6 cm

Diameter of Belly 6.1 cm

The snuff bottle is in the shape of a small flat jar with ears in the shape of animal masks holding rings on the two symmetrical sides of the shoulder. One side at the interior of the bottle is painted with a portrait in sepia ink, and the facial features of the portrait and the shading effects show the style of western painting. The other side is written, in regular script, with an extract from the calligraphic work *Jiuchenggong Liquanming* by Ouyang Xun of the Tang Dynasty, which literally describes, "In the fourth month of the sixth year of the Zhenguan period, the Emperor retreated to the Jiucheng Palace in summer, and later he retreated to the Renshou Palace. This palace faces majestic mountains with cliffs above a pond, and water is falling down around the palace – an extract." At the beginning of the extract is an inscription which literary describes "for the appreciation of the master, Xiaoquan the second brother", and at the end is a mark "Shaoxuan Ma Guangjia" and a seal mark "Shaoxuan" in red in seal script. The snuff bottle has a red coral stopper and an ivory spoon with a green glass support, which was broken.

Ma Shaoxuan (1867 – 1937 A.D.) was a master of inside painting of snuff bottles, who commanded a variety of decorative subjects, in particularly portraits and figures from operas. He often painted on one side and wrote calligraphy on the other side inside the snuff bottles. Most of his paintings were portraits, while his calligraphy style showed the legacy of the Tang calligrapher Ouyang Xun.

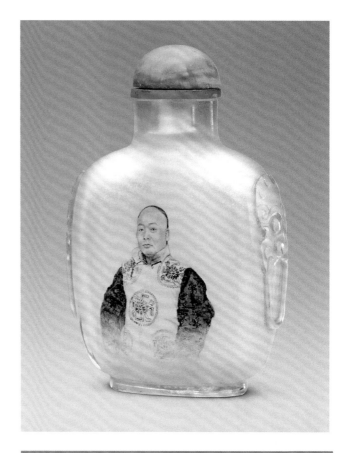

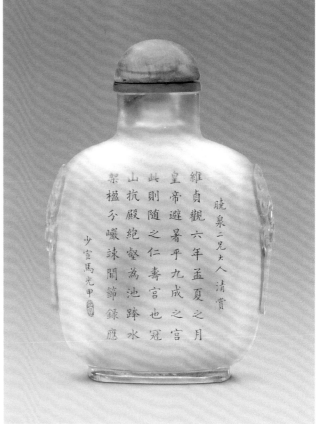

42

Agate flower receptade
in the shape of a pine stump
with designs of *lingzhi* fungi

Mid Qing period

Height 10.1 cm
Width 7 cm
Qing court collection

The flower receptade is in the shape of a pale brown tree stump. The exterior side is carved with designs of *lingzhi* fungi, plum blossoms, bamboos, and pines in relief and openwork.

The receptade is made with fine quality agate with bright colour and skilfully treated decorations. The small hole inside the receptade is too small for holding flowers, and hence this ware might not be a functional object. Instead, it was rather a decorative object or an object for scholar's table. In ancient China, the *lingzhi* fungi were regarded as a kind of herb of immortality, which could bring the dead back to life, thus it carried the same blessing of longevity as pines. Pine, bamboo, and plum flowers could survive cold winter, and they were collectively known as the "three friends of winter", symbolizing the lofty and transcended characters of the literati.

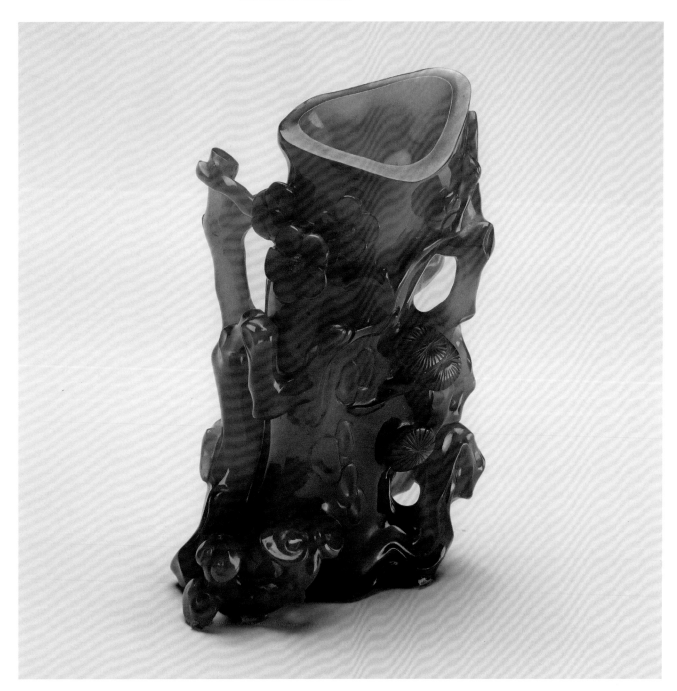

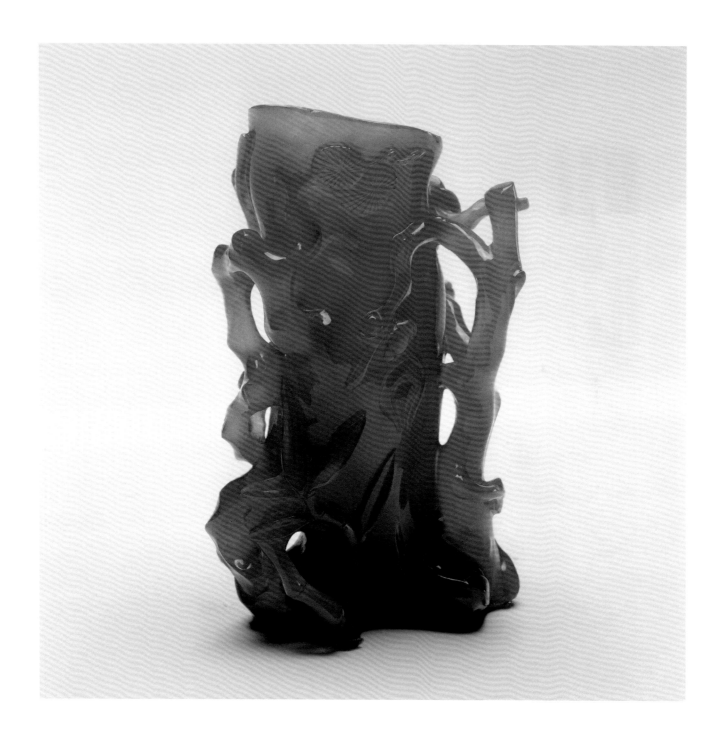

43

Jadeite recumbent buffalo

Mid Qing period

Height 6.6 cm
Length 15.1 cm
Width 7.7 cm
Qing court collection

The buffalo with the head turning back is carved in the round. The top of the head, the two horns, and the right side of the body keep the original deep yellow colour of the jadeite skin. The upper mouth lip, the nose, and some areas on the body have green striations. It has a fitting sandalwood stand carved with designs of crested waves.

According to the archive of tributary objects of the Qing court, on the 14th day of the 10th month of the 23rd year of the Jiaqing period (1818 A.D.), Akezhang A, Director General of Salt Industry of the two Huai regions had sent a jadeite recumbent buffalo to the court as a tribute, which might be this piece. In carving this work, different colours of yellow on the original skin of the stone and the green colour jadeite were utilized skilfully to decorate the body of the buffalo. It was then finely polished with the quality of jadeite and carving matching harmoniously.

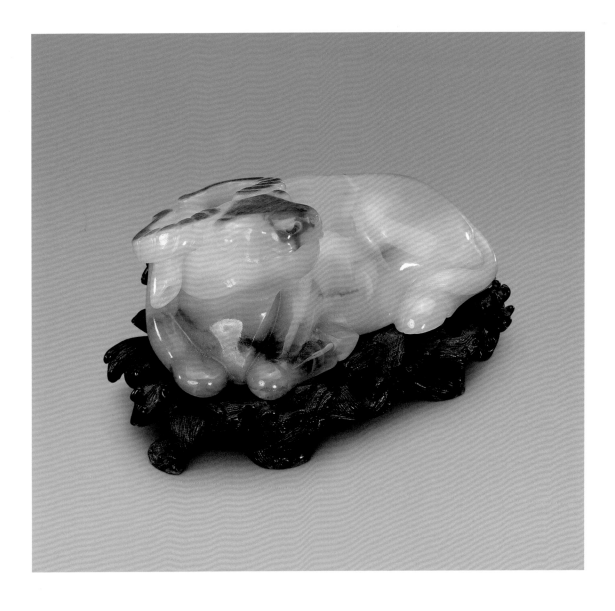

44

Tianhuang stone imperial seal "Yushang"

Qingtian stone imperial seal "Tongdaotang"

Qing Dynasty Xianfeng period

Yushang Overall Height 5 cm
Length of Sides 2 x 1 cm
Tongtaotang Overall Height 8 cm
Length of Sides 2 cm
Qing court collection

The imperial seal with the inscription "*yushang*" is carved with relief seal scripts read from top to bottom, while the imperial seal with the inscription "*tongtaotang*" is carved in engraved seal scripts read from upper right to left.

These two seals were originally the imperial seals of Emperor Xianfeng, who bestowed *Yushang* to Empress Ci'an before he passed away and *Tongtaotang* to Prince Zai Chun, the later Emperor Tongzhi. As Zai Chun was still too young, the imperial seal *Tongtaotang* was kept by his mother Concubine Yi, the later Empress Dowager Ci'xi. Emperor Xianfeng ordered that the seal mark of "*yushang*" must be stamped on the beginning part of an imperial edict to announce the opening part, and the seal mark of "*tongtaotang*" must be stamped at the end of the edict to mark the closing part, in order to assure its validity. Thus these two seals were once a symbol of the imperial sovereignty.

Tianhuang stone is mostly found at the Putian and Shoushan districts of the Fujian province and belongs to a highly valuable category of *shoushan* stones. Since the Ming and Qing dynasties, this type of stones has been often used for carving seals. *Qingtian* stone is found at the Qingtian district in the Zhejiang province and thus named after Qiantian. This type of stones is one of the earliest stones used for carving seals.

45

Jadeite flower receptade
with carved designs
of flowers and birds

Qing Dynasty

Height 25 cm
Diameter of Mouth 5.9 x 8.6 cm
Diameter of Foot 5 x 7.3 cm
Qing court collection

The flower receptade is carved in the shape of an old tree stump by utilizing the ingenious colour of reddish jadeite skin and the green colour striations on the jadeite piece. In the middle is a hole for holding flowers, and the tree stump is carved with fresh branches in openwork and a peony spray in relief, on which are a recumbent bird and below which is a crane standing. On the rock is a phoenix carved in openwork. On the other side of this object are decorations of a bird on a branch of peony and two small toads on the leaves below. The flower receptade has a red sandalwood stand with decorations carved in openwork.

The flower receptade is a decorative object for holding flowers or other objects. It had already appeared in the jade carvings of the Ming Dynasty, which was often modeled with a tubular shape. The forms of flower receptades increased in the Qing Dynasty, with a popular form carved in the shape of a tree stump. This flower receptade is carved from jadeite with a high degree of transparency and pretty colours, with some parts also in deep green colour, representing a refined piece of its type among the Qing jade carvings by utilizing the natural colours of the materials to match the desired effects of decotations.

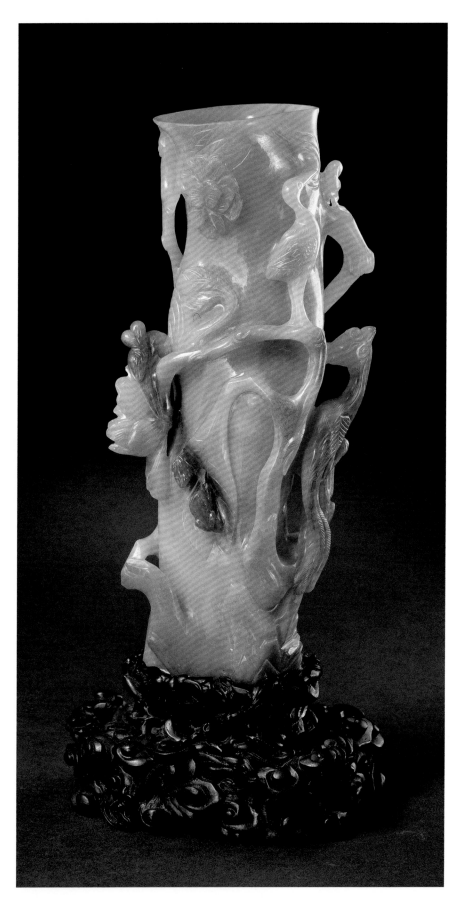

46
Jadeite miniature landscape
with designs of bamboos

Qing Dynasty

Overall Height 25 cm
Length of Basin 23.5 cm
Width of Basin 17 cm
Qing court collection

The miniature landscape comprises of two parts: the basin and the miniature landscape. The basin is made with wood in the shape of a holly-hock with four petals. Its exterior wall is decorated with plum blossoms on an ice-crackled ground, and is supported by four short legs in the shape of clouds. The miniature landscape represents a landscape with rocks and bamboos which are set with four white jade rocks, three green jadeite bamboos, and a bamboo shoot. The branches are made with woven gold wires on which are jadeite leaves.

This miniature landscape is skilfully carved by utilizing different colours and striations of jadeite, exuding a charm of harmony, vividness, and delicacy, and represents a refined piece of jade miniature landscapes of the Qing court.

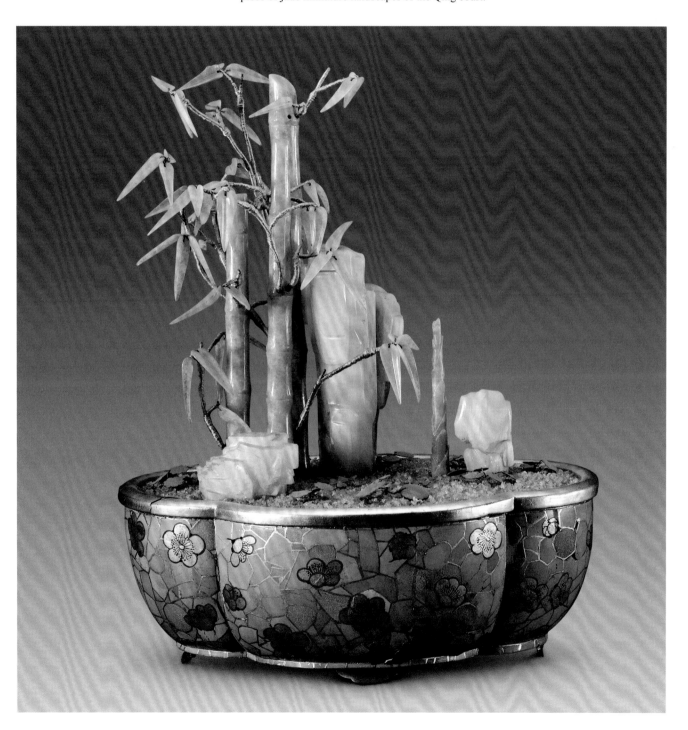

47

Miniature landscape
with a gold rectangular basin
with angular corners and
plum blossoms set
with rubies

Qing Dynasty

Overall Height 38.5 cm
Length of Basin 22 cm
Width of Basin 14.5 cm
Qing court collection

The miniature landscape comprises of two parts: the basin and the miniature landscape. The gold rectangular basin has angular corners, a flared upper part, and a tapering lower part. It is decorated with a ground with swastikas (卍), on which is a border of characters "*shou*" (longevity) carved in relief. The miniature landscape is a plum blossom tree with fully blooming flowers. The tree has a gilt bronze tree trunk, jadeite leaves, ruby flower petals, and gold stamens. Surrounding the tree are camellias made with jadeite and agate, an evergreen plant with leaves set with jadeite and coral beads, rocks set with lapis lazuli and corals, and *lingzhi* fungi inlaid with precious stones.

The materials used for producing this miniature landscape are most luxurious, including two hundred and eight-four rubies to set the plum blossoms with a strong sense of dimensionality and perspective, showing superb workmanship. It is a representative piece of work for celebrating imperial birthday in the Qing Dynasty.

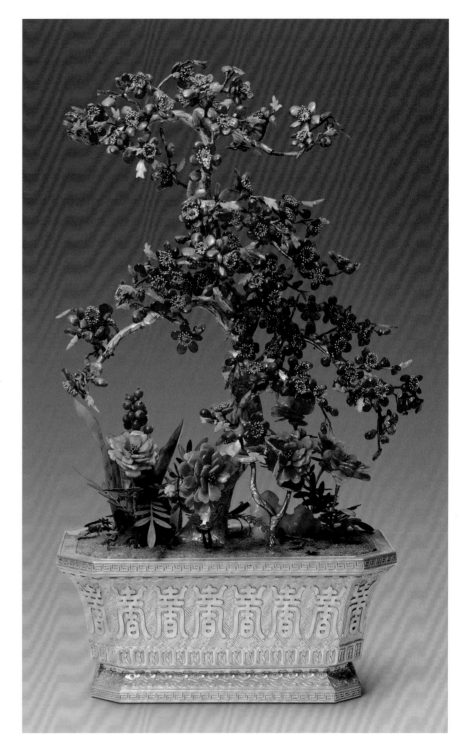

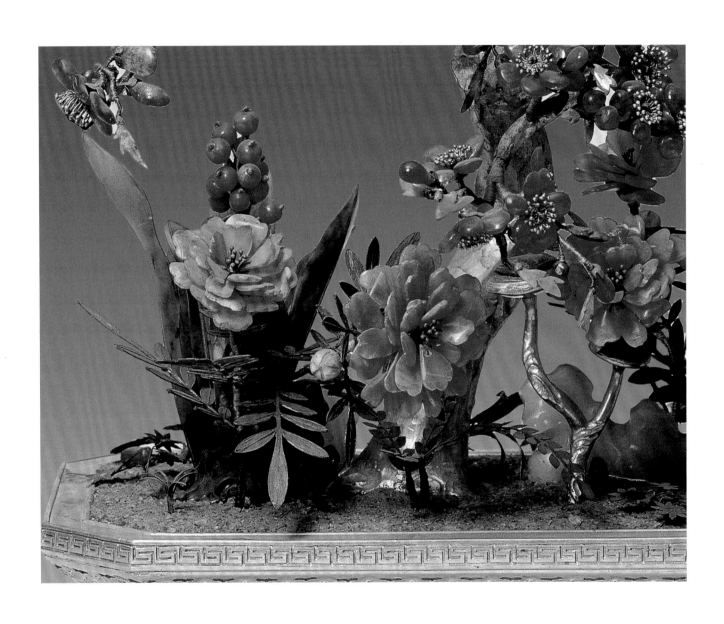

48

Miniature landscape
with a gilt copper basin
with gold filigree
designs and set with precious
stones and pearls, and
with designs for blessing ten
thousand years of longevity

Qing Dynasty

Overall Height 69 cm
Length of Basin 51.5 cm
Width of Basin 28.6 cm
Qing court collection

The miniature comprises of two parts: the basin and the miniature landscape. The front and rear sides of the rectangular basin are gold filigree designs of dragons amidst clouds and crested waves and towers and pavilions in an immortal's land, which are set and inlaid with several pearls and rubies. The rim of the basin is carved with two dragons holding a character "*shou*" (longevity) and various precious emblems. The underside of the mouth rim is layered with green glass and decorated with a border of cloud patterns inlaid with rubies. Under the glass cover on the surface of the basin is a groove with mercury inside. The miniature landscape comprises of the deity of longevity set with red corals, gilt copper attendants, and deer, etc. The deity of longevity is holding a staff in his left hand, and a *lingzhi* fungus made with jadeite in his right hand, which carries the blessing of celebrating birthday. Other designs include rocks and landscapes set with rubies and peacock stones, gilt copper pine trees inlaid with pearls, plum blossom trees inlaid with tourmalines and rubies, and various flowers and plants set with red corals and other precious stones. It is supported by a red sandalwood stand with its supporting panel set with tinted ivory designs of lotuses and characters "*shou*" (longevity).

The materials used for producing this miniature landscape are very luxurious, and the work is marvelously modeled with a large rocky mountain with holes, which is made with peacock stones, in the centre. This work represents a refined piece produced with rare precious stones and superb craftsmanship of Qing decorative arts in pursuit of extravagance and exquisiteness.

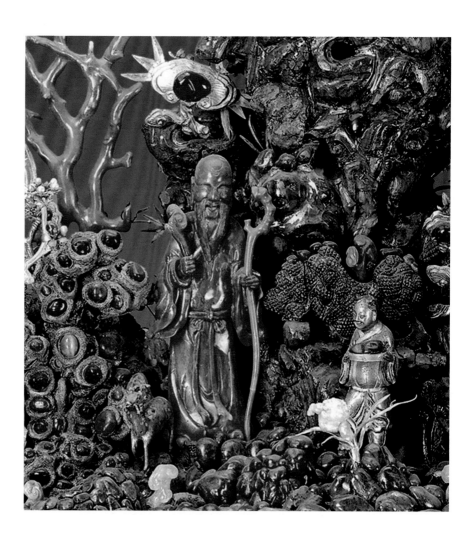

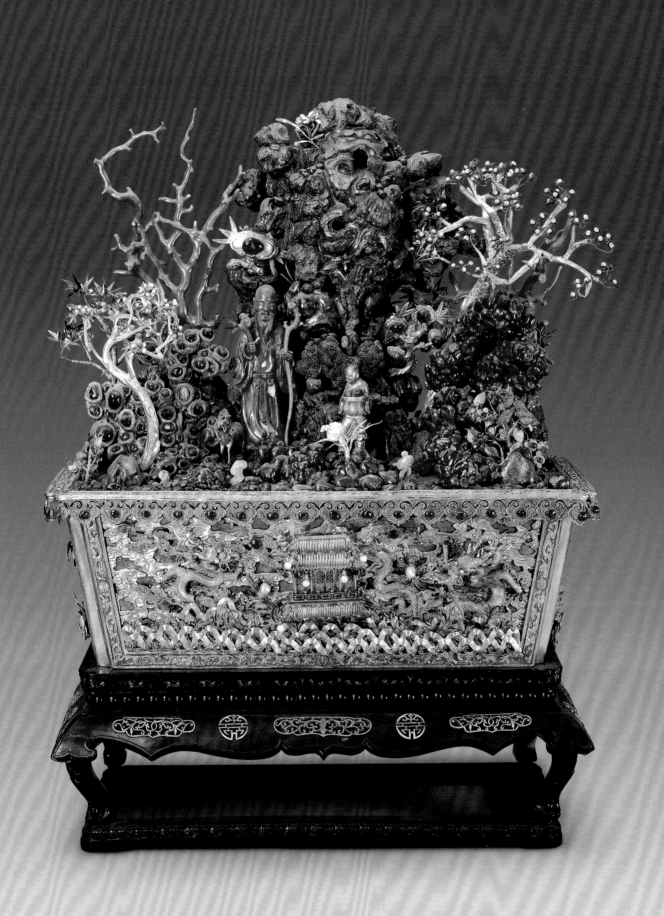

49

Crystal flower receptade
in the shape of twin-fish

Qing Dynasty

Height 14.8 cm
Width 11 cm
Qing court collection

The crystal flower receptade is in the shape of twin-fish with their mouths wide open and the bodies leaping. The belly is empty for holding flowers. The tails of the fish intertwine to form the legs. It is supported by a red sandalwood stand carved with designs of crested waves. Being put on a stand, its form suggests the motif of carps leaping the Dragon Gate.

Crystal was known as "water jade" or "water gem" in ancient times, which was a kind of rare mineral and precious stone. Flower receptades in the shape of twin-fish were rather commonly used by the Qing court. Other than crystal, flower receptades were also made with jade, agate, and other precious stones.

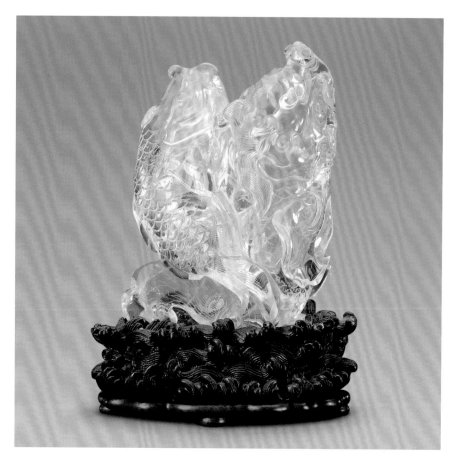

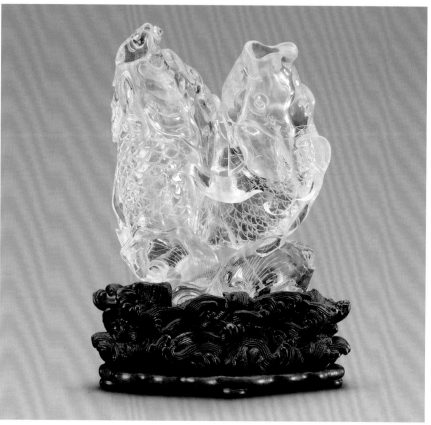

50

Crystal water pot
in the shape of a wild duck

Qing Dynasty

Height 9.8 cm
Width 12.2 cm
Thickness 6.9 cm
Qing court collection

The water pot is carved in the round and ornamented in relief and openwork. It is in the shape of a wild duck carrying a *lingzhi* fungus on its back and with its head turning back. The inside of the wild duck is hollow, and the back has an opening with recessed decoration of a *lingzhi* fungus.

The character "*fu*" (wild duck) is a homonym for "*fu*" (fortune). In ancient China, it was believed that the *lingzhi* fungus was a kind of herb of immortality which could bring the dead back to life, and thus was a symbol of longevity. The form and decorations of this water pot thus carry the blessing of fortune and longevity.

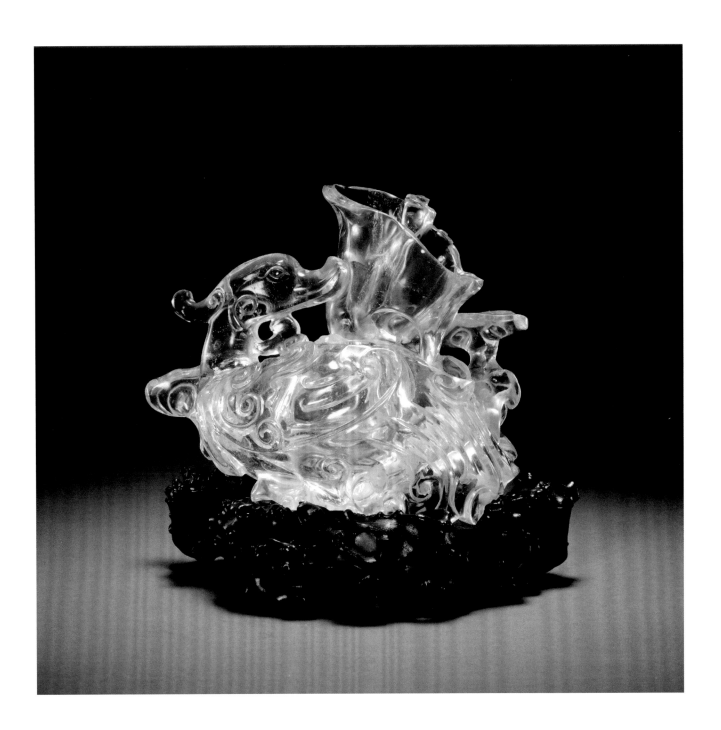

51

Winter imperial mink court hat
decorated with gold phoenixes worn by the Empress

Qing Dynasty

Height 30 cm
Diameter of Mouth 23 cm
Qing court collection

The court hat is made of mink with an everted eave and red embroidered wrappings. The centre of the hat is decorated with three layers of birch skin studded with gold phoenixes, and in between each layer is a big first grade east pearl. The head and wings of each gold phoenix are decorated with three east pearls of second grade and one east pearl of third grade. The tail of the gold phoenix is decorated with sixteen small pearls. The back is inlaid with a cat's eye stone. Each of the three gold phoenixes is holding an east pearl of third grade in the mouth. The eaves of the hat are ornamented with seven gold phoenixes. Each phoenix is inlaid with nine east pearls of second grade, twenty-one small pearls, and one cat's eye stone. The back of the hat is decorated with a gold pheasant, one cat's eye stone, and sixteen small pearls. At the tail of the pheasant are chains in five vertical columns and two horizontal rows with altogether three hundred and two fourth grade east pearls. At the centre of the chains is a double face gold filigree knob inlaid with lapis lazuli and hung with gold filigree weights set with corals.

The *Imperial Qing Collected Statutes* recorded that there were two types of imperial court hats used respectively in winter and summer for the Empress. The winter court hat was made of mink, and the summer court hat was made of cotton flannel. This court hat was worn by the Empress during court ceremonies in winter. The home land of Manchus of the Qing court was in Northeast China, and therefore birch skins and east pearls (pearls from Northeast China) were used to decorate the court hats of the Empress, signifying the origin of imperial sovereignty of the Manchus.

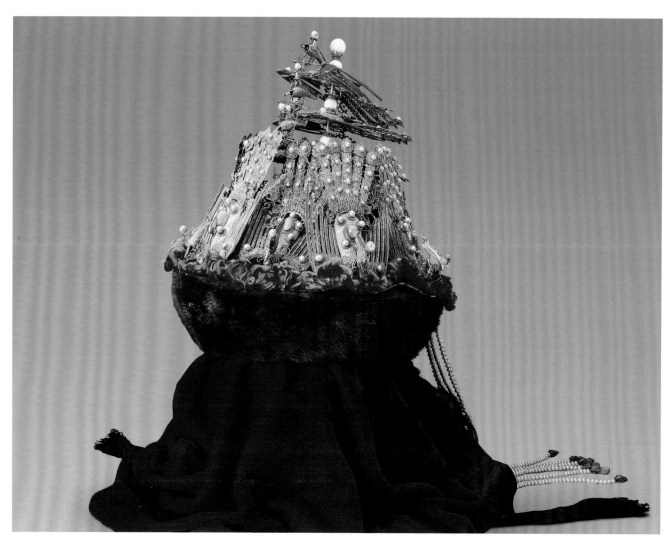

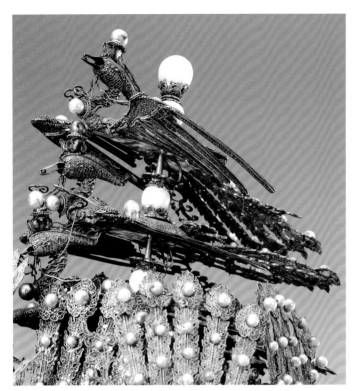

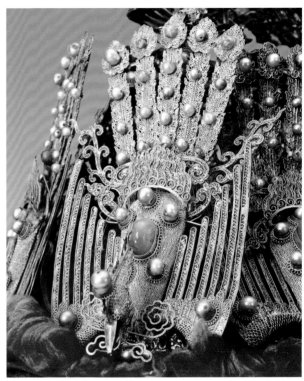

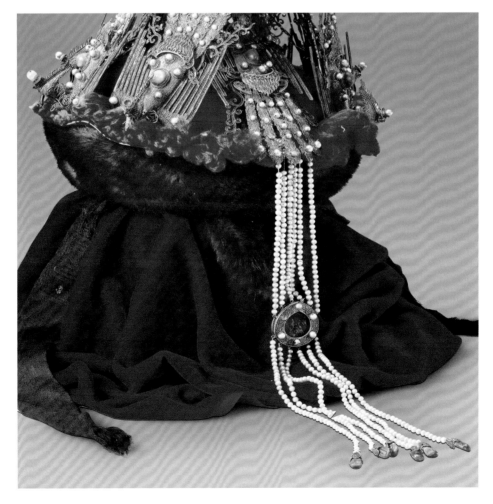

52

Headddress (*dianzi*)
with gold filigree
designs of five phoenixes
and inlaid
with precious stones

Qing Dynasty

Height 25 cm
Width 31 cm
Qing court collection

The headddress has a curved upper side and a wide lower side. The front is in the shape of a fan with its top slanting downwards. Frames are made of iron wires and paper, and decorated with net patterns interspersed by green wires, on which king-fisher feathers are added. The front of the headddress is decorated with five gold filigree phoenixes and set with pearls, precious stones, cat's eye stones, etc. The gold phoenixes hold pearl chains in their mouths, and hung with ruby and sapphire beads as pendants. The rim of the headddress is decorated with nine gilt and silver pheasants with short tails and inlaid with rubies. Their mouths are holding chains fastened with precious stones, tourmalines, corals, jadeite, and pearls. At the back of the headddress are eleven chains of pearls hung with precious stones as weights.

In making this headddress, fifty large pearls, over one hundred pearls of second grade, over three hundred pearls of third grade, and over two hundred precious stones were used for decorating with a touch of extravagance. Headddresses were part of the costume of Empresses and concubines in the Qing Dynasty, and they were categorized as phoenix headddresses and floral headddresses. In wearing ceremonial dresses, phoenix headddresses had to be worn; and in wearing daily dresses, floral headddresses would be worn instead. Phoenix headddresses were often worn with colourful and luxurious dresses during ceremonial and festive occasions, such as the lantern festival, dragon-boat festival, and other traditional festivals.

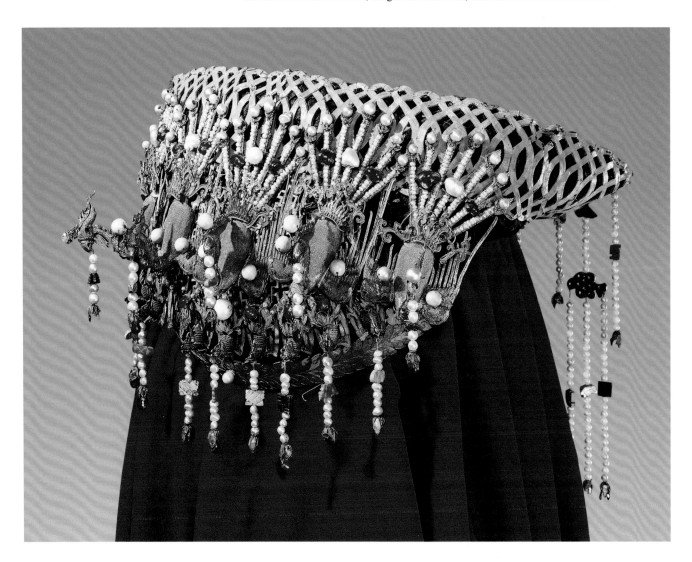

53

Jadeite rectangular pendant

with designs of two phoenixes and the inscription *"wanshou wujiang"* (boundless longevity)

Qing Dynasty

Length 7.3 cm Width 5.1 cm
Thickness 0.4 cm
Qing court collection

The rectangular pendant is inscribed with *"wanshou"* (ten thousand years of longevity) on one side and *"wujiang"* (boundless) on the other side in clerical script in relief, and enclosed by two phoenixes and clouds carved in openwork. The pendant is fastened with a tassel with a coral bead which has a cluster of small pearls on the two sides of the bead.

In ancient China, pendant was fastened and carried on a dress as a kind of decorative accessory. This pendant was carved with delicate and precise decorations with auspicious blessing of longevity, which was used as an accessory by the Emperor.

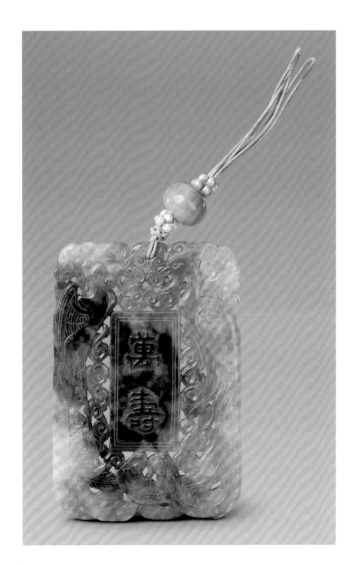

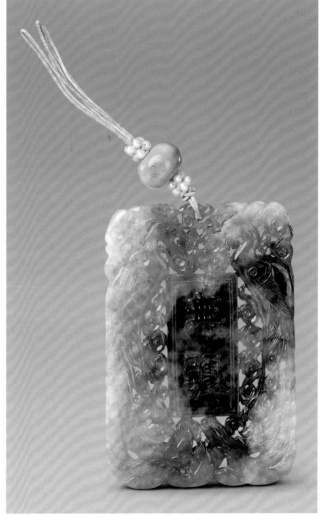

54

Gilt silver hair crosspiece (*bianfang*) set with pearls, precious stones, and decorated with openwork designs

Qing Dynasty

Length 32.5 cm
Width 3.5 cm
Qing court collection

The hair crosspiece (*bianfang*) is in the shape of a Chinese horizontal stroke and decorated with openwork designs of lotuses. The lotus flowers are inlaid with tourmalines and other precious stones, while the lotus seeds and leaves are inlaid with jadeite. Half of the one side of the exterior rim is inlaid with pearls.

Bianfang is a kind of large hair crosspieces for fastening hair buns by Manchu ladies to prevent hair from falling down. Most of the extant hair crosspieces are now in the collection of the Qing court objects. They have been produced with a variety of materials with exquisite workmanship by blending the essence of various arts and crafts.

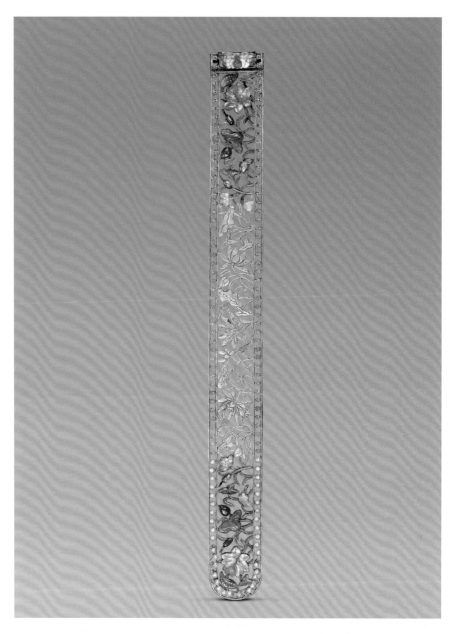

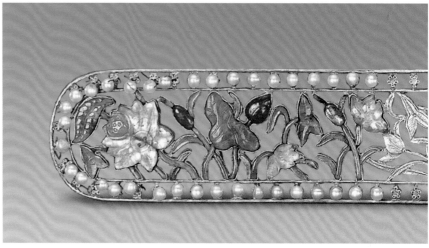

55

Gold hairpin
with designs of orchids and
a katydid set with pearls and
precious stones

Qing Dynasty

Height 21 cm
Widest 6 cm
Thickness 3 cm
Qing court collection

The long slim hairpin has a gold filigree support inlaid with king-fisher feathers to form an orchid-shaped support at the tail, on which are a *lingzhi* fungus inlaid with white jade and a *lingzhi* fungus inlaid with red coral. A gold filigree katydid inlaid with king-fisher feathers and sapphires at the belly is reclining amidst flowers and leaves set with cat's eye stones, tea-coloured crystals, and pearls.

The hairpin is an ornament to keep women's hair in shape. This hairpin was made with precious stones and rendered in a vivid manner with a touch of naturalism, which was used by Empresses or concubines of the Qing court.

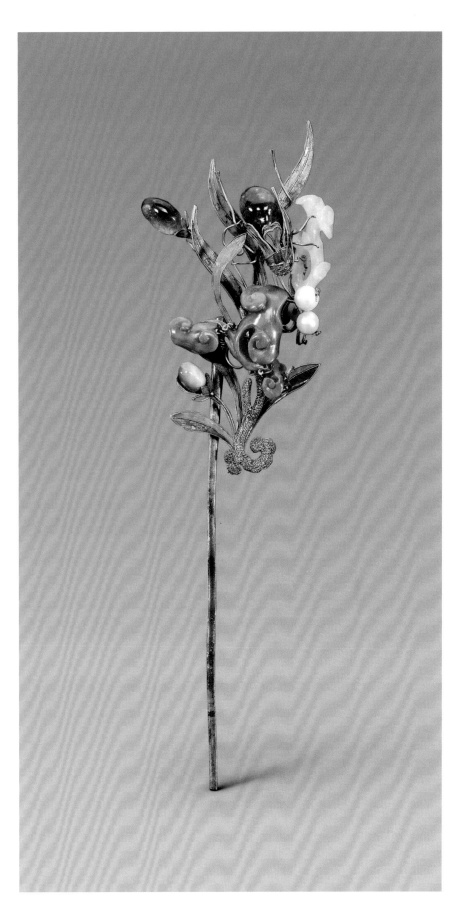

56

A pair of gold bracelets
set with pearls and
with designs of two dragons
in pursuit of a pearl

Qing Dynasty

Diameter 7.8 cm
Qing court collection

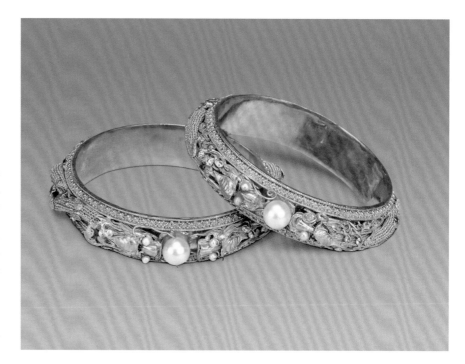

Each of the bracelets is in the shape of a ring, and the exterior is decorated with two gold filigee dragons. The eyes of the dragons are set with small pearls. The tails of the dragons entwine with their heads confronting each other; in between the two heads is a large pearl, representing the motif of two dragons in pursuit of a pearl.

In ancient China, bracelets were also known as "arm's rings", and both men and women worn bracelets. Since the Tang and Song dynasties, they had become an exclusive decorative accessory for ladies. In the Qing Dynasty, wearing bracelets had become a fashionable practice of ladies. Various types of bracelets inlaid with jade, jadeite, agate, agalloch eaglewood, amber, Bodhi-tree seed, gold, silver, and other designs were used by members of the Qing court.

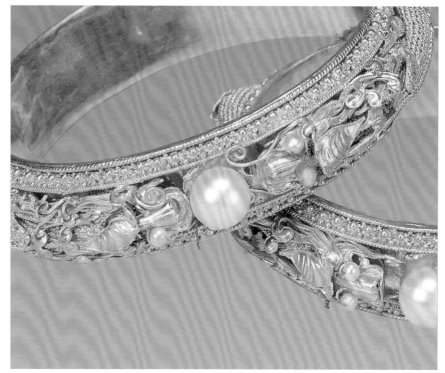

A collection of gold and white gold rings
set with pearls and precious stones

Qing Dynasty

This collection of rings was used by Pu Yi, the last Emperor of the Qing Dynasty. Influenced by western fashion, Pu Yi wore rings with larger diameters with the form and decorative motif also reflecting the decorative style of the West, while the sizes of precious stones were also larger. The marks such as "pure gold from Dehua" and others on the rings were brand names of jewellery shops or goldsmiths that were commissioned by the Qing court to produce jewellery and decorative accessories.

(1) Emerald and diamond ring set in yellow gold
Diameter 2.1 cm

The gold ring is in open end. The surface of the ring is decorated with foliage scrolls in relief, and set with three emeralds and three diamonds.

(2) Sapphire ring set in white gold
Diameter 1.7 cm

The white gold ring has the two ends decorated with pearl patterns and has four point settings with a sapphire in a plain and pure colour with bubble fluid inclusion. The base has elephant trunk eyes. The piece was originally designated for use as an ornament; however, it was modified into a ring.

(3) Diamond ring set in white gold
Diameter 1.7 cm

The white gold ring is set with a diamond of superb quality and cutting.

(4) Pearl ring set in yellow gold
Diameter 1.9 cm

The gold ring is in open end. It has a setting decorated with foliage scrolls and inlaid with five pearls. The interior of the ring is engraved with a mark "pure gold from Dehua".

(5) Sapphire ring set in yellow gold
Diameter 1.5 cm

The yellow gold ring is decorated with carved and openwork designs of bead chains, cloud, see-saw, fish-scale, geometric, and banana leaf patterns around. The surface of the ring is set with a sapphire.

(6) Silver ring set with tourmaline Diameter 1.5 cm

The silver ring is decorated with openwork designs of leave patterns and lozenge patterns. The ring is set with a pink tourmaline.

(7) Diamond ring set in white gold Diameter 1.7 cm

The white gold ring is decorated with relief designs of flowers and leaves. An east pearl is set in the middle of the round frame mounted with sixteen diamonds on its side.

(8) Ruby ring set in yellow gold Diameter 2.1 cm

The gold ring is decorated with openwork designs of flowers, leaves, and ruyi clouds. The ring is set with a ruby. The interior of the loop is inscribed with "90% gold from Zhicheng in the year gengchen (1880 A.D.). The gengchen year corresponded to the sixth year of the Guangxu period (1880 A.D.).

(9) Ruby ring set in K-white gold Diameter 2.2 cm

The K-white gold ring has a wide arm surface and set with a ruby. K-white gold was first produced in the late Qing period and was much esteemed.

58

A pair of jadeite archer's thumb rings

Qing Dynasty

Diameter 3.2 cm
Height 2.5 cm
Qing court collection

The archer's rings are in the shape of round tubes. The interior of one of them is coated with gold inside and engraved with a mark "*jiuru*", and a Suzhou weight mark "*bawu*" and a mark "*cheng*". Another one is plain with its upper mouth rim roundly polished and the lower rim flat and straight.

Archer's ring was known as "*she*" in ancient China. It was worn on the thumb during archery in order to protect the thumb. The Qing Dynasty was known for archery, and archer's thumb rings were frequently used during battles and military actions which finally led to the successful conquering of China. Later, archer's thumb rings had become decorative accessories, and were made with jade, jadeite, gold, silver, and other materials. Some of them were often ornamented with various decorations or poem inscriptions to symbolize the status of their owners. This set of thumb rings was produced by the Imperial Workshops of the Qing court for the exclusive use of the Emperor. The jadeite has pure colour with lustrous quality and glare, representing a set of refined jadeite accessories.

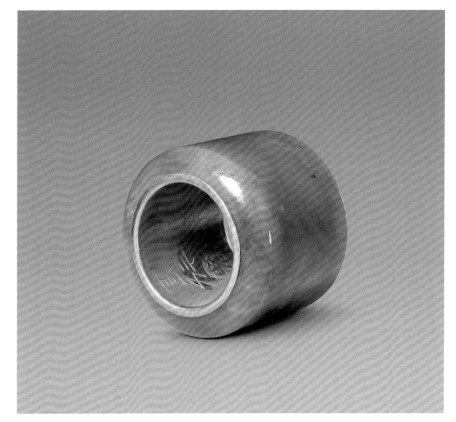

59

Three-legged rhinoceros horn cup
with carved designs of floral sprays in relief

Early Ming period

Height 16.7 cm
Diameter of Mouth 13.6 x 10.5 cm
Qing court collection

The mouth of the cup is in the shape of a fully blooming flower. The exterior is carved with designs of lotuses, begonias, holly-hocks, and lichees interspersed in various forms, which carry auspicious blessings. The three legs are carved in the shape of three bundles of floral and fruit sprays with entwined branches to support the cup.

The technique of carving in openwork is utilized to split the tip of the rhinoceros horn into three parts. After heating, they would be softened and flared to form the three legs to enrich the configuration of the cup. The body of the cup is finely polished with the decorations rendered with dimensionality simulating a style of carving in the round. The quality and colour of this cup are as lustrous and brilliant as jade, representing a refined piece of work of rhinoceros horns of the Ming Dynasty.

60

Rhinoceros horn cup
carved in the shape of a
lotus leaf in the round

Early Ming period

Height 15.8 cm
Diameter of Mouth 19.3 x 13.8 cm
Qing court collection

The cup is carved in the shape of a lotus bouquet by using a single rhinoceros horn. The body of the cup is carved in the shape of a big lotus leaf with small stems around, and is accompanied by more lotus leaves, lotus seeds, lotus flowers, lotus buds, and a stem of reeds. A vivid small crab is carved near the mouth rim. The spout is hollow and links to the body of the cup, suggestive of the poetic attribution that "our mind and thoughts are connected by a rhinoceros horn".

Techniques of carving in openwork and relief are utilized in producing this decorative work. A large rhinoceros horn has been chosen, carved, and then heated, so that it becomes soft and bent. The spout is slightly higher than the mouth of the cup and is slightly curved, adding a sense of delicacy to this work.

61

Rhinoceros horn cup
with carved designs of
hibiscus sprays and
mandarin ducks

You Kan

Late Ming period

Height 8.3 cm
Diameter of Mouth 12 x 8 cm
Diameter of Foot 4.5 x 3 cm

The cup has a flared mouth, a contracted leg, and a flat base. The exterior is decorated with carved designs of mandarin ducks, hibiscuses, and rocks. The upper part of the cup is in different relief and recess layers that look like cliffs and rocks, and is further carved with hibiscus sprays climbing into the mouth of the cup in relief and openwork. The ear of the cup is carved in the shape of rocks and floral sprays. The lower part of the cup is decorated with carved designs of a pair of mandarin ducks under floral sprays beside a stream. The base of the cup is inscribed with a round and square double pearl mark "*zhisheng*" and "*You Kan*" in seal script in relief.

This cup is modeled with techniques of carving in openwork and relief. The carved decorations are rendered skilfully with most of the decorations clustered as principal designs while the other areas of the cup are left plain. The decorations resemble a painting of flowers and birds with superb quality and artistic merits. Among the rhinoceros horns attributed to You Kan, this cup represents a refined piece of work with high artistic merit by this artist.

The years of birth and death of You Kan were unknown. He was a native of Wuxi and a renowned craftsman from the late Ming to the early Qing period. His works of rhinoceros horns are highly esteemed.

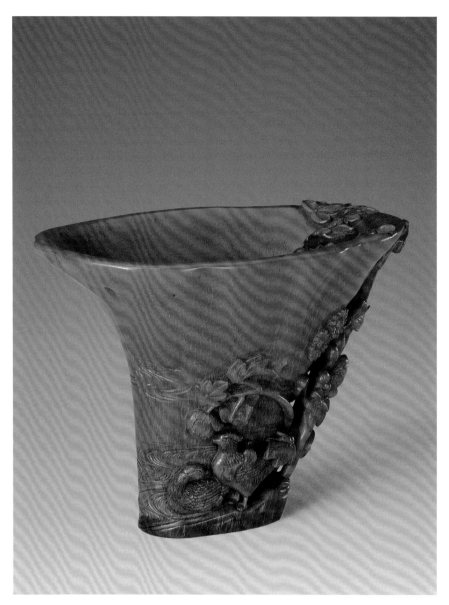

62

Rhinoceros horn cup
in the form of
an immortal riding on a raft

You Tong

Late Ming period

Height 11.7 cm
Length 27 cm
Width 8.7 cm
Qing court collection

The rhinoceros horn cup is carved in the round in the shape of a raft shaped like an old tree stump. The front of the raft has a spout. The middle part is carved with designs of entwining plum blossoms, peonies, and lotuses in openwork to form a seat. An immortal is holding a *ruyi* scepter and sitting amidst flowers and woods. The base of the cup is carved with designs of waves and has a round hole linking to the sucking hole inside the raft. The rear of the raft has an inscription which literally describes "another cycle of sixty years (of age) will come again" in seal script in relief with the mark of You Tong. Beneath is a seal mark "*yuyuan*" in seal script. The interior of the belly of the raft is engraved with an imperial poem by Emperor Qianlong in regular script and two square seal marks "*bide*" and "*langrun*" in seal script.

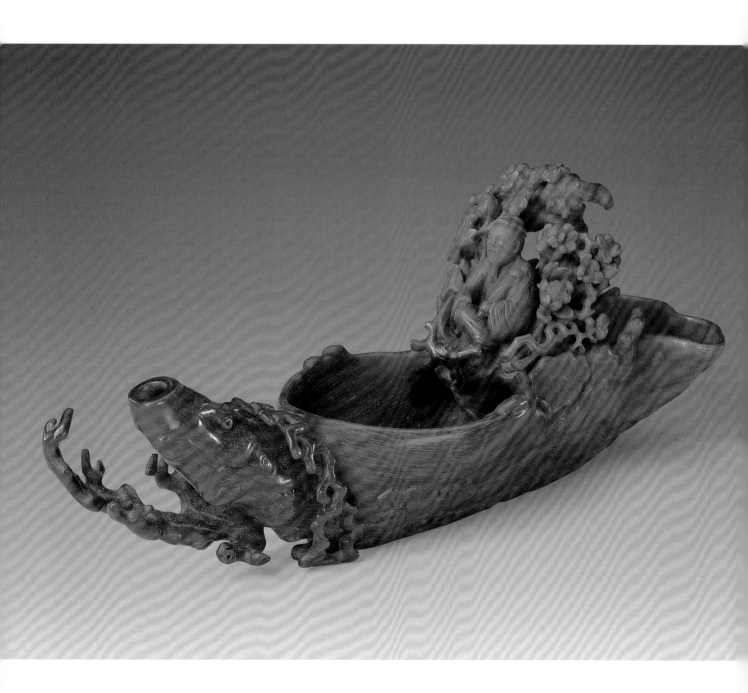

The form of this raft cup has been adopted from the silver raft-cup made by Zhu Bishan of the Yuan Dynasty (plate 1). It is carved with skilful workmanship, and the quality of the rhinoceros horn is lustrous and translucent, representing a refined piece of work of rhinoceros horns.

Historical records such as *Gazetteer of Wuxi District* documented that a craftsman surnamed You in the Wuxi district was known for carving rhinoceros horns which were credited as "rhinoceros horn cups of You". In the Kangxi period, You was summoned to work for the court. Emperor Qianlong opined that You was You Tong, yet his authentication need further study. However, it was sure that You Tong excelled in producing rhinoceros horn ware. The mark "*yuyuan*" often appeared together with the mark of You Tong, and should have been the pseudonym of You Tong.

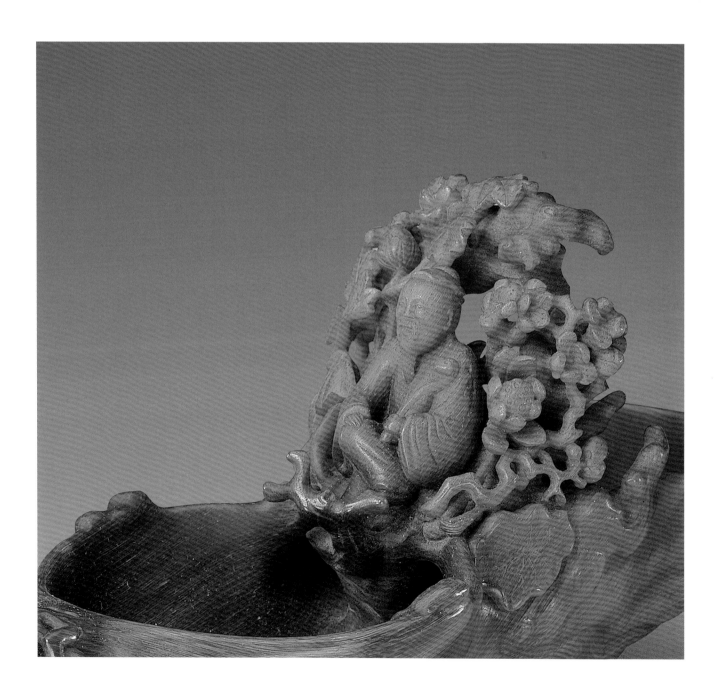

63

Rhinoceros horn cup
with carved designs of *xiuxi* literary gathering at the Lanting Pavilion

Late Ming period

Height 37.4 cm Diameter of Mouth 17.8 cm
Qing court collection

This large cup in the original shape of a rhinoceros horn is decorated with spiraling design of a scene of literary gathering and wine drinking by picking up wine cups from a stream beside the Lanting Pavilion at the hillside of Mount Kuaiji, in which Wang Xizhi and other men-of-letters attended. There are altogether twenty-three figures amidst a landscape setting of peaks, hills, bamboo groves, pavilions, bridges, streams, and white geese. The interior of the mouth is carved with the design of a dragon amidst clouds in openwork.

The upper part of this cup is principally decorated with designs carved in relief, whereas the lower part is decorated with designs carved in openwork, exuding a strong sense of dimensionality and layered perspective.

The *xiuxi* gathering was a kind of folk custom that people would take bath in a stream to wipe off evils and calamities at the *si* day in the beginning of the third month of the Chinese lunar year. Later the term was also used to describe literary gatherings held on the same day. In the third day of the third month of the ninth year of the Yonghe period (353 A.D.) of the Eastern Jin Dynasty, Wang Xizhi and other men-of-letters, including Xie An and Sun Chuo, attended a literary gathering at the Lanting Pavilion at the hillside of Mount Kuaiji. They chanted poems together and subsequently compiled the *Poem Collection of the Lanting Pavilion* with a famous preface written by the renowned calligrapher Wang Xizhi, which was known as the *Preface to the Lanting Pavilion*. Such a scene of literary gathering at the Lanting Pavilion had then become a classical symbol and was used as a popular decorative motif for art objects.

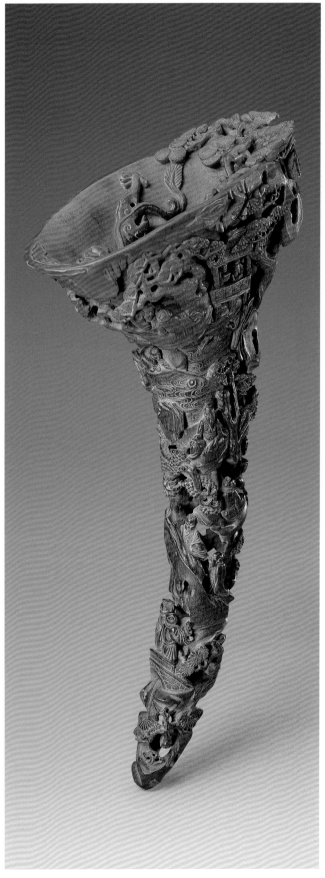

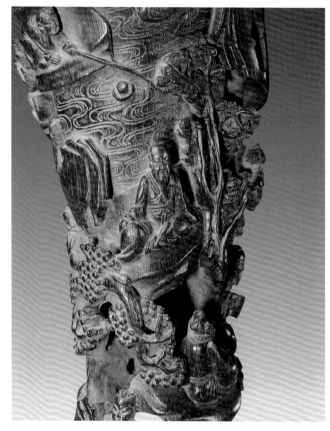

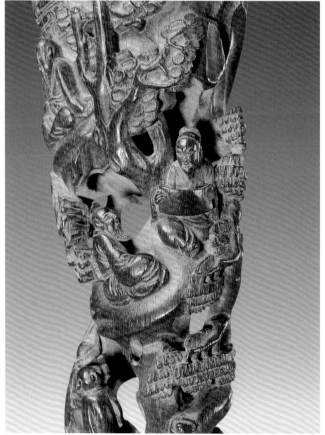

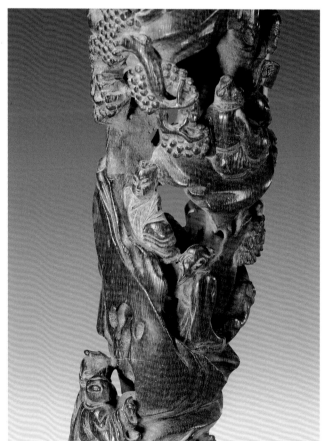

64

Rhinoceros horn cup
with carved designs of nine dragons

Mid Qing period

Height 21.3 cm
Diameter of Mouth 19.5 x 11.5 cm
Diameter of Foot 7.3 cm
Qing court collection

The cup is carved in accordance with the natural shape of a rhinoceros horn. It has a flared mouth and a contracted leg, like an ancient *jue* wine cup. The exterior is decorated with carved designs of nine dragons flying amidst clouds with a touch of heroic vigour. The ear is carved in two strips in the form of a dragon flying amidst clouds and climbing into the mouth of the cup in openwork.

The quality of the rhinoceros horn is lustrous, and the extravagant decorations are finely rendered and polished, showing the taste and decorative style of the Qing court. It was much appreciated by Emperor Qianlong who had written a poem to praise its artistic merit.

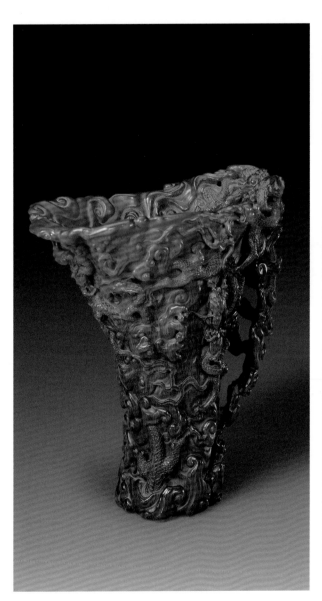
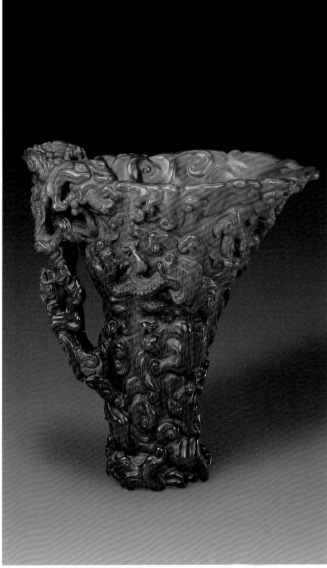

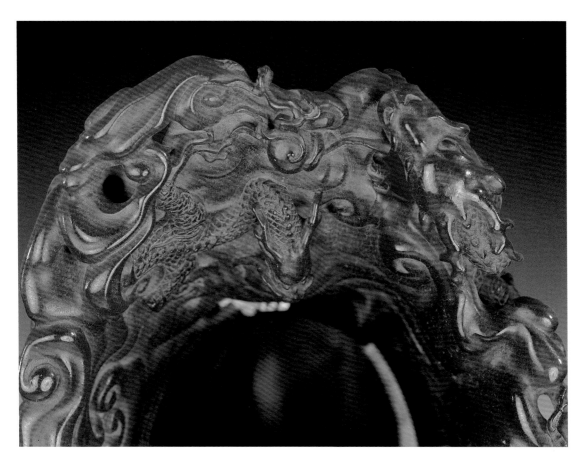

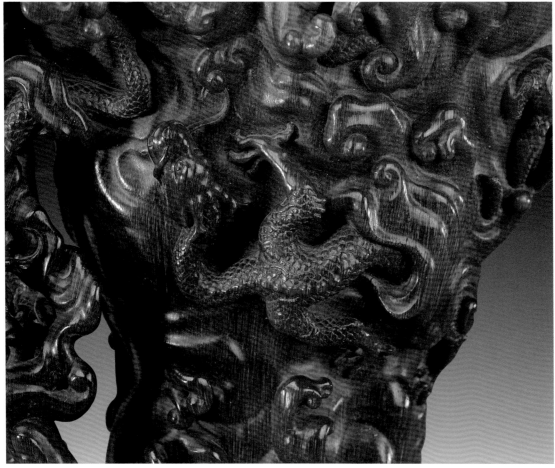

Rhinoceros horn archer's thumb rings
inlaid with gold and silver wires

Mid Qing period

Height 2.3 cm
Diameter of Mouth 3.1 x 2.8 cm
Thickness 0.5 x 0.2 cm
Qing court collection

These seven extant archer's rings have similar forms and sizes, and are made with rhinoceros horns with tubular shapes. They are inlaid with gold and silver wired archaic designs and are kept in a begonia-shaped red sandalwood box inlaid with gold and silver flakes. Two of them have the marks "*qian*", "*long*", "*nian*", "*zhi*" (Made in the Qianlong period), while the other five pieces are only decorated with animal-mask patterns with slight variations, revealing that they were not produced at the same time.

According to the record *Checklist Archive of Objects* of the Imperial Workshops, this set of archer's thumb rings were made from the 17th to the 22nd year of the Qianlong period (1752 – 1757 A.D.). They were skilfully made with gold and silver inlaid designs for the exclusive use by the Emperor.

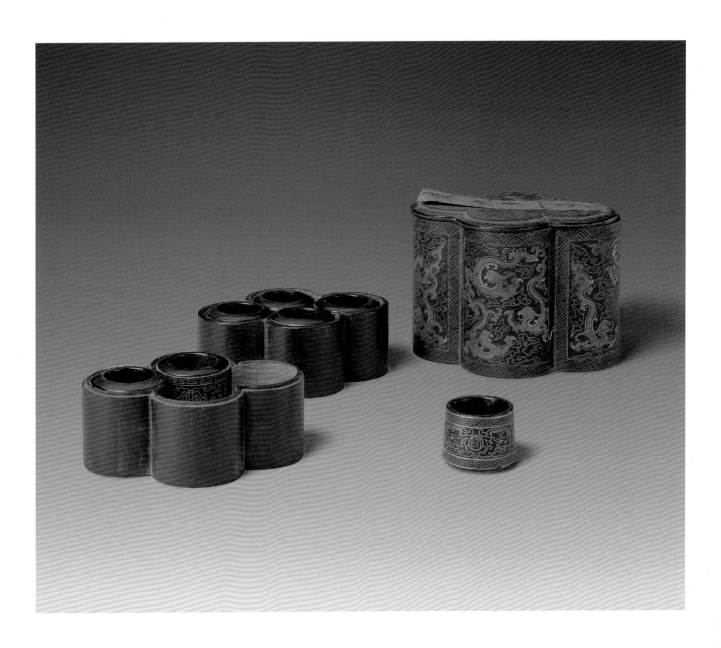

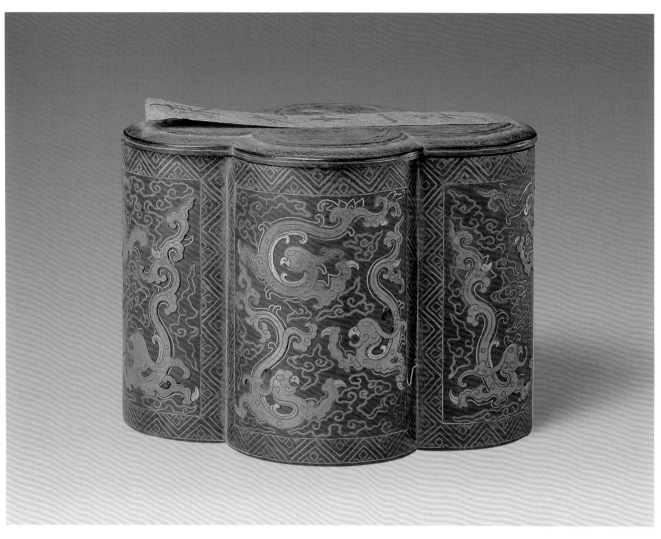

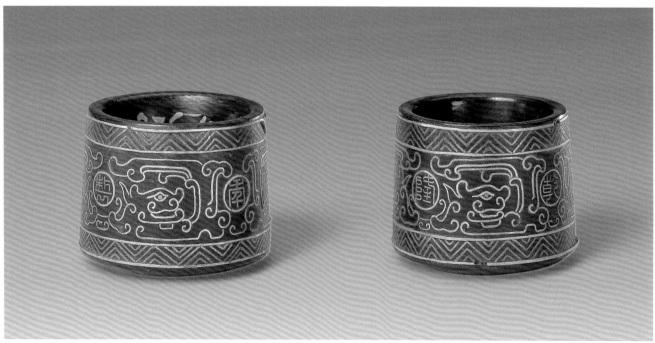

66

Ivory brush-holder
with carved designs of a scene of fishermen's families in amusement in relief

Huang Zhenxiao

Qing Dynasty Qianlong period

Height 12 cm
Diameter of Mouth 9.7 cm
Qing court collection

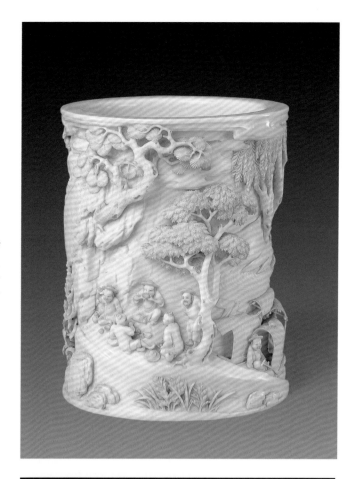

The exterior of the brush-holder is decorated a scene of fishermen's families in amusement. In a landscape setting with mountains, rocks, and willow trees, several fishermen anchor their boats beside the river bank and gather together to drink wine under a pine tree. In the boat, the wife of a fisherman is holding her child. On one side of a mountain rock is an incised inscription in intaglio of an imperial poem by Emperor Qianlong in regular script filled with cinnabar lacquer, with also two seal marks "*chen*" and "*han*" in seal script filled with cinnabar lacquer. Near the foot is an inscription which literally describes, "In the *changzhi* month of the year *wuwu* of the Qianlong period, made by humble official Huang Zhenxiao." The *wuwu* year corresponded to the third year of the Qianlong period (1738 A.D.), and the *changzhi* month corresponded to the fifth month of the Chinese Lunar Year.

Both carving in high relief and openwork were utilized to decorate this object with skilful pictorial treatment, exuding a sense of naturalism. This brush-holder revealed the richness of ivory carving during the zenith of decorative carvings in the Qing Dynasty. The choice of motif and the pictorial execution were quite similar to the style of bamboo carving of the Jiading School, showing the style of ivory carving of the Qing court in general followed the decorative style in vogue in the Jiangnan region at the time.

The years of birth and death of Huang Zhenxiao were unknown. He was an ivory craftsman from Guangdong and summoned to work for the court with the recommendation of the Customs House of Guangdong in the second year of the Qianlong period (1737 A.D.). He served at the Imperial Workshops until the ninth year of the Qianlong period, and this work should have been made by him shortly after he arrived at the Imperial Workshops of the court.

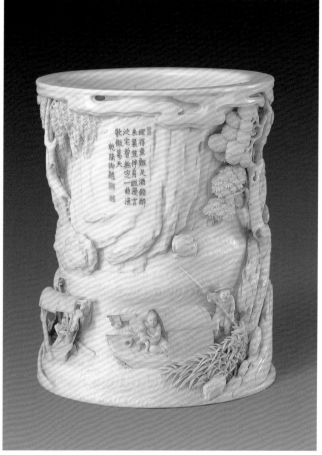

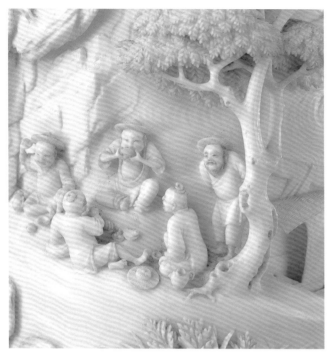

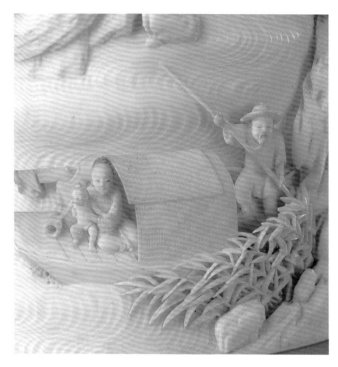

乾隆戊午長至月
小臣黃振效恭製

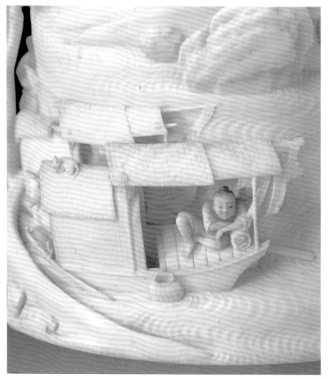

67

Small rectangular ivory box set
with carved designs of *ruyi* cloud patterns in openwork

Li Juelu

Qing Dynasty Qianlong period

Height 2.3 cm Length 5.3 cm Width 4.2 cm
Qing court collection

The surface of the cover of the rectangular box set is carved with movable interlocking *ruyi* cloud patterns in openwork. The four sides of the cover and box are carved with diagonal "十" shaped patterns. Inside the box are eighteen small boxes with a small size similar to a finger-nail, and carved with thunder designs, *ruyi* cloud patterns, twin *kui*-dragons, coin patterns, etc. These boxes contain various objects such as miniature carvings of fruits, insects, and their covers are interlinked with chains. The exterior base of the large box has an inscription, in intaglio with lacquer, which literary describes, "made by humble official Li Juelu at the close of the spring of the *guiwei* year of the Qianlong period." The *guiwei* year of the Qianlong period corresponded to the 28th year of the Qianlong period (1763 A.D.)

The walls of these boxes are as thin as egg-shells, and the carved decorations in openwork are rendered in the most delicate manner and are as thin as hair. This piece of work represents the superb craftsmanship of ivory carving of the Imperial Workshops of the Qing court.

From the archives of the Imperial Workshops, it was known that Li Juelu was a craftsman of ivory carving from Guangdong, who was summoned to work for the Imperial Workshops in the Qianlong period, and returned to his native place around the 38th year of the Qianlong period (1773 A.D.).

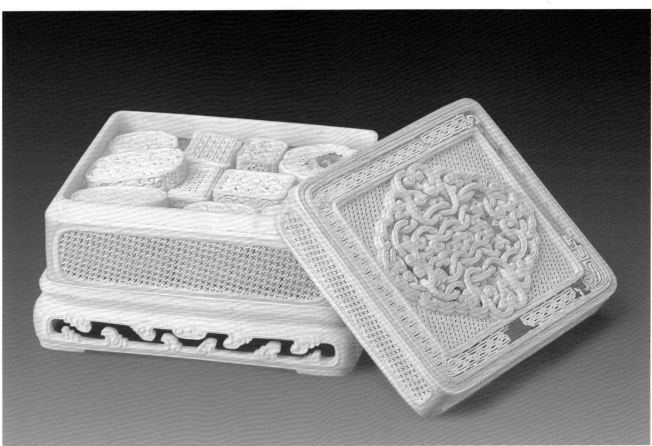

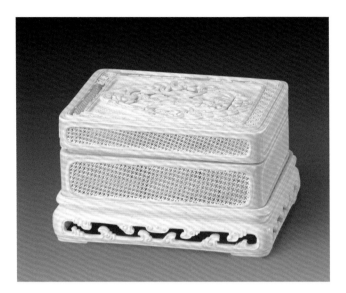

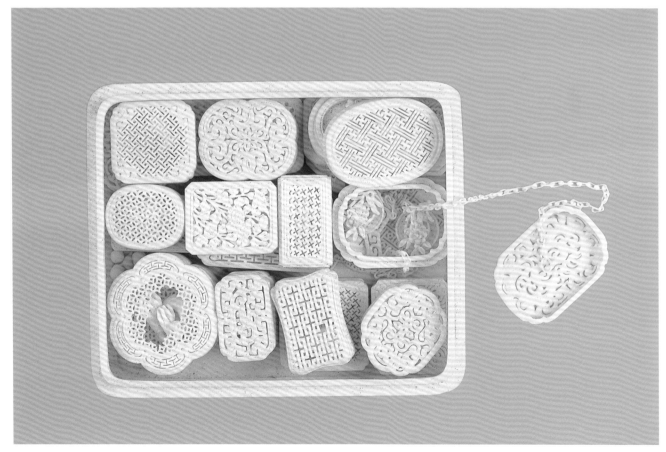

68

Ivory snuff bottle
carved in the shape of a crane

Qing Dynasty Qianlong period

Length 4.7 cm Diameter of Belly 2.9 cm
Qing court collection

The snuff bottle is carved in the shape of a recumbent red-crested crane. The head of the crane is inlaid with a bloodstone to represent the crane's crest. The eyes, beak, and feathers at the tail are inlaid with tortoise-shells, and the two legs are coated with green paint. Under the belly is a lid with a concealed lock, and the lid is inscribed with a four-character mark of Qianlong (Qianlongnian *zhi*) in seal script. The snuff bottle has a fitting ivory spoon.

The Palace Museum has two ivory snuff bottles in the shape of animals in her collection. Another piece is carved in the shape of a fish hawk. Both of them are finely carved and recorded in the archive of the Imperial Workshops.

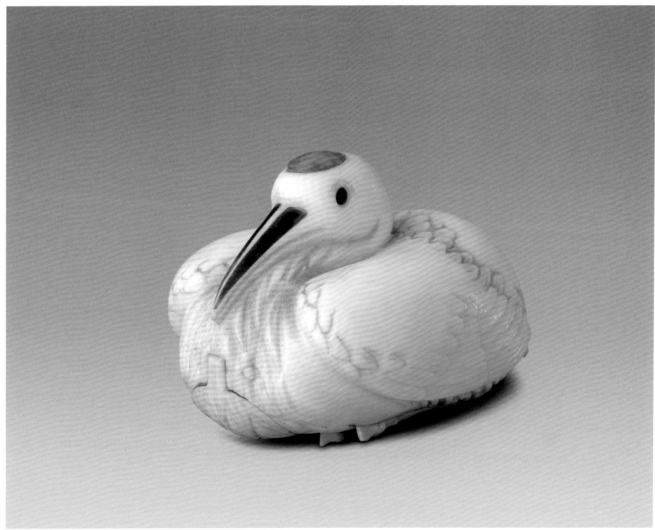

69

Ivory brush with purple hair and holder-tube

with carved coin patterns in openwork and relief

Qing Dynasty Qianlong period

Length of Holder-tube 18.3 cm Diameter of Holder-tube 0.9 cm
Length of Cap 8.7 cm
Qing court collection

The holder-tube of the brush is carved with ancient coin patterns rendered delicately in openwork simulating fish-net eyes, and on the tip are two incised borders in intaglio filled with blue pigment. The cap is carved with five flying bats in relief, interspersed by cloud patterns. The two ends of the cap are carved with key-fret patterns filled with blue pigment. The tip of the brush holds a bundle of purple hair in the shape of an orchid's bud.

Carving techniques in openwork, relief, and incising are utilized to decorate this brush with fine polishing, showing the progressive development of producing Chinese brushes and carving techniques in the Qianlong period. "*Fu*" (bat) is a homonym for "*fu*" (fortune), "*qian*" (coin) is a homonym for "*qian*" (before the eyes), and the coin pattern has a square opening at the centre (the eye of the coin). The combination of these motifs is suggestive of "fortune comes before the eyes".

Purple hair is a kind of rabbit's hair, which is purple in colour and very strong.

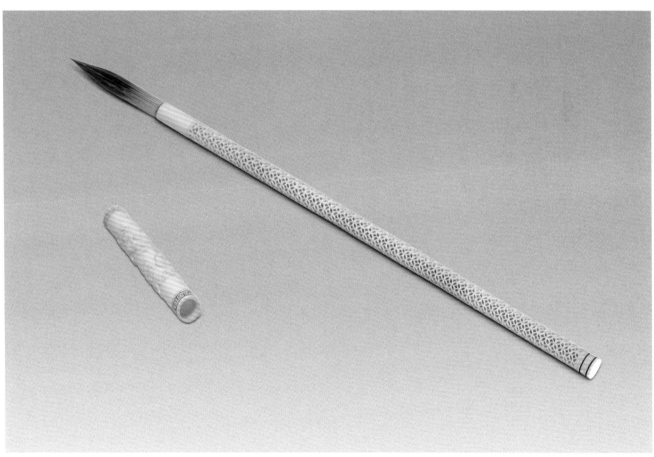

70

Fifty brushes
with purple hair and designs of imperial poems and floral patterns

Qing Dynasty Qianlong period

Length of Holder-tube 17.3 cm
Diameter of Holder-tube 0.9 cm
Length of Cap 9.8 cm
Qing court collection

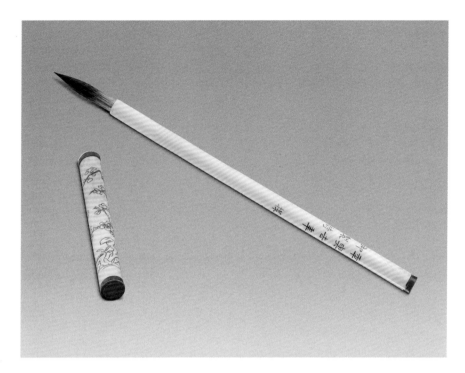

The holder-tubes are made with ivory, bamboo, sandalwood, and other materials. The holder-tubes are incised with imperial poems of Emperor Qianlong to describe various flowers in clerical script. In accordance with the contents of the poems, the caps are decorated with various flowers such as peonies, camellias, hibiscuses, hollyhocks, plum blossoms, peach, blossoms, chrysanthemums, gardenias, and others. The holder of the brush holds a bundle of purple hair in the shape of an orchid's bud. These brushes are kept inside a cinnabar lacquer cabinet with carved designs of landscapes, and there should have been a jade title tablet inlaid at the centre of the top panel, which is now lost. Inside the cabinet are five layers of drawers, each with ten grooves for storing the brushes.

This set of brushes and cabinet is ornamented extravagantly with different materials for making the holder-tubes, and the craftsmen blend techniques of various crafts in making them. The brush hair with glare is of very high quality. This set of brushes with cabinet is both decorative and functional, revealing the pursuit of luxury in producing court objects in the Qianlong period. The cinnabar lacquer box is in bright colour and ornamented with designs in high relief, showing the representative style of carved lacquer ware of the Qianlong period.

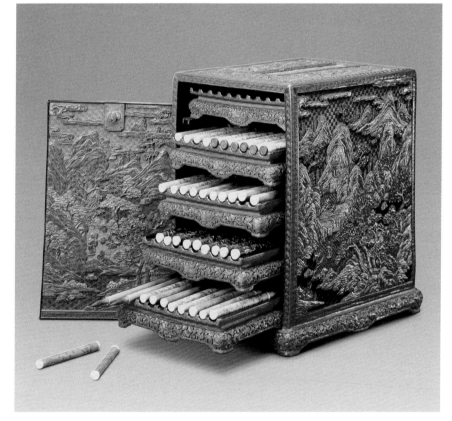

71

Ivory grasp brush
with boar's hair and holder-tube with carved designs of a hundred bats amidst clouds in relief

Mid Qing period

Length of Holder-tube 11.8 cm
Diameter of Holder 6.6 cm
Qing court collection

The brush holder-tube is decorated with carved designs of bats and clouds in relief and painted in red. The flat tip of the holder-tube is carved with the "*shou*" (longevity) character in seal script, suggestive of fortune and longevity. The brush tip is made with boar's hair and further strengthened by fastening with yellow silk threads.

Grasp brush is the largest among the various types of Chinese brushes. The brush tip made with boar's hair is for writing huge characters.

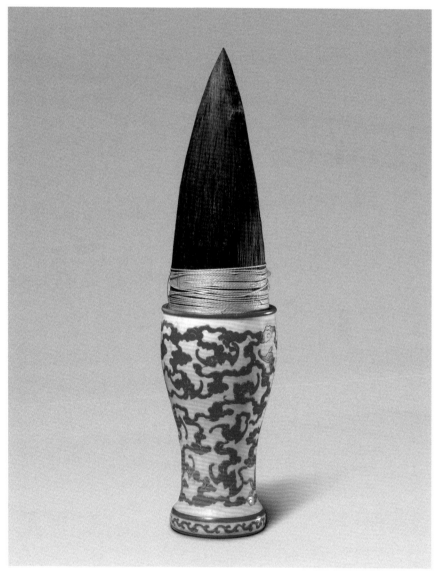

72

**Square ivory
brush-holder**
with carved
designs of figures

Mid Qing period

Height 11.7 cm
Length 9 cm
Width 9 cm
Qing court collection

The four corners of the square brush-holder are concave to form the shape of a holly hock and further incised with line borders as decorations. At the centre of the base is a hollow hole, on which there should be a supporting stand but is now lost. On the four sides of the brush-holder are four panels with angular corners, in each of which is another panel in the shape of variegated *kui*-dragons carved in high relief on a plain ground. Inside these panels are carved designs of scenes of literary activities, such as figures playing the *qin* zither, playing chess, writing calligraphy on a cliff, scholars getting drunk, etc. in landscape settings.

This ware is skilfully ornamented with lyrical decorative motifs. Although the figures are in small sizes, their physical features and facial expressions are fully rendered with details in a meticulous manner. The landscape settings are depicted partially, yet they play a vital role in enriching the artistic rendering, representing the typical style of ivory carving of the court in the mid Qing period.

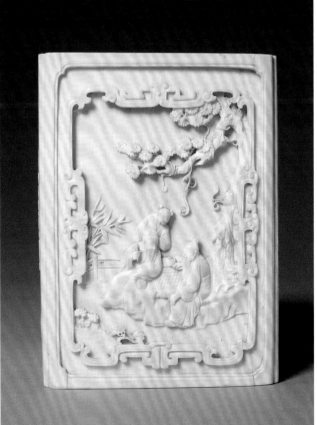
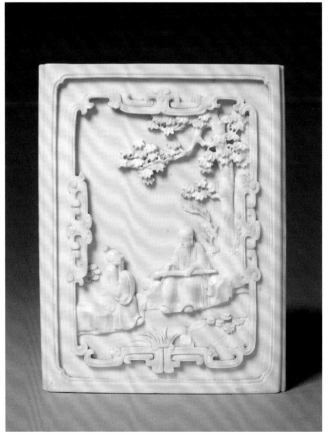

73

Ivory brush-holder
with carved designs of
flowers of the four seasons
on a ground filled
with black lacquer

Mid Qing period

Height 13.7 cm
Widest Diameter 11.5 cm
Qing court collection

The brush-holder is in the shape of a flower with six lobes. Each side is slightly recessed, and at the base are six short legs. The rim of the mouth and legs are decorated with variegated *kui*-dragons. The sides of the brush-holder are decorated with panels in which are designs of peonies, magnolias, chrysanthemums, plum blossoms, and other floral sprays.

This work with white ivory colour and a ground layered in black lacquer produces an eminent aesthetic effect with a sharp contrast. The production technique is to remove the surface skin of ivory and carve decorative designs in low relief at first. Then, the empty spaces in between the designs are filled with black lacquer that levels with the designs, which are then polished. Other designs such as flower stamens and leaf veins are also incised and filled with lacquer. Such a distinctive technique successfully breaks the monotony of the single colour of ivory with other colours added, marking a step forward in decorative rendering.

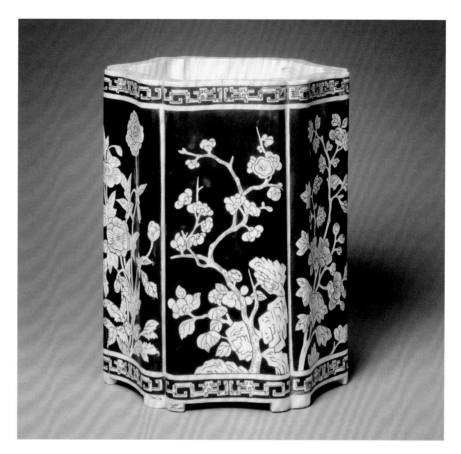

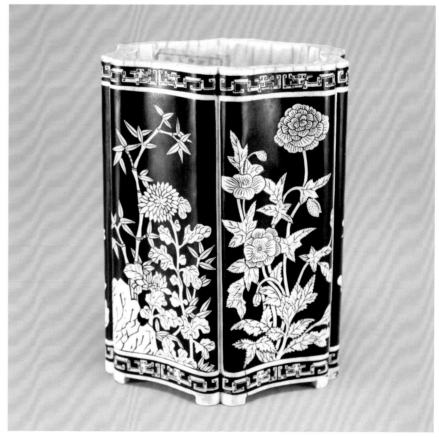

Ivory wrist-rest
with carved designs of
eighteen arhats crossing
the sea in relief

Mid Qing period

Length 29.1 cm Width 6.1 cm
Thickness 2.4 cm
Qing court collection

The wrist-rest is narrow on the upper side and wide at the lower side, which looks like an inverted tile. It is carved in the shape of a bamboo trunk with four short legs. The front side is carved with the design of a monk sitting in lotus posture in relief. Smoke comes out from an incense burner and ascends to turn into an imagery of a palace tower. The scene may be suggestive of the legend that Bodhidharma obtained enlightenment by facing the cliff rock at the Shaolin Monastery at Mount Song. The concave side of the wrist-rest is carved with Buddha Maitreya and the eighteen arhats crossing the sea. Buddha Maitreya is sitting on an embroidered cushion with attendants standing behind, and is carried by three yaksas below. The arhats are holding ritual vessels in their hands and riding on the dragon, monkey, lion, *qilin* unicorn, tortoise, fish, ox, tiger, and other auspicious beasts to cross the wavy sea.

This work is decorated with carved designs in an exquisite manner. The designs in low relief at the front are rendered with aesthetic appeal simulating Chinese ink painting. This wrist-rest represents a refined ivory scholar's object of the mid-Qing period.

Bodhidharma was a sacred monk from South Sindhu (present day India), who had crossed the sea to China for pronouncing Buddhism, and later became the first patriarch of Zen Buddhism in China. The eighteen arhats referred to the legendary sixteen Buddhist saints by also adding two *zunzhe*, who pledged to stay in the world forever to uphold the Buddhist doctrines.

75

Ivory box
in the shape of a quail

Mid Qing period

Height 5.6 cm
Length 12 cm
Width 4.5 cm
Qing court collection

The box is carved in the shape of a quail in the round. It is opened at the centre, with the head and back of the bird to form the lid, and the belly to form the body. The claws are hidden under the belly. After carving, the feathers of the bird were further tinted to perfectly hide the joint of the lid and the body. Objects with the decorative motif of a quail often carry the auspicious blessing of peace.

This box was a cosmetic box used by court ladies. The round form of the quail is reasonably exaggerated to enhance the touch of realism, yet keeping the practical function of this ware. It shows the skilful carving workmanship of Qing craftsmen and represents a realistic style of ivory carving of the Qing Dynasty.

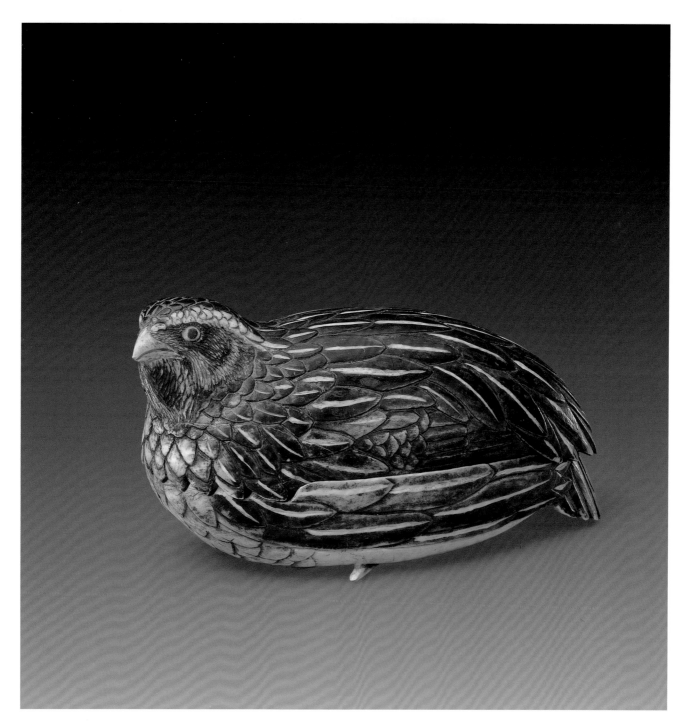

76

Ivory flower-perfume holder
with carved designs of double happiness and great fortune in openwork

Mid Qing period

Overall Height 18.8 cm
Diameter of Mouth 2.8 cm
Qing court collection

The perfume-holder is in the shape of a gourd and has a lid. The body is decorated with a ground of coin patterns carved in openwork, on which are decorations of hibiscuses, butterflies, bats, and floral sprays entwined with small gourds in relief. Each of the two sides has one panel at the centre. On one panel is an engraved gold openwork design with the characters "*daji*" (great fortune) in regular script, and on the other side is a carved design with the character "*xi*" (double happiness) in clerical script filled with red pigment in openwork. The bottom of the lid is linked to the belly of the perfume-holder by a long chain with designs carved in openwork. On the long chain are three other smaller chains, with each fastened with a small gourd, suggestive of the blessing of fertility and having many offsprings.

This object is produced by techniques of carving in openwork, relief, and colour coating without any traces of welding. It was a refined decorative object produced by the ivory craftsmen in Guangdong at the Imperial Workshops in the Yongzheng or the Qianlong period for imperial use during imperial wedding ceremonies.

 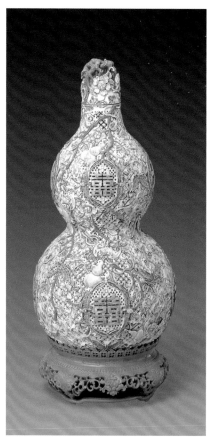

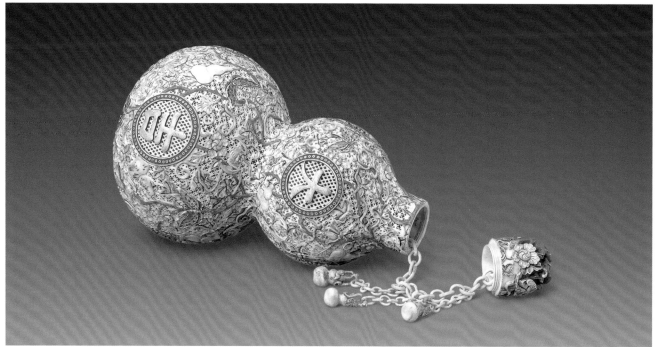

Ivory pomegranate
with carved designs of
acrobatic games

Mid Qing period

Height 5.3 cm
Qing court collection

The work is carved in the shape of
a pomegranate. The exterior is tinted
with colour and carved with designs of
pomegranates, floral sprays, and butterflies.
The base is fixed with a movable tenon and
can be opened into five petals. The interior
is decorated with a round platform on
which are carved decorations of a two-tier
house with miniature carvings of various
figures watching sceneries around, chating,
or performing acrobatic games. The interior
is carved with designs of bats flying amidst
clouds. Pomegranates are an auspicious
symbol suggestive of fertility and having
many offsprings, whereas the red bat is an
auspicious symbol of great fortune.

On this object, techniques of carving
in the round, openwork, relief, and colour
coating are skilfully utilized with a touch
of charm and subtleness. According to the
archive of the Imperial Workshops of the
Qing court, in the 15th year of the Jiaqing
period (1810 A.D.), Mo Chengji, an ivory
craftsman at the Imperial Workshops,
submitted a drawing of a box in the shape
of a pomegranate with designs of abundant
offsprings to the inner court, and Emperor
Jiaqing approved its production. This is the
only extant ware of its type and might have
been the one made by Mo Chengji.

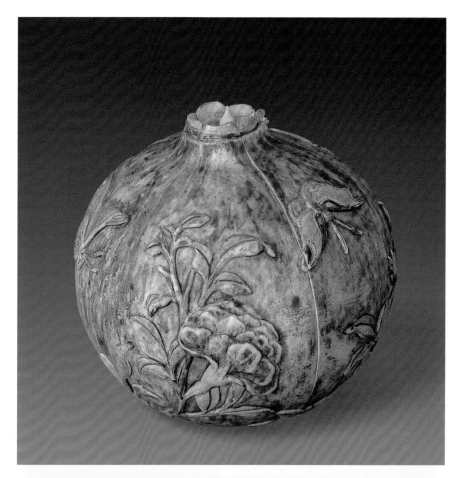

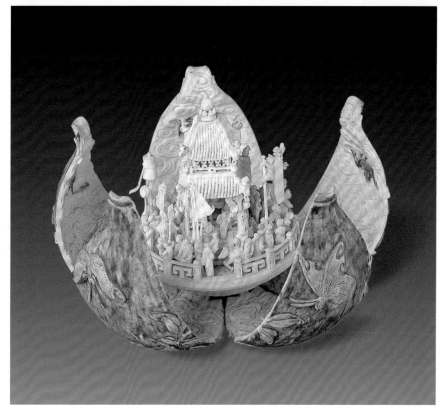

Ivory concentric sphere

with carved designs of characters "*fu*" (fortune), "*shou*" (longevity), and *baoxiang* floral rosettes in openwork

Mid Qing period

Diameter 9.1 cm
Qing court collection

The sphere has eleven layers of concentric spheres carved in openwork. The size of each sphere reduces from outside to inside, and each sphere is movable. The outside sphere is carved with characters "*fu*" (fortune), "*shou*" (longevity), and *baoxiang* floral rosettes in openwork, and the inside spheres are carved with floral patterns, dragons, and phoenixes in openwork.

This concentric sphere is made by using a lathe to cut and carve the designs, and the inner spheres are separated from each other by using a hooked knife to peel off each layer of the spheres, which requires sophisticated technical manipulation. Such a sphere is known as "ghost work ball" and is a representative type of carved ivory craft in Guangdong. Some experts opine that the production of these ivory spheres might have been influenced by the lathe turnery ivory craft which was popular in the Holy Roman Empire from the 16th to the 17th century.

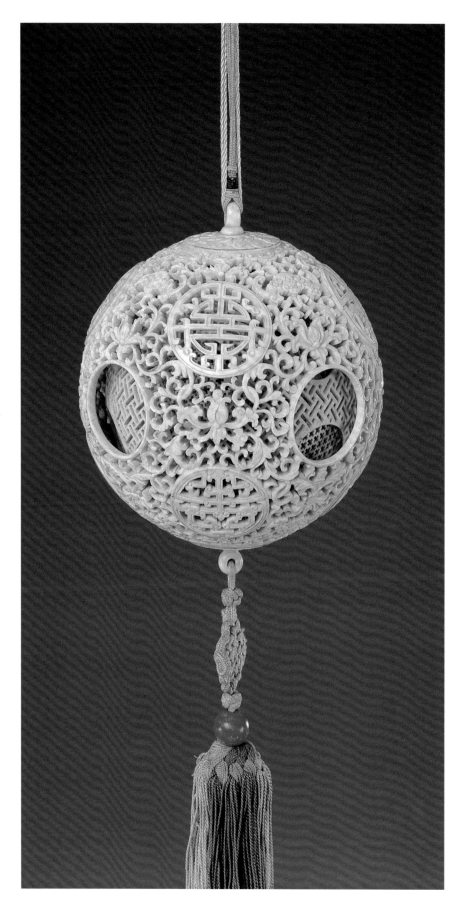

79

Woven ivory
threads fan
with designs of magnolias
and Chinese peonies

Mid Qing period

Overall Length 57.5 cm
Width 33.6 cm
Qing court collection

The fan is in the shape of a banana leaf with a round waist. The surface of the fan is made by using ivory threads with less than 1 mm thickness to form a brocade ground. On its top are relief designs of gouldian finches, magnolias, and Chinese peonies with pictorial compositions resembling Chinese bird-and-flower painting, suggestive of the auspicious meaning of "magnolias to bring wealth and fortune". A vertical bamboo palm strip crosses the centre of the fan, which has a gilt bronze mount caved with bats and decorated with kingfisher feathers to protect the top. The fan's bone strip is also inlaid with four pieces of cloudy amber in orange, purple, yellow, and red, and carved with *kui*-dragons and *baoxiang* floral rosettes in relief as protection mounts. The rim of the fan is mounted with a tortoise-shell frame, and the handle is decorated with flowers and butterflies in painted colour enamels and fastened with a yellow silk tassel.

Techniques of woven ivory threads and relief carving are utilized in decorating this fan with a tidy pictorial composition and dense colours with a touch of extravagance and luxuriance, representing a refined tribute submitted to the court from Guangdong in the 18th century.

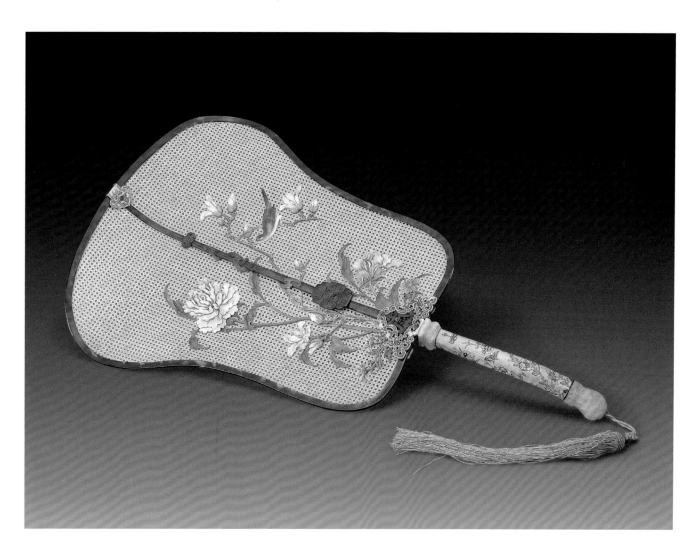

Ivory albums
carved with scenes of
monthly leisure resorts
(twelve albums)

Mid Qing period

Length 39.1 cm Width 32.9 cm
Thickness 3.2 cm
Qing court collection

This work has twelve ivory albums with each one depicting a scene of leisure resort in each month. Each album has two pages opened to the left and right. The left page is decorated with ladies in leisure resorts in different months by utilizing various materials such as jade, precious stones, tortoise-shells, and corals with carving or applique techniques. The right page is decorated with imperial poems by Emperor Qianlong inlaid with mother-of-pearl on a blue sandy lacquered ground. At the end of each poem are seal marks "*shufangrun*" and "*Qianlong chenhan*" in seal script.

This work fully demonstrates the excellent skills of craftsmen in Guangdong in the mastery of the art of ivory craft. The pictorial composition was derived from the painting "A Hundred Beauties" by the court painter Chen Mei, and the albums were made by the ivory carvers Chen Zuzhang, Xiao Hanzhen, Chen Guanquan, Gu Pengnian, and Chang Cun from the fourth to the sixth year of the Qianlong period (1739 – 1741 A.D.) at the Ruyi Workshop Studio. This work represents a refined piece of ivory craft produced in the early Qianlong period and reveals the classical and elegant taste of the court.

Scenes of leisure resorts in the twelve months:

Album 1: The first month
Contemplating plum blossoms in a wintry night

It depicts ladies contemplating plum blossoms at night during the Chinese Lantern Festival. A lady is holding a lantern and leading five ladies to come. Lanterns are hung under the eaves of a mansion with two fully bloomed plum blossom trees under shiny moon night. Four ladies are either sitting or standing at the zigzag corridor to contemplate plum blossoms and the moon.

Album 2: The second month
Playing chess in a pavilion

In a courtyard with bamboos, wisterias, flowers, and trees, two ladies are playing chess in a pavilion, with four ladies watching the chess game. Two maids are holding tea set and food containers, and walking towards the pavilion.

Album 3: The third month
Playing on a swing beside willow trees

A swing is hung in the courtyard with willow trees. A lady is playing on the swing, and seven ladies are either sitting or standing around.

Album 4: The fourth month
Contemplating flowers in a courtyard

Beside a studio and a zigzag corridor, magnolias, peonies, and Chinese peonies are fully in bloom. Several ladies are sitting inside the zigzag corridor to chat, or standing outside the corridor to contemplate flowers with one lady holding a pot of flowers.

Album 5: The fifth month
Make-up in a water pavilion

During the Dragon Boat Festival in the fifth month, five ladies are resting inside a water pavilion in front of a pond. They are either making up themselves or watching gold fish in the pond. Another lady is carrying a tea set and walking towards them.

Album 6: The sixth month
Picking lotuses in a willow pond

Under willow trees and beside the willow shade and zigzag corridor, six ladies are standing on a bridge beside a pond. They are chating with each other and waiting for the return of four ladies in a boat, who just finished picking lotuses from the pond.

Album 7: The seventh month
Celebration of Double-seventh day under a phoenix tree

Several ladies gather under a phoenix tree and competing themselves with the game of needlework. Playing needlework was a folk custom in ancient China. On the double-seventh day of the seventh month, they would perfrom needlework or float needles on the water as competitions. Those who performed the best needlework or had the needle float on the water without being sunk would win the competition.

Album 8: The eighth month
Contemplating the moon on a terrace

The beautiful full moon shines over a high terrace. Ladies are standing or sitting along the railings to contemplate moonlight.

Album 9: The ninth month
Contemplating chrysanthemums in the double-ninth Festival

In a courtyard with potted chrysanthemums and cockscombs, ladies gather and contemplate flowers.

Album 10: The tenth month
Embroidery work in front of a clear window

When the weather becomes cold, ladies set up embroidery racks in a studio. Some of them are doing embroidery with others either watching or commenting on their works.

Album 11: The eleventh month
Literary gathering and warming up

In a studio, ladies are either holding warmers for keeping warm, holding archaic objects, or opening a painting scroll for watching.

Album 12: The twelveth month
Strolling on snow and composing poems

In cold winter, four ladies are contemplating snowy scenery in a courtyard. Another three ladies are holding umbrellas or warmers and coming forward for a gathering to compose poems.

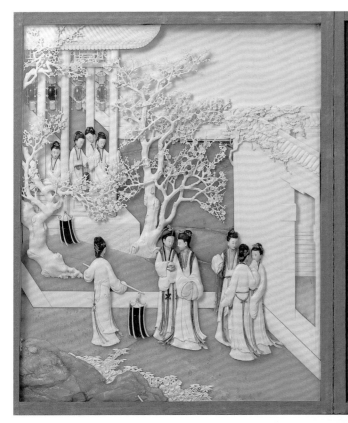

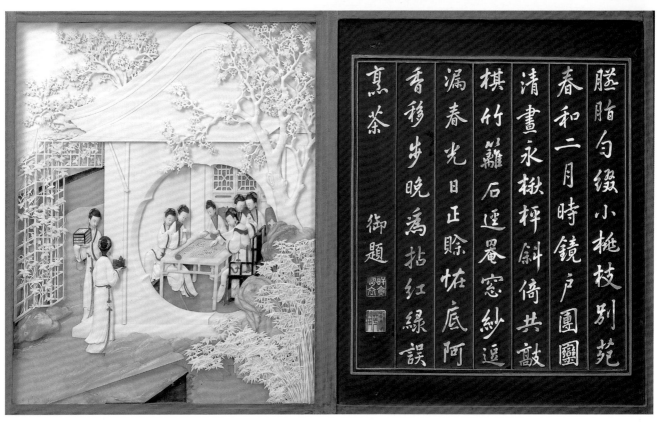

春信偶嘗樊外梅倚吟
京緗共徘徊輕雲不入
深庭院妙伴攜將酒之
未闌銀檠子上東墻繡
線花藥不讓光翠蛾無
語舍情霞一枝春風卜
短長　御題

胭脂勻綴小桃枝別苑
春和二月時鏡戶團圓
清畫永楸枰斜倚共敲
棋竹籬石逕罨窗紗逗
漏春光日正晬悵底阿
香移步晚為拈紅綠誤
烹茶　御題

清明時節杏苍天㟝柳
輕垂漠漠烟寰是春閨
識風景翠翹紅袖蹴秋
千曲池風靜鏡澄波絲
柳青輸兩髻螺未許人
開輕比似壺中游戲半
仙娥

御題

日㟝韶華闘麗新鼠姑
獨殿一圍春蛾眉倚檻
相看裊寂妩沉香亭畔
人天香國色兩相争轉
覺詩人費品評氣韵風
標都不讓只饒無語一
般情

御題

池亭消夏坐薰風韻雅
琴箏水竹同何用需笙竽
重揆撫絃人去鏡光
中翠母陰來夜日書沱
孤光波年風涼玉魚貼
體淋宇句只少南才藝
子雰　御題

薄風孤句物季絲若笑
為中澤翠眉小主那日
澤不它碧波形湃一爱
時漏湖雲誋漢淋風緬
袂拙呼聲佳回不身飄
蓋灣生之盡光六當絲
翠藝　御題

桐軒晝靜絲繩倚
紅德笑語吝是爻斷
工氣巧梳樂文筆漫相目
嘴新糯庭院足清候線
蔭修格弎兩株步履倏
橋橫籟弄娉艇紅恵倩
久嬌
御題

石欄湖收透冰紗徙倚
中宵玩月華環珮風清
涼夜永水晶宮裡綠華
家峭寒日切薄羅裳雲
外風飄桂子香摘就秋
光含意變色空月色正
蒼工
御題

深閨窔靜重帷暖尋羇鼎
縱橫白壁雙沙進閒情
塞不到小陽春日度明
窓何靄行來洛浦仙衣
裳如霧髮如烟瑤池玉
簡群尋捨不數米家書
畫船
御題

溫風重闈暖氣貞貞實家
炎日是三吉寶音會雲
興座本漫傲銷金帳裏
飛貼上貂茸橋賴橬步
來陪闈即彎三粉牆厲
囿重角門鎖櫃花青衣干
往還
御題

81

Ivory pagoda
with carved designs of immortals celebrating birthday

Late Qing period

Height 102 cm
Length 98 cm Width 54 cm
Qing court collection

This work comprises of four layers of buildings with different heights, and is surrounded by a border of railings with pillars. At the front layer, the three immortals of fortune, prosperity, and longevity are standing under an arch decorated with dragons, with other immortals standing around the Bridge of Golden Water. In the middle layer, there is a palace with double eaves and nine ridges decorated with dragons in pursuit of pearls. Lanterns are hung under the eaves, and the Mother of the West Paradise is sitting solemnly inside. Outside the palace are gold trees inlaid and set with pearls and precious stones. At the back is a hexagonal pagoda with thirteen tiers. The railing at each tier is carved with flying dragons, mythical beasts, characters "*fu*" (fortune) and "*shou*" (longevity), and *baoxiang* floral rosettes with immortals walking around in each tier. Bells are hung at the corners of eaves, and at the top is a gourd-shaped spire inlaid with beewax. The rear layer is an immortals' mountain with winding staircases, pavilions, and towers. Various immortals dwell in the mountain with pines, cypresses, wisterias, and *lingzhi* fungi around.

This work is basically made from ivory and decorated with other precious stones and valuable materials by utilizing different techniques of carving in openwork, carving in the round, applique and inlay, and colour coating, exuding a touch of extravagance and elegance. It was a tributary gift with distinctive features of ivory art in Guangdong and sent to the court to celebrate the birthday of Empress Dowager Ci'xi from the officials in Guangdong. The costume of the Mother of West Paradise also carried the features of court costumes of the Qing Dynasty.

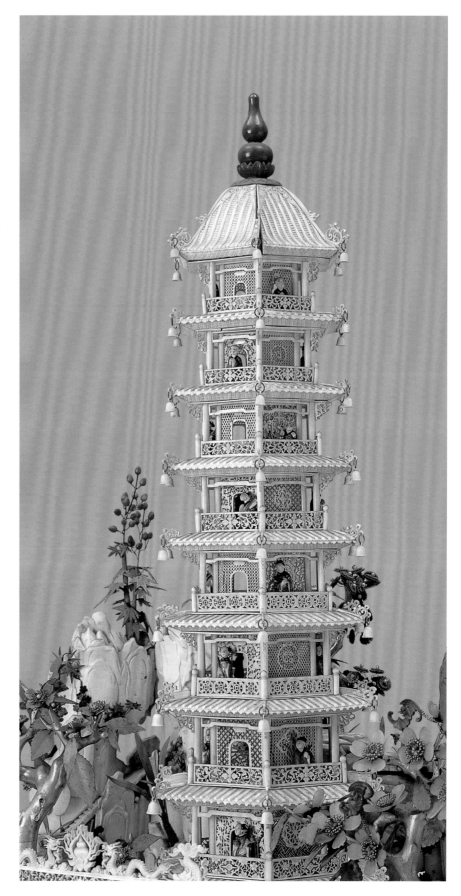

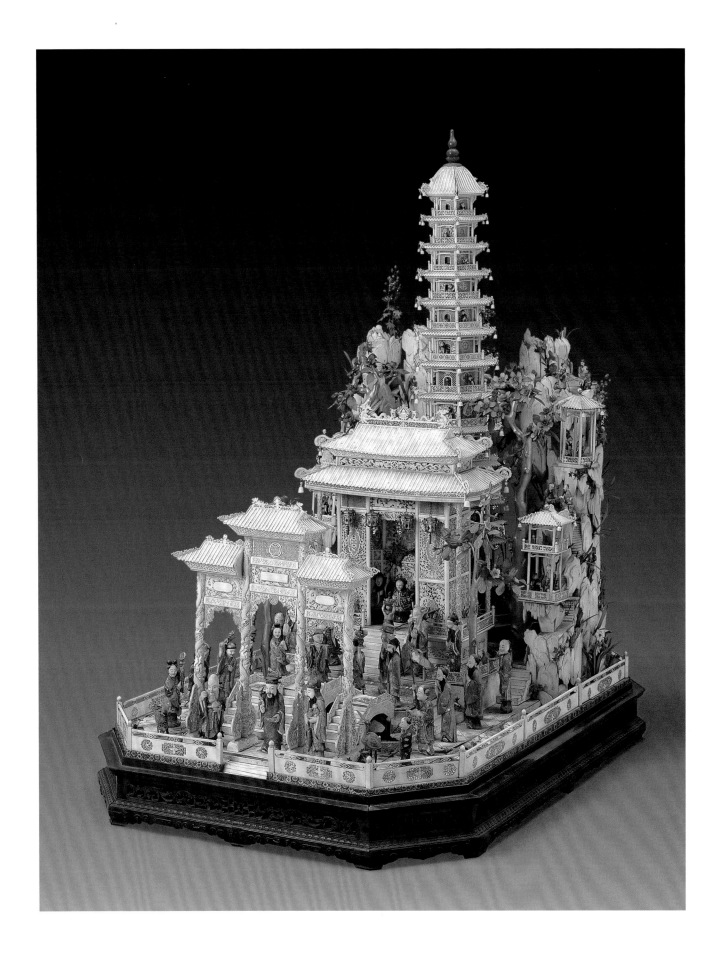

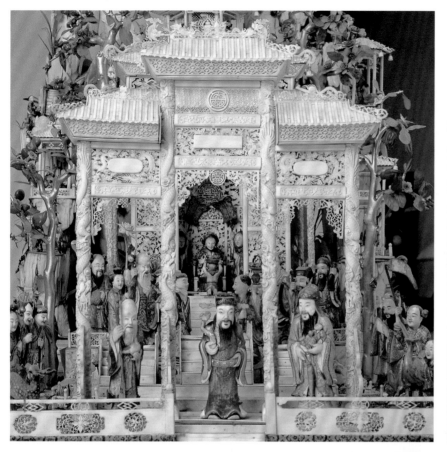

82

Peach-shaped gold box
with carved coral designs of dragons
amidst clouds, bats, and the character "*shou*"
(longevity)

Qing Dynasty Yongzheng period

Height 19 cm
Length 24.5 cm
Width 20.5 cm
Qing court collection

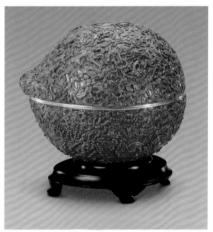

The peach-shaped box has a gold body on which several red corals are set to coat the box. The box has a fitting lid. The surface of the lid is carved with dragons amidst clouds in relief. The top of the lid is carved with bats and *shou* (longevity) medallions in relief. The body is carved with clouds and waves in relief.

According to the records in the Qing court Archive, this box with rich decorations and auspicious motifs was made to celebrate the birthday of Emperor Yongzheng. The carved designs are marvelously and skilfully rendered and polished, showing high technical production standard and artistic merits.

Coral is formed by chalky skeleton remains of actinozoan. It is in the shape of tree branches, most of which are in red colour. There are also corals in white or black colour which are much treasured since the ancient times. Currently, coral, rhinoceros horns, and ivory are regarded as organic precious stones.

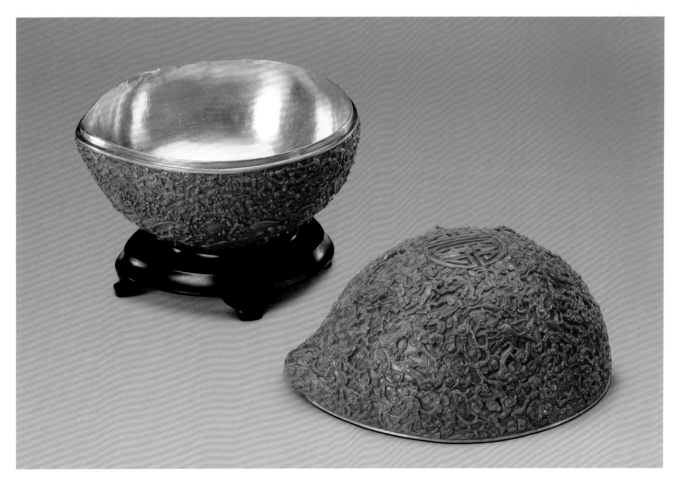

83

Coral lion

Mid Qing period

Height 14.3 cm
Length 23 cm
Qing court collection

The red coral lion is carved in the round. The lion's tail is made by a natural oval coral piece fixed to the lion's body. It has a fitting red sandalwood stand with carved designs of rocks in openwork.

Coral objects were popular decorative objects for the Qing court. Mostly, natural forms of corals were utilized to produce works, or they were used for set and inlaid decorations. Coral objects carved in the round were very rare and unusual.

84

Coral miniature landscape
with a cloisonné enamel basin in the shape of a peach

Qing Dynasty

Overall Height 108.5 cm
Length of Basin 65 cm
Width of Basin 32 cm
Qing court collection

The work comprises of two parts: the basin and the miniature landscape. The basin is made with various techniques of engraving, gilt, cloisonné, and painted enamels. It is modeled in the form of a peach with three tiers, which looks like the Chinese character "*shan*" (mountain). The front and back of the basin are decorated with two large red bats holding a *shou* medallion with seven small gilt bronze bats flying amidst peach leaves. The combination of these decorative motifs is suggestive of the auspicious blessing of wealth and longevity. On the basin a large red coral tree is inserted. The work has a fitting red sandalwood stand carved with cloud patterns in relief.

Red coral is a rare material for making decorative objects. Despite many of them were produced for court use, such a large red coral object with an elegant naturalistic form like this one was very unusual.

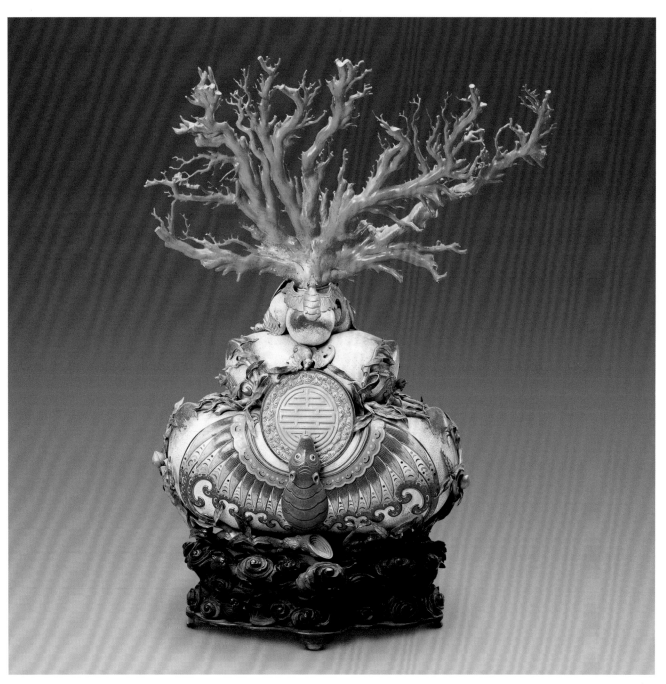

85

Cloudy amber flower receptade
with two holes and designs of deer and cranes

Qing Dynasty

Height 18.7 cm
Length 16.5 cm
Width 6.3 cm
Qing court collection

The flower receptade has two holes and is in the shape of pine and bamboo stumps carved with various techniques in the round, relief, and openwork. The large hole is shaped like a pine stump with abundant branches. The small hole is shaped like a bamboo stump. The work is further decorated with auspicious motifs such as cranes, deer, and *lingzhi* fungi. It has a fitting ivory stand tinted with colour in the shape of a peach branch carved in openwork.

Cloudy amber is a kind of opaque or semi-transparent amber. When the pine rosin is buried in the ground under high temperature and pressure for many years, it would become cloudy amber, and the one with charming colours is very valuable. The material is rather soft and can be carved by simply using a small cutter or

knife, but it is very fragile and difficult to handle during carving to produce a perfect piece.

The colour of this flower receptade is pure, and the carved designs are skilfully rendered. Pines, bamboos, cranes, and *lingzhi* fungi were regarded as symbols of long life and everlasting green in ancient times, and thus the combination of these motifs carried the auspicious blessing of "attaining long life of a crane and reaching the advanced age of a pine". The combination of the motifs of pines and bamboos is also suggestive of bringing long life. The pronunciation of "*luhe*" (deer and cranes) is a homonym for "*liuhe*" (six harmonies which refer to heaven, earth, and the four directions), and thus suggestive of "six harmonies in spring", which carries the blessing of long life and prosperity.

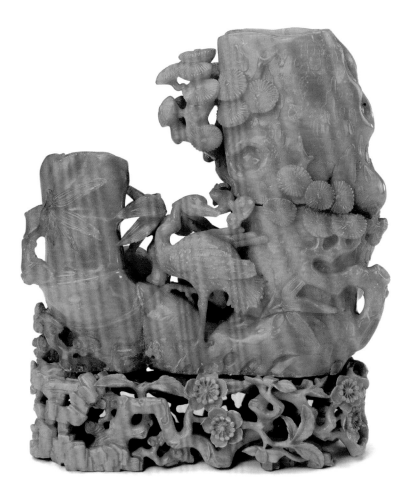

86

Chengni inkstone
with designs of sea beasts

Ming Dynasty

Height 4.3 cm Length 18.5 cm Width 12 cm
Qing court collection

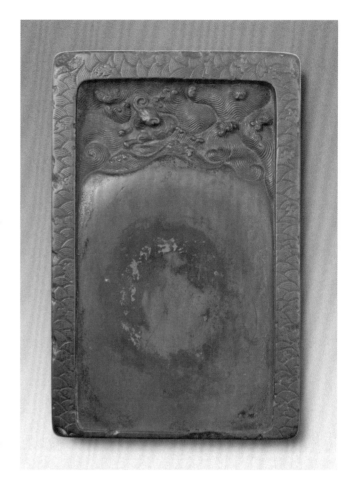

The inkstone is rectangular in shape with a shallow ink pool opened on the surface of the inkstone. On the top side is a deeply recessed water pool carved with designs of sea beasts in relief. At the border frame of the inkstone are engraved with designs of waves. The back of the inkstone is deeply recessed and carved with a *bixi* tortoise carrying a stelae decorated with two *chi*-dragons at its back in relief. The side of the inkstone is engraved with an imperial poem by Emperor Qianlong with an inscription "inscribed by Emperor Qianlong in the *wuxu* year" in regular script and two seal marks "*bide*" and "*langrun*". The *wuxu* year corresponded to the 43rd year of the Qianlong period (1778 A.D.).

The inkstone is carved in a delicate manner and represents a refined piece of *chengni* inkstones of the Ming Dynasty. It is recorded in the book *Xiqing Collection of Inkstones*.

Inkstones, also known as ink slabs, belong to one of the traditional four treasures of a scholar's studio for grinding ink for writing. Most of them are made with stones, but there are also others made with sands, jade, pottery, and porcelain. It is used for grinding ink, keeping ink, and for dipping the brush to absorb ink for writing. There are many famous types of ancient inkstones, with *duan* inkstones, *she* inkstones, *tao* inkstones, red thread inkstones, and *chengni* inkstones the most esteemed. Other well-known types of inkstones include *songhua* inkstones, jade inkstones, and sandy lacquer inkstones, as recorded in the history of Chinese inkstones. In Chinese legend, the mythical *bixi* tortoise is said to be one of the nine sons of the dragon. It is shaped like a tortoise but has teeth. It is fond of carrying heavy stuff, and is often rendered in the form of carrying a stele on its back.

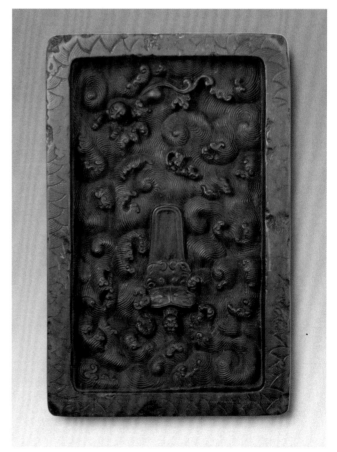

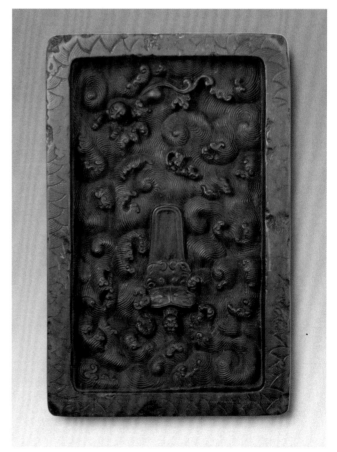

乾隆戊戌
御題

出許多奇
後挨天鎔
木家成賦
若披疑供
鼇騰濤濤
若痕施獸
知雕不辨

130

87

Rectangular *chengni* inkstone

Ming Dynasty

Height 4.3 cm Length 29.4 cm Width 17.3 cm
Qing court collection

The inkstone is rectangular in shape with the ink pool opened at the surface. The four sides have border frames. The water pool is carved deeply and widely and can store ink as well. The back has a hand well for holding and is engraved with a eulogy of inkstones in regular script by Emperor Qianlong, with an inscription "inscribed by Emperor Qianlong in the *wuxu* year", and two seal marks "*Qianlong chenhan*" and "*weijing weiyi*". It has a fitting red sandalwood box inlaid with jade. The cover of the box is engraved with a eulogy of the inkstone in clerical script filled with gold pigment, and two seal marks "*qian*" and "*long*".

The quality of this inkstone is hard and compact, resembling the quality of jade, which can match the fine quality of *duan* and *she* inkstones. The colour is yellow with a brownish tint, which is known as "eel yellow". It represents a valuable piece of *chengni* inkstones. The inkstone keeps its original texture without any decorations added. It is recorded in the book *Xiqing Collection of Inkstones*.

Chengni inkstones are a kind of pottery inkstones made from filtered fine soil. Its production had started in the Tang Dynasty and increased in the Song Dynasty, with the characteristic of hardness and compactness, durable for grinding, easy to give ink, and not damaging the brush or wasting ink, which could match the quality of inkstones made of genuine stones. *Chengni* inkstones are produced at present day at the Lingbao district, Henan, the Jiang district at the region of Fen River, Shanxi, the Zhegou town, Shandong, Hutuo River, Hebei, and other areas.

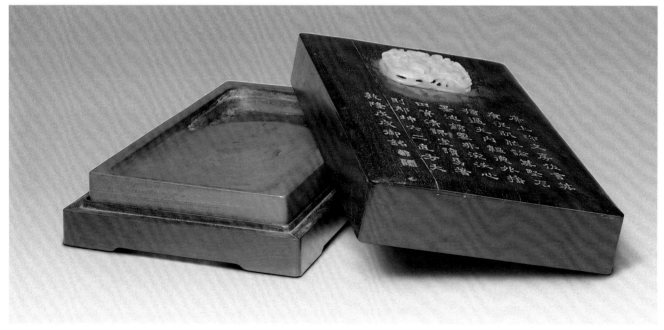

88

Duan inkstone
with a dragon-shaped ink pool

Ming Dynasty

Height 4.2 cm
Length 17.3 cm
Width 12.3 cm
Qing court collection

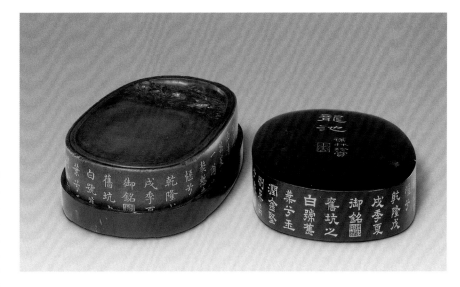

The inkstone is oval in shape. The four sides of the ink pool are bordered with lines. The water pool at the top is carved with the design of a dragon amidst waves in relief with a short pillar supporting a "stone eye" inside, resembling a design of a dragon in pursurt of a peal. The back of the inkstone is recessed more than one Chinese inch, and has two pillars with stone eyes. The side of the inkstone is engraved with a eulogy by Emperor Qianlong in regular script. It has a fitting black lacquer box, on top of which is an inscription "*longchi*" (a dragon pool) in clerical script written by Liang Qingbiao of the Qing Dynasty and filled with gold pigment, with a signature mark "*Jiaolin zhenshang*" and a seal mark "*yuli*". The wall of the cover is an engraved border of a eulogy of inkstones in clerical script by Emperor Qianlong filled with gold pigment.

The quality of the inkstone is compact, and "banana leaf white" markings are found on the surface. The stone texture is as fine and lustrous as jade. It was collected by Liang Qingbiao, a scholar of the early Qing Dynasty, and recorded in the book *Xiqing Collection of Inkstones*.

The *duan* stone was found at the Duan stream at the western hill slope of the Mount Lanke, Zhaoqing City, Guangdong. Zhaoqing was known as Duanzhou in the past, and inkstones made with the stones obtained there were known as *duan* inkstones.

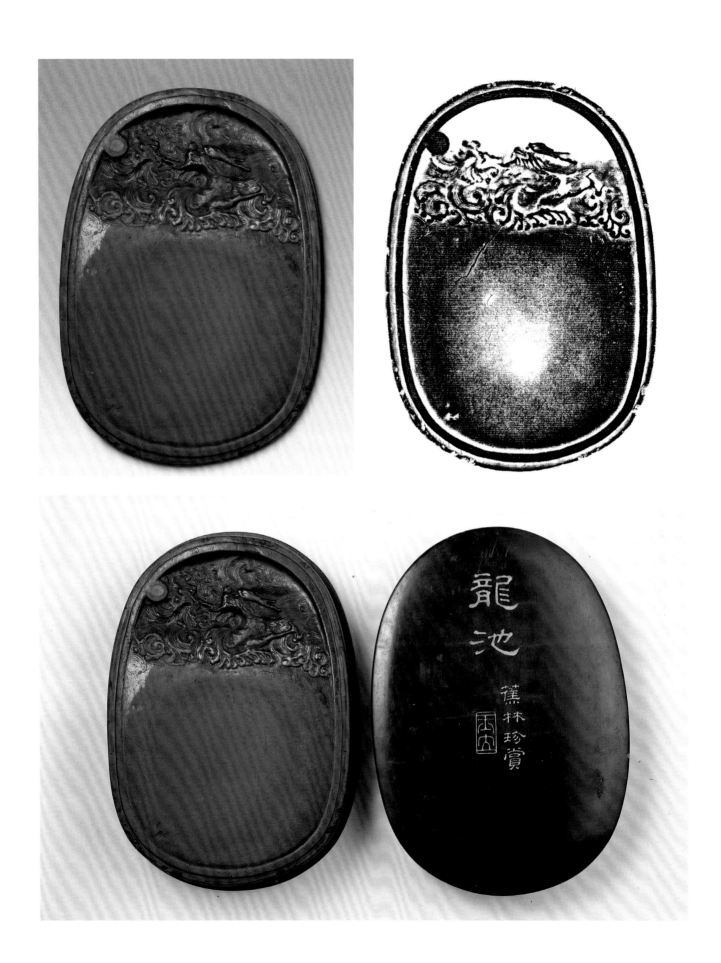

89

She inkstone
with a *chaoshou* recessed back
and eyebrow markings

Ming Dynasty

Height 9.7 cm
Length 24.9 cm
Width 15 cm

The inkstone is rectangular in shape and has a recessed back. One side of the ink pool has a rectangular water pool with round corners. On the surface of the inkstone are eyebrow markings. The side of the inkstone is engraved with a eulogy of inkstones in running script, which literally describes "dry but do not hinder the brush, smooth and can keep ink, the surface has claw-like markings, and its sound is like hitting gold with jade-like virtues. It is hard and compact, and can be used to assess human's behaviour in the past and nowadays. It is thick and heavy, and cannot be carried to accompany its owner to travel to the south and the north", with a signature mark "*Su Shi*" and a seal mark "*Zizhan*" which were added later.

This inkstone is in deep greenish black colour with hard, lustrous, and compact qualities. The eyebrow markings are clear and subtle, and it represents a refined piece of *she* inkstones.

The inkstone with a *chaoshou* recessed back is made by carving away a designated portion of the stone at the back to form a space which is lower at the front and higher at the back, with the top front linking to the two sides to form a leg for the inkstone, so that the hand could be inserted from the back for holding up the inkstone. *She* stones were found at the Wuyuan district, Jiangxi, but inkstones were produced in the *She* district, Anhui, thus known as *she* inkstones. The *she* inkstones have the features of greenish-black colour and fine and lustrous textures like jade. They are ideal for grinding ink with an oily quality, and there is no sound during grinding and no harm to the brush. Eyebrow makings are natural textures on the stone, which look like human's eyebrows, and stones with these markings are very rare and valuable.

90

Chengni inkstone
with the design of a herd
boy herding a buffalo

Ming Dynasty

Height 5.8 cm
Length 16 cm
Width 9 cm

The inkstone is carved in the shape of a recumbent buffalo in the round. A herd boy is climbing up the buffalo's back playing. In between the two horns and the neck of the buffalo is a deep water pool. It has a rather deep ink pool in the shape of a full moon. The surface is reddish-yellow in colour with brownish mottles.

This inkstone is carved vividly with creative design. The deep brown colour of the buffalo's body and the shallow colour of the back produce a sharp contrasting aesthetic effect. It is both a functional and decorative object and represents a refined piece of stationery.

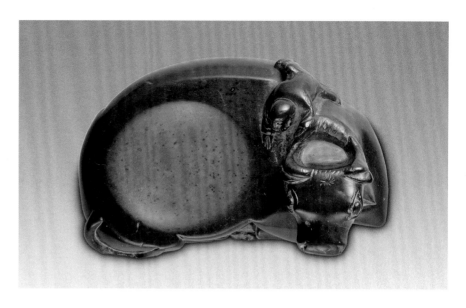

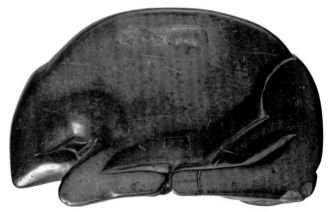

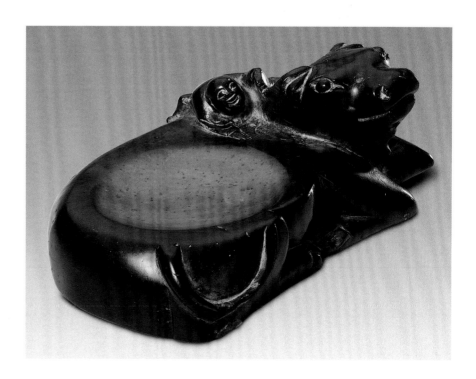

91

Duan inkstone
in the shape of clouds
with the mark of Shentian

Qing Dynasty Kangxi period

Height 4.3 cm Length 26 cm
Width 21.5 cm
Qing court collection

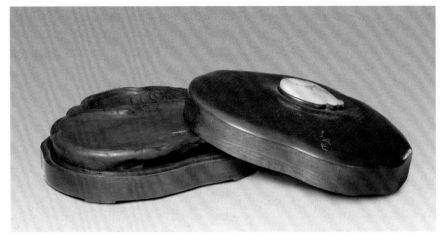

The ink stone is carved in the shape of a cloud in a naturalistic manner, matching the shape of the stone. The ink pool and water pool are naturalisticly rendered in the shape of clouds. At the side of the water pool is a relief pillar with a stone eye. The rim of the inkstone and the ink pool are carved with cloud patterns in relief. The back is recessed to form a pool, in which is a stone eye in relief. The sides are engraved with a eulogy of inkstones in clerical script by Huang Ren with an inscription which describes, "it was obtained at the Lingyang Gorge in the fifth month of summer in the year *xinmao*, and to be treasured for the use by Shentian" with a seal mark "*Ren*". The year *Xinmao* corresponded to the 50th year of the Kangxi period (1711 A.D.). Lingyang Gorge is at the present day Zhaoqing City, Guangdong, and the shale found there is ideal for producing *duan* inkstones.

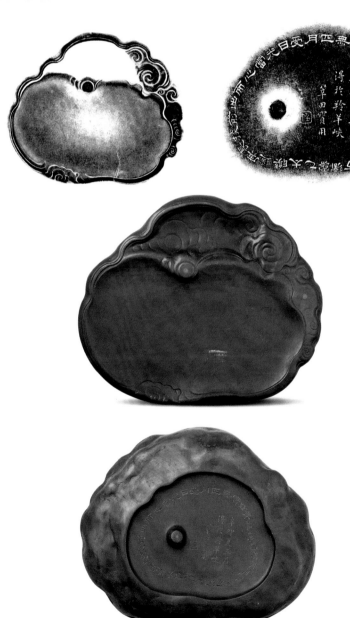

This inkstone is in deep-purplish colour with fine quality and is skilfully carved. It was a scholar's object of Huang Ren and later was collected by the Qing court. Huang Ren (1683 – 1768 A.D.), *zi* Shentian, was a native of Yongfu, Fujian in the Qing Dynasty. He was a *juren* candidate in the civil service examination in the year *renwu* (1702 A.D.) of the Kangxi period and later promoted as the magistrate of the Sihui district, Guangdong in the Yongzheng period. He was fond of collecting inkstones, and named himself "Master of Ten Inkstones" and his studio "Studio of Ten Inkstones" as he had collected ten inkstones with superb quality.

92

Duan inkstone
with a design of a phoenix and the mark of Shentian

Qing Dynasty Kangxi period

Height 2.6 cm
Length 21.5 cm
Width 18.1 cm

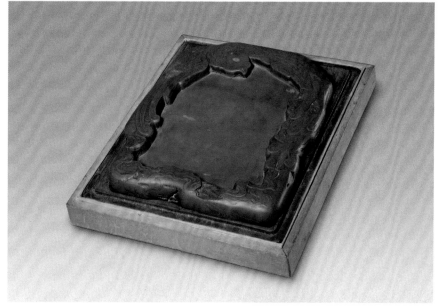

The rim of the inkstone is carved in the shape of a phoenix amidst clouds with its eye represented by a stone eye. The ink pool is opened naturalistically in the shape of a phoenix. The back of the inkstone is carved with two eulogies of inkstones. One of them is a poem with an inscription "eulogy of inkstones collected by Shentien in seal script written by Luyuan Lin Ji" with seal marks "*lin*", "*ji*", and "*Jiren zhici*". Another eulogy is a poem describing that this inkstone was made by a famous inkstone carver Gu Erniang in Suzhou using three months, with an inscription "Shentian Ren in early spring in the year *xinchou*" and seal marks "*huang*" and "*ren*". The side of the inkstone has a mark "made by Gu Erniang from Wumen" in seal script. The year *xinchou* corresponded to the 60th year of the Kangxi period (1721 A.D.)

Lin Ji (1660 - ?), *zi* Jiren, *hao* Luyuan, was a native of Houguan, Fujian. He served as a secretary of the Inner Cabinet of the court. Lin excelled in calligraphy in regular, seal, and clerical scripts, and was a connoisseur of books.

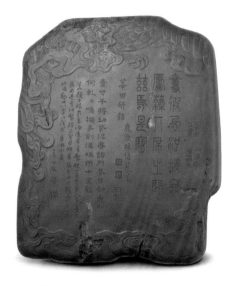

93

Duan inkstone
with designs of two dragons
in pursuit of a pearl

Qing Dynasty Kangxi period

Height 6 cm Length 21.8 cm Width 18.2 cm
Qing court collection

The inkstone is oval in shape with the upper side and rim carved with two dragons in pursuit of a pearl in high relief. Two dragons are flying amidst crested waves and inlaid with a gold bead. The ink pool is formed at the slightly recessed area of the decorative designs, and the water pool is opened at the lower part of the inkstone, which links to the design of sea and clouds above. At the back of the inkstone are designs of waves and clouds, forming two vigourous swirls. The designs at the front and the back match harmoniously and perfectly with a touch of heroic vigour. The back of the inkstone is engraved with imperial inscriptions and poems by Emperor Qianlong. The side of the inkstone is engraved with an inscription in clerical script "humbly made by the junior official Liu Yuan in the fifth month of

the 18th year of the Kangxi period" with a seal mark "*yuan*". The inkstone has a fitting red sandalwood box with the cover inscribed with an imperial poem by Emperor Qianlong in running script filled with gold pigment, and with a eulogy of inkstones by Su Shi. The exterior base of the cover is engraved with designs of twenty-eight constellations with a seal mark "*tianfu yongzang*". The 18th year of the Kangxi period corresponded to 1679 A.D.

This inkstone has compact, lustrous, and pure qualities. The colour of the stone is in greenish-purple with rouge halo and scorched-looking patches. It is skilfully carved with creative designs, representing a refined inkstone of the Qing Dynasty, and is recorded in the book *Xiqing Collection of Inkstones*.

Liu Yuan, *zi* Banruan, was a native of Xiangfu (present day Kaifeng, Henan). His years of birth and death were unknown. In the early Kangxi period, he served as Chancellor of the Ministry of Penalty and at the Inner Court. He was noted for drawings and designs, and had participated in designing imperial porcelain ware, imperial inksticks, and others. This is the only extant inkstone with his mark, which is very rare and valuable.

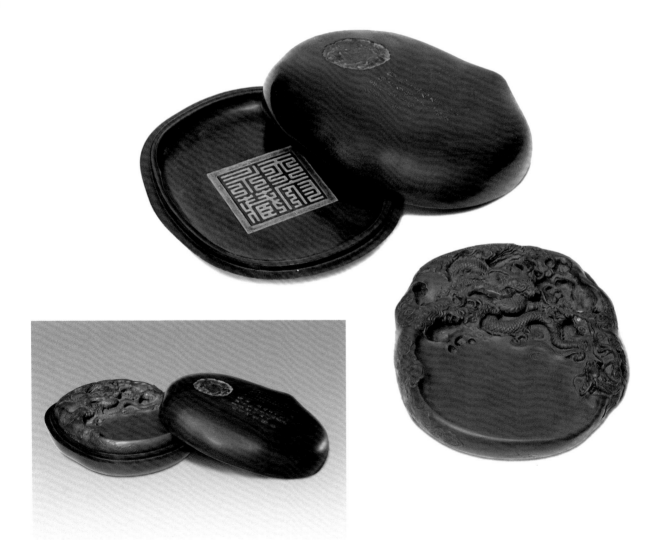

94

Rectangular *songhua* inkstone
with designs of landscapes and figures

Qing Dynasty　Kangxi period

Height 3 cm　　Length 17.3 cm　Width 12.3 cm
Qing court collection

The inkstone is in the shape of a rectangular box and has a fitting cover and body. The inkstone surface and the base of the stone join by creatively utilizing the natural yellow and green markings of the stone. The surface of the cover is carved with landscapes and figures in relief. An elderly man and his attendant are strolling in a landscape setting with a small bridge and stream. The background is decorated with misty distant mountains and birds flying in the sky. The surface is engraved with an inscription "picking chrysanthemums under a bamboo hedge and contemplating the mountains in the south with a tranquil mood" in relief, which was derived from a poem by Tao Yuanming, a literati of the Eastern Jin Dynasty. The back of the inkstone is engraved with a four-character mark of Kangxi (Kangxinian *zhi*) in seal script.

The inkstone is made of stone of superb quality, and the craftsman skilfully utilizes different techniques of carving in low and high relief and openwork to render a lyrical scene of landscapes and figures with clear perspectives and creative design.

Songhua stones are also known as *songhuajiang* stones, *songhua* jade, *dongdi* stones, etc. They are found in the regions of River Songhua in Northeast China. The quality of the stone is hard and lustrous with shiny green colour and beautiful markings, which is comparable to the textures of *duan* stones. As it was found in the region where the Manchus arose to power, the stone had been favoured for use in carving inkstones since the Kangxi period of the Qing Dynasty, and had become one of the popular types of imperial inkstones used by the court.

95

Songhua inkstone
in the shape of conjoined peaches

Qing Dynasty Yongzheng period

Height 1.2 cm Length 13.7 cm Width 8.8 cm
Qing court collection

The inkstone is in the shape of conjoined peaches. Double ink pools are opened on the surface and linked to the water pool. The rim of inkstone is carved with peach branches in relief. The back is recessed for insertion of the hand, and engraved with a four-character mark of Emperor Yongzheng (Yongzhengnian *zhi*).

This inkstone has a fitting box made of yellow *songhua* stones and carved in the shape of conjoined peaches. The surface of the cover is carved with branches and leaves by utilizing the two colours of the stone. The stone is carefully chosen with designs carved in a vivid and naturalistic manner.

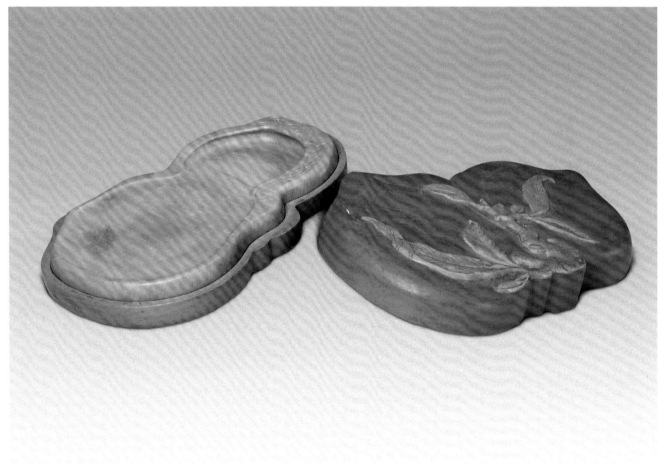

96

Songhua inkstone
carved with a *ruyi* scepter

Qing Dynasty Yongzheng period

Height 1.3 cm Length 11.9 cm
Width 8.2 cm
Qing court collection

The inkstone is rectangular in shape. The upper part of the surface is a slanting water pool which is decorated with a *lingzhi* fungus and a *ruyi* scepter carved in relief. The lower part is a round ink pool. The back is engraved with an inscription which describes "tranquil for use and last forever" in regular script by Emperor Yongzheng and a four-character seal mark of Yongzheng (Yongzhengnian *zhi*). It has a fitting black lacquer box with gilt designs of landscapes.

The quality of this inkstone is compact with charming yellowish-green markings and textures. The black lacquer box with gilt designs of landscapes exudes classical charm and elegance, revealing the typical decorative style in the Yongzheng period, as well as creating colour contrasts with the inkstone, which represents a refined inkstone produced by Imperial Workshops of the court.

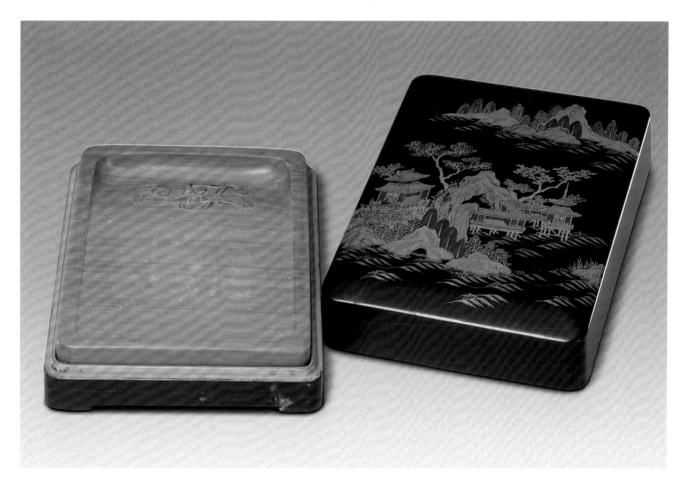

97

Duan inkstone
with designs of twelve emblems of imperial sovereignty

Qing Dynasty　Qianlong period

Height 7 cm
Length 25.8 cm
Width 19.3 cm
Qing court collection

The inkstone is oval in shape. The middle part of it is slightly recessed to form the ink pool and water pool. The exterior rim is engraved with fish and dragons amidst clouds and sea, with a round stone eye to represent a pearl, suggestive of the motif of dragons in pursuit of a pearl. The side of the inkstone is engraved with the twelve emblems of imperial sovereignty. The back is recessed for insertion of the hand, and decorated with thirty-six stone pillars with different heights; among them six have yellowish-green stone eyes. The ground is carved with a scene of the sun rising amidst clouds and from the sea. The rim of the base is engraved in regular script with an imperial poem by Emperor Qianlong with an inscription "inscribed by the Emperor in the mid-summer of *wuxu* year" and a seal mark "*langrun*". The inkstone has a fitting red sandalwood box with designs of two *chi*-dragons inlaid with jade.

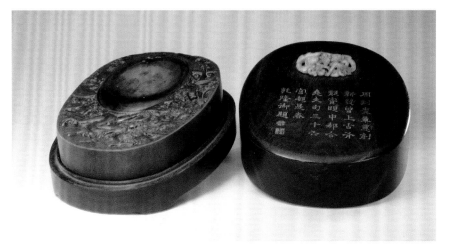

The inkstone is black-brownish in colour and has banana leaf white markings and ink remains. The designs are rendered skilfully and delicately. It was an imperial object collected by Emperor Qianlong and was recorded in the book *Xiqing Collection of Inkstones*.

The motif of twelve emblems of imperial sovereignty comes from the Chapter *Yiji* in the classic *Shangshu*, referring to the sun, moon, constellations, mountains, dragons, pheasants, seaweeds, fire, grains, two goblets, axe-head, and *fu* sign that are attributes of the talents and virtues of the Emperor.

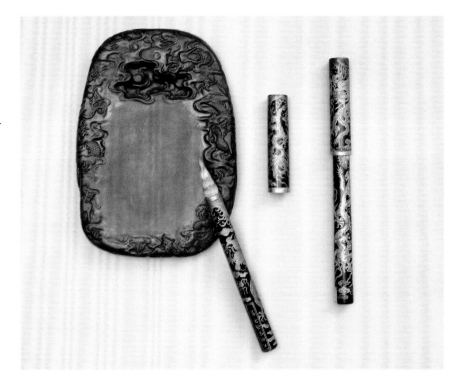

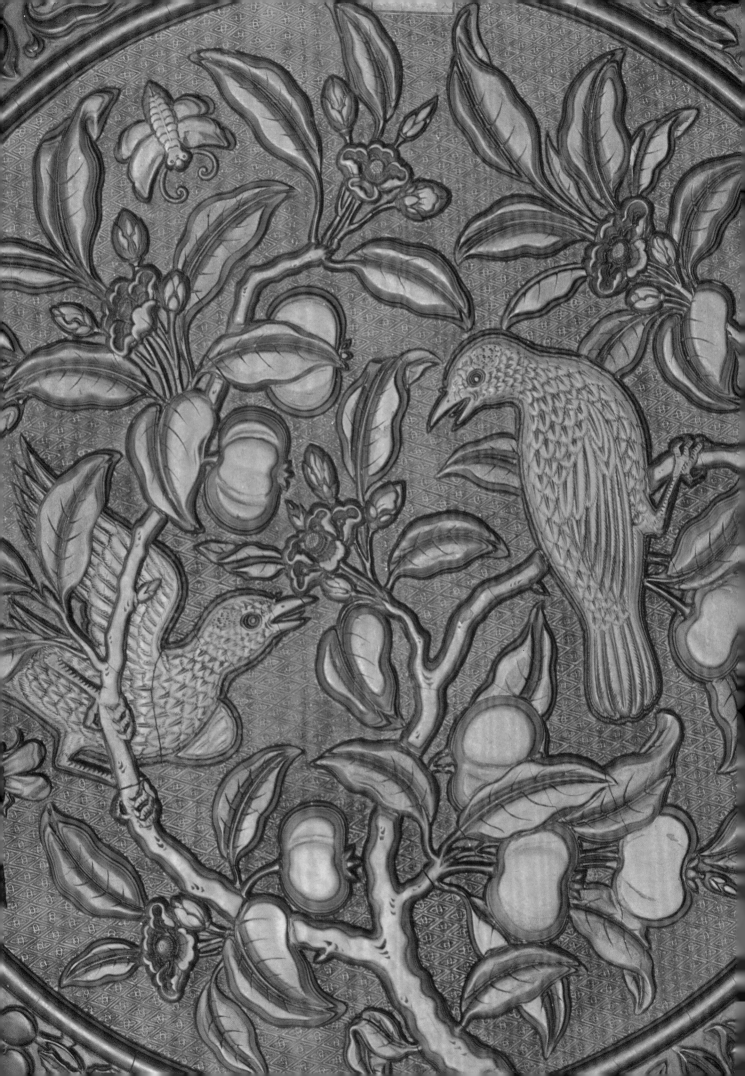

LACQUER, WOOD, AND OTHER CARVINGS

Qin Zithers

Lacquer Ware

Bamboo and Wood Carvings

Ancient Inksticks

98

Qin zither *"Jiuxiao Huanpei"*
(Celestial Tinkle)

Tang Dynasty

Overall Length 124 cm
Width of Forehead 21.8 cm
Width of Tail 15.4 cm
Depth 5.8 cm

Fuxi in style, the zither has a Chinese parasol top and a Chinese fir bottom, both of which have been extensively repaired and coated with red lacquer. The body is layered with aubergine lacquer over a coat of lacquer cement made from antler powders, with cracks resembling "small snake-belly". Oblong in shape, the dragon pond and phoenix pool open onto sound absorbers protruding inside the belly. The *hui*-markers are made of mother-of-pearl, the pegs mahogany, the legs white jade, and the tail red sandalwood. The peg shields are made with red sandalwood, which are not original but added later.

The name of the instrument is inscribed in seal script at the back above the dragon pond as *"Jiuxiao Huanpei"*, or "Celestial Tinkle". Below it is a seal mark *"baohan"* in seal script. Together with a seal mark *"Shimengzhai yin"*, to the right of the dragon pond is an inscription in running script which describes, "A sound rare since antiquity. Collection of Shimengzhai." To the left of the pond and above the feet are inscriptions in running script by Huang Tingjian and Su Shi, but neither are authentic. Above the phoenix pool is a rectangular seal mark *"Santang qinxie"* in seal script, and below is another seal mark *"Chuyuan cang qin"*. The date of making is given in an inscription "produced by Sannian in the year *guichou* of the Kaiyuen period" in regular script carved onto the left of the belly wall. *Kaiyuan* was the reign mark of Emperor Xuanzong of the Tang Dynasty, and the third year of Kaiyuan should be *yimao* instread; therefore, it is plainly a fake in view of the incongruity between the reign year and the Chinese calendar year.

The present example is one of the masterpieces produced by the *Lei* family in Sichuan that boasts nine expert makers spanning three generations.

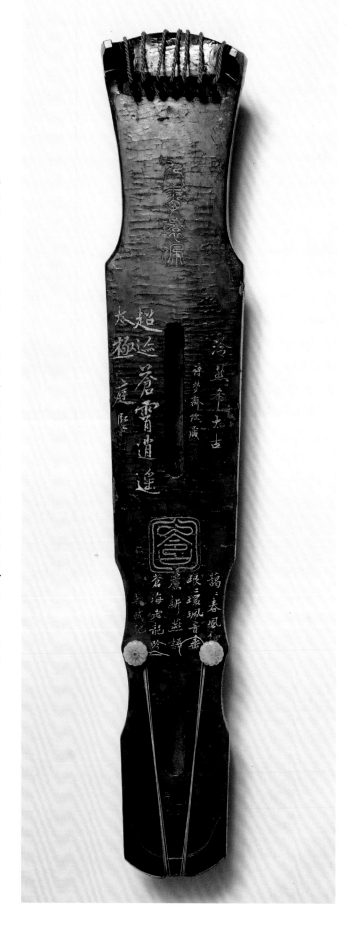

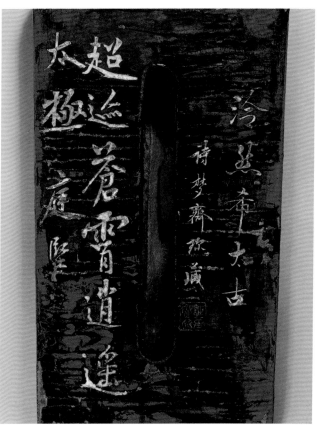

99

Qin zither *"Dasheng Yiyin"*
(Sages' Voice)

Tang Dynasty

Overall Length 120.3 cm
Width of Forehead 19.2 cm
Width of Tail 13.5 cm Depth 5.2 cm
Qing court collection

Shennong in style, the zither is made of Chinese parasol and lacquered entirely in black. Where the lacquer has worn off to expose the maroon body and sometimes the lacquer cement made of antler powder, red lacquer is layered for repair. The cracks resemble either "snake-belly" or "bovine-fur". The dragon pond is round in shape and the phoenix pool oblong. The *hui*-markers are in gold, the pegs jade, and other fittings red sandalwood. Flanking silk yellow tassels, the peg shields are original.

The name of the instrument is inscribed in running script at the back above the dragon pond as *"Dasheng Yiyin"*, or "Sages' Voice". Below it is a seal mark *"baohan"* in seal script. Each side of the pond is flanked by engraved inscriptions which describes "Autumn comes to the myriad ravines, moonlight shines on the cold river" and "Sounds in the universe are being heard, and a lonely phoenix wood cracks in the wind" in clerical script in gilt. At the four corners of the dragon pond inside the belly are cinnabar lacquer inscriptions *"zhide binshen"* written in four characters in clerical script respectively on each of the corners. The year *bingshen* of the Zhide period corresponded to the first year of Emperor Suzong of the Tang Dynasty (756 A.D.).

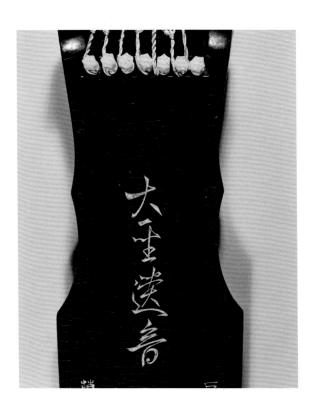

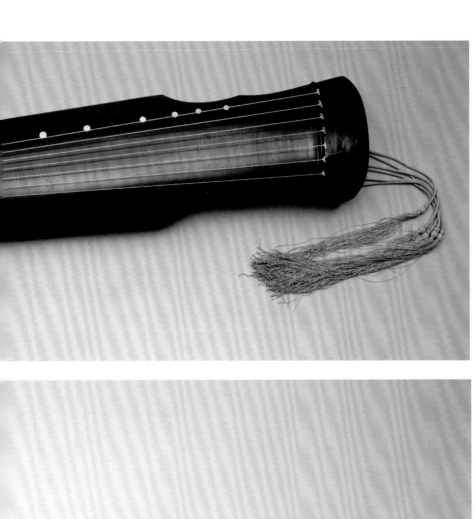

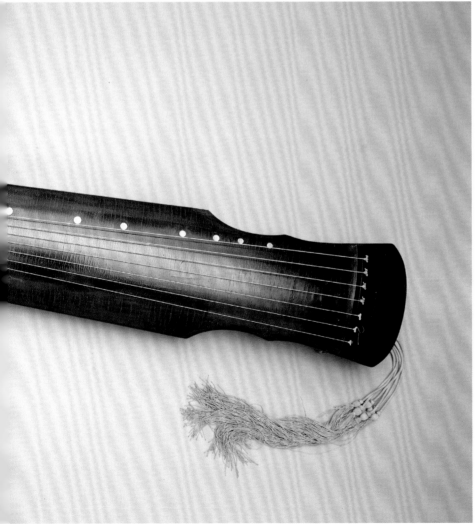

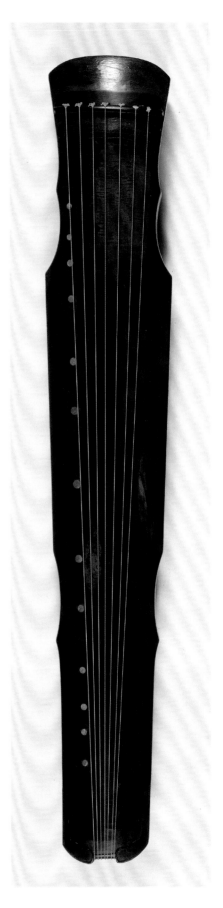

100

Qin zither *"Qinglai"*
(Pristine Lilt)

Southern Song Dynasty

Overall Length 121.2 cm
Width of Forehead 17.6 cm
Width of Tail 13 cm Depth 5.2 cm
Qing court collection

Zhongni in style and with cracks resembling "ice crackles", the zither is made of Chinese parasol and is lacquered entirely in black over a coat of lacquer cement made of antler powder. Both the dragon pond and the phoenix pool are rectangular in shape. The *hui*-markers are made of gold, the pegs white jade, and other fittings red sandalwood.

The name of the instrument is inscribed in seal script at the back above the dragon pond as "*Qinglai*", or "Pristine Lilt". Below it is a square seal mark "*Qianlong yushang*" (appreciated by Emperor Qianlong) of Emperor Qianlong's in cinnabar lacquer. Authored by poet-officials of the Qianlong period including Liang Shizheng, Li Zongwan, Chen Bangyan, Dong Bangda, Wang Youdun, Zhang Ruoai, Qiu Yuexiu, variegated eulogies to the zither fill the spaces from the dragon pond down to the feet. On the inside to the right of the pond is the engraved maker's name, or Yan Gongyuan, in regular script.

Known by various names such as *yao* zither, jade zither, or silk parasol in China, and dating back more than three millennia, the *qin* zither is a traditional Chinese string instrument serving recreational, ritual, and tuning purposes and, to the literati, is a symbol of lofty cultivation. The earliest zither had only five strings, the number of which increased to seven during the Han Dynasty and has remained unchanged ever since. On its body are 13 *hui*-markers to denote the positions of various harmonics. As for styles, there are fourteen types including Fuxi, Shennong, Zhongni, Lianzhu, Jiaoye, Shi Kuang, and so on.

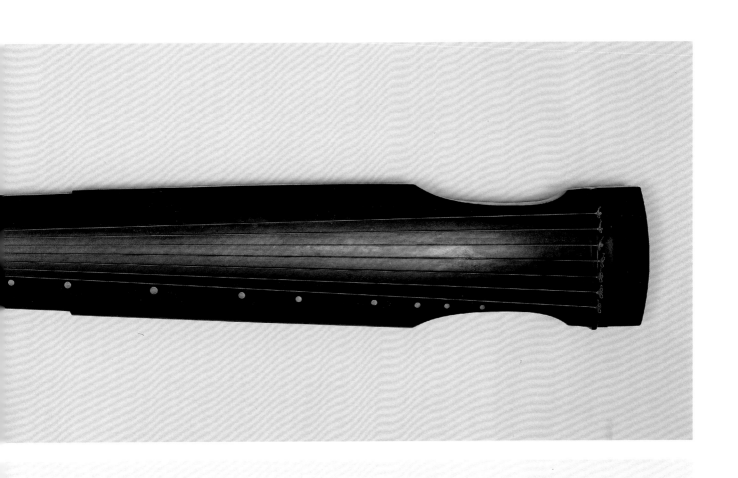

101

Octagonal cinnabar lacquer tray

with carved designs of pavilions and figures

Yang Mao

Yuan Dynasty

Height 2.6 cm
Diameter of Mouth 17.8 cm
Qing court collection

The octagonal tray has a ring foot with its shape identical to the tray. The interior centre is carved in relief with a pavilion, beside which are pine trees with an elderly man standing near the zigzag railing and contemplating the waterfall in front of a mountain. At his back and inside the pavilion is an attendant respectively. The plain interior and exterior walls are layered with yellow lacquer as the ground, on which are carved designs of flowers of the four seasons including camellias, peonies, gardenias, and peach blossoms. The base is layered with black lacquer, and on the upper side is an engraved six-character mark of the Xuande period of the Ming Dynasty (Daming Xuandenian *zhi*) filled with gold pigment in regular script, which was added later. A needle-incised mark "Yang Mao *zao*" (made by Yang Mao) in the typical style of Yang Mao's mark is hidden and barely visible at the left side of the foot.

This tray is an extant refined lacquer object produced by Yang Mao with a tidy form, consummate pictorial treatment, and skilfully rendered decorative designs. Though the figures are depicted in silhouette, their transcending and free characters are fully illustrated.

Carved lacquer ware is produced by layering the wooden or metal body with lacquer first, and then decorative designs would be carved on the lacquered surface. In accordance with the different colours of lacquer, there are carved cinnabar, carved yellow, carved black, and carved colour lacquer ware. Yang Mao's years of birth and death were unknown. He was a famous lacquer carver in the Yuan Dynasty and a native of Xitang, Jiaxing. Only three pieces of ware carved by him are extant in the Mainland, and two of them are in the collection of the Palace Museum.

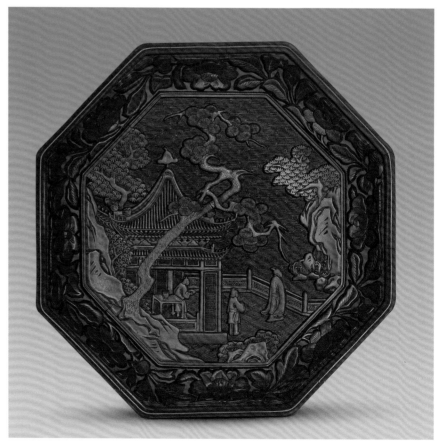

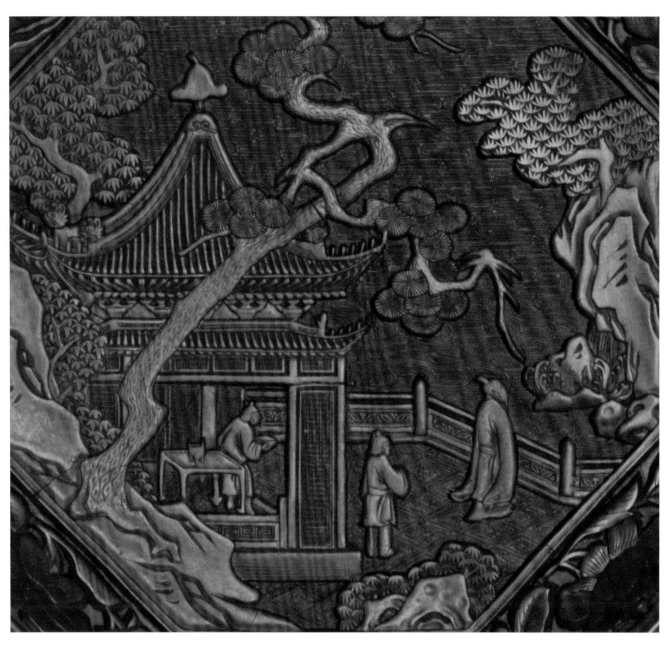

102

Cinnabar *zun* spittoon
with carved floral designs

Yang Mao

Yuan Dynasty

Height 9.5 cm
Diameter of Mouth 12.8 cm
Qing court collection

The *zun* spittoon has a flared mouth, a short neck, a globular belly, and a ring foot. The plain body is layered with yellow lacquer as the ground, on which are carved cinnabar lacquer floral designs. The interior wall of the mouth is carved with four peach blossoms. The neck outside the mouth is carved with one gardenia, one chrysanthemum, and two peach blossoms. The belly is carved with gardenias, camellias, peach blossoms, and peonies. The plain foot has a recessed line border. The interior and exterior bases of the spittoon are layered with black lacquer. The left side of the exterior base has a needle-incised vertical mark "Yang Mao *zao*" (made by Yang Mao).

The spittoon is carved in a thick and stern form with fluent linear configuration and accurate proportion. The colour of lacquer is dense with spacious treatment of flower designs rendered skilfully. It represents a refined extant lacquer object made by Yang Mao.

"Plain ground in yellow lacquer" was a technique that the ware was layered with yellow lacquer first and then with cinnabar lacquer, on which decorative designs were carved. This technique represented a distinctive decorative style on works with designs of large flowers produced from the Yuan to the early Ming period. It was described as "on ware without a brocade ground, the yellow ground would be applied to simulate a brocade ground" in the book *Digest of Traditional Lacquer (Xiushilu)* compiled in the Ming Dynasty.

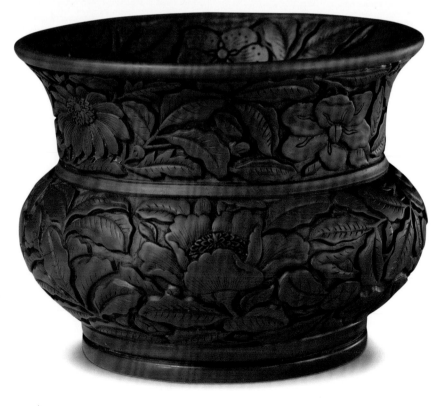

103

Round cinnabar lacquer dish
with carved designs of gardenias

Zhang Cheng

Yuan Dynasty

Height 2.6 cm
Diameter of Mouth 16.7 cm
Qing court collection

This round dish has a curved wall and a low ring foot. The interior and exterior are layered with yellow lacquer as the ground, on which are carved cinnabar lacquer floral designs. The interior wall is carved with a fully blooming gardenia spray with four buds, and foliaged branches and leaves are rendered in relief in a rich manner. The exterior wall is carved with foliage scrolls in relief. The base is layered with brownish- red lacquer. On the left side is a needle- incised vertical mark "Zhang Cheng *zao*" (made by Zhang Cheng).

This lacquer dish is thickly layered with cinnabar lacquer of around 0.4 cm in thickness, and the colour is shiny and in bright red. It is embellished by skilfully carved designs and fine polishing, which fully illustrates the distinctive style of lacquer ware made by Zhang Cheng.

The years of birth and death of Zhang Cheng were unknown. He was a native of Xitang, Jiaxing, and a famous lacquer carver of the Yuan Dynasty. Only three pieces of works by him are now extant in the Mainland, and this is one of them.

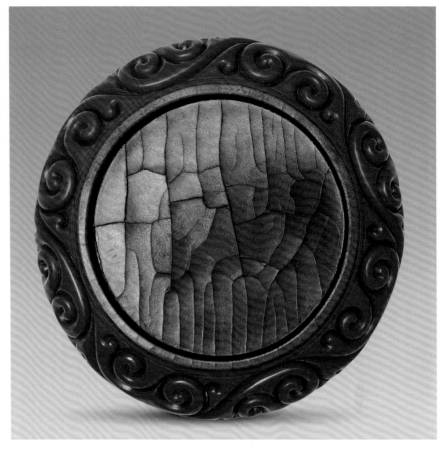

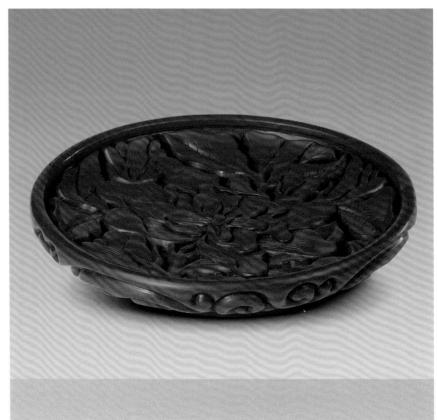

104

Round cinnabar lacquer box
with carved designs of a mansion-pavilion and figures

Zhang Minde

Yuan Dynasty

Height 6.9 cm
Diameter of Mouth 21.5 cm
Qing court collection

The round box has a flat top, a straight wall, and a recessed base. The body is carved with designs in cinnabar lacquer in relief. The surface of the cover is decorated with narrow key-fret patterns and floral squares as brocade grounds to suggest heaven and earth. On top of the grounds is a carved design of a large mansion-pavilion with railings to enclose the courtyard. In the courtyard there are two elderly men chating and contemplating flowers in front of rocks. Inside the mansion-pavilion are two attendants preparing meals, and behind the mansion-pavilion are bamboo groves. The plain exterior wall is layered with yellow lacquer as the ground, on which are carved cinnabar lacquer designs of gardenias, camellias, chrysanthemums, peach blossoms, and other flowers in relief. The interior wall, cover, and base are layered with black lacquer. At the left side of the cover's interior is a needle-incised vertical mark "Zhang Minde *zao*" (made by Zhang Minde).

The box is skilfully decorated in a rich and consummate manner with the pictorial elements rendered realistically, resembling a *gongbi* (fine line) painting. The style of the incised mark and decorations closely followed the style of Zhang Cheng.

Zhang Minde was a noted lacquer carver of the Yuan Dynasty, and his biography was unknown. This box is the only extant lacquer object made by him ever known.

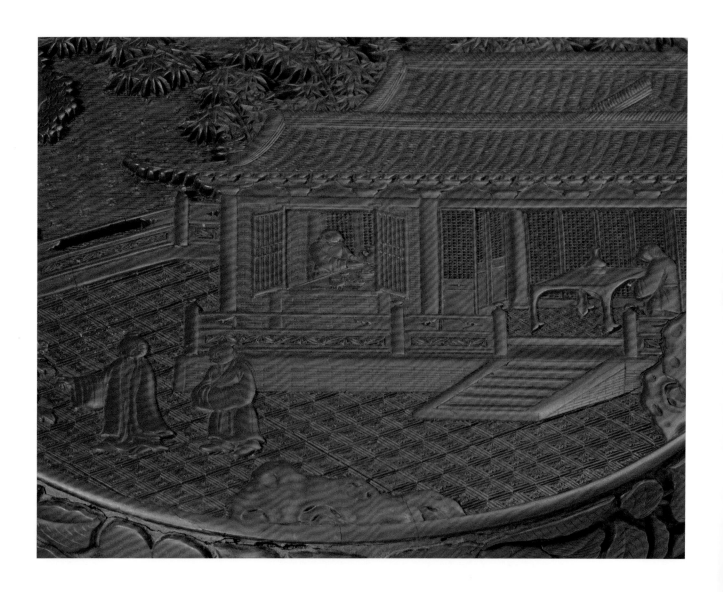

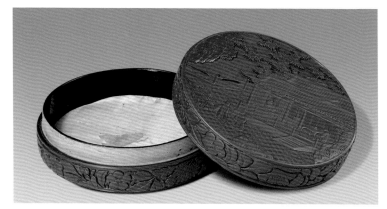

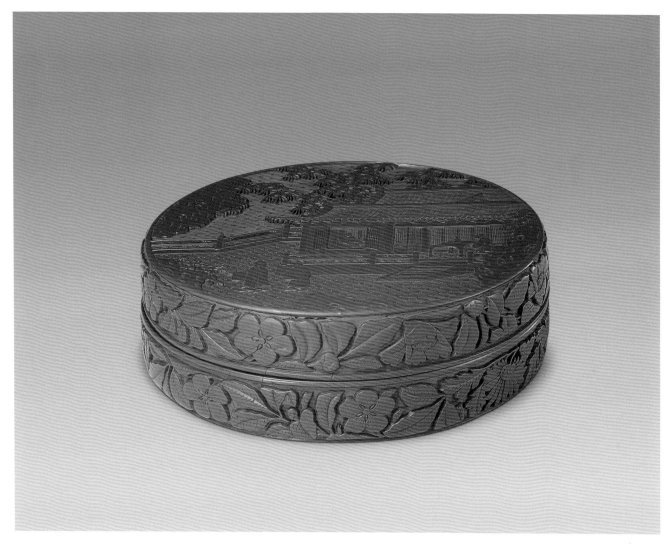

105

Round cinnabar lacquer dish
with carved designs of narcissuses

Yuan Dynasty

Height 3.4 cm
Diameter of Mouth 21 cm
Qing court collection

The round dish has a curved wall and a low ring foot. The plain interior and exterior are layered with yellow lacquer as the ground, on which are carved cinnabar lacquer designs in relief. The interior is carved with narcissuses in relief, and the exterior wall is carved with foliage scrolls in relief. The base is layered with black lacquer with an engraved four-character mark of Qianlong (Qianlongnian *zhi*) in regular script filled with gold pigment, which was added later.

The pictorial treatment of this dish is creative with flowers and leaves swirling around neatly. The carving is round and smooth. Dishes and boxes with flowers and birds as decorative motifs and with the exterior wall decorated with foliage scrolls reveal the typical decorative style in the Yuan Dynasty. However, the base was layered with shiny and glaring black lacquer later in the Qianlong period of the Qing Dynasty.

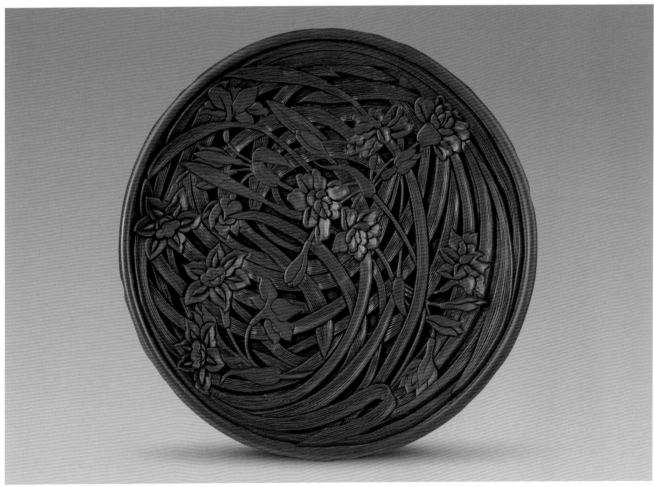

106

Round cinnabar lacquer box
with carved designs of peonies and paradise flycatchers

Yuan Dynasty

Height 12 cm
Diameter of Mouth 46 cm
Qing court collection

The round box has a flat cover, a straight wall, and a recessed base. The plain body is layered with yellow lacquer as the ground, on which are carved cinnabar lacquer designs in relief. The surface of the cover is carved with a scene of peonies and paradise flycatchers. Two long tail paradise flycatchers are flying amidst clusters of peonies. The Chinese pronunciation of paradise flycatchers carries the auspicious blessing of longevity whereas peonies carry the blessing of wealth; thus the combination of these motifs has the blessing of "wealth and long life". The exterior wall of the box is carved with foliage scrolls in relief. The interior and base of the box are layered with black lacquer.

The size of this box is rather large, and it is the largest Yuan cinnabar lacquer ware known. The interior and base were re-coated with lacquer layers in the Qing Dynasty.

107

Round cinnabar lacquer dish
with carved designs of waterside pavilions and figures

Yuan Dynasty

Height 3.2 cm
Diameter of Mouth 17.6 cm
Qing court collection

The round dish has a metal body, a curved wall, and a ring foot. The rim of the dish has four line borders in relief. The interior is carved with three types of brocade grounds representing heaven, earth, and water. On the ground are carved designs of three layers of waterside pavilions and halls in relief. In the courtyard, two children are playing the game of finger guessing. In the waterside pavilion, an elderly man is sitting and watching them playing, and in the upper rear hall, a lady is leaning on the railing and watching. Behind each of them is an attendant holding a plate to serve respectively. Around the waterside

pavilion and halls are willow trees, banana trees, and two swallows flying in the sky. The exterior wall is carved with striated carved lacquer (*tixi*) designs of foliage scrolls. The base is layered with black lacquer, and at the upper middle side is a four-character mark of the Xuande period of the Ming Dynasty (Xuandenian *zhi*) in regular script filled with gold pigment, which was added later.

The decorations on this dish are rendered in four layers with clear perspective treatment and dimensionality. An interesting point to note is that at the middle of the dish's base is a small drilled hole. It was guessed that people in the court had felt that the dish was too heavy and doubted if it was made with gold, and thus drilled a hole for examination.

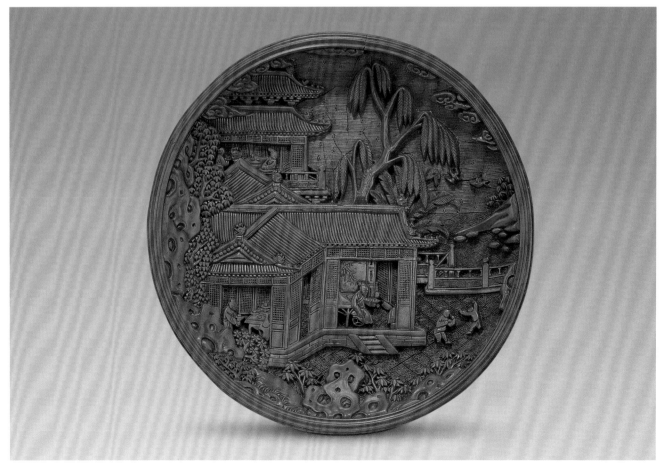

108

Round lacquer dish
with striated carved lacquer
(*tixi*) designs of
cloud patterns

Yuan Dynasty

Height 3 cm
Diameter of Mouth 19.6 cm
Qing court collection

The round dish has a curved wall and a low ring foot. The surface is layered with black lacquer, and the interior and exterior are carved with *ruyi* cloud patterns in relief. The base was re-coated with black lacquer. At the centre is a four-character mark of the Qianlong period of the Qing Dynasty (Qianlongnian *zhi*) in regular script filled with gold pigment, which was carved later during the same time of lacquer re-layering.

The dish is thickly layered with shiny black lacquer and carved roundly and smoothly. Four layers of red lacquer are exposed at the deep cutting edges, as described in the *Digest of Traditional Lacquer* as "interspersed red and black line layers". The colour of lacquer and cutting techniques of this dish are very close to the box with striated carved lacquer (*tixi*) cloud patterns made by Zhang Cheng. However, unfortunately the original mark was hidden during the process of lacquer re-layering in the Qing Dynasty.

Striated carved lacquer (*tixi*) is also known as "cloud carving". The production technique is to layer the body of ware with two or three types of lacquer in different colours, and each layer comprises several coats of lacquer for piling up to the designated thickness. Then the carver would carve various designs such as cloud or key-fret patterns and expose the designated coloured layer at the cutting edges of the designs.

163

109

Black lacquer boat-shaped washer
with designs of flowers and birds inlaid with mother-of-pearl

Yuan Dynasty

Height 7.8 cm Length 38.5 cm Width 21.7 cm
Qing court collection

The oval washer has a leather body and a flat base with its shape like a boat. Inside the washer, a vertical panel separates the body into two compartments. The body is layered with black lacquer and decorated with designs inlaid with thin flakes of mother-of-pearl. The interior base has oval panels in which are designs of pomegranate flower sprays. The interior wall is decorated with lotuses and egrets, suggestive of the auspicious blessing "wealth and prosperity come all along". The interior and exterior rims are separately decorated with *lingzhi* fungus scrolls and continuous border of double-square key-fret patterns. The exterior wall is decorated with pomegranate flower sprays, and the base is decorated with camellia sprays.

The washer is thinly modeled with the designs inlaid with thin and neat strips and flakes of mother-of-pearl. In particular, the feathers of the egrets are rendered in an extremely meticulous manner, revealing the high technical competence of the carver. Extant lacquer ware with inlaid mother-of-pearl designs of the Yuan Dynasty is extremely rare, and only two pieces remaining intact are known in the Mainland. Both have been collected by the Palace Museum, and this is one of them, representing an extant treasured lacquer object with inlaid mother-of-pearl designs of the Yuan Dynasty.

Lacquer ware with mother-of-pearl designs is a kind of craft by combining lacquer layering and mother-of-pearl inlaying techniques. Mother-of-pearl comes from the best parts with natural colour and beautiful glare from shells. After peeling and polishing, mother-of-pearl would be inlaid on a lacquer object in accordance with the designated decorations and embellishments. There are thin and thick flakes of mother-of-pearl and thus came the terms "thick mother-of-pearl" and "thin mother-of-pearl".

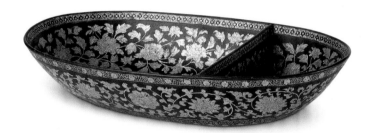

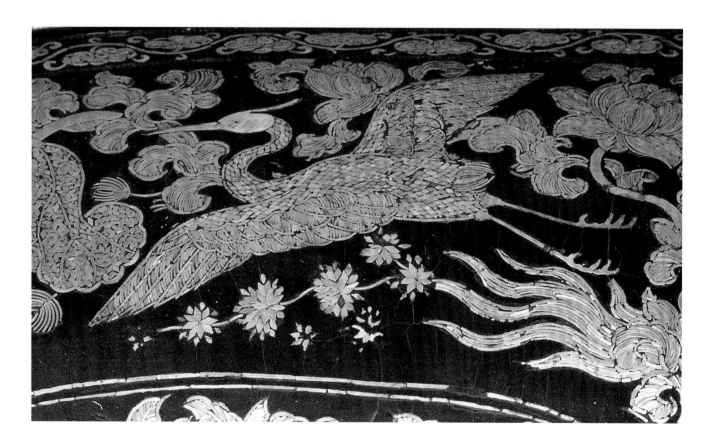

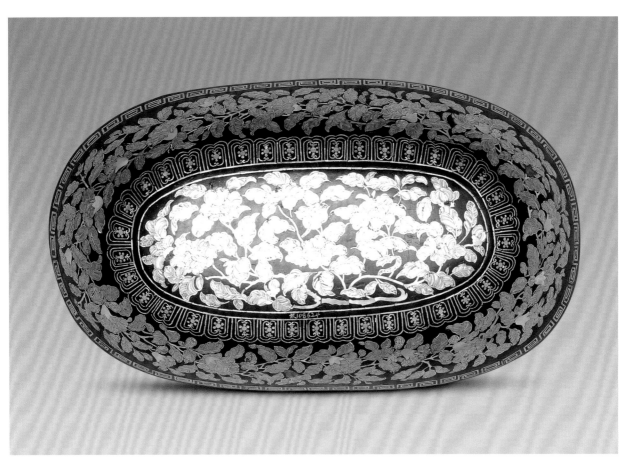

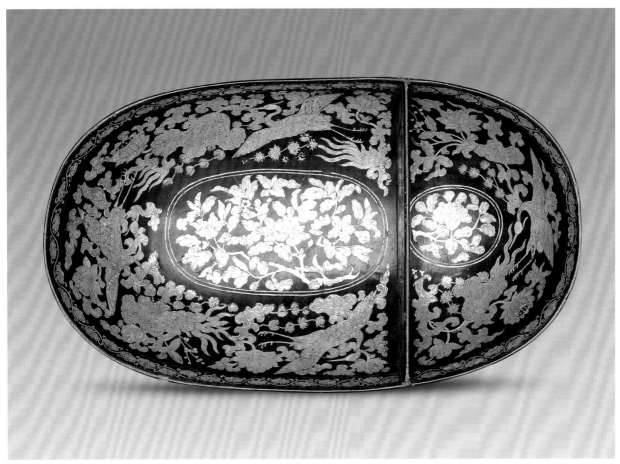

110

Round cinnabar lacquer dish
with carved designs of peonies and peacocks

Ming Dynasty Yongle period

Height 5.8 cm
Diameter of Mouth 44.5 cm
Qing court collection

The round dish has a curved wall and a low ring foot. The plain interior is layered with yellow lacquer as the ground, on which are carved designs of peonies and peacocks layered with cinnabar lacquer in relief. Two peacocks are flying amidst peonies. The plain exterior wall is lacquered with yellow lacquer as the ground, on which are carved designs of peony scrolls layered with cinnabar lacquer in relief. The base is layered with brownish-red lacquer with a needle-incised six-character mark of Yongle (Daming Yonglenian *zhi*).

This dish is exquisitely decorated and skilfully carved with a touch of extravagance. The veins of flowers and leaves and feathers of the birds are carved in a meticulous and delicate manner, exuding a sharp aesthetic contrast with the thick and round flowers. The tail feathers are carved like layers of protruding scales with a strong sense of dimensionality. This lacquer dish represents a refined lacquer object of the Yongle period, Ming Dynasty.

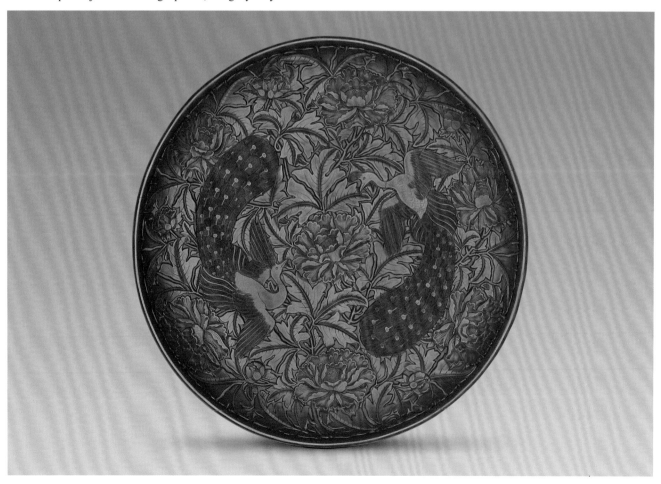

111

Oval cinnabar lacquer dish
with carved designs of grapes

Ming Dynasty Yongle period

Height 3.1 cm
Diameter of Mouth 27 x 18.5 cm
Qing court collection

The oval dish has a curved wall and a ring foot. At the rim of the dish are five ridges in relief. The plain interior is layered with yellow lacquer as the ground, on which are carved designs of large grapes in high relief. The exterior wall is decorated with striated carved (*tixi*) designs of foliage scrolls. The base is layered with black lacquer with an engraved six-character mark of the Xuande period of the Ming Dynasty (Daming Xuandenian *zhi*) filled with gold pigment, and beneath is a hidden original needle-incised six-character mark of the Yongle period of the Ming Dynasty (Daming Yonglenian *zhi*), which is barely visible.

The design of grape is carved with an extraordinary height of around 1.5 cm in relief with a strong sense of dimensionality, which has never been seen before. It represents the refined lacquer ware produced at the official lacquer ware workshops at Guoyuanchang in the early Ming period, and fully reflects the superb workmanship and style of producing lacquer ware at the time. In the Xuande period, Ming Dynasty, there was a practice of modifying or even hiding the marks of former dynasties on lacquer ware. In the book *Scenery and Events in the Capital* compiled by Liu Tong in the late Ming period, it was described that "in the period (of Xuanzong), the quality of ware produced by the Official Workshops had declined, and craftsmen were often punished. As a result, they acquired ware such as dishes and boxes from the collection of the court with their own money and added marks on it for sending to the court as tributary objects. Therefore, all ware with marks of the Xuande period was in fact ware of the Yongle period". Although this statement might not be definitive, it reflected such a practice had existed at the time.

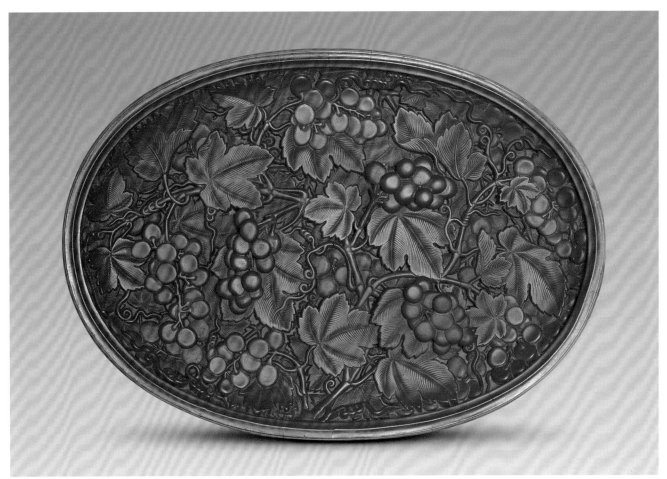

112

Cinnabar tea-bowl stand
in the shape of a holly hock with carved
designs of phoenixes amidst clouds

Ming Dynasty Yongle period

Height 9 cm
Diameter of Mouth 9.7 cm Diameter of Bowl 16.9 cm
Qing court collection

The tea-bowl stand comprises of three parts: a round bowl, a plate in the shape of a
holly-hock, and a flaring high ring foot. The plain body is layered with yellow lacquer as
the ground, on which are carved designs in cinnabar lacquer in relief. The exterior wall
and interior centre of the bowl are carved with two phoenixes flying amidst clouds in relief
respectively. The exterior wall of the plate and the wall of the foot are carved with cloud
patterns in relief. The interior of the stand is hollow and layered with brownish-red lacquer.
The right side of the foot's base has a needle-incised six-character mark of Yongle (Daming
Yonglenian *zhi*).

Lacquer tea-bowl stands were already produced in the Song Dynasty but, most of them
were plain lacquer ware. This tea-bowl stand was a refined piece of lacquer ware produced
at the Official Workshops at Guoyuanchang in the Yongle period. Most of the marks on
Yongle lacquer ware were found on the left side, and this was the only piece with the reign
mark incised on the right side.

113

Round cinnabar lacquer dish
with carved designs of peonies

Ming Dynasty　Yongle period

Height 3.3 cm
Diameter of Mouth 21.2 cm
Qing court collection

The round plate has its plain interior and exterior layered with yellow lacquer as the ground, on which are carved designs in cinnabar lacquer in relief. The centre of the dish is carved with five peonies interspersed by four buds in relief. The exterior wall is carved with six peony sprays in relief. The base is layered with brownish-red lacquer with an engraved six-character mark of the Xuande period of the Ming Dynasty (Daming Xuandenian *zhi*) filled with gold pigment in regular script, which was added later, and with the original needle-incised six-character mark of the Yongle period (Daming Yonglenian *zhi*) barely visible beneath.

Most of the lacquer ware with designs of flowers in the Yongle and Xuande periods of the Ming Dynasty was characterized by designs of several large fully blooming flowers with buds around. The flowers were often rendered in single numbers such as three, five, or seven flowers. The ware was all layered with yellow lacquer as the ground without the use of a brocade ground. As the lacquer layers were thick, these objects exuded a sense of luxuriance and elegance with a distinctive aesthetic effect that they looked like their counterparts in the Yuan Dynasty but surpassed them.

114

Round cinnabar lacquer box
with carved designs of treating plum blossoms as the wife and cranes as the son

Ming Dynasty Yongle period

Height 8.1 cm
Diameter of Mouth 26.5 cm
Qing court collection

The round box is in the shape of a sugar cane stem with the body layered with cinnaber lacquer. The surface of the cover is carved with three types of brocade ground patterns to represent the heaven, water, and earth. On the left and right are carved decorations with water-pavilions and palaces with an elderly man wearing a turban sitting inside a water-pavilion. In the courtyard, an attendant is holding a pot of plum blossoms, and he is followed by another attendant carrying a *qin* zither, and accompanied by a crane. Pines, plum blossoms, and rocks are carved around. The whole scene represents the story of "treating plum blossoms as the wife and cranes as the son". The plain wall of the box is layered with yellow lacquer as the ground on which are designs of chrysanthemums, camellias, peonies, lotuses, Chinese roses, and other flowers carved in relief. Inside the cover is an imperial poem by Emperor Qianlong with an inscription "imperial inscribed in the year *renyin* in the Qianglong period" and a seal mark "*Qianlong chenhan*". The right side of the base is needle-incised with a six-character mark of Yongle (Daming Yonglenian *zhi*).

Ware in the shape of a sugar cane stem was a typical form of lacquer ware produced at the Guoyuanchang Workshops in the Yongle and Xuande periods. It had characteristics of a round shape, a flat top, a straight wall, a low recessed foot or without foot. The story of "treating plum blossoms as the wife and cranes as the son" referred to the legend that Lin Bu (968 – 1028 A.D.) retreated to hermitage at Gushan at the West Lake, Hangzhou for twenty years. He had neither wife nor son, and thus he kept cranes and planted plum blossom trees for self-amusement. As a result, people attributed that he treated plum blossoms as his wife and cranes as his son.

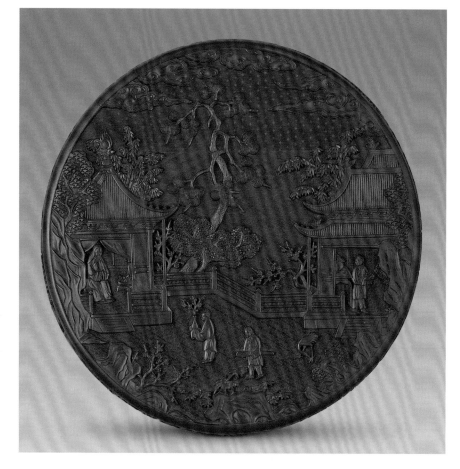

松下曲欄遮孤亭
静且嘉風情敲竹
葉春信遍梅花鶴
豈烹茶避琴非掛
劈斜有僅三兩侍
不認是林家
乾隆壬寅御題

115

Round cinnabar lacquer box
with carved designs of a dragon amidst clouds

Ming Dynasty Yongle period

Height 6.5 cm
Diameter of Mouth 18.6 cm
Qing court collection

The box is in the shape of a sugar cane stem. The exterior plain wall is layered with yellow lacquer as the ground and carved with designs in cinnabar lacquer in relief. The surface of the cover is decorated with lozenge brocade ground, on which are carved designs of a dragon in pursuit of a flaming pearl in relief. The wall of the box is carved with cloud patterns in relief. The interior and base are layered with brownish-red lacquer. The left side of the base is engraved with a six-character mark of Xuande (Daming Xuandenian *zhi*) in regular script filled with gold pigment, which was added later. Beneath is a hidden needle-incised mark of the Yongle period, which is barely visible.

The round and thick carved designs, the colour of lacquer, and the distinctive features of the dragon amidst clouds design characterize this piece as a refined piece of lacquer ware of the Yongle period.

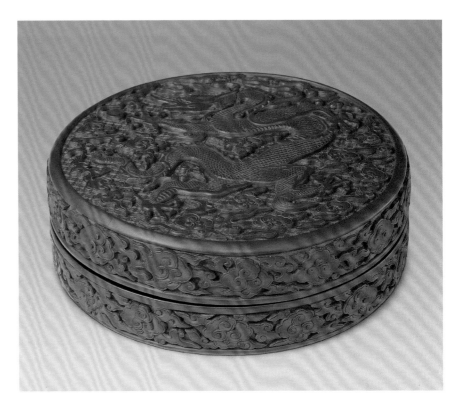

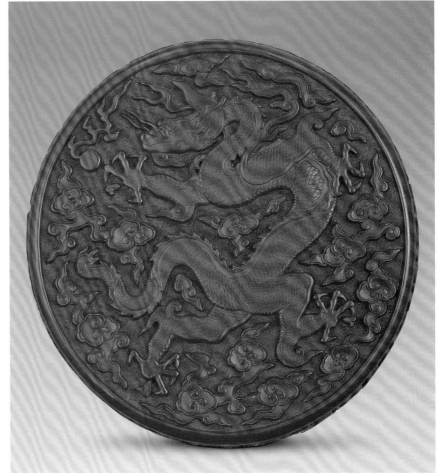

116

Round multi-colour lacquer carrying box
with carved designs of two orioles and an apple tree

Ming Dynasty Xuande period

Height 19.8 cm
Diameter of Mouth 44 cm
Qing court collection

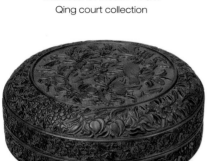

The round box slims to the flat top and has a ring foot and a flat base. The body is layered with cinnabar, green, yellow, and black lacquer alternatively and carved with designs in relief in thirteen layers. The cinnabar lacquer brocade ground with slanting squares on the surface of the cover is carved with an apple tree with abundant fruits and two orioles resting on tree branches, interspersed by dragonflies and butterflies. The side of the cover and the area near the foot are carved with peaches, pomegranates, grapes, and cherries in relief. The vertical wall is carved with sprays of peony, lotus, and other flowers in relief. The interior and base are layered with cinnabar lacquer. Inside the rectangular frame on the surface of the cover is an engraved six-character mark of Xuande (Daming Xuandenian *zhi*) in regular script filled with gold pigment.

Multi-colour lacquer is also known as carved colour lacquer. The technique in producing mutli-colour lacquer ware is to coat the body with different coloured lacquer layers, and then to carve designs to the designated colour layers for exposing the colours according to the desired aesthetic requirements to achieve extravagant colour designs. This is the earliest multi-colour carved lacquer ware found and the only extant piece of the Xuande period, Ming Dynasty. The decorative designs are rendered in an elegant manner with a brilliant colour scheme and fine polishing, representing a valuable piece of work of its type with high artistic merit.

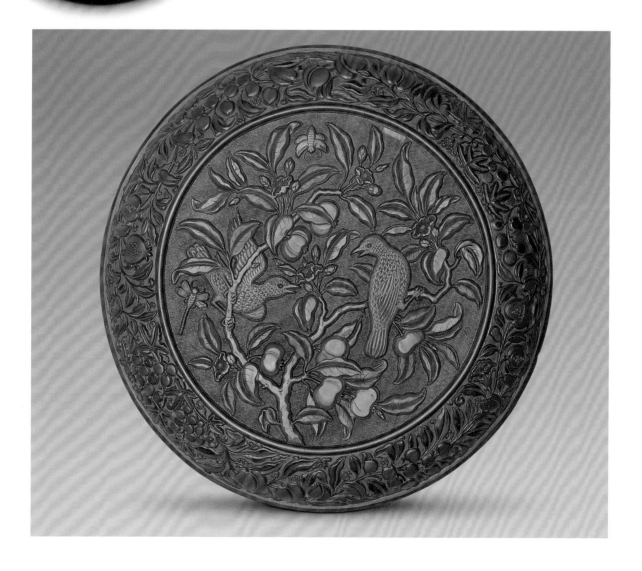

117

Round cinnabar lacquer box
with carved designs of nine dragons

Ming Dynasty Xuande period

Height 12.2 cm
Diameter of Mouth 38.9 cm
Qing court collection

The box is the shape of a sugar cane stem. In the panel in the shape of a caltrop flower on the cover is the carved design of a dragon in pursuit of a flaming pearl in relief. Outside the panel are designs of twelve lotus scrolls carved in relief. The wall of the box has eight panels, and inside each of them is carved with a swimming dragon accompanied by auspicious clouds. With the dragon on the cover, a collective design of "nine dragons" is created. Outside the panels are designs of lotus sprays carved in relief. Inside the cover is an imperial poem by Emperor Qianlong of the Qing Dynasty engraved and filled with gold pigment, with an inscription "inscribed in the year *wushu* of the Qianlong period" and two square seal marks "*qian*" and "*long*". The base is re-coated with black lacquer in the Qing Dynasty, and has an engraved six-character mark of the Xuande period of the Ming Dynasty (Daming Xuandenian *zhi*) in regular script filled with gold pigment, which was imitated in the Qing Dynasty. The original mark of the Xuande period is still visible at the upper part of this mark.

The cinnabar lacquer on this ware is brilliant, and the carved designs are rendered sharply, the style of which is different from that of the former periods. "Nine" was regarded as the largest numeral in ancient times, which carried auspicious tributes. Dragons were the symbol of imperial sovereignty. Design with the combination of "nine" and dragons was only confined to the exclusive use by the Emperor.

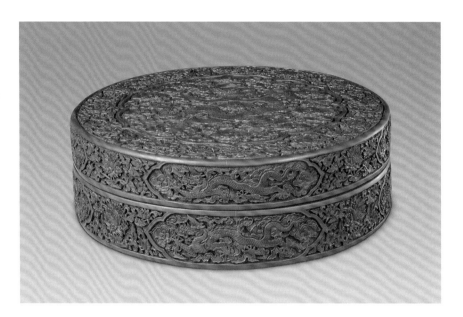

乾　各　赭　類　見　永
隆　蝦　雕　肯　之　樂
戊　略　紋　堂　原　創
戌　粉　細　爲　從　朱
御　本　入　著　果　漆
題　所　絲　色　園　文
　　翁　九　層　製　孫
　　貽　龍　披　亦　應

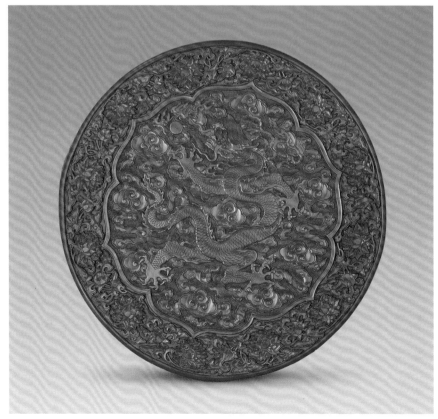

118

Oval engraved gold (*qiang jin*) coloured lacquer box
with designs of peonies

Ming Dynasty Xuande period

Height 7 cm
Diameter of Mouth 18.1 x 13 cm
Qing court collection

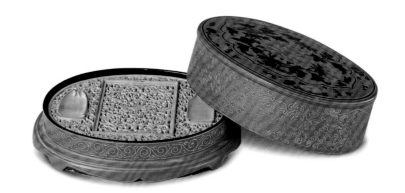

The fitting box with upper and lower sections has a floral rim with ivory strips and four hanging legs. The body is decorated with designs filled with red, yellow, green, and aubergine lacquer. Inside the designs are engraved gold decorations. At the panel in the shape of a caltrop flower on the surface of the cover are ball-shaped brocade patterns with swastikas (卍) engraved and filled with lacquer as the ground. On the ground is the design of peony sprays. Outside the panel is a tortoise-shell brocade ground, on which are *lingzhi* fungi, suggestive of the auspicious meaning of "wealth and good luck". The wall of the cover is decorated with engraved gold peony scrolls. The wall of the box was repaired later, and decorated with engraved gold foliage scrolls. On the rim at the side of the cover is an engraved six-character mark of Xuande (Daming Xuandenian *zao*) in regular script.

Coloured lacquer ware with engraved gold designs refers to ware with carved or engraved designs filled with lacquer. The production technique is to engrave designs on the lacquered ground first, and then fill in different colours. When the object dries, the surface would be polished until the decorations are at the same level with the object's surface. Afterwards, slim grooves would be incised along the designs and then filled with gold gum for fixing gold or silver strips or flakes, so that the designs would be bordered in gold or silver. This type of lacquer ware was first produced in the Xuande period of the Ming Dynasty, and thus this box has high research value.

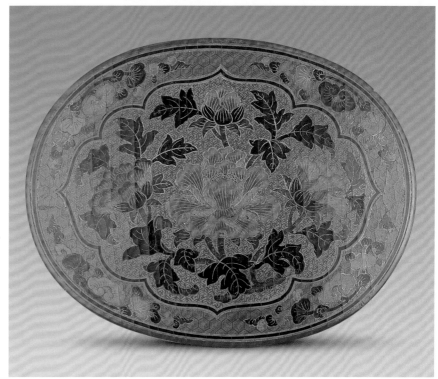

174

119

Brush with mixed hair and black lacquer brush-tube
with gold painted designs of dragons amidst clouds

Ming Dynasty Xuande period

Length of Brush-tube 16.9 cm
Diameter of Brush-tube 1.8 cm
Length of Cap 9.8 cm
Qing court collection

The black lacquer brush is decorated with gold-painted designs of two dragons in pursuit of a pearl. On the upper part of the brush-tube is a double-line rectangle in which is a six-character mark of Xuande (Daming Xuandenian *zhi*) in regular script in gold. The brush has mixed hair shaped like a fresh bamboo shoot which is known as the "bamboo shoot brush tip".

The brush was skilfully produced for imperial use at the court.

Mixed hair refers to the brush tip which is made by mixing hair of different animals. The centre of the tip is usually made with one type of hair surrounded by other types of hair with designated softness and hardness for writing.

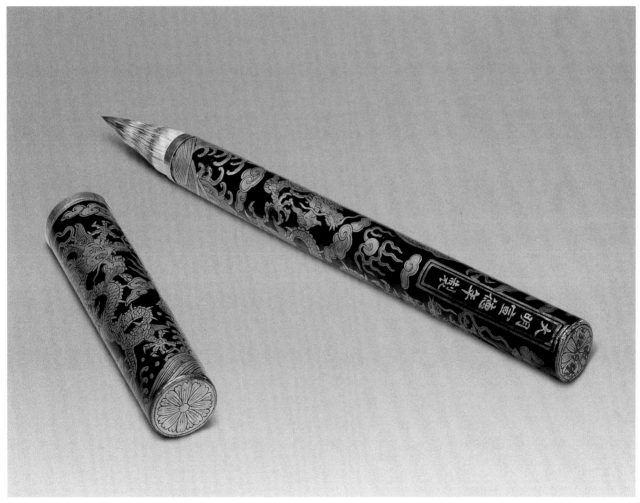

175

120

Cinnabar brush-holder
with carved designs of
plum blossoms

Mid Ming period

Height 14.3 cm
Diameter of Mouth 11.3 cm
Qing court collection

The brush-holder has a round mouth, a straight wall, and three short legs. The body is carved with a brocade ground with wave patterns, on which is a red plum tree. The branches interwine along the tree with flowers in full bloom. Below is the design of water surface on which are several fallen petals. The base is layered with shiny black lacquer with an engraved four-character mark of Qianlong (Qianlongnian *zhi*) in regular script filled with gold pigment, which was added later.

The decorations on this brush-holder are skilfully and creatively rendered with spacious and realistic pictorial treatments. It is finely polished, and the quality of lacquer is lustrous, representing a piece of fine lacquer ware of the mid Ming period. Plum blossoms are one of the motifs of "three friends of winter" and "four gentlemen", and suggestive of the loftiness of the men-of-letters.

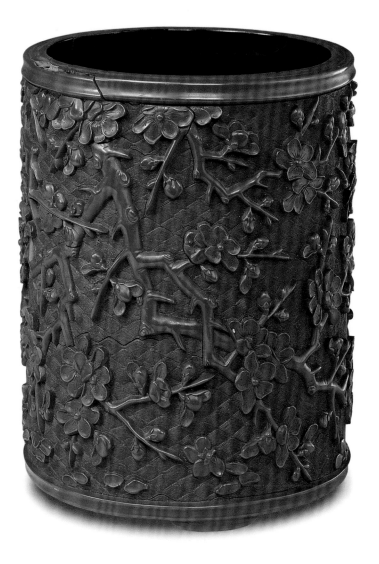

121

Rectangular cinnabar lacquer box

with painted black lacquer designs of two phoenixes

Mid Ming period

Height 7.9 cm Length 22.5 cm
Width 13 cm
Qing court collection

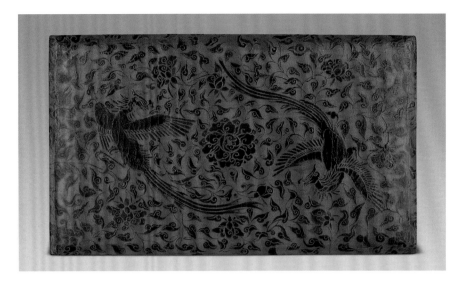

The rectangular box has cinnabar lacquer as the ground and decorated with phoenixes and flowers painted in black lacquer. The surface of the cover is painted with two phoenixes flying swiftly amidst clusters of lotus scrolls. The wall is painted with continuous lotus scrolls. The interior is layered with shiny black lacquer and has a rectangular drawer. The base is layered with cinnabar lacquer.

The decorative designs on this box are meticulously rendered and painted with delicate brush work and fine lines. It is a rare and treasurable piece of extant lacquer ware with painted designs, and also represents the highest standard of producing painted lacquer ware in the Ming Dynasty. Painted lacquer is also known as "painted decorations", referring to ware with painted colour designs. The production technique is to paint decorations in different coloured lacquers on a piece of ware.

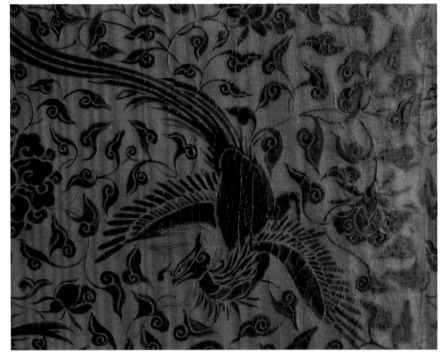

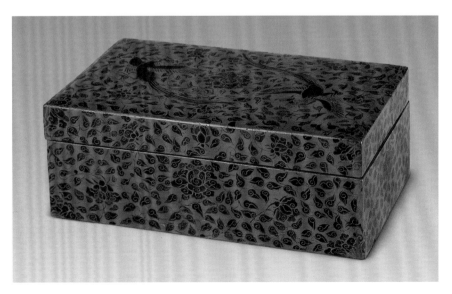

122

Round cinnabar lacquer box
with carved designs of five elderly men celebrating birthday

Ming Dynasty Jiajing period

Height 12 cm
Diameter of Mouth 24.7 cm
Qing court collection

The box is in the shape of a sugar cane stem. The body is layered with green lacquer and carved with brocade cloud patterns as the ground, on which are carved cinnabar designs in relief. The surface is decorated with an immortal holding a *lingzhi* fungus with smoke coming out and rising to form a character "*shou*" (longevity) in the sky, and other four immortals holding a gourd, a plum blossom spray, a peach, and scrolls, holding their hands to bless for long life. Surrounding the figures are pines, rocks, *lingzhi* fungi, herbs, and other auspicious objects with clouds and mist floating in the sky. The wall of the box is carved with crested waves, cliff, and dragons flying amidst clouds. The interior and base are layered with black lacquer, and at the centre of the base is an engraved six-character mark of Jiajing (Daming Jiajingnian *zhi*) filled with gold pigment.

The designs on this box are meticulously and precisely carved with the facial expressions and postures of the figures vividly rendered. It represents a masterpiece of lacquer ware of the Jiajing period. The decorative motifs in the Jiajing period, Ming Dynasty had significantly changed with the emergence of increasing motifs with immortals and auspicious tributes, which was closely associated with the belief in Daoism of Emperor Jiajing.

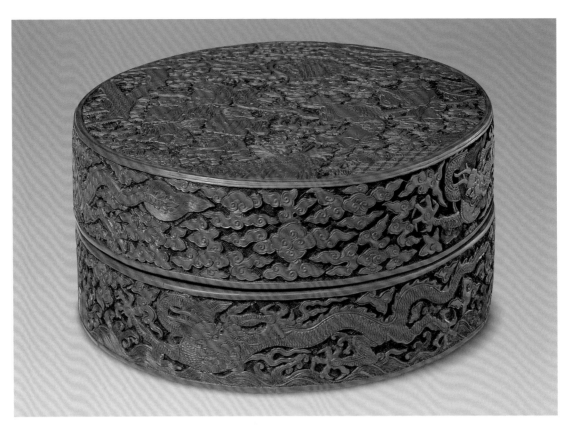

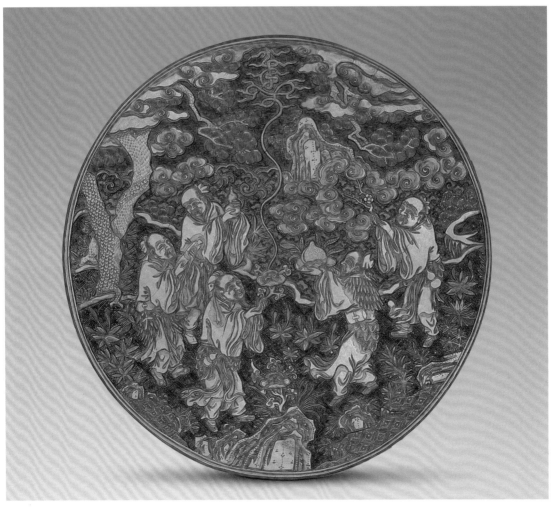

123

Round multi-colour lacquer tray
with carved designs of a scene of a pedlar selling merchandise

Ming Dynasty Jiajing period

Height 5 cm
Diameter of Mouth 32.2 cm
Qing court collection

The round plate has a curved wall and a low ring foot. The body is multi-coloured and coated with five layers of muddy-yellow, red, yellow, green, and cinnabar layer from bottom to top. The centre of the plate has a round panel on which are yellow lacquer brocade grounds suggestive of the heaven and the earth, and above is a carved design of a pedlar scene in relief. In the centre an old man is holding a hand drum and carrying a shoulder pole with baskets containing toys and other stuff for sale. Surrounding him are eight children holding toys and playing. At the back of the pedlar are peach trees with large peaches and rocks. The interior wall of the plate is carved with dragon designs in red and green lacquer. The exterior is carved with *lingzhi* fungi in relief. The base is layered with cinnabar lacquer, and at the centre is an engraved six-character vertical mark of Jiajing (Daming Jiajingnian *zhi*) in regular script filled with gold pigment.

This plate is a representative piece of multi-colour lacquer ware of the Jiajing period with the pictorial scene rendered in cinnabar lacquer as the principal colour supplemented by green and yellow colours. The pictorial theme has been derived from the painting "Pedlar scene" by Su Hanchen, a painter of the Southern Song Dynasty. The artistic rendering is similar to painting on paper or silk, revealing the achievement in producing multi-colour lacquer ware at the time.

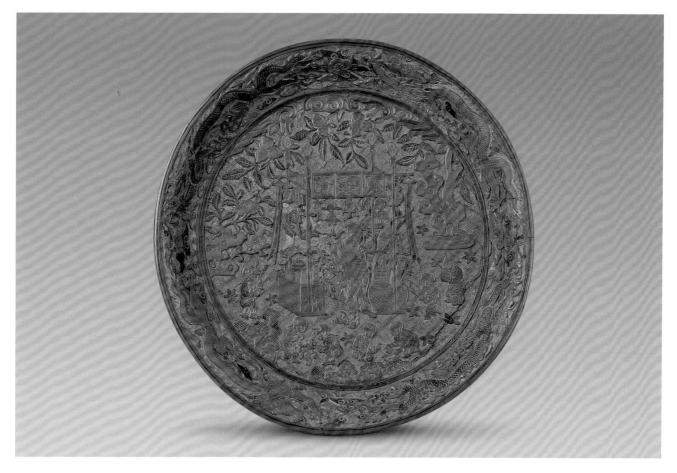

124

Round multi-colour lacquer box
with carved designs of the character "*chun*" (spring) and auspicious symbols of longevity

Ming Dynasty Jiajing period

Overall Height 13 cm
Diameter of Mouth 33.3 cm
Qing court collection

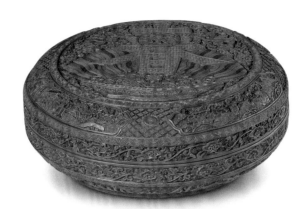

The round box has a slightly convex cover and a low ring foot with mutli-colour layers of lacquer in red, green, and yellow. At the surface of the cover is a carved design of a panel in which swastikas (卍) are carved as the ground, and on which are carved designs in relief, including light beams rising from the treasure basin to support a character "*chun*" (spring). At the centre of the character is another round panel, in which is the immortal of longevity accompanied by pine, cypress, and deer, suggestive of the blessing of "long life in spring". On the two sides of the character are dragon designs and cloud patterns. At the upper and lower part of the wall of the cover are four panels in which waves, clouds, and swirl patterns are carved as the ground, on which are carved designs of figures strolling in spring time, playing chess, and other decorative scenes in relief. Outside the panels are carved designs of precious emblems on a brocade ground with lozenges. The upper and lower rims of the box are carved with *lingzhi* fungi, and the foot is carved with key-fret patterns. The interior and base are layered with shiny black lacquer, and the centre of the base is engraved with a six-character mark of Jiajing (Daming Jiajingnian *zhi*) in regular script filled with gold pigment.

The decorative motif of the character "*chun*" with symbols of longevity had first appeared in the Jiajing period of the Ming Dynasty, and was adopted to decorate lacquer ware and other crafts in the Qing Dynasty.

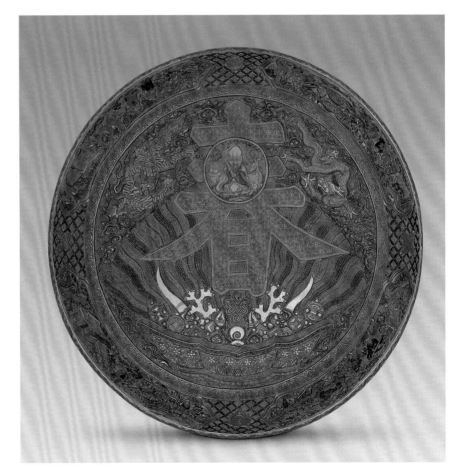

125

Round multi-colour lacquer plate
with engraved gold designs (*qiangjin*) of chrysanthemums and rocks

Ming Dynasty Jiajing period

Height 5.3 cm Diameter of Mouth 34.8 cm
Qing court collection

The round plate has a wide mouth, a curved wall, and a low ring foot. The interior is layered with light yellow lacquer as a rhino hide ground, on which are carved multi-colour lacquer designs of fully blooming hibiscuses, chrysanthemums, and rocks which are further decorated with engraved gold outlines. The decorative designs are suggestive of wealth and longevity. The exterior wall and the base are layered with black lacquer with the centre of the base engraved with a six-character vertical mark of Jiajing (Daming Jiajingnian *zhi*) in regular script filled with gold pigment.

Carved multi-colour lacquer with engraved gold designs and rhino hide ground is a special technique in lacquer art, which is also known as "engraved gold designs interspersed by rhino hide patterns". Carved multi-colour lacquer with engraved gold designs is made by piling up lacquer layers on the body to the designated thickness and then incising outlines along the designs for filling in gold. Rhino hide design is also known as "rhino drill" technique by drilling round mottles at the spaces left in between the designs on the lacquered ground to highlight the lacquer layers and make their colours stand out. The book *Digest of Traditional Lacquer* gives it the term "drilled mottle" technique of rhino hide design.

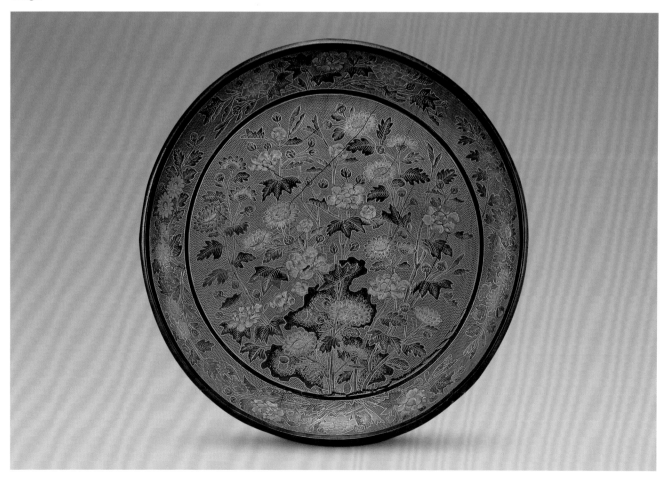

126

Round multi-colour lacquer plate
with carved designs of two dragons in pursuit of a pearl

Ming Dynasty Wanli period

Height 4.6 cm
Diameter of Mouth 28.7 cm
Qing court collection

The shallow plate has a ring foot. The body is layered with yellow, green, and cinnabar lacquer from bottom to top. The interior centre is carved with cinnabar lacquer brocade ground with designs of squares, on which are carved designs of two dragons in pursuit of a pearl in relief layered with cinnabar and green lacquer, and designs of cliff and crested waves. The interior wall has four panels, in which the plain yellow grounds are carved with the motif of "three friends of winter", including pines, bamboos, and plum blossoms. In between the panels are carved designs of peonies and other flowers in relief. The exterior wall is carved with chrysanthemums and other flowers in relief. The base is layered with shiny black lacquer with a mark "made in the year *renchen* of the Wanli period of the Ming Dynasty" in regular script written in cinnabar lacquer, which was hidden but still barely visible. The *renchen* year of the Wanli period of the Ming Dynasty corresponded to the 20th year of the Wanli period (1592 A.D.)

The designs on this box are carved deeply by manipulation of the knife from a steep angle to carve, just like writing with a Chinese brush, showing sharp angles of the designs. It signified a new decorative feature of the lacquer ware of the Jiajing and Wanli periods with the quality of Wanli period more superior, which opened a new path for decorating lacquer ware with a touch of extravagance and luxuriance in the Qianlong period of the Qing Dynasty. On

the other hand, marks on Wanli ware sometimes carried the chronicle of heavenly stems and earthly branches in addition to reign marks, thus increasing the number of characters from six to eight. The decorative motif of pines, bamboos, and plum blossoms, the so-called "three friends of winter", was popularly employed at the time.

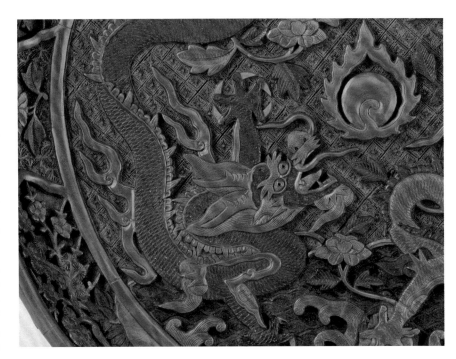

127

Black lacquer balance box
with painted gold designs of dragons amidst clouds

Ming Dynasty Wanli period

Length 57 cm
Widest 11 cm
Qing court collection

The box comprises of two identical upper and lower compartments. It has an elongated shape with a wider head and a narrower tail. At the tail is a knob in the shape of a flower for locking and opening of the box. The body is layered with black lacquer and decorated with identical painted gold designs on the surfaces of the two compartments. The head is decorated with dragons in pursuit of a pearl amid the clouds, and the tail is decorated with *lingzhi* fungi and flowers. The middle part is decorated with brocade designs of swastikas (卍) and cloud patterns. On one compartment is a six-character vertical mark of Wanli (Daming Wanlinian *zao*) painted in gold in regular script.

This box has a specific form with thickly painted gold designs, revealing the skilful workmanship of producing painted gold lacquer ware in the Wanli period of the Ming Dynasty. This box is used for storing a small balance for weighing medicines or precious objects. The largest unit of weight is in tael, and the smallest unit of weight is in *li* (0.05 grams).

128

Cinnabar lacquer ewer
with carved designs of landscapes and figures

Late Ming period

Overall Height 13.2 cm
Diameter of Mouth 7.6 cm
Qing court collection

The ewer has a purple clay biscuit, a round mouth, a square body, and four short legs. On the identical sides of the body are a curved spout and a ring-shaped handle. It has a fitting round lid on which is a knob in the shape of a lotus. The body is layered with cinnabar lacquer and decorated with carved designs. The four sides of the body are in panels and carved with designs of brewing tea under a pine tree and other scenes with landscapes and figures. The lid and the shoulder have brocade grounds, on which are carved designs of precious emblems such as *qing* chimes, conch shells, bells, clappers, corals, *sheng* musical instruments, pearls, and others. The handle and spout are carved with cranes and cloud patterns. The base of the ewer is layered with black lacquer and has a mark "Shi Dabin *zao*" (made by Shi Dabin) in regular script painted in red barely visible underneath.

Shi Dabin, *hao* Shaoshan, was a native of Yixing, Jiangsu in the late Ming period with his years of birth and death unknown. He was a renowned potter of Yixing purple clay teapots. This work is the only purple clay ewer layered with cinnabar lacquer extant, and provides useful reference for dating similar carved cinnabar lacquer ware.

129

Rectangular black lacquer box
with designs of dragons amidst clouds inlaid with mother-of-pearl

Late Ming period

Height 7.2 cm Length 12.6 cm
Width 9.4 cm
Qing court collection

The box has a cover with a flat surface, round corners, straight walls, and a flat base. The body is layered with black lacquer and decorated with designs inlaid with thin mother-of-pearl flakes. The surface of the cover has a seal mark "*Changchun Tang*" (Changchun Studio), a poem with a signature mark "*eulogy by Xibaiming*", and a square seal mark "*Xingben*". The four walls of the box are decorated with flying dragons and clouds. The interior is layered with black lacquer with a seal mark "*Jiang Qianli shi*" (Jiang Qianli's style) in seal script.

This box reveals the production standard of provincial lacquer ware with designs inlaid with mother-of-pearl in the late Ming period. The years of birth and death of Jiang Qianli were unknown. He was a native of Jiaxing, Zhejiang and well-known for making lacquer ware with designs inlaid with mother-of-pearl. At the time, he was adored as "cups and plates for use by every family were made by Jiang Qianli".

186

130

Gu vase
with striated carved lacquer (*tixi*)
designs of *ruyi* clouds

Early Qing period

Height 44 cm
Diameter of Mouth 21.5 cm

The *gu* vase has a porcelain body, a flaring mouth, a long neck, a globular belly, and a flat base. The body is layered with black lacquer with five borders of cinnabar lacquer exposed. The interior of the mouth is carved with key-fret patterns, the body carved with *ruyi* clouds in relief, and the belly carved with four *shou* (longevity) medallions in seal script in relief. The white porcelain biscuit is exposed at the exterior base with an imitated six-character mark of the Chenghua period of the Ming Dynasty (Daming Chenghuanian *zhi*) in regular script engraved within a double-line medallion in underglaze blue.

The designs on this *gu* vase are carved swiftly, showing the special technique known as "black lacquer interspersed by cinnabar lines" in the category of striated carved lacquer ware. The form was derived from the *zun* vase with underglaze blue designs of the Chenghua period, Ming Dynasty. Although it carried a mark of the Chenghua period, the porcelain biscuit was dated to the Kangxi period of the Qing Dynasty after authentication, and thus its date should not be earlier than the Kangxi period.

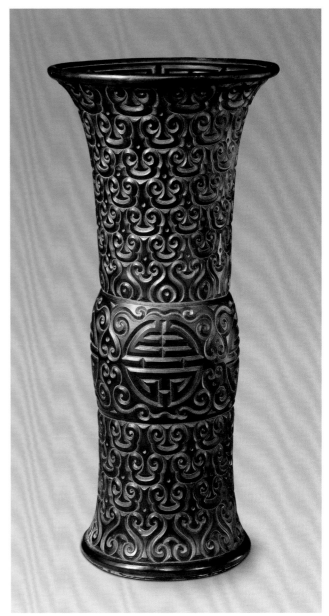

131

Black lacquer cabinet
with designs of
children at play inlaid with
mother-of-pearl

Early Qing period

Height 28.5 cm
Length of Each Side 27.5 cm
Qing court collection

The square cabinet has a front door which can be lifted up for opening. Inside are five drawers, and on the two sides are gilt bronze rings for lifting. The body is layered with black lacquer and decorated with designs inlaid with mother-of-pearl and gold flakes. The top, four walls, and the front of drawers are decorated with scenes of children at play, who are either playing with games of rope jumping, riding on a wooden horse, gyroscope spinning, wrestling, dancing, or playing with puppet. The rim of the cabinet and the rims of the drawers have border decorations made with fine sands grinded from shells.

This cabinet was used for storing inksticks. The mother-of-pearl inlaid is very colourful and brilliant, and this work represents a refined piece of lacquer ware inlaid with mother-of-pearl of the early Qing period.

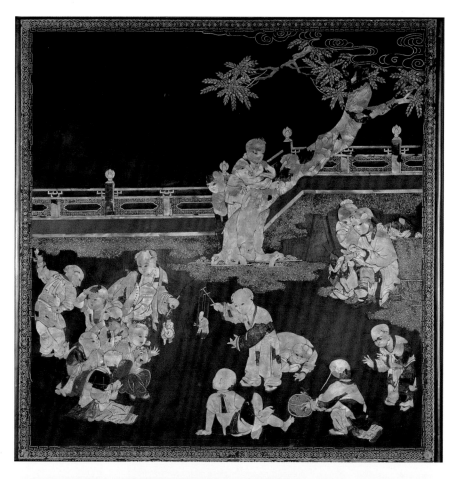

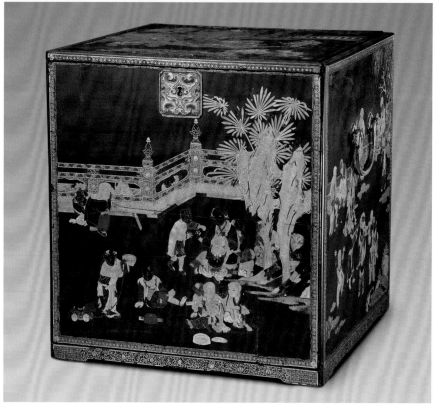

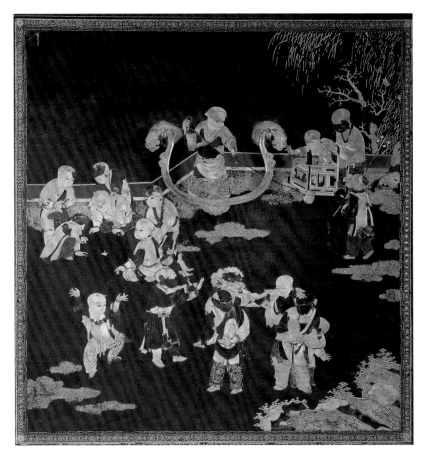

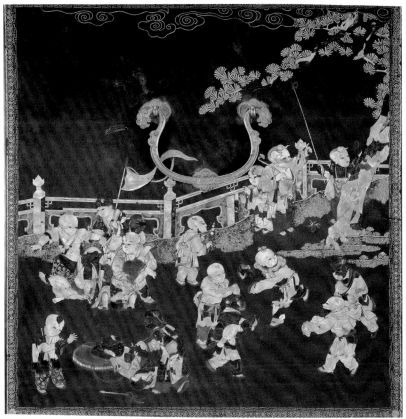

132

Rectangular black lacquer box
with designs of foreign ambassadors sending tributes inlaid with mother-of-pearl

Early Qing period

Height 6.5 cm
Length 43.8 cm
Width 30 cm
Qing court collection

The box is rectangular in shape with fitting upper and lower sides. The body is layered with black lacquer and decorated with a scene of foreign ambassadors sending tributes to the court inlaid with mother-of-pearl and painted in gold. At the lower part is a stone bridge with three holes with a stream passing underneath. Various figures are on the bridge with some leading camels, carrying wooden cases, pulling a lion, holding corals and treasures, etc., and they are in procession to send tributes to the court. Behind the bridge and at the side of a road are trees, and at the other side is a gorge. Figures on the road are walking with their hands holding together. In front of the palace are various figures kneeling and

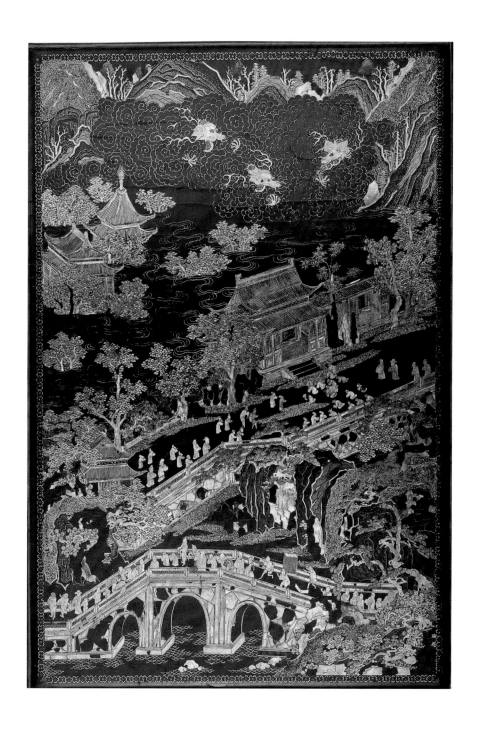

bowing. Behind the grand palace are towers and other palaces. The sky is crowded with clouds with three dragons protruding. The four sides of the box are plain without any decoration.

On this box within limited space, over sixty figures are carved and inlaid with mother-of-pearl reflecting different colours of red, blue, purple, and others with a touch of brilliance and extravagance. This work is a refined representative lacquer object combining the crafts of painting in gold and mother-of-pearl inlay. Such a decorative scene is a depiction of the procession of foreign ambassadors sending tributes to the court.

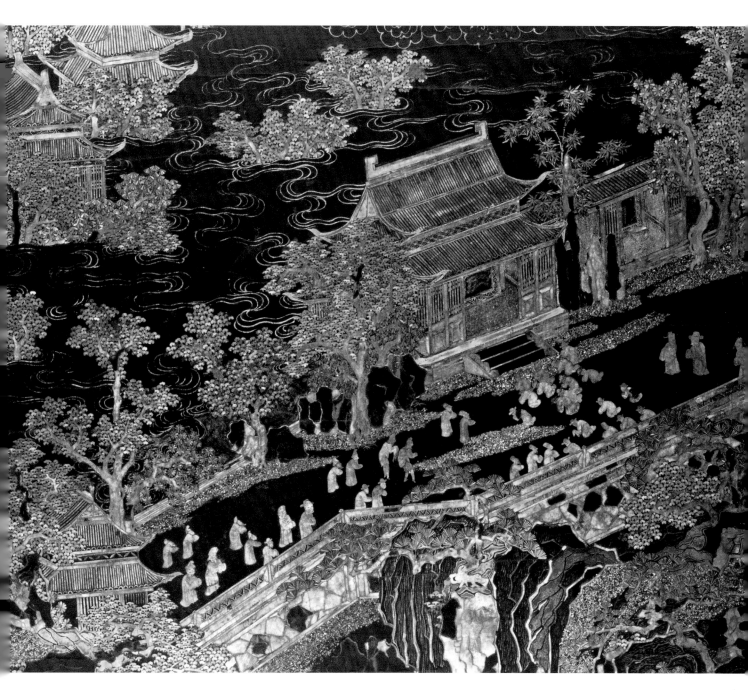

133

Multi-colour lacquer plate
in the shape of a holly-hock petal with engraved gold (*qiang jin*) designs of dragons amidst clouds

Qing Dynasty Kangxi period

Height 2.9 cm
Diameter of Mouth 23.4 cm

The plate is in the shape of a holly-hock petal and has a low ring foot. The interior of the plate is layered with yellow lacquer as the ground, and decorated with designs filled with cinnabar, black, light green, dark green, and brown lacquer with engraved gold outlines. The interior centre is decorated with a red dragon flying above the cliff and crested waves with its claws stretched and mouth opened in pursuit of a flaming pearl. Around the dragons are auspicious clouds. The interior and exterior walls are decorated with cloud patterns. The base is layered with cinnabar lacquer with an engraved six-character mark of Kangxi (Daqing Kangxinian *zhi*) in regular script filled with gold pigment.

Lacquer ware with filled lacquer layers and engraved gold designs were a representative type of lacquer ware produced in the Kangxi, Yongzheng, and Qianlong periods. The technique of filled colour lacquer layers and engraved gold designs was described as "engraved gold, fine outline, and filled lacquer" technique in the book *Digest of Traditional Lacquer*.

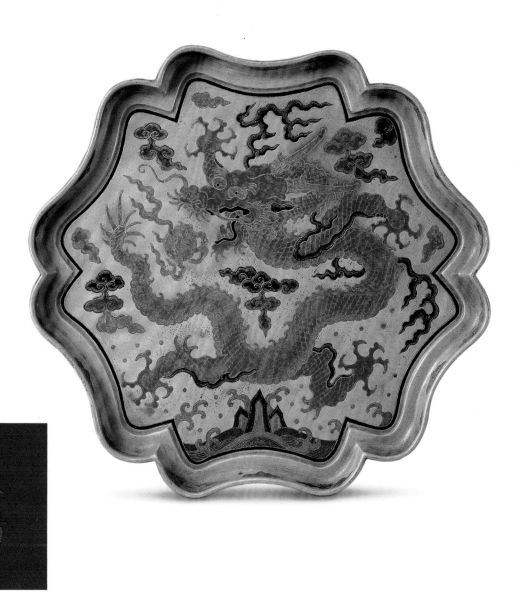

Multi-colour lacquer box
in the shape of a persimmon with engraved gold (*qiangjin*) designs of bats and lotus scrolls

Qing Dynasty Yongzheng period

Height 10 cm
Diameter 20 cm
Qing court collection

The box is in the shape of a persimmon. The body is layered with cinnabar lacquer and decorated with filled multi-colour lacquer and engraved gold designs of bats and lotus scrolls. At the surface of the cover are four bats facing and holding a lotus at the centre, which is suggestive of "fortune and longevity". The sides of the cover and the box are decorated with floral sprays, and the foot is decorated with foliage scrolls. The base is layered with black lacquer, and at the centre is a multi-colour painted design of the pedicel and leaves of a persimmon.

According to the archive of the Qing court, this box was made by the Imperial Workshops in the 11th year of the Yongzheng period (1733 A.D.). The designs are meticulously filled with multi-colour lacquer and finely polished; the engraved gold outlines are also rendered precisely and delicately, revealing the superb multi-colour lacquer and engraved gold techniques in the Yongzheng period.

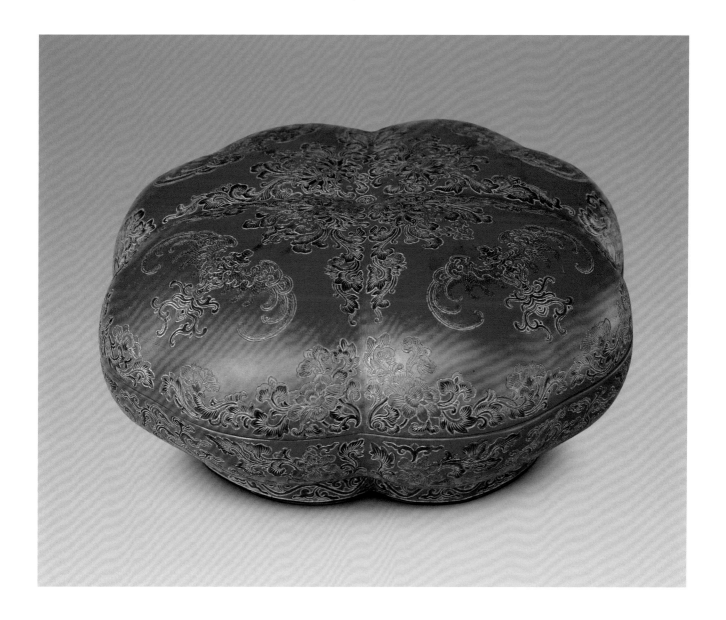

Rectangular black lacquer box
shaped as if wrapped in a piece of cloth and with gold painted designs of "three abundances"

Qing Dynasty Yongzheng period

Height 12 cm Length 21.8 cm Width 11.8 cm
Qing court collection

The rectangular box is shaped as if wrapped in a piece of cloth with a knot at the centre of the lid. The wrapping cloth is decorated with characters "*shou*" (longevity), floral medallions, and brocade patterns with multi-colour lacquer. The exposed areas outside the wrapping cloth is layered with black lacquer and decorated with gold painted citrons, pomegranates, and peaches. The Chinese pronunciation of citrons is a homonym for "*fu*" (fortune). As pomegranates have abundant seeds, they are a symbol of fertility, whereas peaches are a symbol of longevity. Combination of these motifs is thus known as "three abundances", suggestive of fortune, fertility, and longevity.

The decorative style of this box shows strong western influence. The brocade wrapping cloth design has the aesthetic appeal similar to oil painting. According to the archive of the Imperial Workshops of Qing court, "on the 27th day of the second month of the 10th year of the Yongzheng period, the aboriginal leader Sha Muha showed two lacquer boxes shaped as if wrapped in a piece of cloth with foreign lacquered decorations to the Emperor. The Emperor had given order that the forms of the boxes were very interesting, and cinnabar and black lacquer boxes in similar forms should be produced."

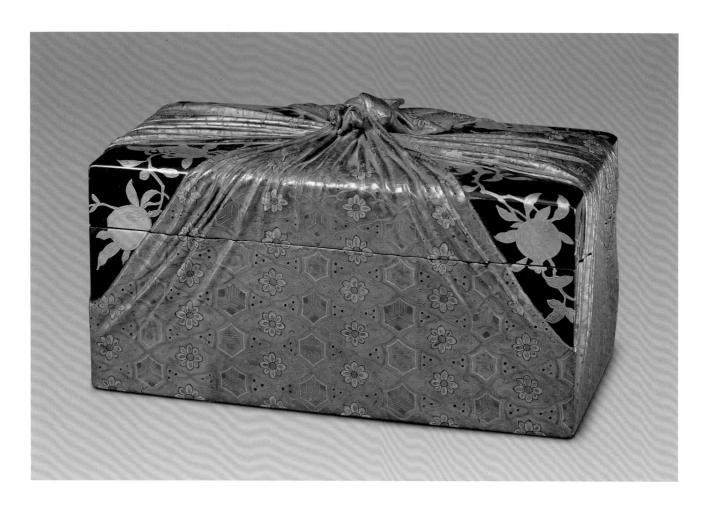

136

Multi-colour lacquer box
in the shape of a caltrop flower with engraved gold (*qiangjin*) designs of phoenixes

Qing Dynasty　Qianlong period

Height 15 cm　Diameter of Mouth 32.5 cm
Qing court collection

The box is in the shape of a caltrop flower with six petals. The body is layered with cinnabar lacquer and decorated with various brocade patterns as the ground. The surface of the cover is decorated with two phoenixes facing each other and flying amidst flower clusters. The wall of the cover and the body are decorated with panels, in which are designs of two cranes flying around a *qing* chime and surrounded by floating cloud patterns. The mouth rim is decorated with floral medallion brocade patterns. The interior and base are layered with matt black lacquer with an engraved six-character mark of Qianlong (Daqing Qianlongnian *zhi*) in regular script filled with gold pigment and a carved inscription *linghuafenghe* (box in the shape of a caltrop flower with designs of phoenixes).

On this box, the techniques of painted lacquer and filled multi-colour lacquer are utilized. The brocade patterns of the box are decorated with the filled lacquer technique, whereas the floral scrolls and phoenixes are painted with lacquer. The decorations are treated in layers with perspectives and further enriched by spacious or dense engraved gold outlines for enhancing its decorative appeal.

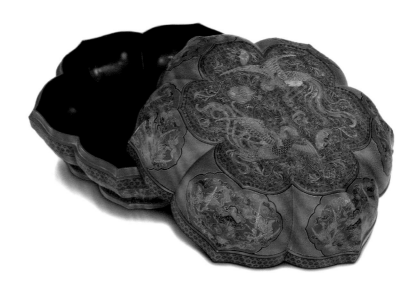

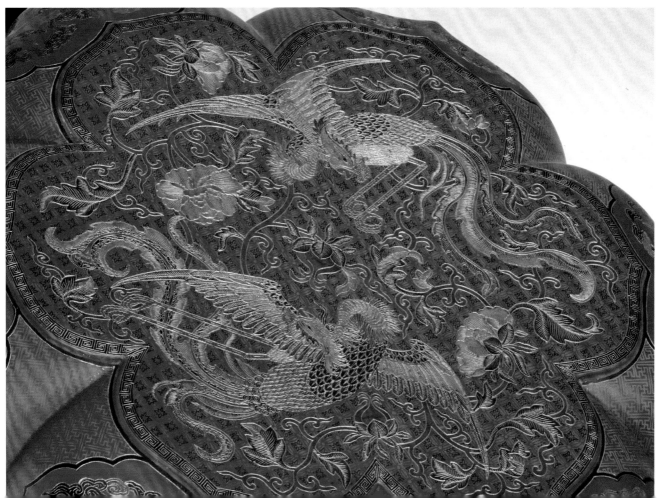

137

Inlaid colour lacquer (*tianqi*) box

in the shape of a caltrop flower with designs of a character "*chun*" (spring) and symbols of longevity

Qing Dynasty　Qianlong period

Height 7 cm
Diameter of Mouth 11.5 cm
Qing court collection

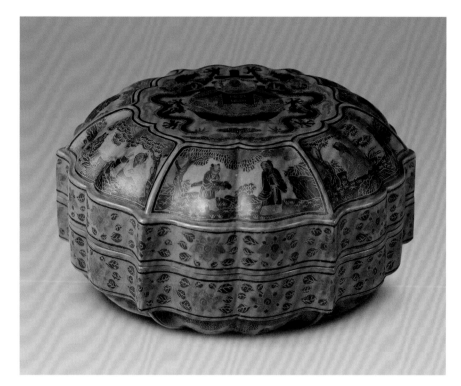

The box is in the shape of a caltrop flower with six petals and a small flat surface on the cover. The body is layered with yellow-brownish lacquer as the ground, and the designs are inlaid with various colour lacquers in red, green, and black. On the surface is a treasure bowl supporting a character "*chun*" (spring), on which are relief designs of the deity of longevity and two dragons, suggestive of the auspicious blessing of spring and longevity. The cover and the side of the body are decorated with panels, in which are inlaid colour lacquer designs of landscapes and figures representing scenes of bringing books for strolling in the mountains, carrying a *qin* zither to visit a friend, waiting for crossing the river, and others. The upper and lower mouth rims are decorated with lotus sprays. The interior and base are layered with black lacquer with an engraved four-character mark of Qianlong (Qianlongnian *zhi*) in regular script filled with gold pigment.

This work is a fine representative piece of lacquer ware with inlaid colour lacquer designs of the Qianlong period. "Inlaid lacquer" is also known as "inlaid colour lacquer", and it is a technique of engraving the designs on the lacquered ground first, then filling the designs with lacquer in different colours and polishing them after drying, so that the designs are at the same level as the lacquered surface.

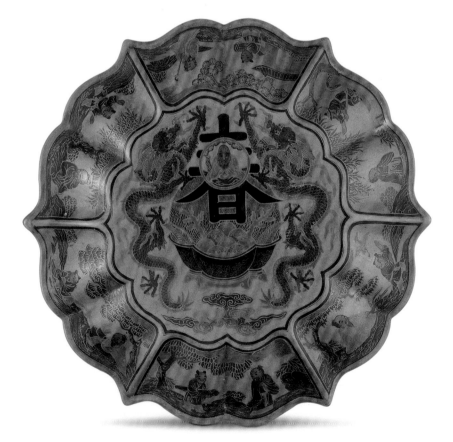

138

Cinnabar lacquer box
with carved designs of a
scene of literary gathering

Qing Dynasty Qianlong period

Height 11.6 cm
Diameter of Mouth 33 cm
Qing court collection

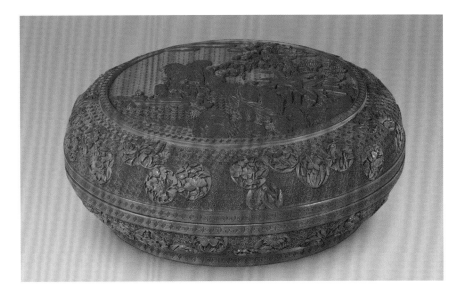

The round box has a cover with a flat surface and a low ring foot. It is carved with cinnabar lacquer designs in relief. In the round panel on the surface of the cover are three kinds of brocade patterns as grounds, suggestive of heaven, water, and earth. On the surface of the grounds are designs of pines, wisterias, banana trees, and huge rocks as landscape setting. A long beard elderly man is holding a brush to paint. On his side are four figures either sitting or standing, watching the elderly man to execute his artistic endeavour. The motifs represent the pictorial treatment of a literary gathering. The wall of the box is carved with tortoise-shell brocade patterns as the ground, on which are carved designs of foliage or overlapped peony scroll medallions in relief. The upper and lower mouth rims are carved with continuous key-fret patterns. The interior and base are layered with black lacquer. Inside the cover is an engraved mark "*yaji baohe*" (a precious box with designs of a scene of literary gathering), and the base is engraved with a six-character mark of Qianlong (Daqing Qianlongnian *zhi*) in regular script.

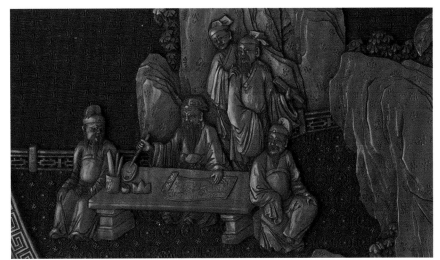

The colour of cinnabar lacquer on this box is brilliant, and the designs are carved meticulously with a touch of delicacy, showing sharp angles in carving the designs. It marks a distinctive carving style different from that of the Ming Dynasty. The floral medallion designs and the carving techniques are innovative of the Qianlong period.

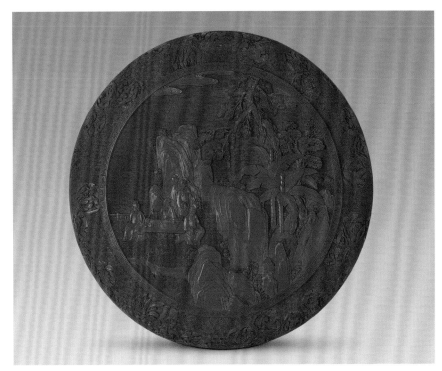

139

Cinnabar lacquer box
with carved designs of
a hundred children at play

Qing Dynasty Qianlong period

Height 8.7 cm
Diameter of Mouth 14.2 cm
Qing court collection

The box has a metal body and is round in shape with a flat cover, a flat base, and a fitting mouth. The body is layered with cinnabar lacquer and carved with a scene of hundred children at play in low relief. The cover and the base are carved with twenty-six children respectively who are playing drums, blowing trumpet, wrestling, playing music, dancing, playing with fire crackers, or playing the game of contending for championship, etc. The wall of the box is carved with forty-eight children who are playing the cricket game, hide-and-seek, etc. This collective design is known as "a hundred children at play". The interior of the cover is layered with black lacquer with an engraved mark "*baizi baohe*" (a precious box with designs of a hundred children at play). The interior of the body is engraved with a four-character mark of Qianlong (Qianlongnian *zhi*) in regular script.

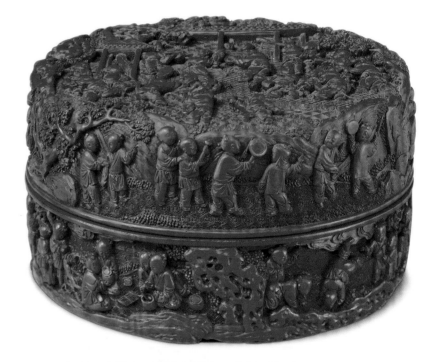

The designs on this box are thickly and roundly carved to depict children with the aesthetic appeal similar to carving in the round, showing high artistic merit. Engraving the title description of the ware on specific objects was a new practice in the Qianlong period. Most of the engraved marks of the ware or reign marks were often found at the centre of the base, inside the cover, or at the interior base of the ware.

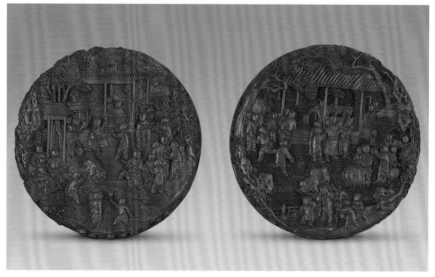

140

Cinnabar lacquer fitting box
with carved designs of dragons amidst waves

Qing Dynasty Qianlong period

Height 9.6 cm
Diameter of Mouth 9.4 cm
Qing court collection

The box is in the shape of a round fitting cylinder. The body is carved with cinnabar lacquer designs in relief. On the surface of the cover is a round panel, in which is a carved design of a dragon amidst waves in relief, enclosed by a border of *kui*-dragons in relief outside. The wall of the cover is carved with four dragons swimming and swirling in waves in relief. The upper and lower sides of the wall are carved with designs of *kui*-dragons in relief. The exterior rim of the base is carved with key-fret patterns in relief. The base is layered with black lacquer with an engraved six-character mark of Qianlong (Daqing Qianlongnian *zhi*) in regular script filled with gold pigment.

The wave design on this box was carved extremely thin like threads, and rendered most meticulously which was never found in the past. According to the archive of the Qing Imperial Workshops, in the early Qianlong period, there were no competent carvers working at the lacquer workshop of the Imperial Workshops. As a result, craftsmen from South China, who excelled in carving bamboo ware in the Ivory Workshop, were summoned to carve designs on lacquer objects, and then sent them for production in Suzhou. Therefore the delicate and meticulous style of bamboo carvings was utilized to decorate lacquer ware, and marked a distinctive decorative feature of Qianlong lacquer ware.

141

Cinnabar lacquer plate
with carved designs of the legend of a rabbit in the moon and the sea

Qing Dynasty Qianlong period

Height 3.5 cm
Diameter of Mouth 21.4 x 16.5 cm
Qing court collection

The plate is in the shape of a lotus leaf with the body carved with cinnabar lacquer designs of waves. In the centre of the plate is a round panel to represent the moon, in which the legend of "a rabbit pounding herb medicine under an osmanthus tree" is carved with multi-colour lacquer and engraved in gold on the ground layered with yellow lacquer. The legend describes the ancient Chinese myth that a rabbit pounded herb medicine in the moon. The base is layered with black lacquer with an engraved mark "*haiyue xiangpan*" (a fragrant plate with designs of the sea and the moon) filled with gold pigment and a six-character mark of Qianlong (Daqing Qianlongnian *zhi*) in regular script.

The plate is in the shape of a lotus leaf. The interior and exterior are meticulously carved with waves in the sea, and the waves are embellished delicately, showing the superb carving technique of the carver. This work represents a refined piece of ware by combining carving techniques with multi-colour lacquer and engraved gold techniques. The lacquer ware of the Qing Dynasty was often decorated by utilizing various carving techniques to achieve the desired distinctive aesthetic appeal.

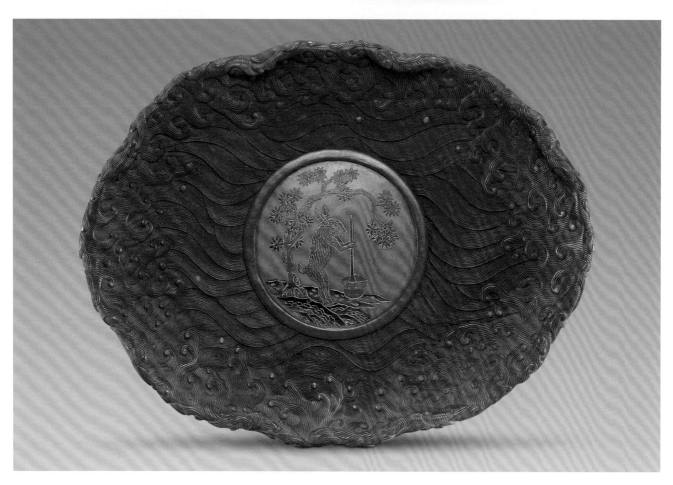

142

Cinnabar lacquer box
in the shape of a maple leaf with carved designs of autumn insects

Qing Dynasty Qianlong period

Height 8.5 cm
Diameter of Mouth 13.5 cm
Qing court collection

The box is in the shape of a maple leaf. The body is decorated with cinnabar brocade patterns as the ground, on which are carved designs of vines of the maple leaf in relief. The cover of the box is carved with an autumn cicada and a katydid reclining on the leaf in a realistic and lively manner. The interior is layered with black lacquer, and at the interior base is an engraved six-character mark of Qianlong (Daqing Qianlongnian *zhi*) in regular script filled with gold pigment. The box has a fitting cinnabar lacquer stand carved with waves, banana leaves, and square brocade patterns in relief.

The box is made with a creative form, and the decorative designs are skilfully and vividly rendered with superb carving techniques, representing a distinctive piece of lacquer ware of the Qianlong period.

143

Multi-colour lacquer tray
with carved designs of a hundred children at play to celebrate the first birth anniversary of a child

Qing Dynasty Qianlong period

Height 5.6 cm
Diameter of Mouth 58.7 x 32.7 cm
Qing court collection

The rectangular tray is decorated with multi-colour lacquer in red, yellow, green, and aubergine. The interior is carved with brocade patterns layered with aubergine lacquer and lotus leaves floating on water layered with green lacquer. The surface of the tray is decorated with carved cinnabar lacquer scene of a hundred children at play in relief, who are playing the games of dragon boat races, dragon dances, rope jumping, music performance, holding lanterns in the shape of halberds, *qing* chimes, fish, rabbit or pig's head, reading and writing calligraphy, etc. with great joy, suggesting the blessing of an abundant harvest and a peaceful nation, and echoing the decorative practice that "decorative designs should always carry auspicious blessings" in the artistic creations in the Qing Dynasty. The base is layered with black lacquer, and at the centre is an engraved six-character mark of Qianlong (Daqing Qianlongnian *zhi*) in regular script filled with gold pigment and another mark "*baizi zuipan*" (a tray for celebrating the first birth anniversary of a child with designs of a hundred children at play).

When a child reached the first age, a custom known as the *zui* test ceremony would be held in ancient China. This *zui* tray was used to test a child whether he/she could control his/her hands and pick up stuff successfully. The holding test in the *zui* ceremony was known as "a pick-up game at the first age" or "a test at the first age". The writing *Family Teachings of the Yan Clan* by Yan Zhitui of the Northern Qi Dynasty described, "In the Jiangnan regions, there was a folk practice that when a child reached his first birth anniversary…for a boy, he would be given a bow, an arrow, paper, and a brush; and for a girl, she would be given a knife, a ruler, needles, and threads. Then foods, treasures, or precious stuff would be put in front of the child to see which objects he/she would pick in order to foretell the child's character and see if he or she is greedy, righteous, stupid, or wise. The custom was known as "a pick-up test for a child'." According to the record of the archive of the Imperial Workshops of the Qing Dynasty, there were two pieces of this tray produced from the seventh to the eighth year at Suzhou for testing princes and princesses when they reached their first age.

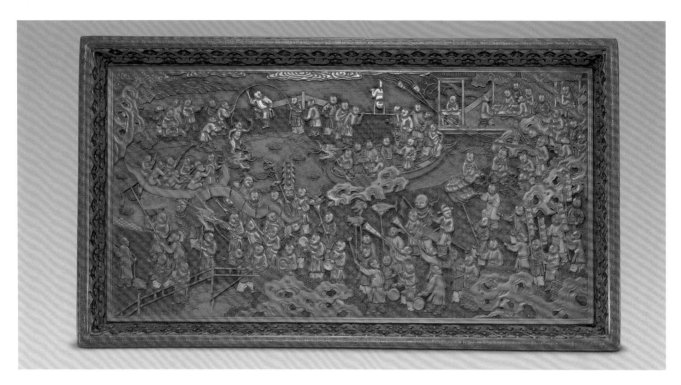

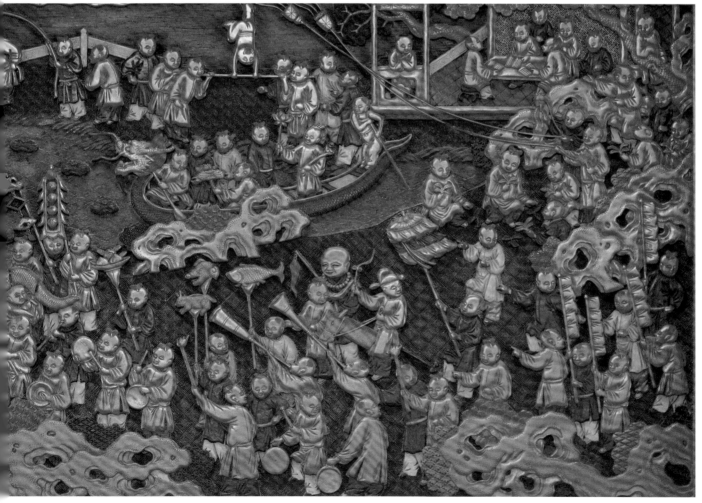

144

Diaper-shaped black lacquer tray

with gold painted designs of landscapes

Qing Dynasty Qianlong period

Height 3.7 cm
Diameter of Mouth 36.7 x 19 cm
Qing court collection

The tray is in the shape of a diaper, and the body is layered with black lacquer with gold painted designs. In the centre of the tray is a panel in which are designs of distant mountains, streams, pavilions, terraces, and water-pavilions with a figure riding on a boat, showing a charming scene of landscape painting. The interior wall is decorated with floral brocade patterns. The exterior wall is decorated with chrysanthemum, dahlia, plum blossom, orchid, and peony medallions. The base is decorated with chrysanthemums, peonies, and other flowers painted in gold, and at the centre is a four-character mark of Qianlong (Qianlongnian *zhi*) in regular script painted in gold within a double line square.

The decorative designs on this tray are painted in gold. Dense brush work is utilized to outline the designs, and the textures of rocks are depicted with light black lacquer in order to highlight the gold colour with shading effects and a strong sense of dimensionality. In the book *Digest of Traditional Lacquer*, such a decorative technique is known as "multi-colour gold designs". The border decorations on this tray reveal the influence of Japanese lacquer ware painted in gold, which creates a sharp contrast with the traditional Chinese decorations at the centre.

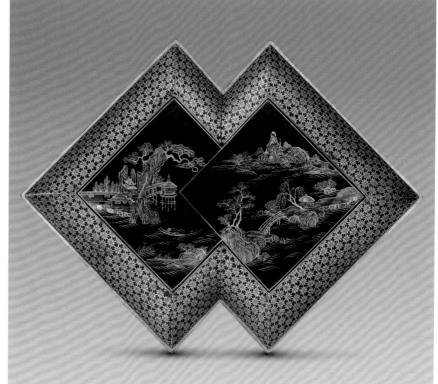

204

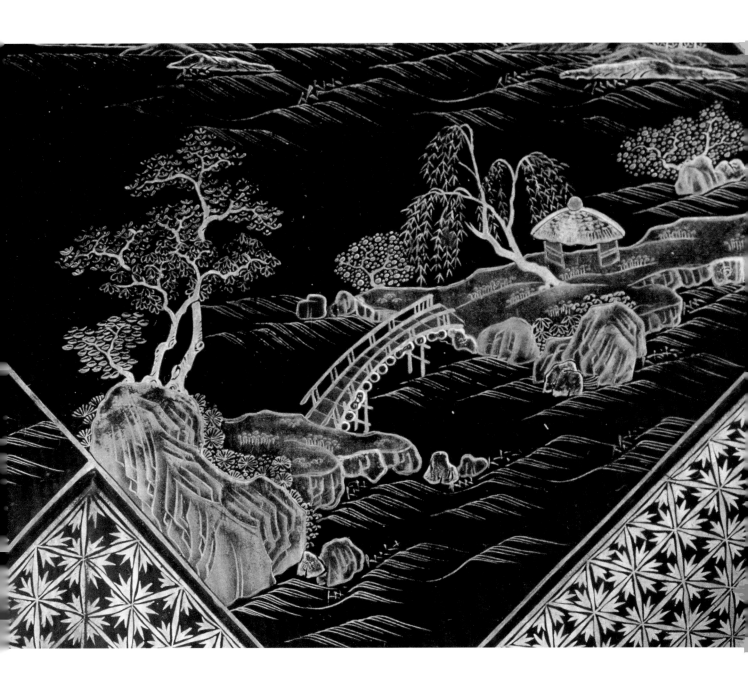

145

Black lacquer dipper-shaped grasp brush

with holder-tube decorated with a hundred "*shou*" (longevity) characters and purple hair

Qing Dynasty Qianlong period

Length of Brush-tube 22.5 cm
Diameter of Brush-tube 2.1 cm
Length of Dipper-shaped Holder 4 cm
Diameter of Dipper-shaped Holder 3.6 cm
Qing court collection

The brush-tube thickens from bottom to top. The body is layered with black lacquer with gold painted designs of a hundred characters "*shou*" (longevity). The upper part of the brush-tube and the dipper-shaped holder are decorated with two borders of lotus scrolls interspersed by key-fret patterns respectively. The tip of the brush tube is painted with designs of bats. The purple hair is bound in the shape of a bamboo shoot.

The gold-painted designs on this brush were rendered in brilliant gold colour, and the designs carried auspicious blessings of fortune and longevity. It was a typical imperial brush for court use in the Qianlong period. This type of brush was also known as the grasping shaft brush or shaft brush, which was a large-size brush. It was used by grasping up the whole large brush, and the hair was bound in a dipper-shaped shaft, and thus got its name.

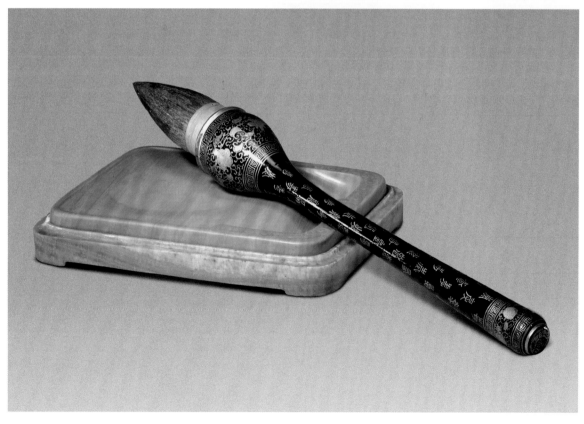

146

Black lacquer hanging screen

with raised gold and painted designs (*zhiwen*) of Emperor Minghuang riding on a horse in relief

Qing Dynasty Qianlong period

Height 86.5 cm
Width 54.5 cm
Qing court collection

The rectangular hanging screen is mounted on a red sandalwood frame. The screen is layered with black lacquer, on which are raised gold, silver, and multi-colour painted lacquer designs copying the painting "Emperor Minghuang riding on a horse" by Han Gan, a painter of the Tianbao period, Tang Dynasty, and various collectors' seal marks on the original painting. It is further decorated with an imperial inscription of Qianlong to describe the painting, an inscription "*zizisunsun yongbaojianzi*" (to be treasured and appreciated by the posterity), and imperial collection marks of the Qianlong period.

This screen is made with superb techniques with the painting reproduced in a realistic manner and representing a refined piece of decorative hanging screens. The "raised (*zhiwen*) gold-painted design is a technique to pile up raised designs by utilizing lacquer ash or thick lacquer glue, and then decorate with gold-painted or gold-applied designs. Such type of designs is also known as "hidden raised designs", referring to designs raised in relief. Thus, "hidden raised designs" (*zhiwen*) refer to designs in relief. As the designs are piled up in high relief and highlighted with raised gold-painted or gold-applied decorations, such type of lacquer ware is even more valuable than the ware just decorated with gold-painted designs or gold-applique designs on the flat surfaces, and has been regarded as a type of gold-painted lacquer ware with high technical achievements in the Qing Dynasty.

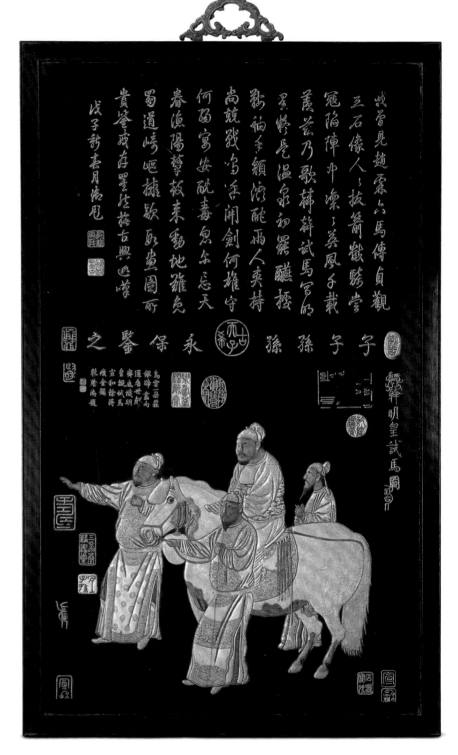

147

Cinnabar lacquer plate
in the shape of chrysanthemum petals

Qing Dynasty　Qianlong period

Height 3 cm
Diameter of Mouth 14.2 cm
Qing court collection

The body of the tray is made with a dry lacquer tire. It is in the shape of chrysanthemum petals and has a ring foot. The body is layered with cinnabar lacquer. At the centre of the plate is an imperial poem by Emperor Qianlong in clerical script filled with gold pigment, followed by an inscription "*Qianlong jiawu yuti*" (imperial inscribed in the year *jiawu* of the Qianlong period) and two square seal marks "*qian*" and "*long*". The base is layered with shiny black lacquer and has an engraved mark of Qianlong in regular stript filled with gold. The *jiawu* year corresponded to the 39th year of the Qianlong period (1774 A.D.)

According to the archive of the Imperial Workshops of the Qing palace, this plate was produced in Suzhou with the use of a very thin and light silk lacquer tire with a thickness less than 1 mm, and layered with brilliant and lustrous cinnabar lacquer with a colour like red corals. Lacquer ware with a dry lacquer tire was known as "bodiless lacquer ware" in the Qing Dynasty, and belonged to the category of "thickly coated cloth tires" as described in the *Digest of Traditional Lacquer*. The production technique is to use clay to make the biscuit first, and then coat it with many layers of gunny (or silk) by using lacquer glue. After dried, the clay biscuit would be removed, and a lacquer object with a very thin or bodiless body would be produced.

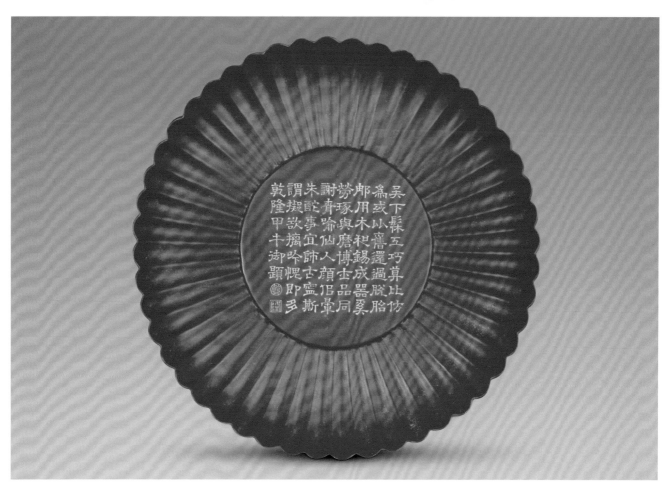

148

Cinnabar lacquer brush-holder
with carved designs of Wang Xizhi and the geese

Qing Dynasty Jiaqing period

Height 15.3 cm
Diameter of Mouth 10.3 cm
Qing court collection

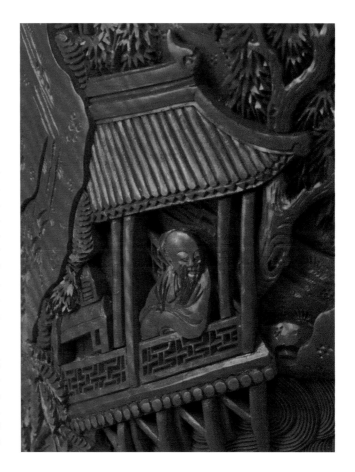

The brush-holder has a round mouth with a narrow folded mouth rim, a flat base, and a fitting stand. The body is layered with cinnabar lacquer and decorated with a scene of Wang Xizhi and the geese. At the distant background are the sky, sea, ravines, and mountains. At the near distance are trees, a stream, and a small bridge. An elderly man is sitting in front of the railings of a water pavilion and watching geese swimming in the pond. The whole scene exudes a lyrical mood of a Chinese painting. The interior and base are layered with black lacquer, and at the base is an engraved four-character mark of Jiaqing (Jiaqingnian *zhi*) in seal script filled with gold pigment.

This brush-holder is a lacquer object typical of the Jiaqing period. The carved designs are neatly and skilfully treated with strong pictorial perspectives and a sense of dimensionality, although they are rendered sharply without smooth round angles. This work is the only lacquer ware of the Jiaqing period in the collection of the Palace Museum and provides important reference for the study of lacquer ware produced after the Qianlong period.

The legend of Wang Xizhi and geese was a popular decorative motif on the crafts of the Ming and Qing dynasties, which described the legendary story that the renowned calligrapher Wang Xizhi of the Eastern Jin Dynasty was particularly fond of geese. According to the legend, Wang kept geese and was inspired by their vivid movements and the spirals created when they swam, incorporating these into his calligraphic art.

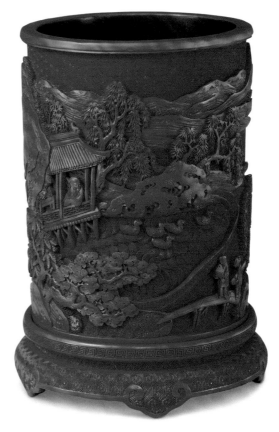

149

Sandy lacquer inkstone box
with designs of three cocks inlaid with *baibao* (a hundred precious) stones

Lu Kuisheng

Qing Dynasty　Daoguang period

Height 5.7 cm　Length 22.6 cm　Width 15 cm

The rectangular box has round angles and is layered with sandy lacquer. The surface is decorated with chrysanthemums, rocks, and three cocks with one of them standing to cry and the other two looking for food. The designs are inlaid with jade, mother-of-pearl, red coral, turquoise, ivory, and tortoise shell. The wall of the box is plain. Inside the box is a sandy lacquer inkstone. At the centre of the exterior base is a seal mark "*Lu Kuisheng zhi*" (Made by Lu Kuisheng) in seal script written with cinnabar lacquer. On one side of the inkstone is an inscription "Made by Lu Kuishen of Jiangdu in a spring day of the *jiachen* year of Daoguang". The year *jiachen* corresponded to the 24th year of the Daoguang period (1844 A.D.)

Lu Kuisheng, original name Dong, *zi* Kuisheng, was a well-known craftsman noted for producing sandy lacquer inkstones at Yangzhou in the Jiaqing and Daoguang periods. His extant works include sandy inkstones and inkstone boxes, boxes for storing stationery, etc. The choice of material and production of this work were refined, but some of the inlays were replaced later.

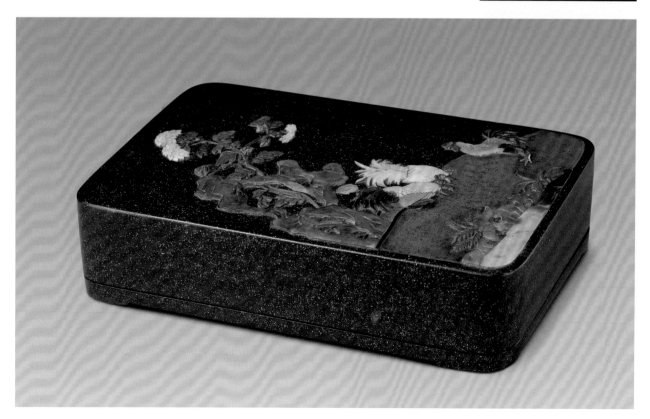

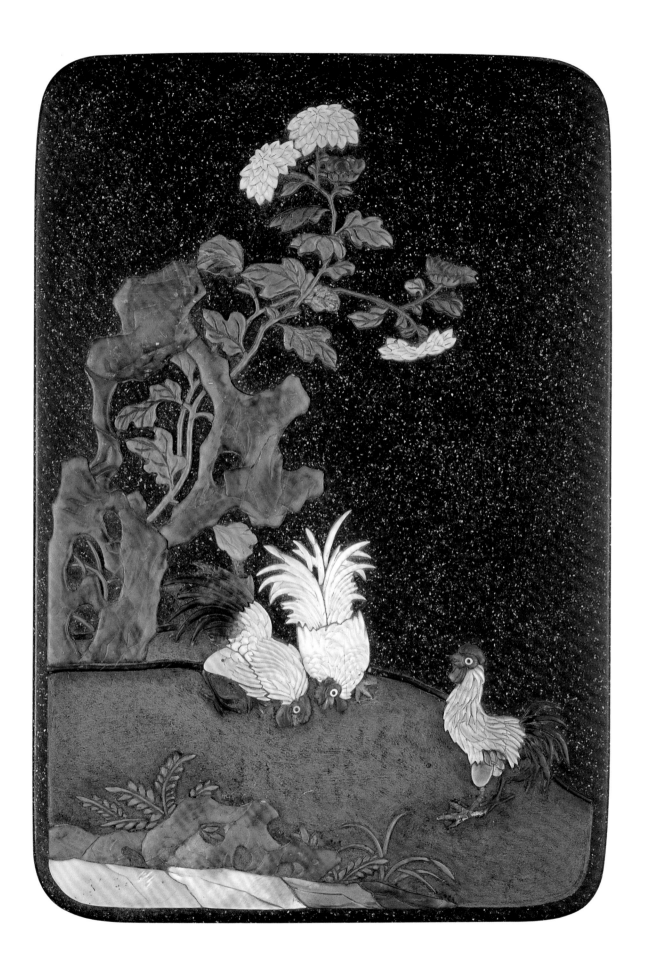

150

Cinnabar lacquer portable casket
carved with designs of a scene of literary gathering

Mid Qing period

Overall Height 35 cm Length 34 cm
Width 19.5 cm
Qing court collection

The casket is in the shape of the Chinese character "凸" with a gilt bronze over-head handle decorated with two *chi*-dragons. The body is layered with cinnabar lacquer with a brocade ground of turtle shell patterns and bordered with key-fret patterns. On the front side of the casket with square panels are carved brocade grounds suggesting heaven, water, and earth in relief. The left door panel is decorated with the legendary story of literary gathering at the Lanting pavilion in relief, which depicts scholars drinking and chating in a bamboo grove along a stream on which wine cups are floating. The right door panel is decorated with another legendary story of the "seven sages of the bamboo grove" in relief, depicting seven elderly men playing chess, chatting, or contemplating painting in the bamboo grove. On the two sides of the casket are carved designs of figures amidst landscapes. The surface of the lid is carved with designs of landscapes, goats, and cranes in relief. The interior of the casket is layered with black lacquer and has several drawers inside.

The casket is decorated with skilful pictorial rendering, showing panoramic landscape scenes with impeccable carving techniques, representing the high artistic merit of carved

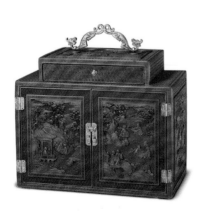

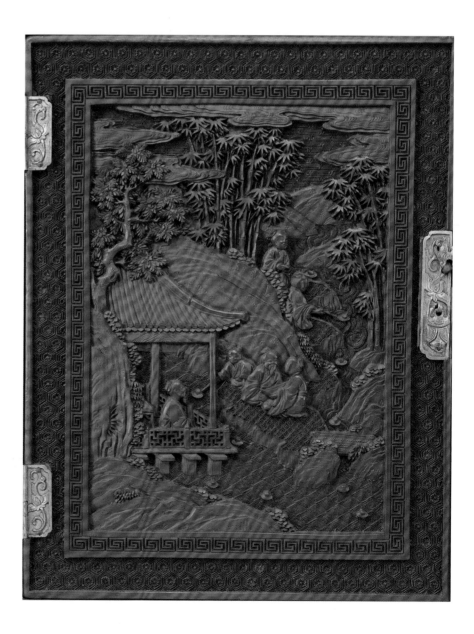

lacquer ware in the Qianlong period. The story of the Lanting Literary Gathering is about the renowned Eastern Jin calligrapher Wang Xizhi and other scholars engaging in poetry writing and wine drinking in a literary gathering at the hillside of Mount Kuaiji. The story of the seven sages of the bamboo grove describes seven lofty scholars of the Wei Kingdom of the Three Kingdoms period, including Ji Kang, Ruan Ji, Liu Ling, and others, who retreated to a life of hermitage and amused themselves with wine-drinking, chatting, playing the *qin* zither, and writing poems during literary gatherings in the bamboo grove.

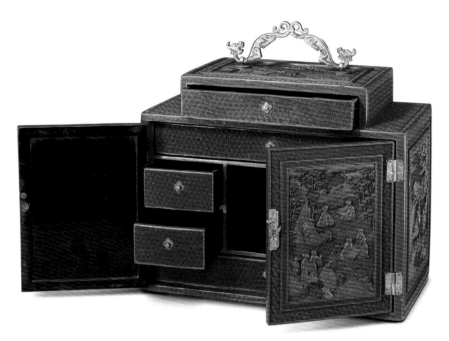

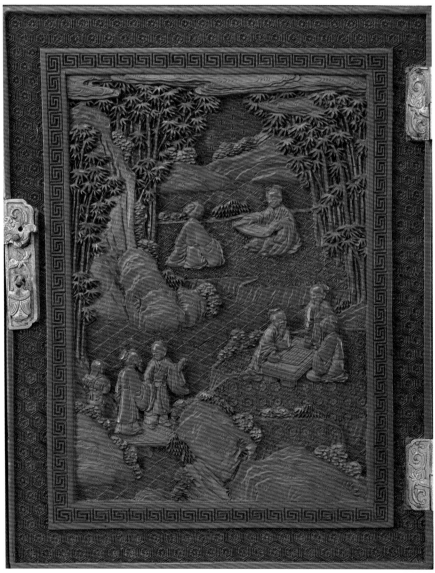

151

Cinnabar lacquer stationery case
in the shape of a book casket and carved with floral medallions

Mid Qing period

Height 30 cm
Length 32.7 cm
Width 20.2 cm
Qing court collection

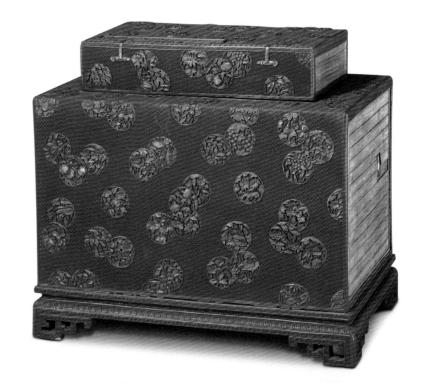

The stationery case is in the shape of a book casket which can be opened. It has four small drawers inside, and is supported by a base-stand with legs. The surface of the top is carved with four characters "*Taiping Guangji*". The front and back sides are layered with cinnabar lacquer and carved with a brocade ground of key-fret patterns, on which are carved designs of pomegranates, peonies, *lingzhi* fungi, gourds, grapes, plum blossoms, and chrysanthemums in relief, which carry the auspicious blessing of wealth, longevity, and fertiliy. The base rim and foot are carved with key-fret patterns, variegated lotus petals, and a continuous border of "⊤"-shaped patterns. The base is layered with black lacquer.

The design of the case is very creative and carved in an exquisite manner without any polishing afterwards. The carving technique of floral medallions and the form of the case reveal the new stylistic features of the mid Qing Dynasty. *Taiping Guangji* is a collection of classical Chinese novels compiled by Li Fang and others with the imperial order of Emperor Taizong in the Song Dynasty. The title of the collection of novels was named after the Taiping period in the Song Dynasty when it was completed. This case was likely used for storing such a collection of books.

152

Cinnabar lacquer hat hanger
carved with designs of dragons amidst clouds

Mid Qing period

Height 29 cm
Diameter of Top 13 cm
Qing court collection

The hat hanger has a round top and a cylindrical stand supported on an oval base with a contracted waist, and the stand is connected to four *ruyi* cloud-shaped legs. The body is layered with cinnabar lacquer with the top surface and base decorated with two dragons amidst waves in relief, and the cylindrical stand is carved and ornamented with bats amidst clouds, lotus petals, and continuous key-fret patterns in relief. The supporting stand and four legs are carved with tortoise-shell patterns in relief. The centre of the top is in gilt bronze and carved with medallions of *shou* (longevity) in openwork, and fragrant sandalwood can be put inside for giving aroma to the hats being hung.

The hat hanger is gracefully designed and carved skilfully with fine workmanship. It is both a functional object for hanging hats and a decorative object.

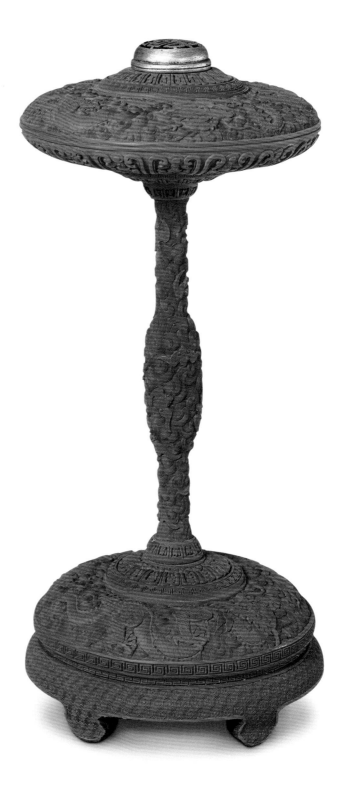

153

Cinnabar lacquer screen
carved with designs of mountain of longevity and sea of fortune

Mid Qing period

Overall Height 67 cm
Width of Screen 60 cm
Qing court collection

The body of the screen is layered with cinnabar lacquer with carved designs in relief. The front side of the screen is carved with brocade grounds suggestive of heaven, earth, and water with several boats sailing amidst waves. In the centre of an island are mansions surrounded by mountains, rocks, and trees with a seven-storied pagoda on the peak. The landscape scene is tranquil, looking like an immortal's land, and is suggestive of longevity and fortune. The back side is layered with yellow lacquer as the ground and carved with one hundred and twenty characters "*fu*" (fortune) and "*shou*" (longevity) lacquered in cinnabar in relief. The borders of the screen are decorated with tortoise-shell patterns as the ground, on top of which is a panel carved with floral designs. It has a three-tier stand decorated with cinnabar lacqauer floral patterns in openwork.

The screen is meticulously carved with towers, pavilions, and mansions in openwork. The cinnabar lacquer is thick with brilliant red colour, and this ware fully illustrates the high standard of lacquer ware of the mid Qing Dynasty.

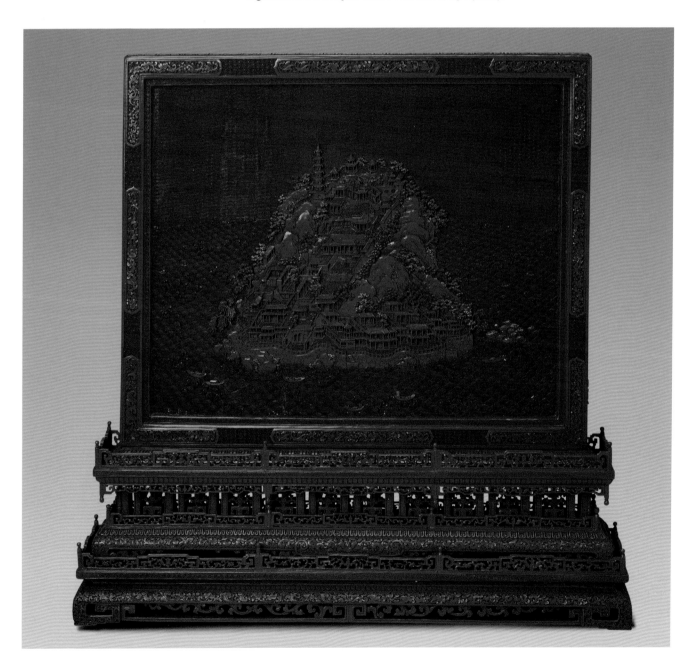

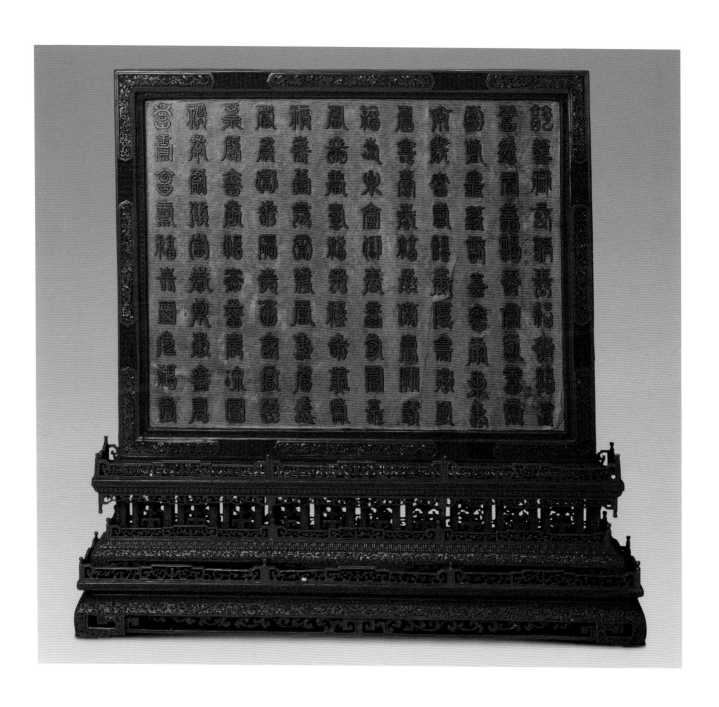

217

154

Multi-lacquer peach-shaped box
with carved designs of clobbering Zhang Guolao crossing the sea in green and coloured lacquer

Mid Qing period

Height 7 cm
Diameter of Mouth 13 cm
Qing court collection

The box is in the shape of a peach with the body layered with green lacquer and carved with crested sea waves in relief. Designs of flowers floating on the sea and a long beard elderly man looking back with his hand holding up a whip while riding a donkey across the sea are carved in cinnabar lacquer in relief. The interior of the box and the base are layered with cinnabar lacquer.

The cinnabar lacquer designs on this box are produced by partially filling with coloured lacquer. The production technique is to layer the whole object with green lacquer and to carve wave patterns; then the green lacquer on designated designs of the figure, animal, and flower petals are removed and replaced by cinnabar lacquer with details further embellished. Such a technique was a kind of "multi-colour embossed technique", and was described as *duise* (piled colours) in the book *Digest of Traditional Lacquer*. The figure of the old man is Zhang Guolao, one of the legendary eight immortals, who is said to have the abilities to walk, roll, swing, and run across water on a donkey.

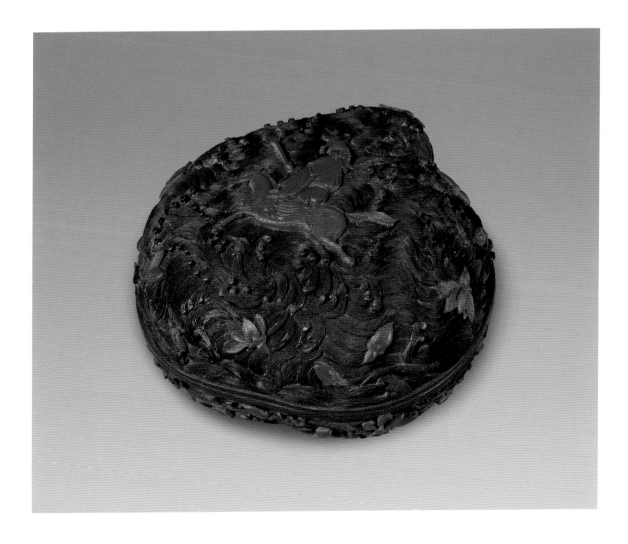

155

Cinnabar lacquer snuff bottle
carved with designs of the story "fondness for lotuses"

Mid Qing period

Overall Height 7 cm Diameter of Belly 5.8 cm
Qing court collection

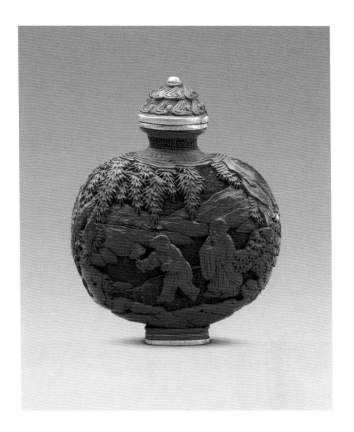

The bronze ovoid snuff bottle has a flared mouth and a ring foot. The body is layered with cinnabar lacquer and carved with a continuous scene of the story "fondness for lotuses" with majestic mountains and willows around. On one side is an elderly man contemplating lotuses in a pond, accompanied by a boy attendant at his side. On the other side is a boy attendant holding a lotus while leading an elderly man on the way. The designs describe the story of the renowned Neo-Confucian scholar Zhou Dunyi in the Song Dynasty and his fondness for lotuses. It has a cinnabar lacquer stopper with a fitting ivory spoon.

Zhou Dunyi's fondness for lotuses is a classical decorative motif much favoured with other motifs including Wang Xizhi's fondness for geese, Tao Yuanming's fondness for chrysanthemums, and Lin Hejing's fondness for cranes (and plum blossoms). These four decorative motifs are collectively known as "the four fondnesses" to represent the loftiness and transcended literati spirit of the elite class in ancient China.

156

Reddish-brown bodiless lacquer snuff bottle
with gilt designs with a carp leaping the Dragon Gate

Mid Qing period

Overall Height 6.2 cm Diameter of Belly 4.9 cm
Qing court collection

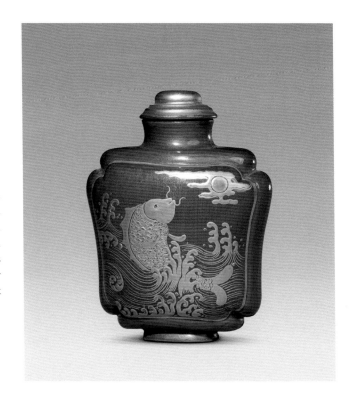

The snuff bottle has a bodiless biscuit, a slightly flat belly, and a base. The bottle is layered with reddish-brown lacquer and decorated with painted designs. Both sides of the belly are outlined with a panel in accordance with the shape of the bottle, in which are similar decorations of a carp leaping the Dragon Gate painted in two varied gold colours: a carp is leaping high above crested waves in a background setting of the red sun rising high up in the sky surrounded by floating clouds, which carries auspicious blessing. It has a gold lacquer stopper with a fitting ivory spoon.

The snuff bottle was made in the Fujian province.

157

Black lacquer hand-warmer
with gilt and painted designs of landscapes in panels

Mid Qing period

Overall Height 14 cm
Length 18.4 cm
Width 12.9 cm
Qing court collection

The warmer is in the shape of intertwining clouds and has a lid and a gilt bronze overhead handle. The interior has a gilt bronze bladder which fits the lid mounted with copper wires. The warmer has four panels layered with black lacquer and decorated with gilt and painted designs of landscapes with towers, mansions, and pavilions. Outside the panels is a yellowish-brown ground with lotus scrolls painted in red and black. The borders of the lid and the over-head handle are lacquered in black and ornamented with gold painted brocade ground of lozenges. The base is layered with black lacquer with a small round hole at the centre.

The designs on the warmer are skilfully painted with contrasts in the nuances of gilt, resembling the consummate treatments of ink paintings by painters. The rocks at the front distance are outlined in gold with textural strokes, and some elements are further highlighted by red or black lacquer to enhance the rugged feeling of landscapes. The distant mountains are outlined in light gold with the lacquered layer at the base barely exposed to generate a sense of the void and solid with eminent perspectives of the pictorial treatments. This work is a representative piece of gilt and painted lacquer ware.

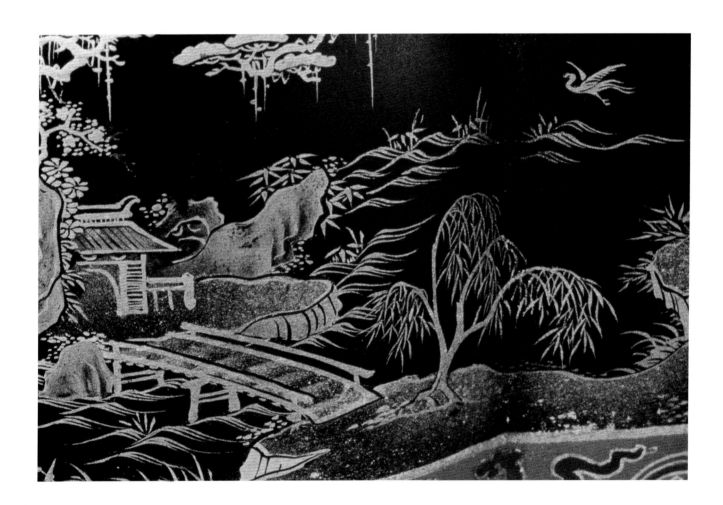

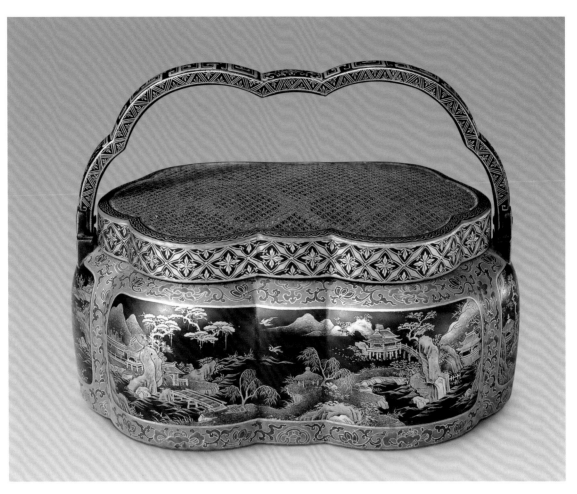

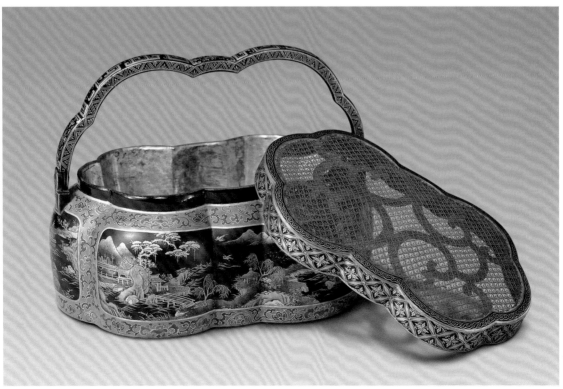

158

A set of lacquer boxes
with raised decorations (*zhiwen*) and gold
painted designs of melons and fruits

Mid Qing period

Overall Height 28 cm Diameter 18.2 cm
Qing court collection

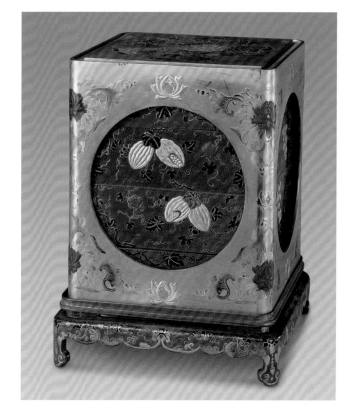

This set of boxes has three tiers with a fitting outer hood and
a square stand. The boxes are layered with aubergine lacquer with
sprinkled gold and raised decorations painted in gold and silver.
The surface of the cover is painted with peaches, pomegranates,
and citrons, the so-called "three abundances" design that
symbolizes longevity, fertility, and fortune. The four sides of the
box set are decorated with grapes, bitter gourds, and gourd design
which also symbolize fertility with many offsprings. The base tier
has five fitting boxes decorated with bats and the character "*shou*"
(longevity) which are suggestive of fortune and long life lasting
forever. The fitting box hood is layered with gold lacquer with four
decorative round panels. The four sides and the surface of the top
are decorated with the hundred flowers design. The stand is layered
with aubergine lacquer and decorated with gold painted designs of
flowers, which is supported by four legs in the shape of clouds.

The design of this box set is creative, showing superb
workmanship by blending various techniques of lacquered
decorations, and it represents a very unusual and valuable lacquer
object of its type.

159

Rectangular lacquer box
with designs of lotuses and butterflies painted in coloured oils

Mid Qing period

Height 6.2 cm
Length 21.7 cm
Width 18 cm
Qing court collection

The rectangular box has slanting corners, a fitting cover and body, a flat surface, and four legs in the shape of clouds. The surface of the cover is layered with cinnabar lacquer as the brocade ground which is decorated with swastikas (卍), and the centre is a variegated lotus painted in coloured oil. Each of the four corners is decorated with a butterfly in red, white, blue, and other colours respectively. The wall of the cover is painted with a brocade ground of swastikas (卍) in coloured oil and decorated with lotus designs on top.

Painted oil decorations refer to the technique of using oil instead of lacquer to render decorations on lacquer ware. The difference between oil and lacquer is that oil can be mixed with more colours to produce designs with a luxuriant colour scheme. Such an oil-painted technique was often employed to decorate lacquer ware of the Qing Dynasty with a delightful colour scheme, as represented by this piece. This ware is a representative piece of lacquer ware painted in coloured oil of the Qing Dynasty.

160

Lacquer treasure box
with painted designs
of fans in gold tracery over a
gold-sprinkled ground

Qing Dynasty

Height 21 cm
Length 26.6 cm
Width 21.5 cm
Qing court collection

The rectangular box has a wooden body and a fitting cover. The surface of the cover and the exterior of the box are decorated with fan designs in gold tracery. The box is set with copper handles on the walls, and the surface of the cover has a yellow slip on which is written with an inscription "*renzi di yiqianyibaier hao*" (no. 1102 in the *ren* series) in ink. Inside of the box are upper and lower compartments, and each has compartments in different sizes for storage of forty-one pieces of water pots, paper weights, calligraphy scrolls, calculation tables, metal knifes, fasting and ablution tablets, jade *bi* disks, vases, and others. Most of these objects are made with precious stones, jade, agate, crystal, cloudy amber, glass with aventurine sprinkled glass, etc.

This treasure box was modeled after a Japanese lacquer object and used for storing objects produced in the Kangxi and Qianlong periods, as well as some imperial collection items of Song and Yuan objects, which were for the appreciation of Emperors of the Qing Dynasty. These items were categorized as "a hundred assorted collectibles" in the Qing court Archive.

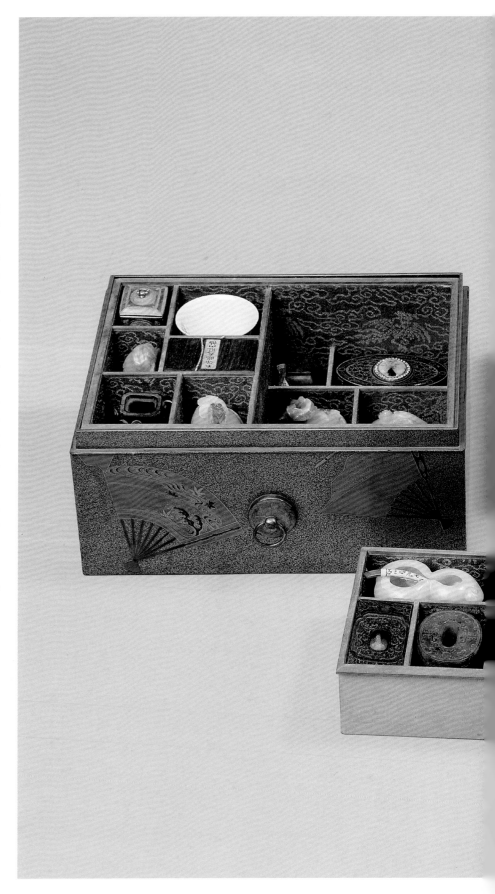

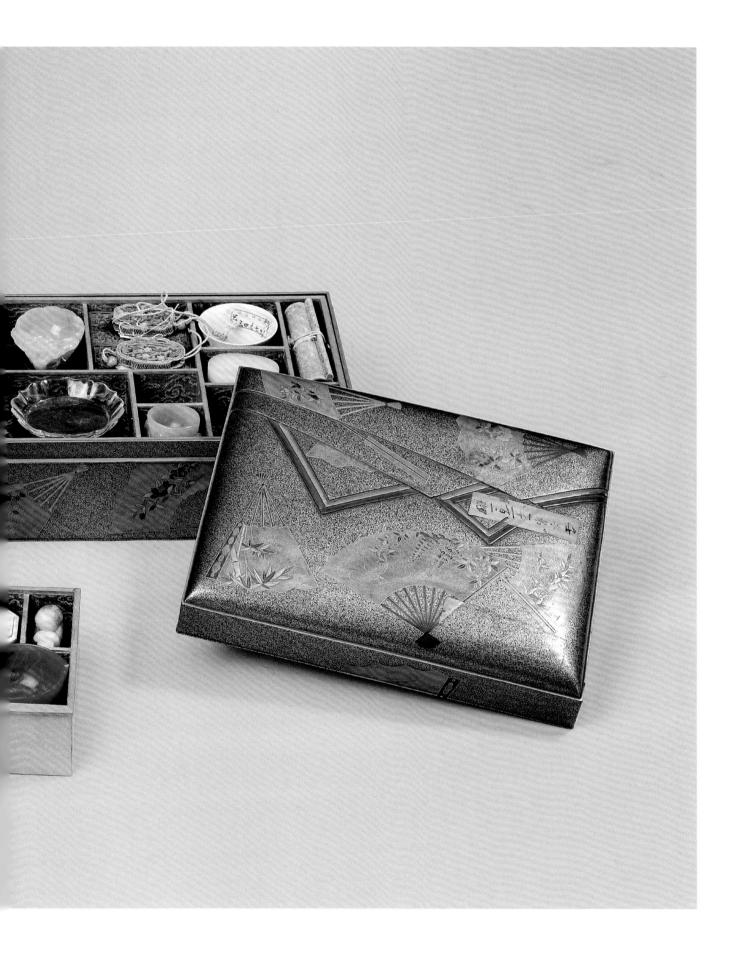

161

Sandalwood brush
with rabbit's hair (*huahao*)
and carved designs of
dragons and phoenixes
in relief on the holder-tube

Ming Dynasty Wanli period

Length of Holder-tube 16.1 cm
Diameter of Holder-tube 1.9 cm
Length of Cap 9.6 cm
Qing court collection

The holder-tube is carved with dragon and phoenix designs in low relief, and complemented by floral patterns such as holly-hocks and chrysanthemums. In the rectangular frame on the upper side is an incised inscription "*Daming Wanlinian zhi*" (made in the Wanli period of the Ming Dynasty) in regular script filled with blue pigment. The cap of the brush is carved with two dragons with the top inlaid with mother-of-pearl. The brush tip has rabbit's hair bound in the shape of a gourd.

The brush was finely craved, and the colour of mother-of-pearl was brilliant and bright, which was for imperial use in the Ming court.

This brush gets its name as "*huahao*" (colour hair) as it is made with rabbit's hair in interspersed colours of yellow and brown.

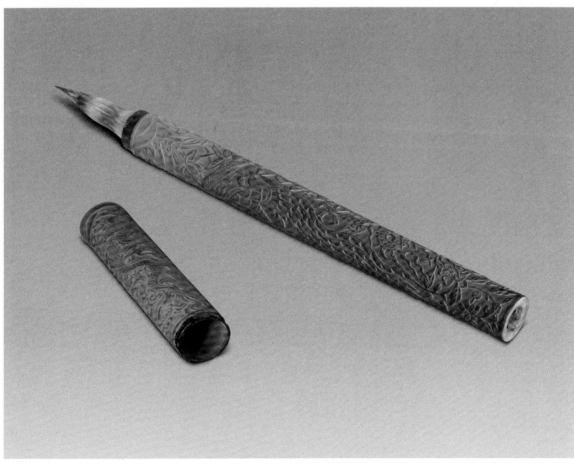

226

162

Bamboo brush-holder
with carved designs of ladies

Zhu Sanson

Ming Dynasty Wanli period

Height 14.6 cm
Diameter of Mouth 7.8 cm Diameter of Leg 7.7 cm
Qing court collection

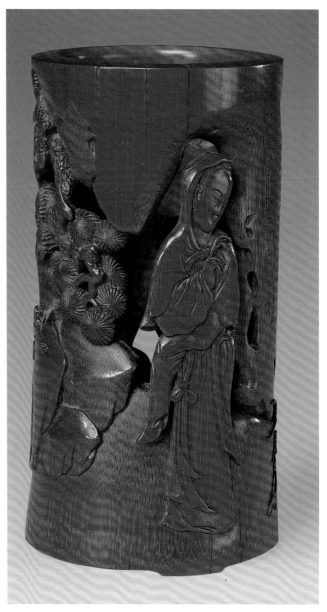

The brush-holder is cylindrical in shape and is supported on three legs. The exterior wall is carved with a lady wearing a winter hat on the head and holding orchids by the side of a rock. In front of her are rocks with holes and a pine tree protruding from a hole robustly. Underneath the pine tree is a stone table on which a cup and an inkstone are placed. On the rock is an engraved mark "*Wanli jiayin qiu bayue, Sansong zuo*" (made by Sansong in the eighth month of the year *jiayin* of the Wanli period) in running script. On the side of this mark are an engraved imperial poem by Emperor Qianlong in clerical script and an inscription "*Qianlong dingyou xinyue yuti*", below which are two engraved square seal marks "*qian*" and "*long*". The year *jiayin* corresponded to the 42nd year of the Wanli period (1614 A.D.) while the year *dingyou* corresponded to the 42nd year of the Qianlong period (1777 A.D.), and *xinyue* referred to the first month of Chinese lunar year.

On this brush-holder, various carving techniques in openwork, relief, and engraving are utilized to render the decorations in a skilful manner with superb workmanship, and the work represents a refined piece of bamboo carvings.

Zhu Sansong, oriental name Zhizheng, was reputed as the "three Zhus of Jiading" together with his father Zhu Xiaosong and grandfather Zhu Songlin. They were all masters who marked the zenith of Chinese bamboo carvings in history. Among the three, Zhu Sansong's achievement was the most distinguished, surpassing that of his father and grandfather.

163

Small bamboo vase
carved in the shape of a pine tree

Pu Cheng

Late Ming period

Overall Height 12.3 cm
Diameter of Mouth 8.4 cm
Diameter of Base 8.5 cm
Qing court collection

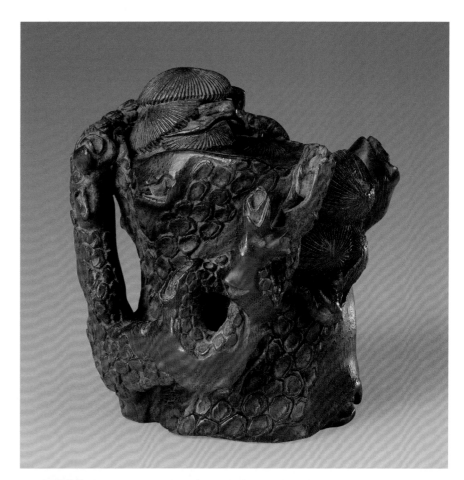

The vase in the shape of a pine tree is carved from a bamboo root, with the body in the shape of a pine tree stump, a handle in the shape of pine branches, and the spout in the shape of a broken stem. The lid of the vase is creatively carved into layers of branches and leaves, and linked to the stump. Underneath the handle is an engraved mark "*Zhongqian*" in regular script.

The vase is creatively carved in accordance with the natural form of the bamboo root, and the decorations are rendered by carving techniques in deep and low relief with a touch of lyricism and archaic flavour. Though such a decorative style is quite different from the typical style of Pu Cheng, which is naturalistic and simple as recorded in historical documents, this piece with creative design and skilful workmanship is of high historic value.

Pu Cheng (1582 A.D. - ?), *zi* Zhongqian, was a renowned bamboo carver in Jinling (present day Nanjing, Jiangsu) in the late Ming period. Pu was fond of utilizing naturally twisted forms and features of bamboo roots to carve bamboo ware with simple and precise techniques and with modest details to keep the naturalistic charm of bamboo in his works.

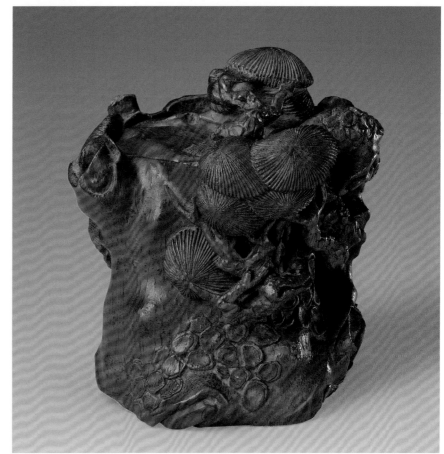

164

Bamboo brush-holder
with carved designs
of an old man picking his ear

Late Ming period

Height 15 cm
Diameter of Mouth 10 cm
Diameter of Leg 10 cm
Qing court collection

The brush-holder is cylindrical in shape and is supported on three short legs. The exterior wall is carved with designs of inverted mountain rocks, pines, and bamboos in openwork and relief. An elderly man is leaning on a slope with one hand holding a tablet and the other hand picking his ear with a small strip. His facial expressions show that he feels very comfortable and is amused with picking ears, and the figure is depicted vividly.

The carving techniques in producing this bamboo ware are manipulated skilfully with the figure consummately depicted. With close examination of his physical features, the figure might be Zhong Kui from the Chinese legend.

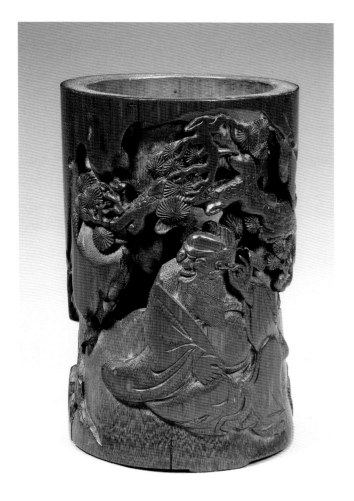

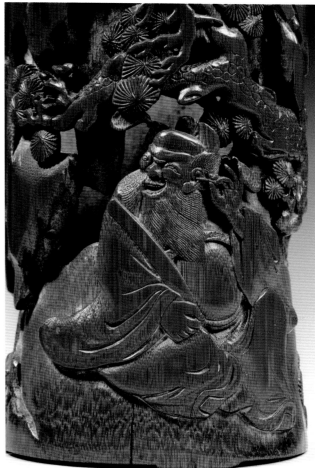

165

Red sandalwood gift case
inlaid with a hundred precious stones and *chi*-dragons amidst clouds

Late Ming period

Height 10.7 cm
Length 29.5 cm
Width 18.5 cm
Qing court collection

The rectangular case has fitting upper and lower parts and a recessed base. The four walls are carved with massive *chi*-dragons in different postures in low relief. The surface of the cover is carved with floating clouds. Six *chi*-dragons and flames visible amidst clouds are set and inlaid with pearls, corals, lapis lazuli, cloudy amber, jade, and various precious stones. Inside the box are partitioning panels engraved with imperial poems and annotations by Emperor Qianlong in clerical script filled with gold pigment and with inscriptions "*Qianlong jiyou yuti*" (Imperial inscribed in the year *jiyou*), together with one relief and one engraved seal mark "*guxitianzi zhibao*" and "*youri zizi*" in seal script. The year *jiyou* corresponded to the 54th year of the Qianlong period (1789 A.D.).

The form of the case is similar to the case for storing letters or gifts, but according to Emperor Qianlong's poem, it has been used for storing a white jade tablet. The case demonstrates superb workmanship with decorative designs sophistically and extravagantly rendered, and the designs match with the box perfectly. The six colours of red, orange, yellow, blue, white, and black stand out prominently and brilliantly against the deep colour of red sandalwood, marking it a very rare and valuable piece of its type.

This type of rectangular cases was traditionally used for storing letters or gifts during visits to seniors. Inlaid designs of a hundred precious stones (*baibaoqian*) refer to decorations inlaid or set with precious materials such as jadeite, agate, coral, lapis, ivory, turquoise stones, and others on wood or lacquer ware. These objects include large pieces such as screens and bookcases, and small pieces such as brush-holders, inkstone boxes, etc., which are often decorated with fine pictorial treatment and a brilliant colour scheme.

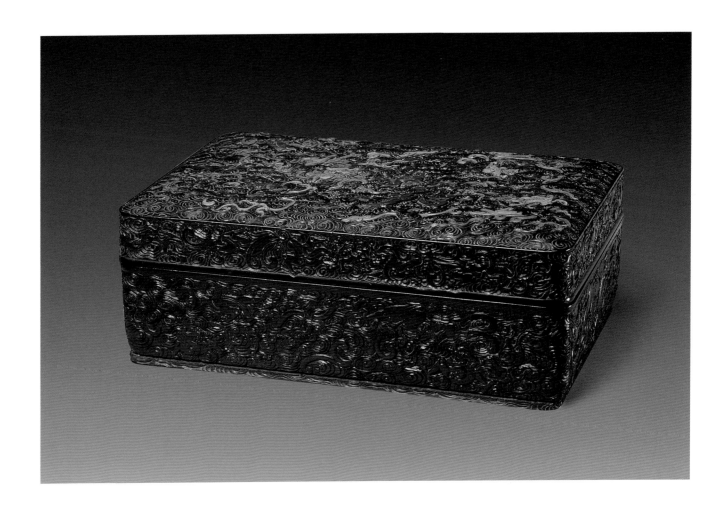

相聲平帶峯山質琢而更
籍鎪何時出土上誰氏
佩耳邊比德剛柔協論
杅環珮連几陳資睇玩
匣行引吟詮昔有餘堪
憶今暢用無用以萬弄斯捐莫教成
有用暢以萬弄斯捐莫教成

玉具玉鈐之不
玉庶可度制不能帶而以綿之緒錫
可及謨改有後於堪惑不為國家
向謂諜元人鑒流為有億萬用
本冠著於且舉朝之北我則賞之
漢禮一之此乃代器舊魏我于物之
漢冠代之子於北我則我于丰

乾隆己酉御題

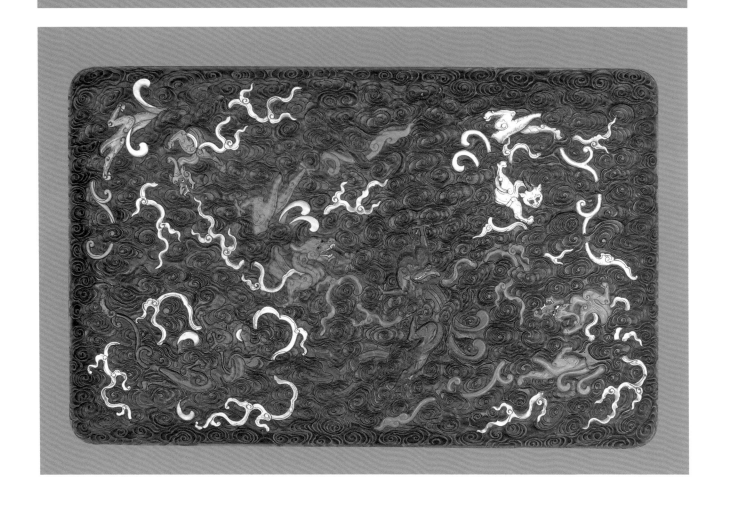

166

Bamboo root carving
of an old man picking herbal medicine

Early Qing period

Height 14.7 cm
Diameter of Base 12.1 cm
Qing court collection

The bamboo root is carved in the form of an old man having his hair coiled up, with long beards and a slender body, in the round. He is wearing a pair of sandals knitted by grasses, holding a basket of flowers, and sitting on a rock with his clothes loosely hanging down to expose his knees. A hoe to pick herbs for medicinal use is at his side, and he seems to be taking a break, or contemplating. The figure is carved in an enlivened and realistic manner.

In carving this work, various techniques of craving in the round and openwork are skilfully utilized to capture the posture, facial expression, and costume of the old man in order to highlight his identity and his life of having spent long time in doing outdoor works. The peaches, *lingzhi* fungi, and narcissuses in his baskets carry the auspicious blessing of longevity, and this work is a very unusal and refined piece of bamboo carvings.

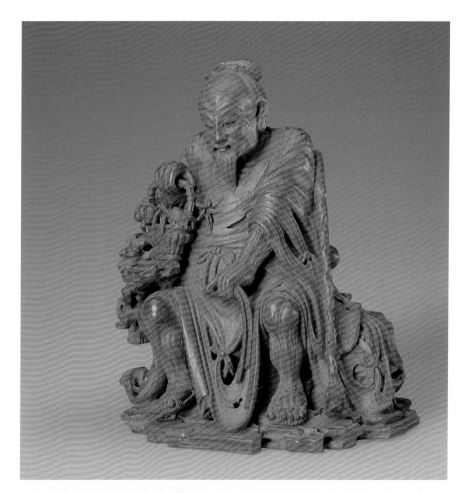

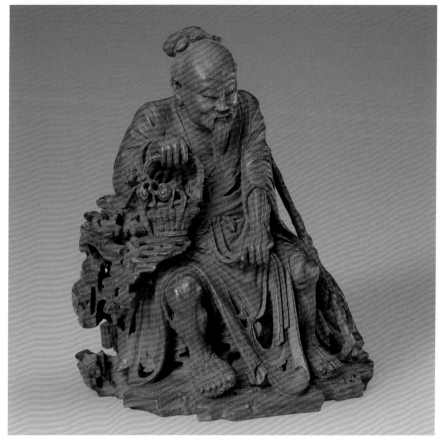

Boxwood brush-holder
carved with the scene of announcing victory at Dongshan

Early Qing period

Height 17.8 cm Diameter of Mouth 13.5 x 8.5 cm
Qing court collection

The brush-holder is cylindrical in shape and is supported on three short legs. The exterior wall is carved with a scene of the Battle at Fei River (Feishui zhizhan). The battle scene is replaced by depicting a cliff as the boundary to separately depict two scenes – announcing victory of the battle and playing chess. On one side of the cliff is a scene with an old pine with shades, and Xie An is playing chess with an old man under it. Another man is watching the chess game with a maid and a servant standing behind. The other side is carved with a soldier messenger riding on a horse and running among rocks and trees while holding a flag to announce victory of the battle. The contrast of the two scenes – one in tranquility while another in action, brings out the theme of the military strategy of Xie An, who fully commands fighting the battle and waiting for victory when he is playing the chess game. On the cliff is an engraved mark "*Chaxi Wu Zhifan*" in clerical script with a seal mark "*Lu Zhen*" in seal script beneath. On the left is an engraved imperial poem by Emperor Qianlong with two seal marks "*gu*" and "*xiang*" beneath.

This brush-holder is carved with the techniques of high relief and openwork. The pictorial composition is sophisticatedly and skilfully modulated with layered perspectives and spacious treatment, and carved in a delicate manner, showing the artistic charm of boxwood carvings.

Wu Zhifan, *zi* Lu Zhen, was a native of Jiading (present day Shanghai). His years of birth and death were unknown, but he was known to be active from the mid to the late Kangxi period and was renowned for carving bamboo ware. Reputed craftsmen at the period were often specialized in one kind of craft, yet they were able to command other crafts as well. This work is a representative piece of wood carvings by Wu Zifan.

168

Red sandalwood brush-holder
carved with designs of *chi*-dragons and *kui*-phoenixes

Early Qing period

Height 17.8 cm
Diameter of Mouth 13.1 cm
Diameter of Foot 13.8 cm
Qing court collection

The brush-holder is cylindrical in shape with three redwood short legs inlaid underneath. The mouth rim is inlaid with copper wires as branches and vines, and agate, turquoise, and lapis lazuli as grapes and leaves. Among the flowers and leaves are six mythical beasts inlaid with mother-of-pearl. The exterior wall is carved with clouds in low relief as the ground on which are intertwining dancing *chi*-dragons and *kui*-phoenixes in flight carved in high relief and openwork. The eyes of the dragons and phoenixes are set with mother-of-pearl and rhino horn flakes.

This brush-holder is in deep colour and has a robust form. The relief and openwork designs are rendered in a sophisticated yet precise manner and finely polished. The designs exude an archaic flavour but at the same time reveal the spontaneous and free style in vogue at the time. It is a refined and representative piece of sandalwood stationery of the period.

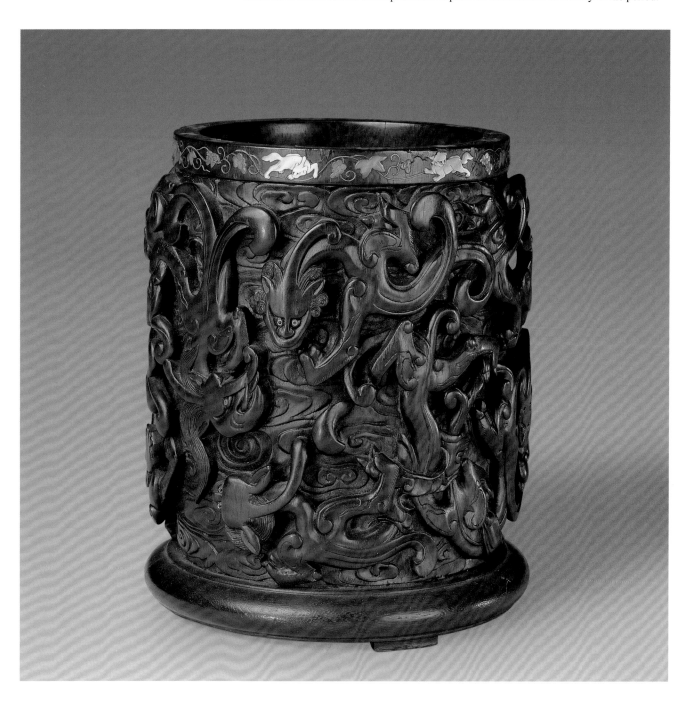

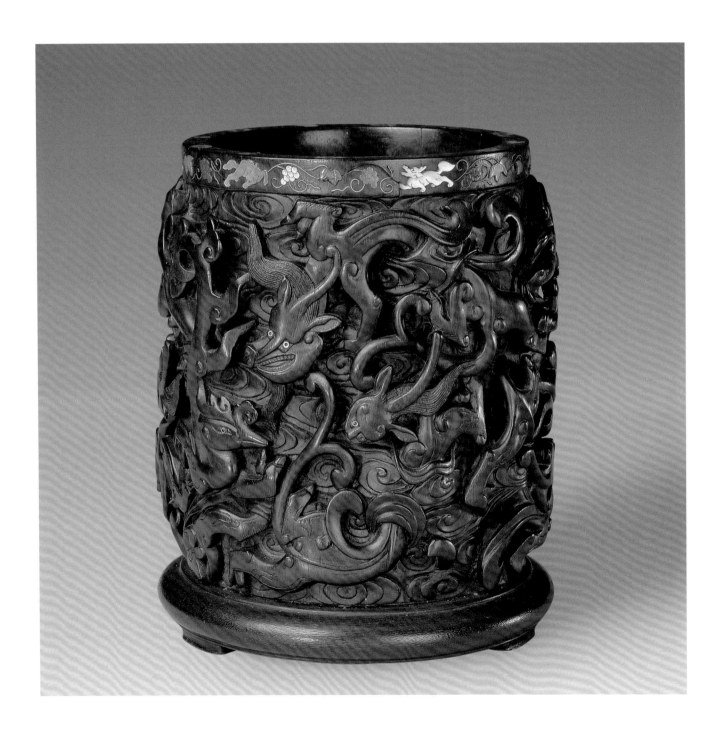

169

Red sandalwood gift box

inlaid with a hundred precious stones and designs of lotus roots

Early Qing period

Height 8.8 cm Length 29.2 cm
Width 23.4 cm
Qing court collection

The box is rectangular in shape with a fitting cover. The mouth rim is decorated with key-fret patterns inlaid with silver wires. The designs of lotus roots, lotus cups, bamboos, orchids, chrysanthemums, and lycium seeds on the surface of the cover are inlaid with lapis lazuli, mother-of-pearl, precious stones, tourmalines, corals, turquoises, and coloured ivory. The decorative motifs are suggestive of integrity, righteousness, and longevity. The drawer in the case is for storing books.

The box has a neatly modeled form and is made with fine quality materials. The pictorial composition of the designs is treated meticulously with a bright colour scheme and a delicate inlay technique. It is a representative and extant piece of work inlaid and set with a hundred precious stones (*baibaoqian*) of the court.

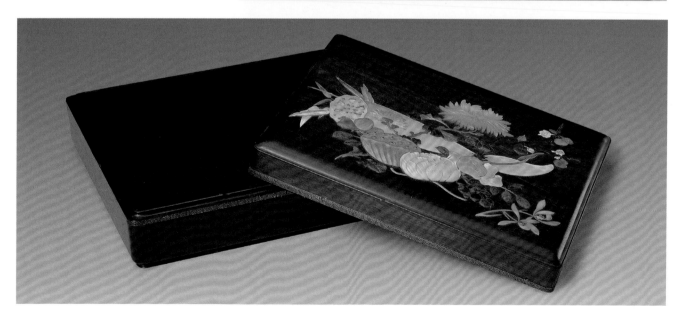

236

170

Small boxwood box
carved in the shape of *lingzhi* fungi

Qing Dynasty Yongzheng Period

Height 2.9 cm
Diameter of Mouth 7.4 x 5.7 cm
Qing court collection

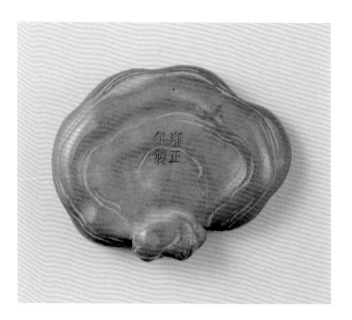

The box is carved in the shape of three stalks of *lingzhi* fungi overlapping each other and has a fitting cover. The largest stalk of *lingzhi* fungi forms the body which is very thin. The exterior base is engraved with a four-character mark of Yongzheng (Yongzhengnian *zhi*) in regular script.

The box is carved according to the natural form of the piece of boxwood which is impeccable in craftsmanship and carries auspicious blessings. It is a refined and rare extant piece of boxwood ware of the Yongzheng period.

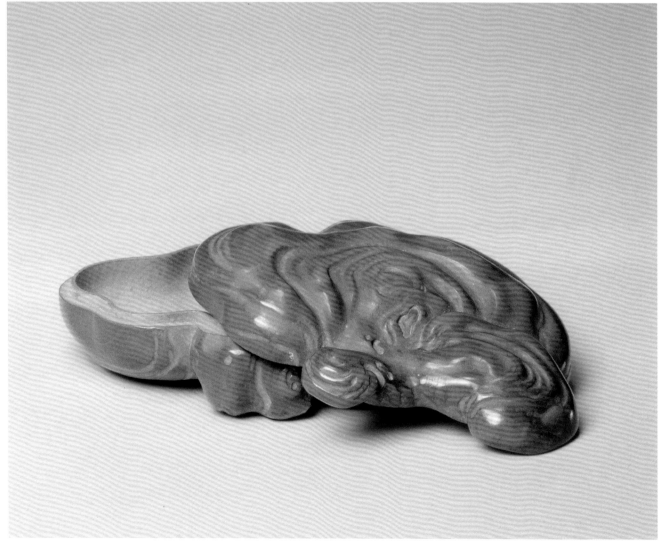

171

Red sandalwood table screen

with carved designs of *chi*-dragons and inlaid with a white jade *bi* disk

Qing Dynasty Qianlong period

Overall Height 21.7 cm Width 15.8 cm
Qing court collection

The red sandalwood screen has the centre of its front side inlaid with a white jade *bi* disk decorated with three *chi*-dragons. The back side is engraved with an imperial poem by Emperor Qianlong in clerical script filled with gold pigment, and the inscription "*yuti*" (imperial inscribed) and two seal marks "*jixiayiqing*" and "*dejiaqu*" in seal script, which describe the amusement obtained during leisurely pursuits. The four sides are engraved with variegated *kui*-dragons filled with gold pigment. The base of the screen is also engraved with variegated *kui*-dragons filled with gold pigment.

The table screen has its form and style similar to a single panel standing screen, but smaller in size, and is often placed on a table for decorative and appreciation purposes.

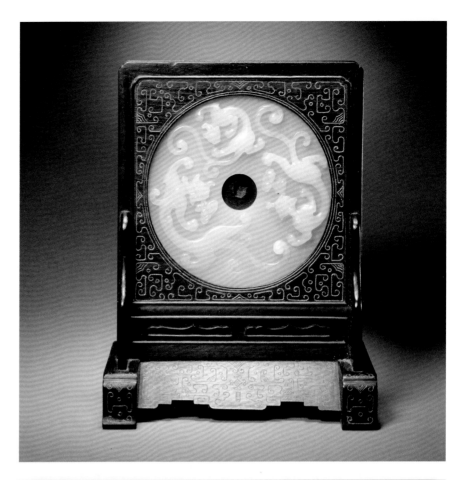

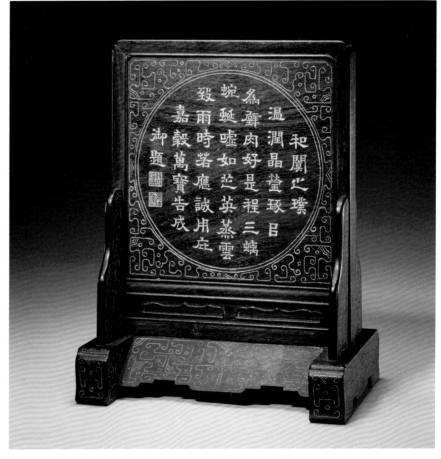

238

172

Red sandalwood brush-holder
with carved designs of Wang Xizhi's fondness for geese inlaid with a hundred precious stones

Mid Qing period

Height 13.9 cm
Diameter of Mouth 12.2 cm
Qing court collection

The brush-holder has a recessed mouth rim, and the base is set with three short red sandalwood legs. The exterior wall is decorated with a composite scene of Wang Xizhi's fondness for geese and Wang Xizhi writing on a fan, set and inlaid with mother-of-pearl, coloured ivory, tortoise shells, cloudy amber, boxwood flakes, etc. Wang Xizhi, wearing a brown hat, a yellow robe, and a white dress, is looking back and pointing with a finger on his right hand. Behind him is an old woman walking towards Wang Xizhi, who is carrying a basket with two round fans inside on her right hand, and holding a goose on her left hand.

The pictorial composition of the designs is gracefully rendered with details, and facial expressions of the figures are vividly depicted like a painting. It is set and inlaid with precious stones with abundant colours, as well as complemented by skilful carving techniques, making the designs fully stand out on the deep colour red sandalwood.

The Chapter *Biography of Wang Xizhi* in the *History of Jin* described that during his travel, Wang met an old lady selling round fans in the market place but in vain. Feeling sympathy for her, Wang wrote five characters on the fans and told the old woman to say that the fans were written by Wang Youjun (Wang Xizhi who was a renowned calligrapher). As a result, many people were attracted to buy the fans from her. Later, the old lady requested Wang to inscribe her fans again but Wang declined with courtesy. This story was then treated as a proof that Wang's calligraphy was highly esteemed at the time.

173

Red sandalwood box
in the shape of a bookcase and with carved designs of "three abundances" inlaid with a hundred precious stones

Mid Qing period

Height 25 cm Length 34 cm Width 19.8 cm
Qing court collection

The case has a fitting cover and body. The two sides of the cover are inlaid with bamboo strips in the shape of the binding of a bookcase, and exposing the book pages inside with a very creative design. The cover, front, and back sides of the case are decorated with the designs of "three abundances", including peaches, citrons, and pomegranates set and inlaid with precious stones, jade, coloured ivory, agate, and mother-of-pearl, suggestive of longevity, fortune, and fertilty. Inside the case are drawers with horizontal partition panels decorated with openwork designs. Beneath is a wooden stand with a contracted waist on which are carved railings in openwork with four small stands at the four corners set with a bronze knob.

The hood of this covered box is highly creative in design and shows exquisite workmanship, and the work is a representative piece of imperial stationery set and inlaid with a hundred precious stones (*baibaoqian*) of the mid Qing period.

174

Bamboo box with four small boxes

carved with characters *"chun"* (spring) and *"shou"* (longevity) in bamboo skin veneered relief (*wenzhu*)

Mid Qing period

Height 11.2 cm
Diameter 19.2 cm
Qing court collection

The box has a fitting cover and body. The cover is square in shape with a round enclosure at the centre, which is shaped like an ancient jade *cong* tube. The surface of the cover is decorated with a treasure basin and a character *"chun"* (spring) as the major design, and accompanied by two dragons. The four sides are decorated with ninety-six characters *"shou"* (longevity) in various scripts and supplementary four designs with the blessing of long life, adding up to suggest a long life lasting a hundred years of age. In the box are four small square boxes, the surface of which is decorated with bamboo skin veneered designs of the characters *"tian"*, *"di"*, *"tong"*, and *"chun"*, which collectively mean "harmony of spring comes to heaven and earth".

This box is made by utilizing the bamboo skin veneered technique (*wenzhu*) with the designs fit and set perfectly together with a harmonious and elegant colour scheme, reflecting marvelous craftsmanship. The form and design of this kind of boxes had already appeared in the carved lacquer ware of the Jiajing period of the Ming Dynasty, and were massively produced with a variety of materials in the Qianlong period of the Qing Dynasty. This work is one of the most typical objects of such ware.

Bamboo skin veneered carving (*wenzhu*) is also known as *zhuhuang* (bamboo skin), and has other descriptions such as "inverted bamboo skin" and "veneered bamboo skin", representing a distinctive category of bamboo carvings. In producing such ware, the large bamboos in South China are used by cutting away the green surface of bamboos and removing textures, so that only thin bamboo skin strips would be left. After boiling, drying, and flattening, the bamboo skin strips would be glued to the surface of ware, and then carved into various designs.

175

Bamboo stationery box
in the shape of a cabinet with carved designs in bamboo skin veneered relief

Mid Qing period

Overall Height 23 cm
Length 20.3 cm
Width 13.2 cm
Qing court collection

The stationery box is shaped like a small cabinet with five drawers, and on top are a vase-shaped box, a box with a contracted waist, and a book-shaped box. The surface of the veneered bamboo box is decorated with inlaid and glued floral scrolls, banana leaves, waves, and tortoise shell patterns made with dark brown bamboo strips, and further set and inlaid with bamboo strips and jade. A *ruyi* scepter is glued inside the small box in the shape of a vase, suggestive of "peace and best wishes".

This work is made by utilizing techniques of bamboo skin veneered relief, set and inlay, engraving, and carving in openwork. It has been used for storing album booklets and jade accesserories, and represents an object that reflects the aesthetic taste of the court and a distinctive period style.

176

Bamboo brush-holder
decorated with bamboo stems in bamboo skin veneered relief

Mid Qing period

Height 15 cm
Diameter 12 cm
Qing court collection

The brush-holder is square in shape and has a slightly thick body and a shallow square foot. Both the interior and exterior walls are layered with veneered bamboo skin with a light patina and decorated with bamboo stem patterns. The irregular stems are rendered in the shape of geometric patterns " ∾ " with a rhythmic representation. The joints of the stems are slightly in relief, and the joints of bamboo branches to the stems are slightly recessed, exuding a sense of dimensionality.

The bamboo skin strips on this ware are glued and joined tightly and smoothly with a touch of fluency and delicacy, generating a lustrous feeling. In the mid Qing period when the crafts of the court were in pursuit of luxuriance and elegance, it was rare to have this simple piece of work produced with a refreshing style and superb workmanship.

177

Bamboo spittoon
with designs in bamboo skin
veneered relief and inlaid
with bamboo palm strips

Mid Qing period

Overall Height 8.9 cm
Diameter of Mouth 11.9 cm
Diameter of Base 6.2 cm
Qing court collection

The spittoon has a hexagonal-shaped mouth, a wide mouth with a slightly flared rim, a deep belly, and a flat base. The spittoon has a fitting lid in the form of an inverted alms bowl. The lid has a flat surface on which is a knob in the shape of a flower bud inlaid with celadon white jade. The lid and the body are modeled in the form of continuous chrysanthemum petals, and further set with brownish bamboo palm strips. The exterior base and interior wall of the lid and the spittoon are set with veneered bamboo skin in relief.

The bamboo palm strips on this ware are neatly and smoothly knitted, demonstrating marvelous craftsmanship. The subtle colour of dark brown bamboo palm strips and the bright colour of veneered bamboo skin, together with the matching colour of the jade knob, have created a delightful and harmonious charm in terms of the treatment of colours, textures, and quality of the materials. It is a representative piece of work by combining both veneered bamboo skin and set brownish bamboo palm strips, which reveals the outstanding achievements of bamboo cravings in the mid Qing period.

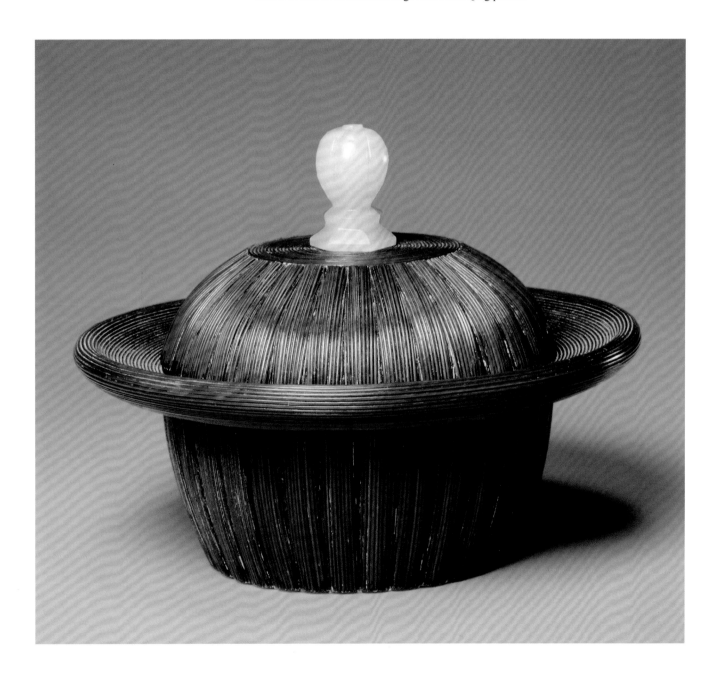

178

Bamboo scepter
set with bamboo skin veneered designs, bamboo strips, and inlaid with jade designs

Mid Qing period

Length 34 cm
Diameter of Head 6.5 cm
Qing court collection

The *ruyi* scepter is layered with veneered bamboo skin and further inlaid with bamboo strips. The oval head is decorated with a tile with a lotus and a pair of mandarin ducks, set and inlaid with white jade, creating the collective design of "mandarin ducks are fond of lotuses". The decorative motif is suggestive of harmony between husband and wife and long lasting love. It has a long, slim, and light handle.

This *ruyi* scepter has survived over two hundred years of history, yet is still in good condition without any cracks or peel-off of bamboo strips, reflecting excellent workmanship. The craft of handling bamboo skin veneered carving is quite complicated. Usually the wooden body is layered with bamboo skin strips. The decorations on this object by using veneered bamboo strips are even more sophisticated. It is necessary to utilize the bamboo strips which were cut slim, polish them roundly, and colour them in deep brownish colour; then bend them into the shape of waves and glue to the handle already layered with bamboo skin strips. The bamboo strips on the head of the handle are then curled into a ring for fastening small jade ornaments with a touch of delicacy, lyricism, refined polish, and tidiness.

179

Olive kernel
with carved designs of poem inscriptions and figures in a small boat

Chen Ziyun

Mid Qing period

Height 1.6 cm
Length 3.4 cm
Qing court collection

The boat is carved with an olive kernel. An elderly man with his legs curled up sits at the front of a boat, drinking tea from a cup in his hand with a boy attendant holding a teapot standing beside him. Carved in openwork, the windows provide a view into the cabin, in which cups and dishes of food are placed on a table, with an elderly man leaning against the table drinking and contemplating the scenery around. At his side, an attendant is leaning against the railings and looking at the distant scenery. At the other side of the boat, a boy attendant is moving a wine barrel. The base of the boat is engraved with a poem in running script with the mark of Chen Ziyun in running script.

Olive kernel carving became popular in the Wuzhong regions since the mid Ming period, which has been esteemed a superb carving technique and utilized to carve small objects such as bead chains and fan pendants.

180

Walnut kernel snuff bottle
with carved designs of a poem and literati figures

Mid Qing period

Overall Height 5 cm
Diameter of Belly 4.3 cm
Qing court collection

The snuff bottle is in the original form of a walnut kernel with its interior hollow. The exterior wall is polished and grinded with one side carved with landscapes, floating clouds, trees and rocks, and two elderly men, one in long hair and holding a staff, and another with beards and wearing a hat following him behind. Their physical features and costumes show that they are probably foreigners. The other side of the snuff bottle is engraved with a poem in clerical script with a title inscription "*xiyin*" (treasure our time) and two seal marks "*zhen*" and "*shang*" in seal script. The snuff bottle has a small mouth on top and a fitting boxwood stopper carved in the shape of a stalk.

Quite a number of walnut kernel snuff bottles were recorded in the Qing court archive, but only few are extant nowadays.

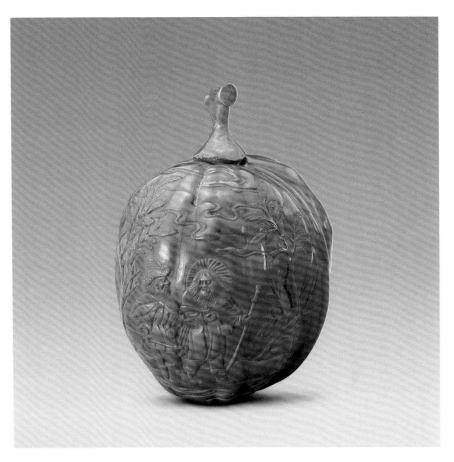

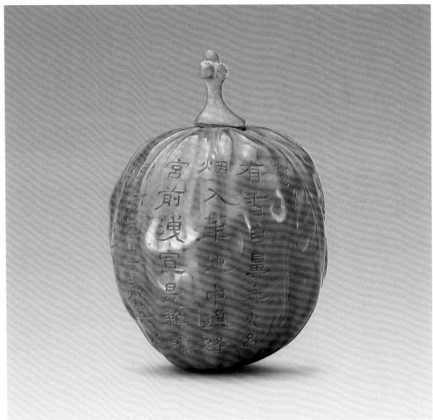

181

Aloeswood wrist-rest
with carved designs of chrysanthemums in relief

Qing Dynasty

Length 26.9 cm
Width 7.6 cm
Qing court collection

The wrist-rest is rectangular in shape like a tile turned over with a high curved surface. The body has a rough surface with textures simulating the surface of an old tree trunk. The front side is carved with a high rock in relief, and on its top are a few stems of wild chrysanthemums and various wild flowers, which are rendered in a lively and realistic style.

This work is carved with meticulous skills to render the decorative designs with a touch of naturalism, while the surface is smoothly polished with a lustrous quality. Though the aloeswood is dark and in aged colour, after touching up with creative and skilful craftsmanship, this piece exudes fresh charm and delicacy.

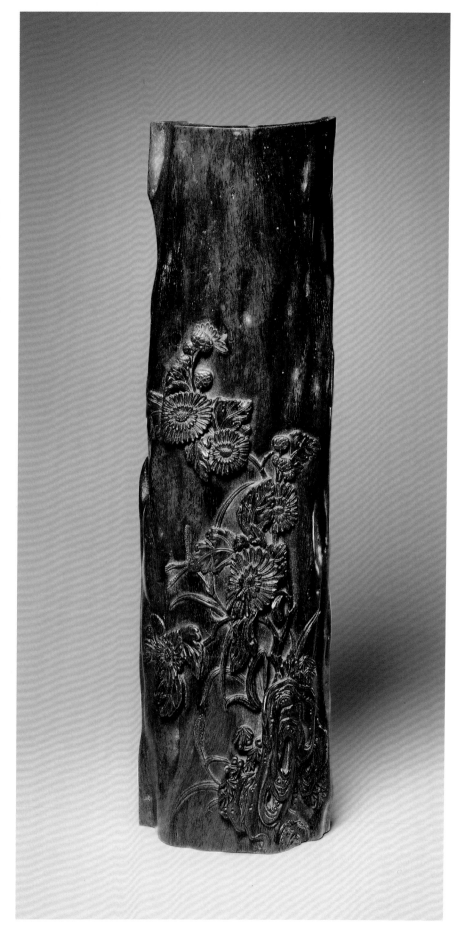

182

Red sandalwood travelling stationery box

Qing Dynasty

Height 14 cm
Length 74 cm
Width 29 cm
Qing court collection

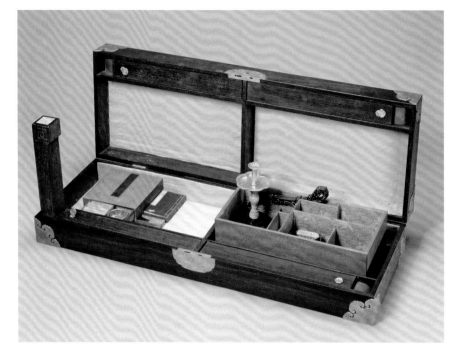

The red sandalwood travelling stationery box is rectangular in shape. After opening the supporting mechanism, it will become a small table supported on four legs. Inside the box are two drawers for storing stationery items such as brushes, ink, candle stands, drafting equipment, *shuanglu* game chess, snuff bottles, etc. There are altogether sixty-four pieces of scholar's objects from various dynasties, including cloisonné ware, lacquer ware, jade, and other crafts for amusement, marking the zenith of utilizing the decorative and appreciative functions of ancient stationery items.

The box is creatively designed, and it is the only extant piece of portable stationery box for use during travelling left over by the Qing court. It was recorded in the archival documents dated to the 22nd year of the Qianlong period (1757 A.D.).

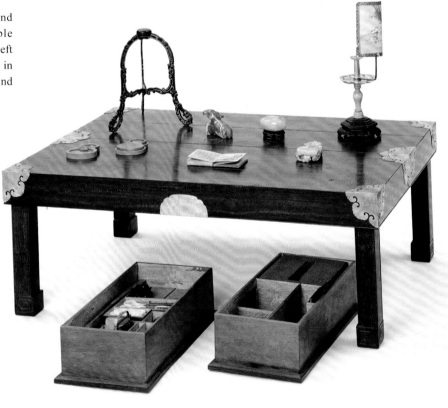

183

Imperial inkstick "Dragon Fragrance"

Ming Dynasty　Xuande period

Height 9.1 cm
Width 3.3 cm
Thickness 2.5 cm

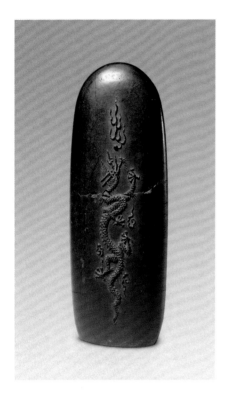

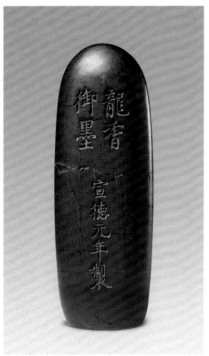

The inkstick is in the shape of a tongue. The front side is carved with a dragon in pursuit of a flaming pearl in relief while the back is engraved with the mark "*Longxiang yumo, Xuande yuannian zhi*" (imperial inkstick "Dragon Fragrance", made in the first year of the Xuande period). The inkstick had been used. The first year of the Xuande period corresponded to 1426 A.D.

Imperial inksticks were specially made for the use of the Emperor. "Dragon fragrance" was an aroma recipe with various kinds of valuable materials, such as dipterocarpaceae and musk, added during the production of inksticks. This inkstick was the earliest extant piece made with "dragon fragrance". The flying dragon is carved with meticulous details with every piece of its scales precisely depicted. Its shape in a tongue represents a typical form of Ming inksticks, and it is with superior quality amongst the imperial inksticks of the Ming Dynasty. The inkstick is recorded in the *Illustrated Catalogue of Inksticks in the Collections of Four Connoisseurs* compiled by Zhang Zigao, Zhang Jiongbo, Yin Runsheng, and Ye Xia'an.

Ink is a black pigment used for writing and painting, with red colour and other coloured inksticks produced subsequently. It is one of the four treasures of a scholar's studio. Based on the production materials, ink is categorized into three kinds, namely oil-soot ink, lacquer-soot ink, and pine-soot ink, which are produced by using burnt *tong* oil, raw lacquer, and pines respectively; the soot gathered is then mixed with collagen extracted from animal skin, musk, and borneol.

184

Coloured inkstick "Morning Glow in the Green Sky"

Ming Dynasty Chenghua period

Height 15 cm
Width 3.5 cm
Thickness 1 cm

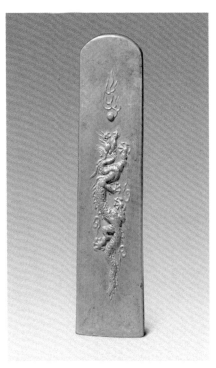

The rectangular-shaped inkstick has a round head and a stele-shaped body in lavender colour. The front side is carved with a dragon in pursuit of a flaming pearl in washed gold while the back side is engraved with "*shuxia feibi*" (morning glow in the green sky) in seal script with an oval seal mark "*Chenghua*".

This inkstick with the mark of Chenghua of the Xianzong period of the Ming Dynasty is very rare. The decorative designs are rendered in high relief with a strong sense of dimensionality, representing a distinctive feature in decorating inksticks in the Ming Dynasty. The inscriptions on the inkstick describe the morning glow in the green sky. It is recorded in *The Collection of Inksticks of Zhong Zhou* compiled by Yuan Lizhun during the Republican period.

Coloured ink, also known as polychrome ink, is produced by mixing colours extracted from natural plants or minerals and is mostly used for painting. Extant coloured inksticks of the Ming Dynasty and before are very rare. There are also various types of ink in gold, including washed gold ink, snow-flake gold ink, lacquered gold ink, and others. Washed gold inksticks refer to inksticks with the whole piece coloured in gold.

185

Ink cake *"Shibao"*
(treasure by generations)
made by Luo Xiaohua

Ming Dynasty Jiajing period

Height 6.1 cm
Width 3.6 cm
Thickness 1 cm
Qing court collection

The ink cake is oval in shape with two intertwining *chi*-dragons carved on the body. The *chi*-dragons are either holding *lingzhi* fungi in their mouths or riding on these plants on their claws. The centre of the ink cake has a panel of lotus petals, which is carved with inscriptions, including *"shibao"* (treasure by generations) in regular script in relief on the front and *"Xiaohua Shanren"* in seal script in relief at the back.

Luo Xiaohua, oringal name Longwen, *zi* Hanzhang, *hao* Xiaohua Shanren, was a native of She district, Anhui, active from the Chenghua to the Jiajing period of the Ming Dynasty. He was a representative master of the She School for the production of inksticks and ink cakes, and those produced by him were reputed as "as hard as jade, textures are like rhinoceros horns, colour is as shiny as black lacquer, and one piece is worth ten thousand coins", which showed that his inksticks had fetched extremely high price at the time. Extant inksticks and ink cakes made by Luo are very rare, and there are many fakes in the market. This ink cake is a refined piece made by Luo, with meticulously molded and compressed designs rendering the decorations, which are further enriched with engraved details.

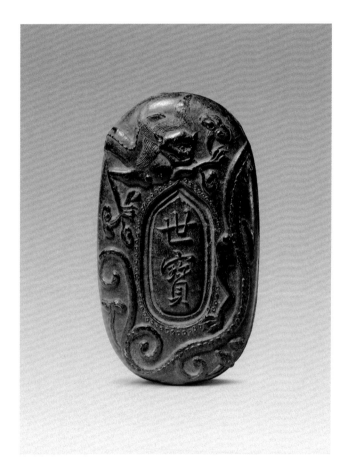

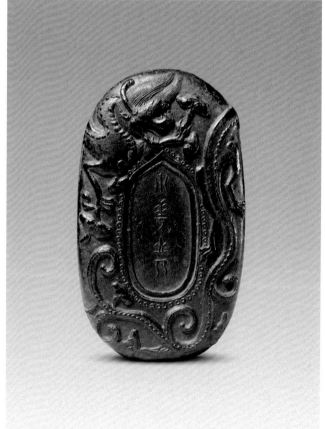

186

Inkstick *"Liaotianyi"*
(great void and origin of the Universe)
made by Cheng Junfang

Ming Dynasty Wanli period

Height 8.5 cm
Width 2.3 cm
Thickness 1 cm
Qing court collection

The inkstick is rectangular in shape with the body as shiny as black lacquer. The front and back sides are carved with peony sprays spreading from one side to the other in relief. The front side is carved with the title of the inkstick *"Liaotianyi"* (great void and origin of the Universe) in regular script in relief with a square seal mark *"Cheng Dayue yin"* (seal of Cheng Dayue) in relief at the left bottom. On the surface of the flanking side is an inscription *"Cheng Junfang mo"* (inkstick made by Cheng Junfang) in relief. On the top of the inkstick is a mark *"guimao"* in regular script in relief. The year *guimao* corresponded to the 31st year of the Wanli period (1603 A.D.)

The inkstick is finely molded with naturalistically rendered designs and superb quality, representing a refined piece of work made by Cheng Junfang. In the classic *Zhuang Zi*, *"liaotianyi"* refers to the state of great void and origin of the Universe.

Cheng Junfang, *zi* Dayue, *hao* Youbo, was a native of She district, Anhui. He was active in the Wanli period of the Ming Dynasty but his years of birth and eath were unknown. He was a master in the production of inksticks and ink cakes, and had set up two ink production houses named "Huanpu Studio" and "Baomo Studio" to run the ink business. The book *Garden of Ink by Master Cheng* illustrates over five hundred types of inkstickes and ink cakes, which has profound influence on the industry of producing inksticks in later times.

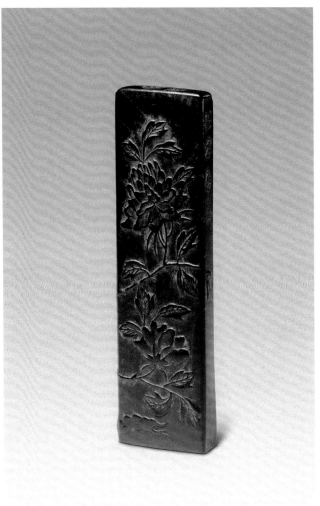

187

Coloured ink cake "*Wenxi Zhaoshui*" (burning a rhinoceros horn to look into water) made by Fang Yulu

Ming Dynasty Wanli period

Height 12.7 cm
Thickness 1.6 cm

The ink cake is round in shape with two sides framed by purple lacquered borders. The front side is carved with the story of "*wenxi zhaoshui*" (burning a rhinoceros horn to look into water) in relief and painted in red, green, and gold, resembling the style of multi-colour lacquer ware. The back side is carved with a red square panel with the title of the ink cake "*Wenxi Zhaoshui*" in regular script in relief. The right flanking side is carved with an inscription "made by Fang Yulu in the year *xinchou* of the Wanli period" in regular script in relief. The left flanking side is carved with an inscription "produced by Lüzhuju (Green Bamboo House)" in regular script in relief. The House was Fang's ink production workshop, and the year *xinchou* corresponded to the 29th year of the Wanli period (1601 A.D.).

Wenxi was a term referring to rhinoceros horns with textural markings. In ancient times, the rhinoceros was regarded as a spiritual animal. The title "*wenxi zhaoshui*" was derived from Chapter *Biography Wen Jiao* in the book *History of the Jin Dynasty*, which described that in the Eastern Jin Dynasty, General Wen Jiao passed by the Niudou waterside where the water was deep and dark. It was said that there were many mythical creatures in the water, and thus Wen Jiao burnt a rhinoceros horn to light up the water, in which he really saw many mythical creatures. Later people use the story as an idiom to describe that one should understand the truth and be able to identify the good and the evil.

The years of birth and death of Fang Yulu were unknown. He was a native of She district, Anhui, and active in the Wanli period. He was a master of the She School of ink production with a fame matching that of Cheng Junfang's. He compiled the book *Manual of Inksticks and Ink Cakes by Master Fang*, which recorded three hundred and eight-five types of inksticks and ink cakes of their own production. His works are noted for fine decorations and the creative style of painting in colours. This ink cake is a representative piece of work by him.

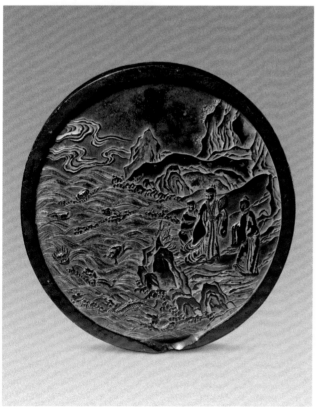

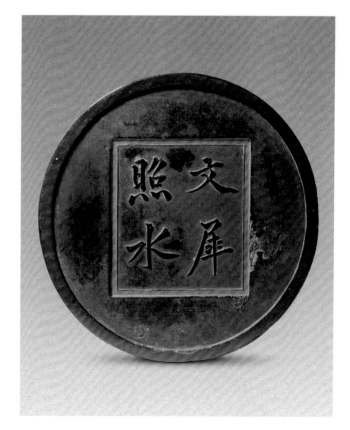

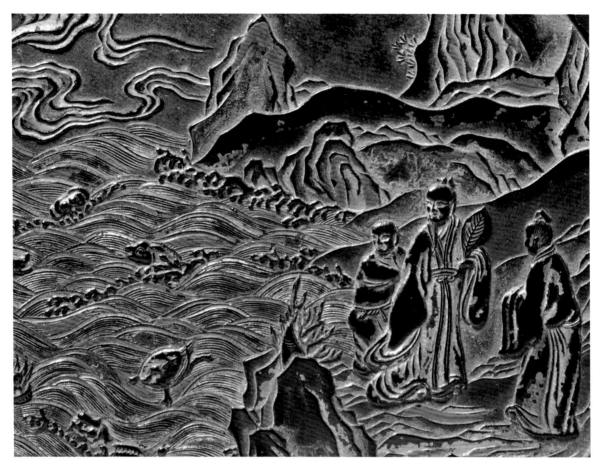

188

A set of inksticks and ink cakes "*Ziyuguang*" decorated with a scene of landscapes at Mount Baiyue made by Cao Sugong (20 pieces)

Qing Dynasty Kangxi period

Height 5.9 cm Width 2.2 cm
Thickness 0.8 cm

This set of inksticks and ink cakes are rectangular in shape. Some are with angular corners, and the two sides are bordered with lacquer. The front is washed in gold, depicting a panoramic scene of landscapes at Mount Baiyue. The back of each piece is inscribed "*ziyuguang*" (purple jade brilliance) in running script filled with blue pigment, and either carry marks "collected by Cao Sugong", "in imitation of archaic inksticks by the Master of Yisu Studio", year mark "*Kangxi dingweinian zhi*" (made in the year *dingwei* of the Kangxi period), as well as seal marks "*yutang qingshang*", "*zisun baozhi*", "*taozhu zhuren*", or others. The inksticks and ink cakes are gracefully stored in a cinnabar lacquer box with gold painted designs. The surface of the box is written with *Eulogy of Ziyuguang* in clerical script in gold. The Year *dingwei* corresponded to the sixth year of the Kangxi period (1667 A.D.).

This set of inksticks and ink cakes was rendered with sophiscated decorations and impeccable craftsmanship, and was made exclusively for court use. Located at Xiuning, Anhui province, Mount Baiyue is one of the four famous Daoist mountains together with Mount Longhu in Jiangxi, Mount Wudang in Hubei, and Mount Qingcheng in Sichuan. Mount Baiyue is famous for its stunning landscapes, and is reputed, together with Mount Huang, as one of the most famous mountains in the Jiangnan region.

Cao Sugong (1615 – 1689 A.D.), original name Shengchen, *zi* Changyan, *hao* Sugong, was a native of the She district, Anhui. He set up the Yisu Studio to produce ink, and was reputed with Wang Jinsheng, Wang Jiean, and Hu Kaiwen as the four masters of ink in the Qing Dynasty. Cao had compiled *The Forest of Ink by Master Cao*, which recorded eighteen kinds of inksticks and ink cakes with *Ziyuguang* ranked the first. The titles of the inksticks and ink cakes were bestowed by Emperor Kangxi during his procession to the South.

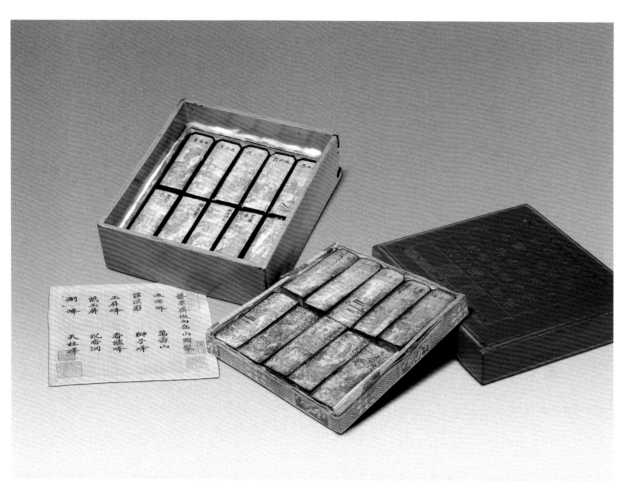

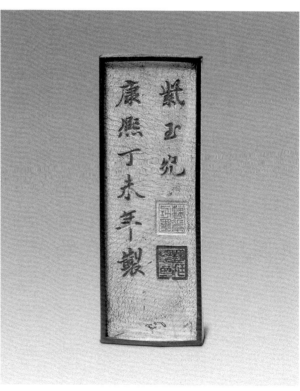

189

Assorted ink cakes
decorated with "ten friends of longbin"
(ink guardians) made by Wu Tianzhang
(10 pieces)

Qing Dynasty　Kangxi period

Highest 13.4 cm　Width 1.27 cm
Thickness 0.85 cm

The ink cakes are in various shapes: inkstones, bamboo slips, *qin* zithers, book weights, etc. The surfaces are decorated with historical stories or legends, including carving on the Zhuyang rocks, flowers blooming at Mount Dream Brush, two swordsmen in Fengcheng, a bed of books, phoenix trees at Mount Yi, man-of-letters, reading books for cultivation, the imperial inkstone of the Xuanhe period, old bamboo slips, and other designs. The ink cakes have various marks including "*Tianzhangshi fanggu*" (modeled after the ancients by Tian Zhang), " *Anranshi*" (Anran Studio), "*Wu Tianzhang jianzhi*" (produced by Wu Tianzhang)", and "*Tianzhangshi mo*" (in imitation of the ancients by Tianzhang). They are stored in a black lacquer box with the surface of the cover decorated with antique patterns painted in colours and an inscription which literally describes "Ten friends of Longbin making close friendship at a scholar's studio. Their friendship is as close as glued with lacquer, which is solid and lofty with fragrance" in seal script filled with gold pigment, as well as seal marks "*Zhuoyin*" and "*Tianzhang*".

This collection of assorted ink cakes are finely produced with brilliant colours, reflecting the exquisite craftsmanship in producing assorted inksticks and ink cakes in the early Qing Dynasty. "Longbin" was said to be the guardian of ink and thus was taken as another name for ink. The term was first mentioned in *Miscellaneous Notes of Yunxian* compiled by Feng Zhi in the Tang Dynasty, which was quoted from *Miscellaneous Matters of Taojiaping*, "For the men-of-letters who excel in writing, the inksticks and ink cakes they use must carry the images of the twelve friends of Longbin."

Wu Zhuo, *zi* Tianzhang, was active in the Chongzhen period of the late Ming period. He was a master of the Xiuning School of producing ink at Huizhou in the early Qing Dynasty with his studio named Anran Studio.

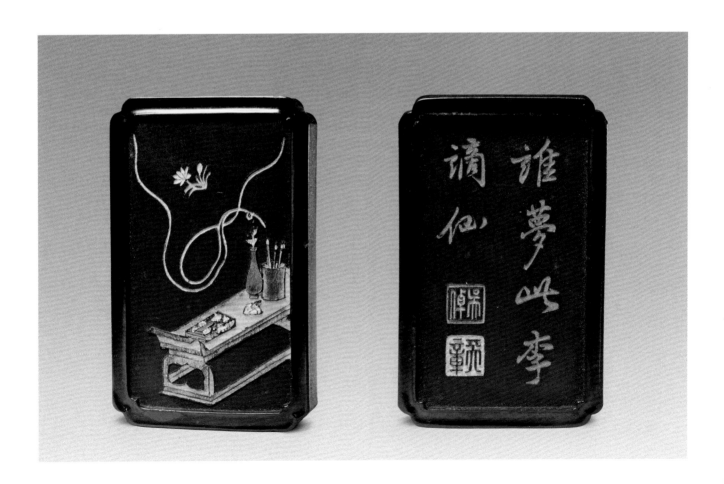

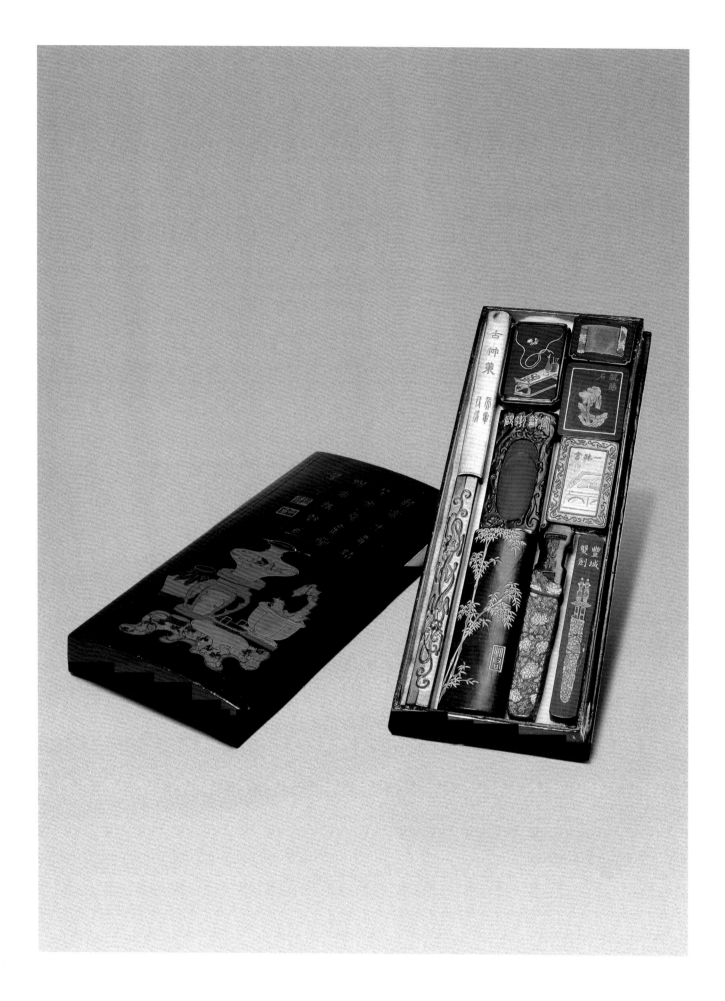

190

Assorted coloured ink cakes
decorated with ten scenes of West Lake made by Wang Jie'an (10 pieces)

Qing Dynasty Qianlong period

Highest 9.1 cm
Width 5.2 cm
Thickness 0.9 cm

The ink cakes are rectangular, square with angular corners, *gui* tablet, etc, in shape, and are coloured in blue, red, green, yellow, brown, white, etc. The front sides of the ink cakes are decorated respectively with the ten famous scenes of West Lake, which include spring dawn in Su Causeway, melting snow at the broken bridge, lotuses

stirred by breeze in Quyuan Garden, three pools mirroring the moon, autumn moon on a calm lake, orioles singing in the willows, twin peaks piercing the clouds, late evening bells at the Nanping Hill, viewing fish at Flower Pond, and sunset at Leifeng Pagoda. On each of the ink cakes, the back side is engraved with an imperial poem by Emperor Qianlong to praise the respective scenery in regular script filled with gold pigment. On the flanking side at one of the cakes is an inscribed mark *"made by Wang Jie'an of the She district"*. All the ink cakes are stored in a black lacquer box decorated with dragons amidst clouds painted in gold with the cover written with an inscription "coloured ink cakes decorated with ten scenes of West Lake with imperial inscribed poems" in clerical script filled with gold pigment.

This set of ink cakes is in bright and brilliant colours with various forms. The carved designs on the original molds should have been meticulously rendered, and this set was made by Wang Jie'an as a tribute to the court.

Wang Jie'an, original name Xuanli, *zi* Rongwu, was a native of She district, Anhui. His years of birth and death were unknown but he should have been active in the Qianlong and Jiaqing periods. He was one of the four great masters in producing ink in the Qing Dynasty with his studio named Hanpu Studio. In producing ink, he used excellent formulas in mixing the materials, thus his works were often used as tributary items to the court.

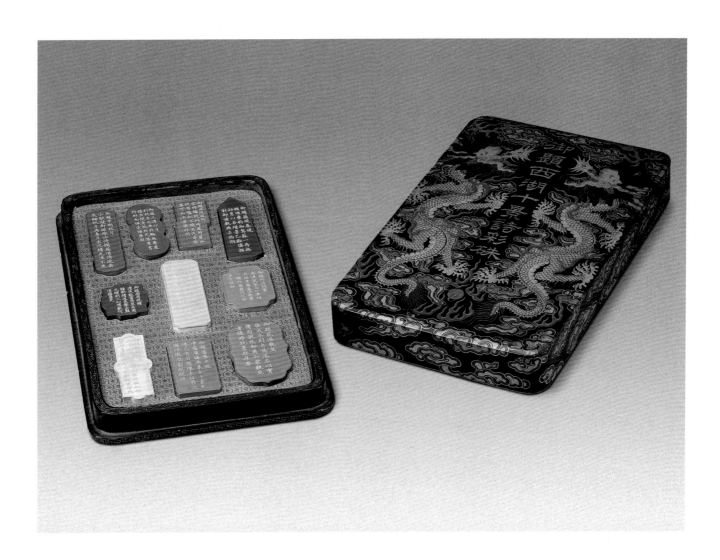

191

Assorted imperial ink cakes
decorated with poems extracted from the
Complete Library of Four Branches of Literature
(5 pieces)

Qing Dynasty Qianlong period

Highest 15.6 cm Width 6.1 cm Thickness 1.9 cm

Qing court collection

The ink cakes are in various shapes: round, chime-shape, elongated round, conjoined elongated round, and jade *huang* disk. The front sides are carved with the twelve Chinese astrological animals in relief and diagrams of the Wenyuan Chamber, Wenyuan Chamber, Wenjin Chamber, and Wensu Chamber. The back sides are engraved poems by Emperor Qianlong in regular script filled with gold pigment. The flanking sides of the cakes are carved with a four-character mark of Qianlong (Qianlongnian *zhi*) in regular script and the title of the ink cake in relief. This set of ink cakes are stored inside a black lacquer box, and the cover has a title "Imperial ink cakes decorated with poems extracted from the *Complete Library of Four Branches of Literature*" in clerical script inlaid with mother-of-pearl.

In the Qianlong period, the court launched the compilation of the largest encyclopedia collection of literature and history entitled *Complete Library of Four Branches of Literature*, which was later produced in seven copies. Seven library chambers were specially built in North and South China to house the seven copies of the encyclopedia, including Wenyuan Chamber in the Forbidden City, Wenyuan Chamber in the Yuanmingyuan Summer Palace, Wensu Chamber in Shenyang, Wenjin Chamber in Chengde, Wenhui Chamber in Yangzhou, Wenlan Chamber in Hangzhou, and Wenzong Chamber in Zhenjiang, which were collectively known as the Siku library chambers. The texts and diagrams on this set of ink cakes are about the four library chambers in North China, and the set of ink cakes are finely produced with extravagant packaging, representing refined pieces of imperial ink cakes in the Qianglong period. This set of ink cakes was produced by Jiangu Studio of the reputed ink master Wang Jinsheng at the commission of the court.

Wang Jinsheng, original name Jiangu, was a native of Jixi district, in Huizhou. His years of birth and death were unknown. He was a master in the production of ink in the Qing Dynasty. He learnt his skills from Cao Sugong while working as an apprentice, began to be known in the Kangxi and Yongzheng periods, and set up his own ink production studio named Jiangu Studio. Wang's consummate carving and engraving skills as well as marvelous decorations were particularly reputed.

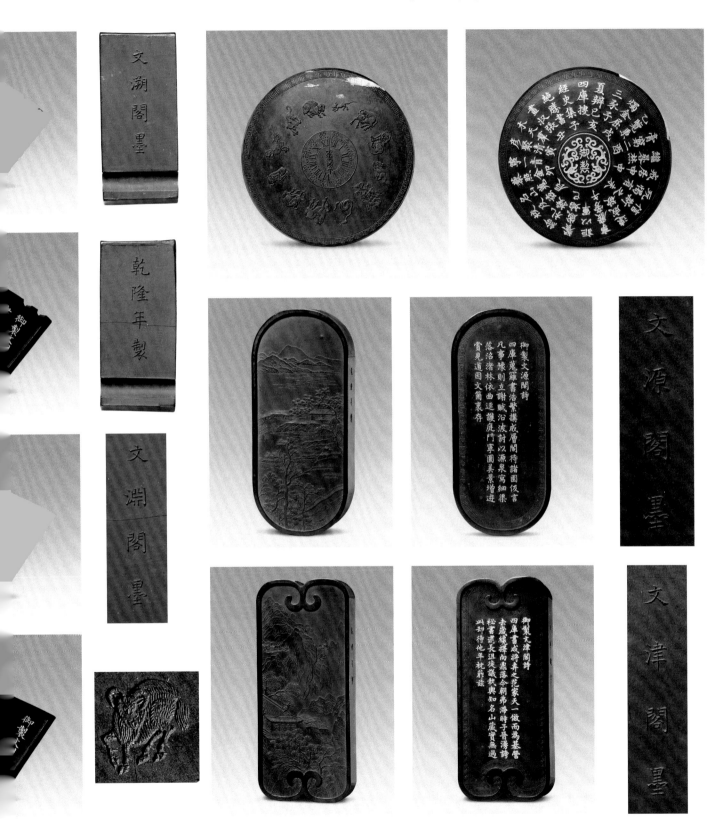

192

A set of ink cakes
decorated with seventy-two
pentads in lunar months
(72 pieces)

Qing Dynasty　Qianlong period

Highest 16.7 cm
Width 9.9 cm
Thickness 2.2 cm
Qing court collection

This set of ink cakes are in various shapes and colours. The shapes include square, rectangle, jade *jue* semi-circular pendants, jade *huang* semi-circular pendants, bells, and *qing* chimes with colours in green, yellow, red, blue, and white. The front sides are engraved with pentads patterns, and the back sides are engraved with imperial poems of seventy-two pentads in lunar months by Emperor Qianlong and written by Cao Wenzhi in regular script filled with gold pigment. The ink cakes are stored in the drawers of two black lacquer cabinets with designs of dragons painted in gold.

This set comprises of seventy-two ink cakes and is a magnificent piece of work produced, representing refined works of imperial ink in the Qianlong period.

In ancient China, five days made up one pentad, three pentads made up one solar term, two solar terms made up one month, three months made up one season, and four seasons made up one year. There were seventy-two pentads in a year, and each pentad was marked with a specific climatic phenomenon. For plants, the phenomenon included budding, blossoming of flowers, bearing fruits, etc. For animals, it came with vibration, uttering, mating, migrating, and others. For non-living creatures, the phenomenon included weather becoming icy, ice melting, and beginning of thundering. Agricultural works had to take these phenomena into consideration for implementation.

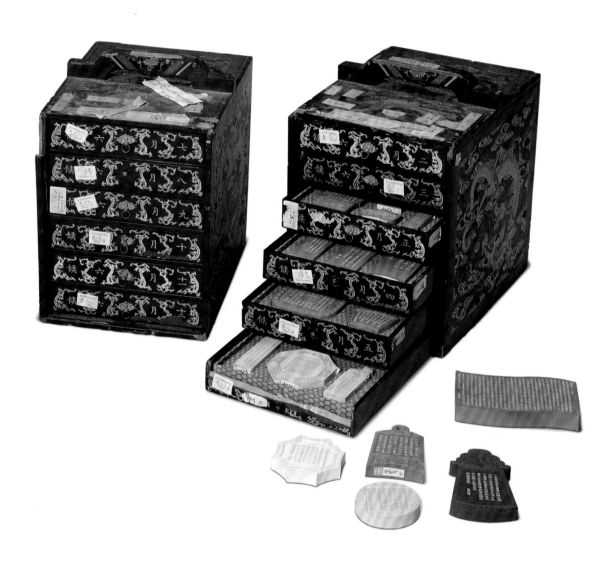

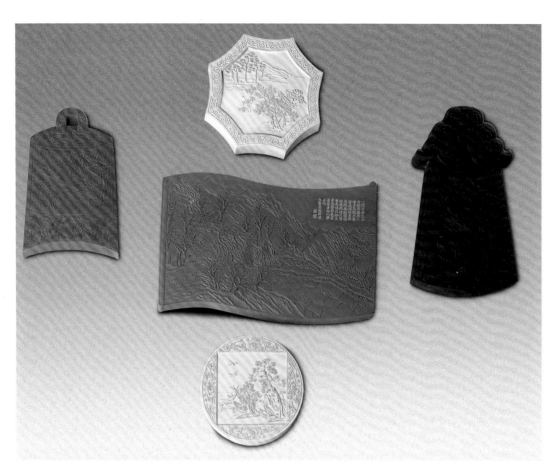

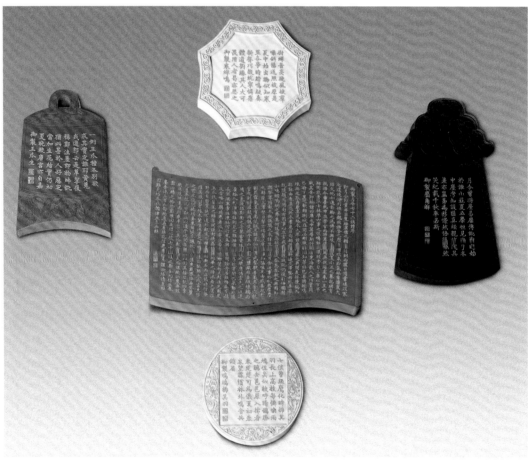

ENAMEL WARE WITH METALLIC BODIES

193

Cloisonné enamel censer
with elephant-shaped handles and designs of lotus scrolls

Yuan Dynasty

Height 13.9 cm
Diameter of Mouth 16 cm
Diameter of Foot 13.5 cm
Qing court collection

The censer has a round mouth, a globular belly, and a ring foot. The two sides are decorated with a pair of gilt bronze elephant-head handles, and the interior has a gilt moveable bladder. Under the gilt bronze mouth are decorations of chrysanthemums in various colours on a ground of light blue enamel. The stamens are set with gilt bronze nipple nails. The body of the censer is layered with blue enamel as the ground and decorated with six lotus scrolls in red, yellow, and white. Underneath the belly is a decorative border of lotus petals.

The colours of enamel on this censer are brilliant, and its form is modeled in a stern manner with the cloisonné enamel design of flowers rendered with a touch of roundness. It was a representative piece of cloisonné enamel ware of the Yuan Dynasty, but the elephant-head shaped handles, moveable bladder inside, and the ring foot were added later.

Enamel is made of silicon, lead-oxide, feldspar, and quartz mixed in designated proportions, and then with various metallic oxide materials as colourants added for baking and grinding into colour powder. Afterwards, colour enamels would be inlaid, layered, or painted on metallic bodies of the ware (most of which are made with bronze or copper), which are then fired again to produce enamel ware. According to different production techniques, enamel ware is categorized into cloisonné enamel, champlevé enamel, and painted enamel ware.

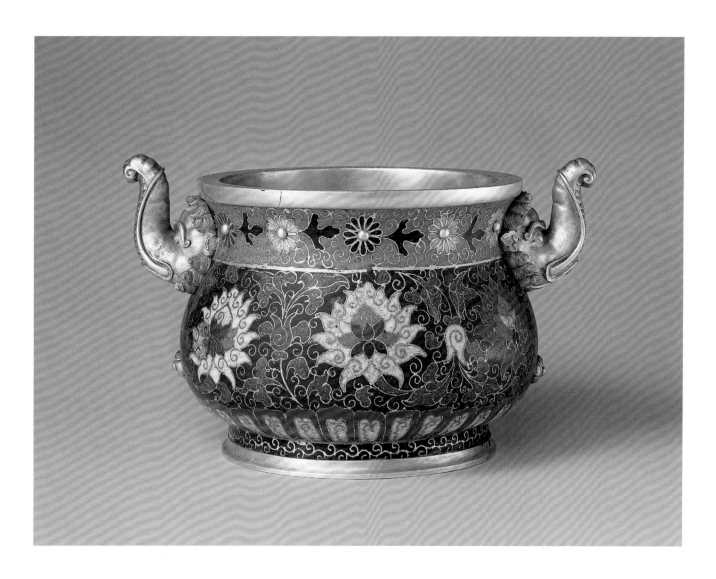

194

Cloisonné enamel
zun vase

with designs of three animal
heads holding rings and
lotus scrolls

Yuan Dynasty

Height 71 cm
Diameter of Mouth 36.3 cm
Diameter of Base 23.1 cm
Qing court collection

The *zun* vase has a flared mouth, a long
neck, a wide shoulder, and a contracted
belly. On the two symmetrical sides of the
neck are two enameled gilt bronze animal-
masked handles. The shoulder is decorated
with three relief animal heads holding rings
in enamels. The vase is supported on three
gilt bronze legs in the shape of winged
beasts. The mouth rim and interior are in
gilt while the body is in light blue enamel
as the ground and decorated with cloisonné
floral patterns. The mouth rim and shoulder
are decorated with hanging cloud patterns,
and inside the clouds are floral designs on
an aubergine ground. The neck and the feet
are decorated with grapes and banana leaves
while the belly is decorated with six lotus
scrolls in aubergine, white, yellow, red, and
other colours. The base has a six-character
mark of the Jingtai period of the Ming
Dynasty (Daming Jingtainian *zhi*) in regular
script enclosed by two gilt dragons in relief.

The belly of this *zun* vase is decorated
with brilliant colours, especially the
dark green and aubergine colours are
exceptionally bright and shiny which
are seldom found in later dynasties. The
lotus scrolls with large flowers, branches,
and leaves are rendered with a touch of
vibrancy and dynamism; complemented
by banana leaves on top and below, they
represent a decorative style quite similar
to that on the ceramic ware of the Yuan
Dynasty. The neck and the foot are covered
with greyish and dark colours with the
stylistic rendering quite different from the
designs on the belly. Judging from these
observations, the *zun* vase was produced
in the Yuan Dynasty, but the neck, ears,
rings, and legs were added onto it in later
dynasties, and so was the mark on the base.

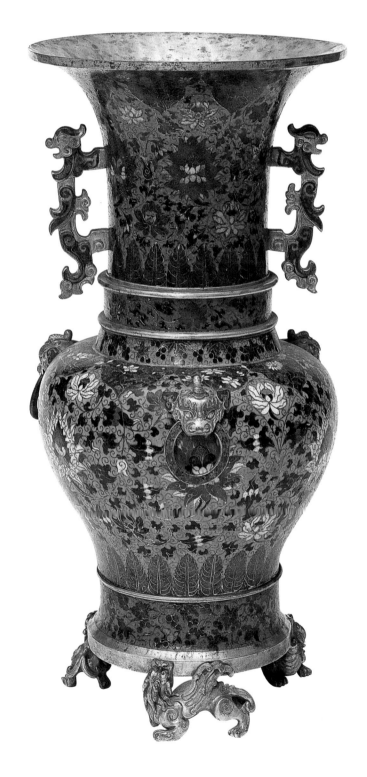

Cloisonné enamel spherical censer
with designs of lotus scrolls

Early Ming period

Diameter 14 cm
Qing court collection

The censer is in the shape of a sphere with two semi-spherical halves and a knob to unlock the censer in the middle. Inside the censer are three layers of round rings in large, middle, and small sizes with moveable axis. The axis of each ring is linked to the axis at the ears to form crosses, so that no matter how the censer is turned in any direction, the central censer sphere inside would still keep at a horizontal position without losing balance; therefore it is known as "hanging central censers". The exterior of the censer is covered with sky blue enamel as the ground and decorated with three colour cloisonné enameled layers of lotus scrolls with twelve flowers altogether. The cloisonné decorations are meticulously rendered and fully filled with colour enamels. The top, base, and mouth rim are decorated with gilt round ancient coin patterns.

This ware was used as a censer, and silver censers of this type dated to the Tang Dynasty had been unearthed. But this is the only censer with a central hanging sphere of the early Ming Dynasty extant, which still retains the stylistic legacy of cloisonné enamel ware of the Yuan Dynasty, representing a piece of work produced in the transitional period from the Yuan to the Ming Dynasty. Cloisonné enamel is rendered by welding metallic wires on the metallic ware to produce decorative designs, which is to be filled with colour enamels, followed by firing, polishing, and gilt.

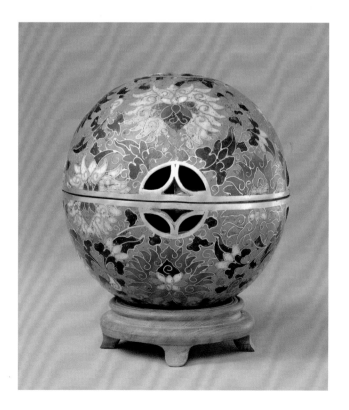

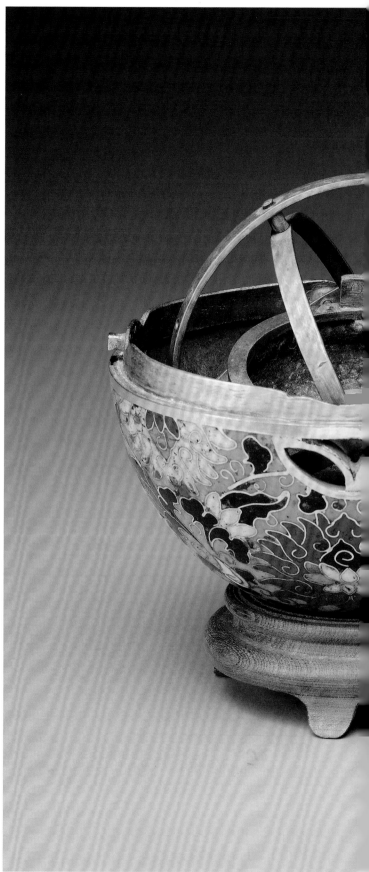

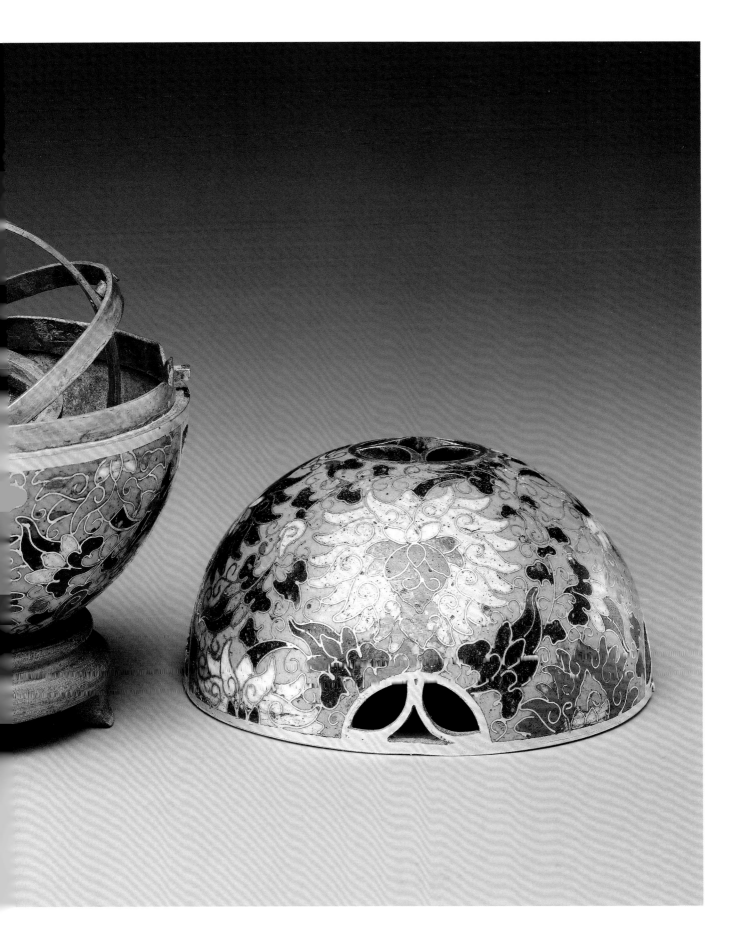

196

Cloisonné enamel *gu* vase

with flanges and designs of lotus scrolls

Ming Dynasty　Xuande period

Height 28.4 cm
Diameter of Mouth 16.3 cm
Diameter of Foot 9.8 cm
Qing court collection

The vase is modeled after the ancient bronze *gu* wine-container. It has a flared mouth, a straight cylindrical belly, and a flared ring foot. The belly and the foot are set with eight gilt bronze flanges with designs of *chi*-dragons. The vase is layered with light blue enamel as the ground and decorated with continuous lotus scrolls. The interior of the mouth is decorated with two lotus scrolls in deep blue, yellow, and red enamels alternatively. The neck is decorated with panels in the shape of banana leaves with the inside and outside decorated with lotus scrolls. The belly and the foot are decorated with lotus scrolls in red, white, yellow, and blue enamels, and the foot rim is decorated with foliage scrolls. The gilt bronze base is engraved with a four-character mark of Xuande (Xuandenian *zhi*) in regular script enclosed by two borders.

The cloisonné enamel designs on this work are meticulously and vividly rendered in bright colours and thickly gilt layers, representing a refined piece of Xuande cloisonné enamel ware. The flanges and the foot were added later.

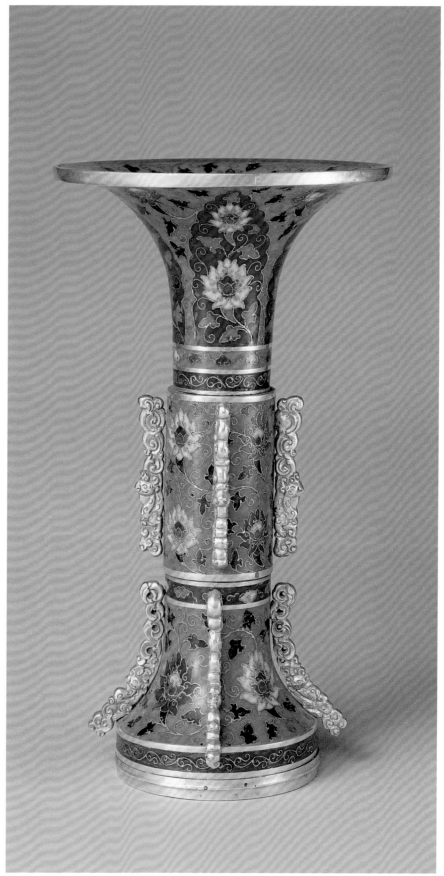

197

Cloisonné enamel bowl
with designs of lotus scrolls

Ming Dynasty　Xuande period

Height 13.9 cm
Diameter of Mouth 29.7 cm
Diameter of Foot 13 cm
Qing court collection

The bowl has a flared mouth, a curved wall, and a flared ring foot. The interior wall is layered with blue enamel as the ground and decorated with two dragons in pursuit of a pearl complemented by auspicious clouds in five colours around. The exterior wall is decorated with branches and leaves interweaved in white and green enamels to highlight six groups of lotus scrolls in equal distance. The fully blooming flowers are in different colours. The exterior of the ring foot is decorated with a ridge of rhombus designs. The exterior base is decorated with a border of lozenge patterns with several chrysanthemums, and at the centre is a gold square with its inside in red enamel and with a gilt cloisonné four-character mark of Xuande (Xuandenian *zao*) in seal script.

The bowl is enameled with pure and luxuriant colours, and decorated with spontaneous designs with distinctive period features of the Xuande period. Cloisonné enamel techniques were introduced into the Yuan Empire from Arabian countries. Ware produced in the early period still carried the exotic style; but after entering the Xuande period of the Ming Dynasty, the craft was localized in terms of changes made in the design of forms, decorative techniques, choice of decorative motifs, and the use of enamels. In the Xuande period, reign marks were first introduced on enamel ware, and this period marked a landmark in terms of the progressive development of cloisonné enamel ware.

198

Champlevé enamel box
with designs of lotus scrolls

Ming Dynasty Xuande period

Height 5.5 cm
Diameter 11.3 cm
Qing court collection

The box has a round mouth, a straight wall, and a flat cover surface. The body is layered with blue enamel as the ground, and the surface of the cover is decorated with a champlevé enamel design of a lotus scroll in deep blue colour. The exterior wall of the bowl is decorated with lotus scrolls in colour enamels. The base is decorated with a floral medallion with lotus petals in colour enamels and a four-character mark of Xuande (Xuandenian *zao*) in regular script inlaid with copper wires.

This box is produced by utilizing champlevé enamel technique, representing the only extant early ware with champlevé enamel designs and reign marks, and has high research value for the study of early champlevé enamel ware. Champlevé enamel is also known as "fill-in enamel", which is different from cloisonné enamel as the technique is to carve and reduce the ground on the surface so that the relief decorative designs could stand out, and then fill in colour enamels on the recessed areas for firing, polishing, and gilt. The distinctive feature of such a technique is that the lines are thick and strong, making the decorative designs stand out vigorously and forcefully, and the ware does not have welding traces like those of the cloisonné ware.

199

Cloisonné enamel
***zun* vase**
**with designs of lion play
and three rings**

Mid Ming period

Height 28.6 cm
Diameter of Mouth 21.2 cm
Distance between Legs 17.5 cm
Qing court collection

The vase has a flared mouth, a long neck, a wide shoulder on which is inlaid with gilt bronze designs of three animal masks holding rings as ears, and a ring foot which is supported by three gilt bronze winged beasts. The body is layered with blue enamel as the ground on which are decorations of cloisonné enamel interlocking clouds as brocade patterns. The neck and belly are decorated respectively with four lions playing with a ball in colour enamels, and interspersed by various precious emblems. The shoulder and wall of the foot are decorated with lotus petals and cloud patterns. The base is carved with a four-character mark of Jingtai (Jingtainian *zhi*) in regular script in relief.

The neck, belly, and foot were added onto this *zun* vase in a later period with traces of welding at the joints of these parts visible. The colours of enamels on the upper and lower parts were obviously different, and the mark was also added later.

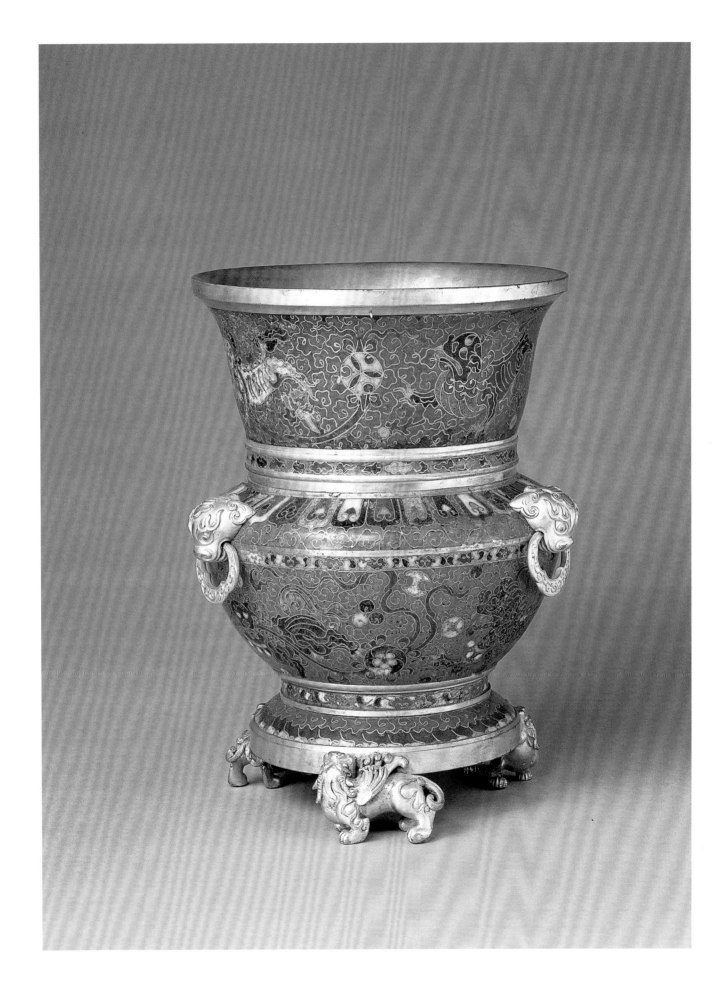

200

Cloisonné enamel foliated plate

with designs of two dragons
in pursuit of a pearl

Ming Dynasty Wanli period

Height 8 cm
Diameter of Mouth 51.8 cm
Diameter of Foot 31.8 cm
Qing court collection

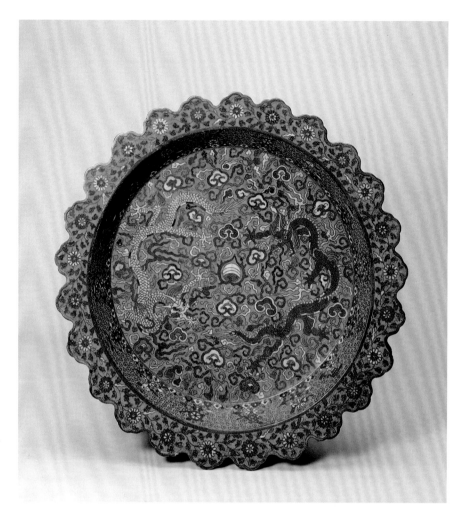

The plate has its mouth rim in the shape of chrysanthemum petals. It has a folded rim, a straight wall, a flat base, and a low ring foot. The interior and exterior of the plate are layered with blue enamel as the ground, and the centre of the plate is decorated with two dragons in pursuit of a pearl. Two dragons in red and yellow enamels are confronting each other in pursuit of a flaming pearl and interspersed by auspicious clouds in five colours. The interior wall of the plate is decorated with eight auspicious symbols including the wheel of the dharma, conch shell, victory banner, parasol, lotus flower, treasure vase, fish pair, and the endless knot. The rim of the plate is decorated with floral sprays while the exterior wall is decorated with continuous lotus scrolls. The base has six interlocking lotus floral scrolls with the centre inlaid with a rectangular gilt bronze flake on which is an engraved six-character mark of Jingtai (Daming Jingtainian *zhi*) in regular script within double borders.

The plate is huge in size, and the cloisonné decorations are impeccable and skilfully rendered, which is a refined and representative piece of work of the Wanli period. The mark was added later with the original six-character mark of Wanli (Daming Wanlinian *zhi*) probably hidden underneath the gold flake.

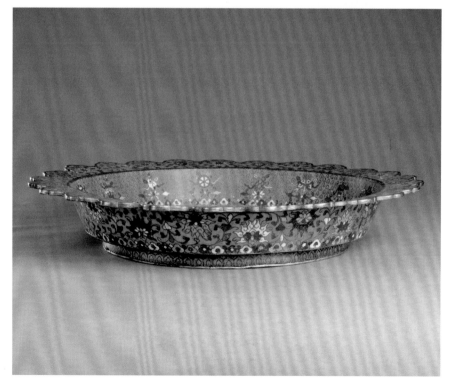

201

Rectangular cloisonné enamel censer
with designs of eight auspicious symbols

Ming Dynasty Wanli period

Height 8.1 cm
Length of Sides 26.8 x 14.4 cm
Qing court collection

The rectangular-shaped censer comprises of two parts: the cover and the body. On the two symmetrical sides of the body are two upright handles, and the base is supported on four legs in the shape of clouds. The surface of the cover is decorated with openwork designs of brocade balls in gilt, and the four sides are decorated with brocade swastika patterns (卍). The wall and base of the censer are layered with white enamel as the ground. On the wall are designs of floral scrolls and the eight auspicious symbols. The base is decorated with cloisonné enamel continuous cloud patterns, and at the centre of the base is a panel outlined with *ruyi* cloud patterns in which is a six-character cloisonné enamel mark of Wanli (Daming Wanlinian *zao*) in regular script filled with red enamel.

The style of the reign mark and the decorations show the typical distinctive features of cloisonné enamel ware produced in the Wanli period of the Ming Dynasty.

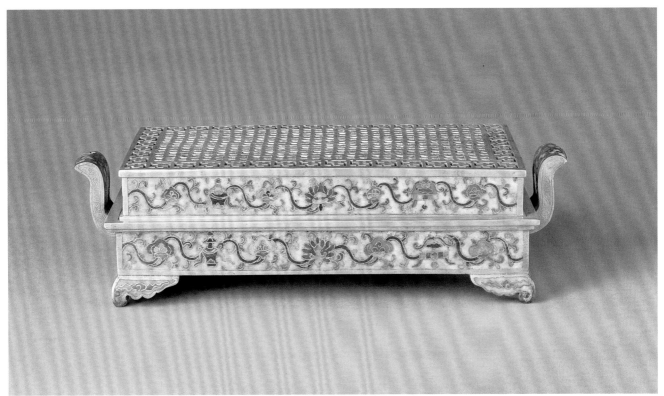

202

Cloisonné enamel censer
in the shape of a mandarin duck

Late Ming period

Height 20 cm
Length 17.3 cm
Qing court collection

The censer is in the shape of a mandarin duck with the head lifting up, tail curling up, and one leg standing on a lotus leaf. The feathers are decorated with various colour enamels while the beak and legs are in gilt. The veins on the lotus leaf are rendered with cloisonné enamel technique with gradations of green to suggest washed effect. The back of the mandarin duck has a round cover in the shape of an ancient coin with a square hole for releasing fragrant smoke.

The censer is creatively modeled in a distinctive manner, which is both a functional and a decorative object showing marvellous workmanship. Enamel ware in animal forms began to appear in the late Ming period and enriched the repertoire of enamel ware.

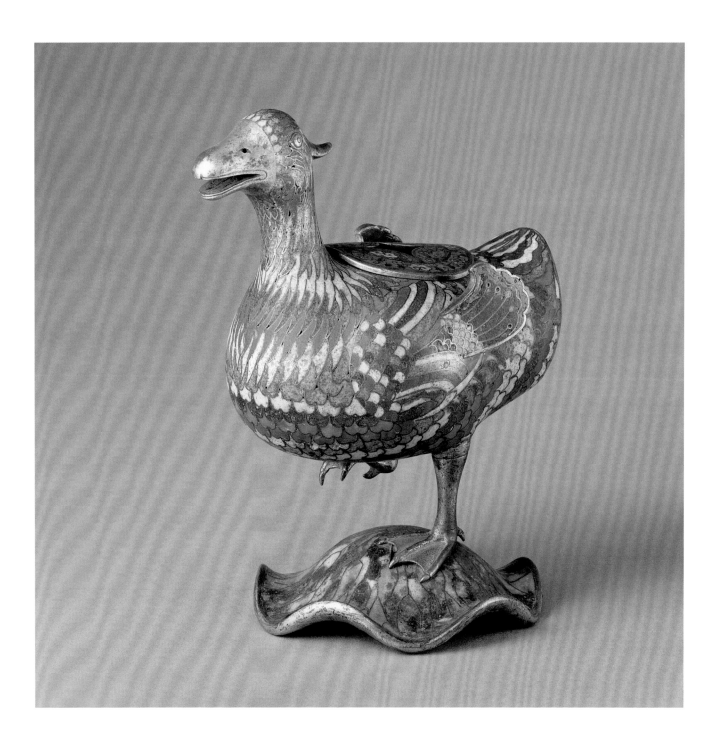

203

Cloisonné enamel incense burner
with designs of the eight trigrams and lotus scrolls

Qing Dynasty Kangxi period

Overall Height 65 cm
Diameter of Mouth 22 cm
Distance between Legs 19 cm
Qing court collection

The incense burner has a bronze body, a barrel-shaped belly, upright ears, and three elephant-head legs. It has a cover on which is a knob with openwork designs of a dragon amidst clouds in gilt. The body is layered with ocean blue enamel as the ground. The surface of the cover is decorated with eight round panels in deep blue enamel, on which are openwork designs of the eight trigrams surrounded by sprays of chrysanthemums, peonies, and other flowers. The rim of the cover and the mouth are layered with deep blue enamel as the ground, and decorated respectively with a border of foliage scrolls and *kui*-dragons. The belly is decorated with six lotus flowers with two in red, two in white, and two in lotus root colours. The elephant-head shaped legs are set and inlaid with lapis lazuli, red corals, and turquoise stones. The mouth rim is engraved with a six-character mark of Kangxi (Daqing Kangxinian *zhi*) in regular script.

The incense burner is thickly modeled with fine cloisonné enamel decorations, yet the colour is rather pale and dark, reflecting features of cloisonné enamel ware in the early Kangxi period. The eight trigrams are derived from the *Classic of Changes* with continuous stokes to represent *yang* (−) and broken strokes to represent *yin* (--), and each trigram comprises of three strokes of *yang* and *yin* respectively, including *qian*, *kun*, *zhen*, *xun*, *kan*, *li*, *gen*, and *dui*, which are symbols of all beings in the universe.

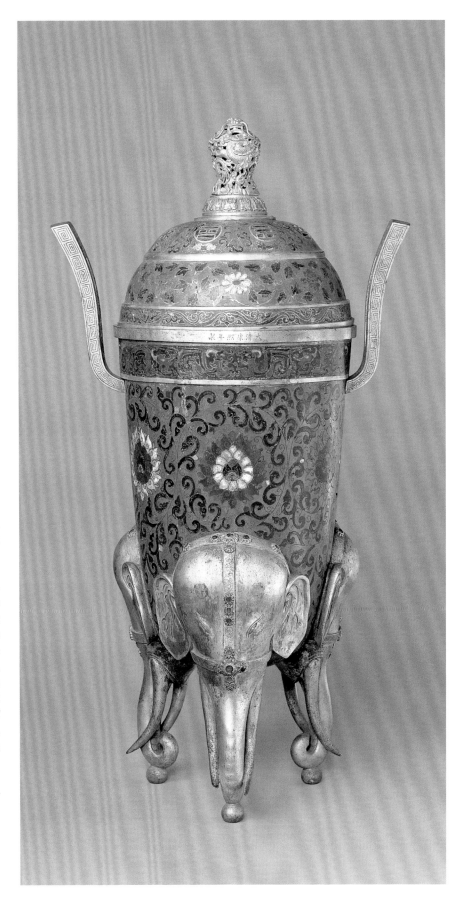

204

Cloisonné enamel warming inkstone box
with designs of *kui*-dragons

Qing Dynasty Kangxi period

Height 5 cm
Length 14.7 cm
Width 11.5 cm
Qing court collection

The inkstone box is rectangular in shape with a charcoal box underneath and a *songhua* inkstone on top. The inkstone is carved with *kui*-dragons in relief, and the quality of stone is refined and lustrous. The four sides of the box are layered with light blue enamel as the ground on which are designs of *kui*-dragons holding the character "*shou*" (longevity). The four sides of the rim are decorated with openwork gilt designs of *kui*-dragons. The base is engraved with a four-character seal mark of Kangxi (Kangxinian *zhi*) in seal script within a square.

A warming inkstone box was a stationery item specially made for use in cold weather. The box could hold hot water or burning charcoals so that ink would not freeze easily, facilitating writing in winter. This inkstone was a refined piece in the four treasures of the scholar's studio in the early Qing Dynasty with the colours of enamels and technical production improved from the early Kangxi period. *Songhua* stones were found in the region where rivers Helongjiang and Songhujiang converge. As the region was the homeland where the Manchus rose to power, *songhua* inkstones had been exclusively produced for imperial use by the Emperors of the Qing Dynasty.

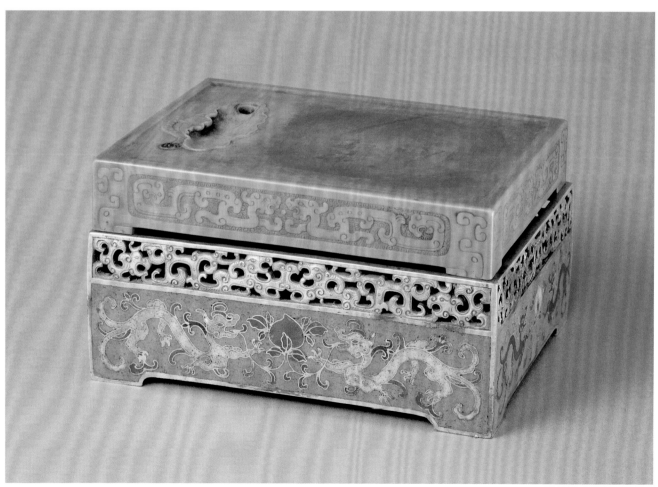

205

Cloisonné enamel conjoined vase
with designs of lotus scrolls

Qing Dynasty Qianlong period

Large Vase Height 27 cm
Diameter of Mouth 6.5 cm
Diameter of Foot 8.5 cm
Small Vase Height 21 cm
Diameter of Mouth 5.5 cm
Diameter of Foot 6.7 cm
Qing court collection

The two vases are in the form of conjoined olives. The mouths and bases are in gilt, and the two vases are linked with a gilt bronze overhead handle in the shape of a *chi*-dragon. The dragon's mouth is holding the mouth of the large vase, and the dragon's body is curling around the bodies of the two vases. The shoulders of the vases are decorated with a border of string patterns with cicada patterns and animal masks holding square rings hanging below. The body is layered with blue enamel as the ground, decorated with cloisonné enamel lotus scrolls and other flowers, and further decorated with gilt champlevé designs of *chi*-dragons. Along the leg and the mouth rim of the large vase are decorations of *ruyi* cloud patterns in deep blue enamel. The base of the large vase is engraved with a six-character mark of Qianlong (Daqing Qianlongnian *zhi*) in regular script within a double-line square.

The form of the ware is thickly modeled with unique and creative design, and the decorations exude an archaic flavour. With utilization of both cloisonné enamel and champlevé enamel techniques, this work is a perfect example that reveals the successful combination of metal craft and enamel craft.

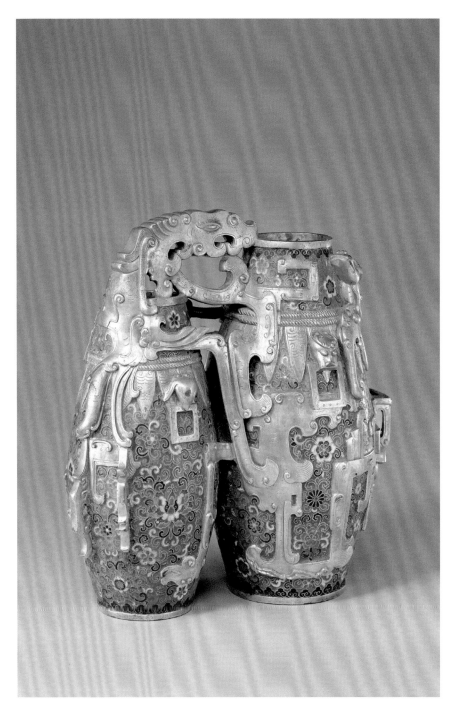

206

Cloisonné and painted enamel gold ewer
with designs of ladies in panels

Qing Dynasty Qianlong period

Overall Height 39 cm
Diameter of Mouth 7.3 cm
Diameter of Foot 12.4 cm
Qing court collection

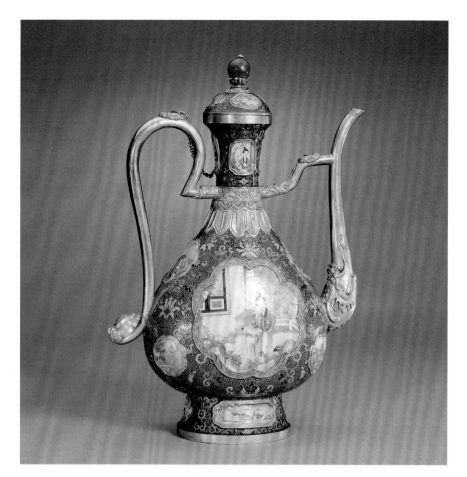

The gold ewer has a round mouth, a long neck, a slanting shoulder, a flat belly, and an oval ring foot. On the two symmetrical sides of the body are a gilt bronze spout in the shape of a dragon head and a curved handle in the shape of a *ruyi* scepter. The ewer has a fitting lid on which is a knob decorated with an inverted lotus-shaped support set with a red coral bead. The body is layered with blue enamel as the ground, and the lid, neck, shoulder, and foot are inlaid with painted enamel panels in which are painted designs of landscapes, flowers, and ladies. Outside the panels are cloisonné enamel designs of lotus scrolls. On both sides of the belly are panels in the shape of flowers with painted designs of mother and child in a garden. The base is engraved with a six-character mark of Qianlong (Daqing Qianlongnian *zhi*) in regular script within a double-line square.

The ewer is decorated with traditional subjects from Chinese paintings with a delicate painting style which matches the imperial aesthetic taste of the time. Using gold for producing ware first started in the Qianlong period, revealing the extravagance and wealth of the imperial court. Blending of both cloisonné and painted enamel techniques was also a new technical innovation in the Qianlong period. This type of ware is representative of refined objects of the Qianlong period.

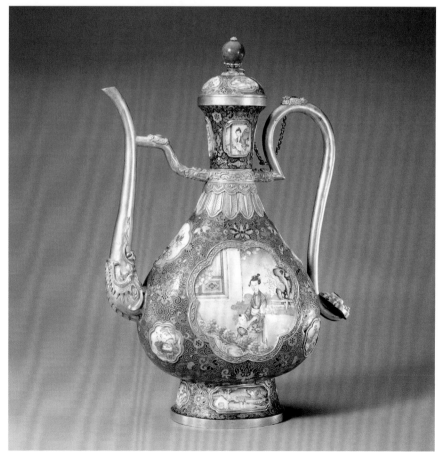

207

Champlevé and painted enamel gold ewer
with designs of western figures in panels

Qing Dynasty Qianlong period

Overall Height 18.7 cm
Diameter of Mouth 2.8 cm
Diameter of Foot 3.9 cm
Qing court collection

The gold ewer has a round mouth, a slim neck, a slanting shoulder, a globular belly, and a ring foot. On the symmetrical sides of the body are a gilt spout in the shape of a dragon head and a curved handle in the shape of a *ruyi* scepter. The ewer has a fitting lid on which is a knob with a support in the shape of a lotus flower and set with a red coral bead. The body is decorated with designs in gilt and champlevé enamels with the recessed areas filled with green enamel. The cover, neck, and ring foot are inlaid with painted enamel panels in which are painted designs of floral sprays. The shoulder and the lower belly have four panels painted with landscapes in rouge red, and both sides of the belly are painted with a panel with designs of western ladies and children. The base is in gilt and engraved with a four-character mark of Qianlong (Qianlongnian *zhi*) in Song script style within a double-line square.

Ware decorated with western figures and buildings began to emerge in the Qianlong period. This ewer is decorated with both traditional Chinese floral motifs and western figures and landscapes, revealing a distinctive practice by blending both Chinese and western decorative elements in the Qianlong period.

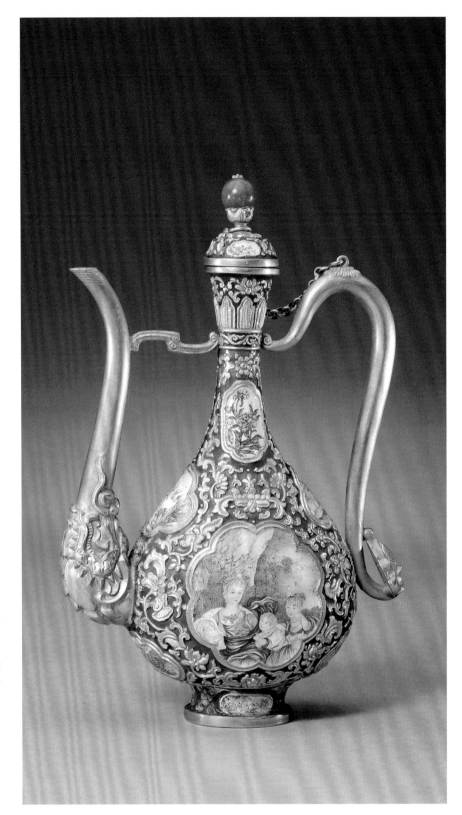

208

Cloisonné enamel *duomu* (*mdong-mo*) pot
with designs of interlocking lotuses and inlaid with precious stones

Qing Dynasty Qianlong period

Overall Height 53 cm
Diameter of Mouth 10.4 cm
Diameter of Foot 15 cm
Qing court collection

The pot has a cylindrical body, a slanting mouth, a straight wall, and a ring foot. On the two symmetrical sides of the body are a spout in the shape of a dragon head and a handle in the shape of a dragon head swallowing fish. The pot has a fitting lid, on which is a knob set with a red coral bead. The mouth rim and ring foot are decorated with gilt bronze ring borders with designs of foliage scrolls in champlevé enamel and set and inlaid with corals and glass beads. The body is layered with sky blue enamel as the ground which are decorated with lotus scrolls and set with three bronze ring borders inlaid with various glass beads and precious stones. The lid's surface has a small panel in which are designs of *panchi*-dragons. One side of the foot has a rectangular gilt panel with an engraved six-character mark of Qianlong (Daqing Qianlongnian *zhi*) in regular script inside.

Duomu pot is a drinking utensil used by Mongolians and Tibetans. The earliest ware of this type was first produced in the Yuan Dynasty. *Duomu* was translated from Mongolian and Tibetan languages (*mdong-mo*), meaning barrels or vases. It was used for containing milk tea or butter tea and was originally made of wood; but later it was also made with metal, enameled bronze, and porcelain. A great number of *duomu* pots in various kinds of materials were produced in the Kangxi, Yongzheng, and Qianlong periods in the Qing Dynasty, which were mainly used in imperial banquets and for bestowing as gifts. This pot should have been a gift for bestowing to Tibetan leaders at the time, and it reflects the high craftsmanship in producing cloisonné ware in the Qianlong period.

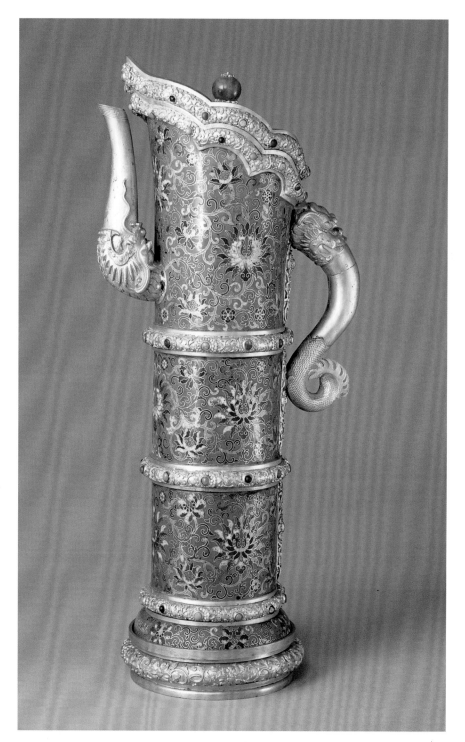

209

Cloisonné enamel *yan* boiler
with designs of animal masks

Qing Dynasty Qianlong period

Overall Height 17.4 cm
Diameter of Mouth 8 cm
Distance between Legs 2.6 cm
Qing court collection

The upper part of the boiler is shaped like a *zhen* rice-steamer with two looped handles in the shape of twin ropes. The lower part is in the shape of a three-legged *li* tripod. It has a fitting cover on which is a gilt lotus pedestal with champlevé enamel and gilt designs of dragons amidst clouds. The body is layered with sky blue enamel as the ground. The exterior wall of the *zhen* rice-steamer is decorated with banana leaves in red, yellow, and blue enamels, and inside the banana leaves are cloisonné enamel designs of animal masks, surrounded by cloisonné enamel designs of geometric brocade patterns outside. The surface of the cover, mouth rim, and foot are decorated with cloisonné enamel designs of variegated animal masks. The foot and base are in gilt, and the centre of the base is carved with a four-character mark of Qianlong (Qianlongnian *zhi*) in regular script in relief.

The form and design of this ware is derived from ancient bronze ware of the Shang and Zhou dynasties. It marks a distinctive type of enamel ware produced in the Qianlong period and is closely associated with the interest in pursuit of antiquity of Emperor Qianlong.

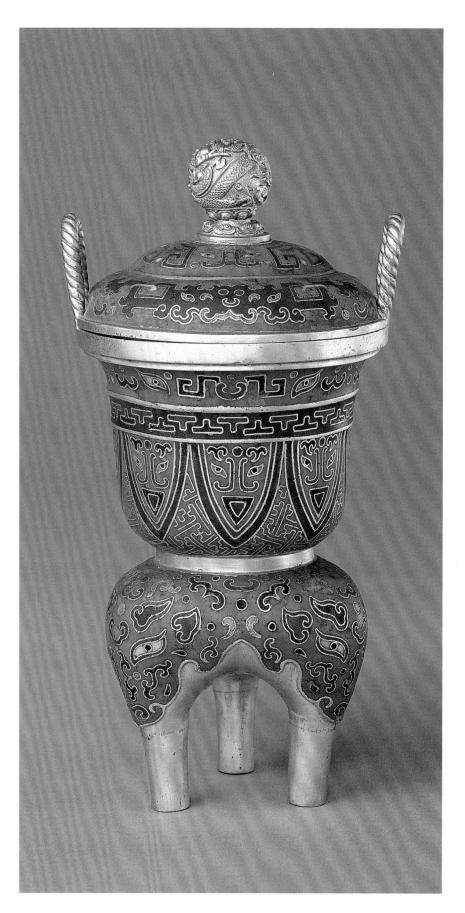

210

Champlevé enamel *zun* vase
in the shape of a sacrificial animal with interlocking cloud patterns

Qing Dynasty Qianlong period

Overall Height 19 cm
Length 21.2 cm
Width 9 cm
Qing court collection

The *zun* vase has a gilt bronze body. The back has conjoined large and small round tubes and a square tube in the shape of scrolls. The body is decorated with champlevé enamel interlocking cloud designs with the recessed areas filled with green enamel as the ground. Underneath the neck and on the belly and legs are decorations of the animal's hair in red enamel and gilt. The vertical side of the square tube on the back has a square panel filled with blue enamel in which is a gilt four-character mark "*Qianlong fanggu*" (in imitation of ancient ware in the Qianlong period) in regular script in relief.

This *zun* vase is modeled with a stern and rustic form. The body is decorated with interlocking cloud patterns with a touch of fluency and swiftness. The hair on the neck and belly are in gilt in deep colour and further highlighted by dots in red enamel gracefully and elegantly, revealing skilful technical production with a sense of archaic flavour that reflects the artistic accomplishments of the crafts of the Qing court in the Qianlong period.

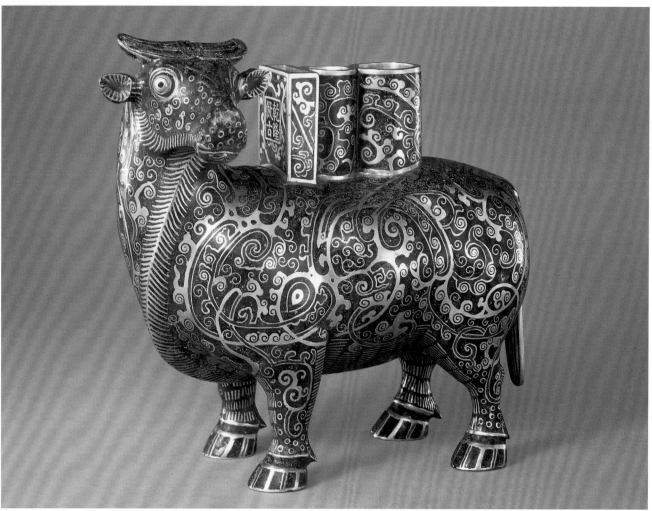

211

Cloisonné enamel chicken *zun* vase

Qing Dynasty Qianlong period

Height 19 cm
Diameter of Mouth 4.5 cm
Length 19 cm
Qing court collection

The *zun* vase is in the shape of a recumbent heavenly chicken with its head bowing down and the two wings curling up to support the *zun* vase on its back. The claws are grabbing the axis of two wheels with openwork designs. The tail curls inwards and is connected to another small wheel. Inside the hanging tail is a small gilt bronze chicken. The body is layered with sky blue enamel as the ground and further decorated with gold mottles and colourful feathers. The vase has a flared mouth, a contracted neck, and a globular belly, with the neck decorated with banana leaves and the shoulder and belly decorated with lotus scrolls. On one side is a gilt bronze handle in the shape of a *chi*-dragon, and on the other symmetrical side is the cock's crest. The chicken's chest is inlaid with a rectangular gilt bronze flake in which is an engraved four-character mark of Qianlong (Qianlongnian *zhi*) in regular script.

The chicken *zun* vase is modeled with creative and innovative design. With the two wheels connected to the small wheel on the tail to form a triangular support, the vase is well balanced and stands stably on its three moveable wheels.

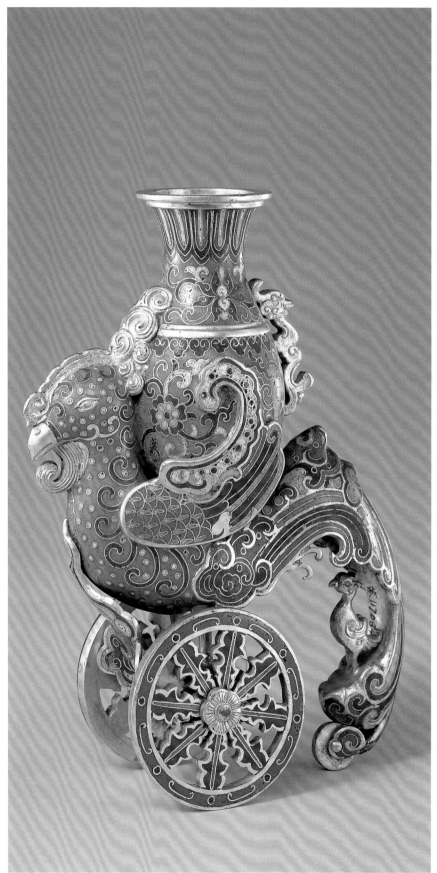

212

Cloisonné enamel Lama stupa

with a gold statue of Buddha and designs of *baoxiang* floral rosettes

Qing Dynasty Qianlong period

Height 231 cm
Length of Stand 94 cm
Qing court collection

The stupa comprises of a pedestal, a stupa, and a spire. The lower part of the pedestal is a throne in the shape of Mount Sumeru, and on each of the four sides of the contracted waist are two panels decorated with lions and clouds inside. In between the panels are decorations of vajras. On top of the pedestal is a mandala stand decorated with sanskirts in colour enamels. The front side of the stupa has a shrine which houses a gold statue of Ushnisha vijaya. The four sides of the shrine's door are decorated with champlevé enamel designs. The spire has thirteen tiers fully engraved with sanskirts. On top of the canopy above is a plate of heaven and earth which is set with designs of the sun, the moon, and a pearl. At the base of the stupa is a red sandalwood supporting plate with engraved designs of lotus petals. On top of the pedestal in the shape of Mount Sumeru is a square frame in deep blue enamel, which is carved with a mark "*Daqing Qianlong jiawunian jingzao*" (respectfully produced in the year *jiawu* of the Qianlong period of the Qing Dynasty) in regular script in relief.

In the 39th year of the Qianlong period (1774 A.D.), six lama stupas were produced with identical sizes but with different shapes, enamel colours, and decorative designs, and this piece was one of them. The six stupas were displayed in Fanhua Tower, the Buddhist hall of the Qing Palace, and are still extant. According to the Qing archive, production of these six stupas had consumed over 689,300 taels of silver. In the 47th year of the Qianlong period (1782 A.D.), another six cloisonné enamel stupas were produced in accordance with the shape and style of these six stupas for display at Baoxiang Tower, another Buddhist hall in the Qing palace. These two groups of cloisonné stupas fully demonstrated the superb accomplishments in producing cloisonné enamel ware in the Qianlong period.

Ushnisha vijaya, Amitayas Buddha, and White Tara are known as the "Three Buddhas of Longevity" with Ushnisha vijaya represented by holding a statue of Amitayas Buddha in her hand.

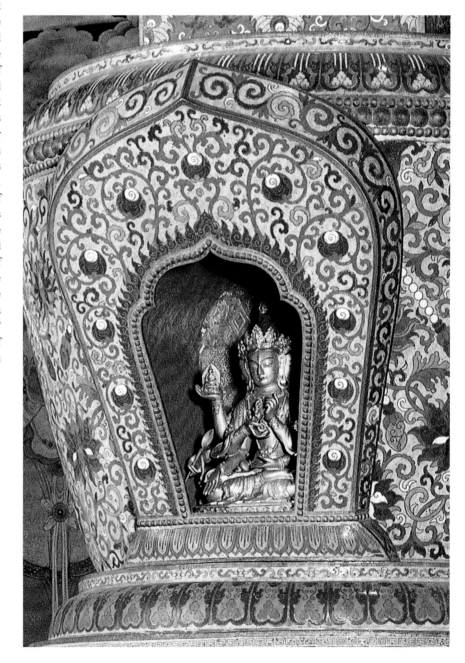

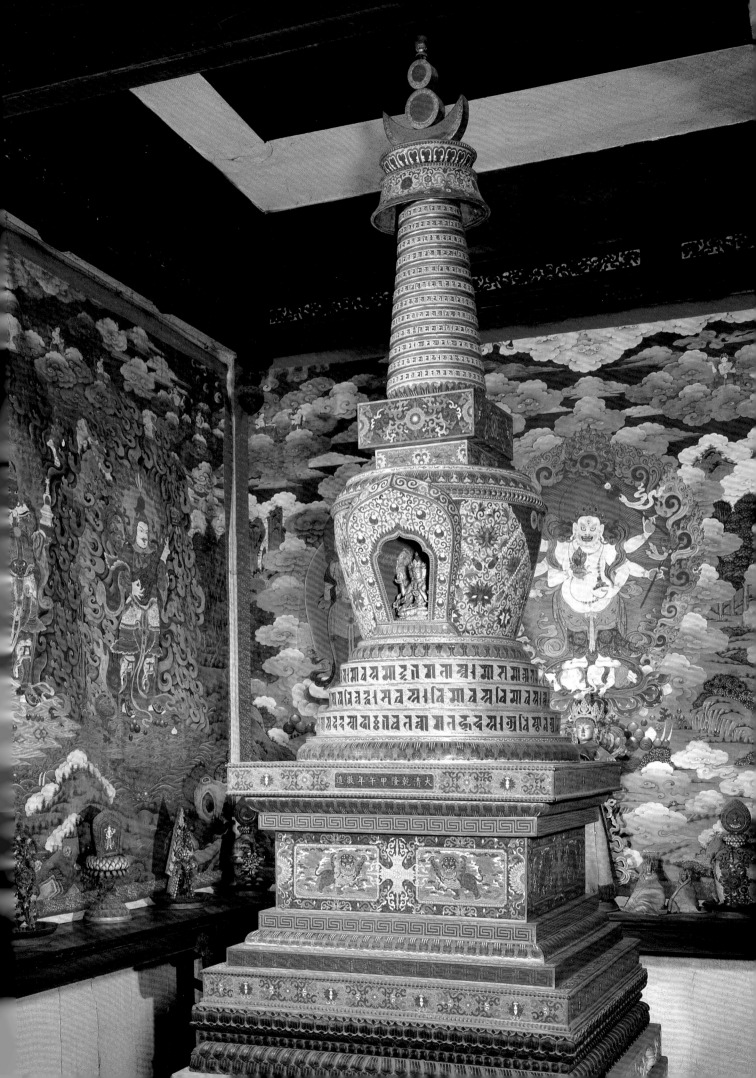

213

Cloisonné enamel gold bowl
set and inlaid with precious stones

Qing Dynasty Qianlong period

Overall Height 23.3 cm
Diameter of Mouth 14.4 cm
Qing court collection

The bowl has a flared mouth and a belly tapering downwards to the ring foot. It has a fitting cover in the shape of a stupa, on top of which is a peach-shaped knob set with rubies. It is supported on a round plate with a knob, underneath which are designs of lotus petals inlaid with rubies. The bowl stand has three tiers. The top tier is in the shape of a drum, and the middle tier is a plate which is supported on a trumpet-shaped high and flaring stemfoot. The bowl, cover, and stand are layered with green enamel as the ground on which are designs of floral scrolls inlaid with rubies and nitrites. The decorative designs are separated by gold borders. The base of the plate is engraved with a six-character mark of Qianlong (Daqing Qianlongnian *zhi*) in regular script.

In the 45th year of the Qianlong period (1780 A.D.), in celebration of the 70th birthday of Emperor Gaozong (Qianlong) of the Qing Dynasty, the sixth Panchen Lama Lobsang Palden Yeshe came to Rehe (present day Chengde in Hebei) and Beijing to present tributes. Emperor Qianlong ordered to reproduce the silver bowl in green enamel to show his high regard of this tribute. The bowl not only demonstrated superb craftsmanship, but also testified the communication and cultural exchanges between the Chinese, Manchurian, and Tibetan people.

293

214

Cloisonné enamel brush-holder
in the shape of a wrapped book scroll

Late Qing period

Height 9.5 cm
Diameter of Mouth 8.5 cm
Distance between Legs 6.7 cm

The gilt bronze brush-holder is in the shape of a wrapped book scroll with five legs in the shape of floating clouds. The body is layered with sky blue enamel as the ground and decorated with cloisonné enamel designs of peonies, bamboos, rocks, chrysanthemums, and birds. The waist is decorated with simulated cloth wrappings with brocade cloud patterns in deep blue enamel in low relief, and underneath is a base stand decorated with lotus scrolls and hanging clouds. At the beginning of the book scroll is a slip in red enamel and a cloisonné mark Zhiyuan Studio in regular script in black.

The brush-holder is modeled with creative and innovative design and utilizes enamels in thirteen colours for the decorations. The cloisonné enamel designs are rendered in a delicate and refined manner with thin gilt, representing a fine piece of work in the late Qing period. Zhiyuan Studio was a private commercial workshop in producing cloisonné enamel ware in Beijing in the late Qing period.

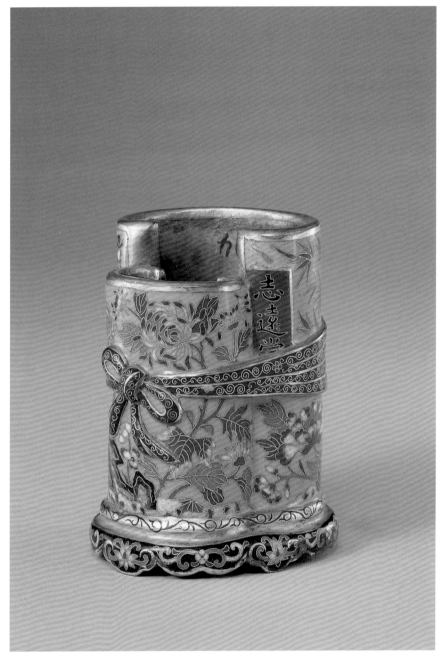

215

Painted enamel vase
with designs of peaches and bats

Qing Dynasty　Kangxi period

Height 13.6 cm
Diameter of Mouth 4.1 cm
Diameter of Foot 4.1 cm
Qing court collection

The vase has a slightly flared mouth, a contracted neck, a hanging belly, and a ring foot. The rim of the mouth and leg are in gilt. The body is layered with white enamel as the ground and decorated with robust peaches and red bats, green bamboos, and rocks interspersed by clouds and streams, suggestive of fortune and longevity. The base is glazed in white and written with a four-character mark of Kangxi (Kangxi *yuzhi*) in regular script within a double-line square in blue.

This vase is a refined piece of painted enamel ware made in the Kangxi period. Decorated with branching out old trees and robust fruits, the pictorial treatment reveals a fresh charm and free brush style, demonstrating the skilful painting techniques in producing imperial painted enamel ware. Painted enamel designs are made by applying colourful enamels directly on the metallic body, and then fired. It was introduced into China during the Kangxi period of the Qing Dynasty.

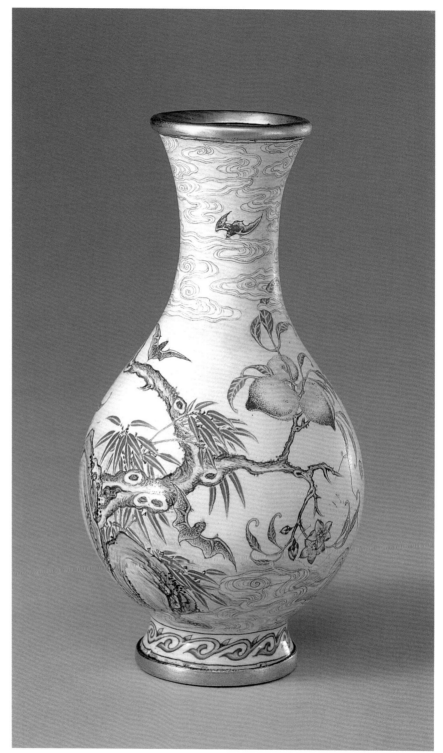

216

Painted enamel flower basket
in the shape of a begonia and decorated with designs of peonies

Qing Dynasty Kangxi period

Overall Height 13.5 cm
Diameter of Mouth 17 x 16.5 cm
Qing court collection

The basket is in the shape of a begonia and has an overhead handle and a low ring foot. The exterior is layered with yellow enamel as the ground on which are designs of blooming peonies in pink enamel and four small flowers beginning to bloom in blue and lotus root colour enamels surrounded by green branches and leaves. The interior of the basket is layered with sky blue enamel. The handle is in yellow enamel with painted designs of floral sprays. The base is glazed in white and written with a four-character mark of Kangxi (Kangxi *yuzhi*) in regular script in purplish-red.

The enamel colours on this basket are lustrous and bright, and this work represents a refined piece of painted enamel ware of the late Kangxi period. During that time, most of the refined painted enamel ware was written with the four-character imperial mark of Kangxi within double-line squares or medallions in blue, endorsing the Emperor's fondness of this type of painted enamel ware.

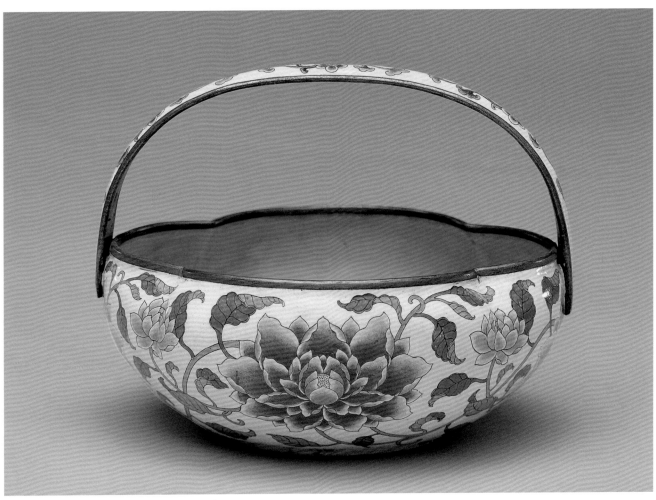

217

Painted enamel snuff bottle
with designs of panels with plum flowers

Qing Dynasty Kangxi period

Overall Height 6 cm Diameter of Belly 4.5 cm
Qing court collection

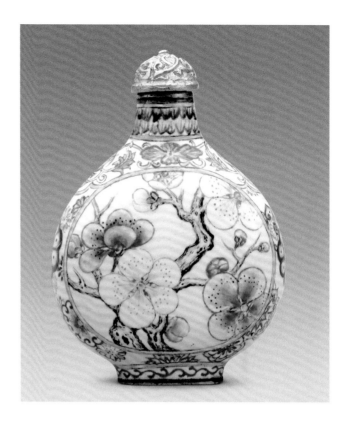

The snuff bottle is in the shape of an ancient pilgrim flask and has an oval ring foot. Both sides of the flask are decorated with a round panel, which is layered inside with white enamel and decorated with a charming stalk of plum flowers in red and white enamels. In painting the petals, light wash painting technique is utilized for applying the colours from light to dark gradations with a touch of dimensionality. Surrounding the panels are various kinds of floral designs in clusters or spaciously scattered to complement the plum flowers. The base is layered with white enamel with the centre written with a four-character imperial mark of Kangxi (Kangxi *yuzhi*) in regular script in blue. The snuff bottle has a gilt bronze stopper with engraved designs and an ivory spoon.

The earliest extant snuff bottles are those painted enamel bronze snuff bottles made in the Kangxi period of the Qing Dynasty. Only two pieces are collected by the Palace Museum, which are very rare and unusual.

218

Painted enamel snuff bottle
with designs of plum flowers
on a black ground

Qing Dynasty Yongzheng period

Overall Height 6 cm Diameter of Belly 4.5 cm
Qing court collection

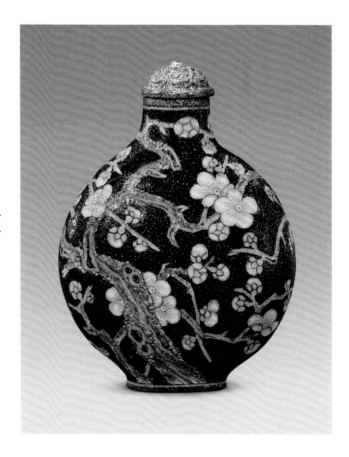

The ovoid snuff bottle has an oval ring foot. The body is layered with black enamel on which is a design of a stalk of old plum blossom tree with branches stretching out and over tens of flowers and buds interspersed in between. The base is glazed in white with the centre written with a four-character mark of Yongzheng (Yongzhengnian *zhi*) in regular script in blue. The snuff bottle has a gilt bronze stopper with engraved designs and an ivory spoon.

The designs on this snuff bottle are meticulously rendered with the slim stamens represented in a delicate manner. The old trees are realistically depicted with vividness. This work represents a refined snuff bottle of the Yongzheng period.

219

Painted enamel teapot
with designs of flowers and butterflies

Qing Dynasty Yongzheng period

Overall Height 8.2 cm
Diameter of Mouth 5.2 cm
Diameter of Foot 5.7 cm
Qing court collection

The teapot has a round mouth, a short neck, a flat and globular belly, and a low ring foot. On the two symmetrical sides of the pot are a gilt bronze spout in the shape of a *kui*-dragon and a gilt bronze ringed handle. The teapot has a lid, on top of which is a knob with carved designs and set with a red coral bead. The teapot is layered with light green enamel as the ground and decorated with flowers and butterflies. The interior of the pot is layered in sky blue enamel. The exterior base is layered with white enamel with the centre written with a four-character mark of Yongzheng (Yongzhengnian *zhi*) in imitation Song style within a double-line square in blue.

The teapot is decorated with painted enamel designs with delicate brushwork and charming colours, representing the distinctive feature of painted enamel ware of the Yongzheng period. Such a lyrical and subtle style was achieved by Emperor Yongzheng's engagement of court painters and calligraphers to participate in the design and painting of decorative designs for the Imperial Workshops at the time.

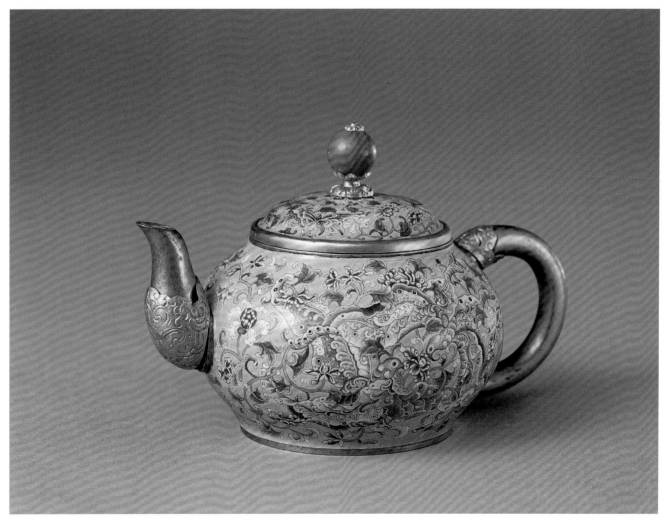

220

Painted enamel spittoon
with designs of flowers and birds in panels

Qing Dynasty Yongzheng period

Height 8.1 cm
Diameter of Mouth 9.2 cm
Diameter of Foot 5.4 cm
Qing court collection

The spittoon has a flared mouth, a short neck, a wide belly, and a ring foot. The rim of the mouth and leg is in gilt. The body is layered with sky blue enamel as the ground. The neck is decorated with banana leaves and lotus scrolls painted in colour enamels, and the belly has four panels with yellow ground in the shape of plucked mandarins, which are decorated with birds and flowers of the four seasons including bamboos, birds, lotuses, butterflies, and plum flowers. Outside the panels are stylized decorations of lotuses and green leaves. The exterior wall of the shoulder and foot are painted with floral designs in black enamel. The base is painted with red bats and plucked mandarin sprays, suggestive of auspicious blessing of fortune and goold luck, and at the centre is a four-character mark of Yongzheng (Yongzhengnian *zhi*) in regular script in blue.

The spittoon has refreshing decorative designs in splendid colours. The black enamel was innovated by the Imperial Workshops and first fired in the Yongzheng period, marking it as a new type of colour enamel of the Yongzheng perio.

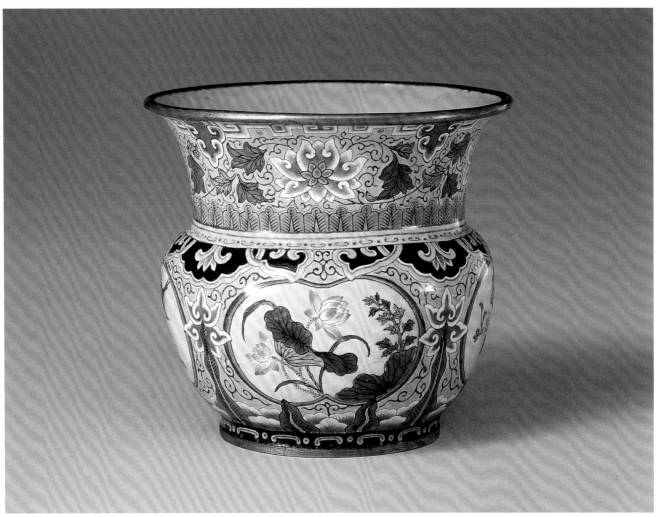

221

Painted enamel washer
in the shape of peaches

Qing Dynasty Yongzheng period

Height 7.5 cm
Diameter of Mouth 6.2 cm
Qing court collection

The washer is in the shape of two conjoined peaches with a round hole on the top surface and two branches in archaic bronze colour spread and joined to form the handle. The two peaches, one bigger and the other smaller in size, are painted with enamel colours which closely look like the colour of freshly ripe peaches, and further decorated with two red bats and green leaves. The two peaches together with bats carry the auspicious blessing of fortune and longevity. The interior of the washer is layered with blue enamel. The base is written with a four-character mark of Yongzheng (Yongzhengnian *zhi*) in regular script in black.

The form of this washer is very creative with a touch of vividness, representing a refined piece of painted enamel ware of the Yongzheng period.

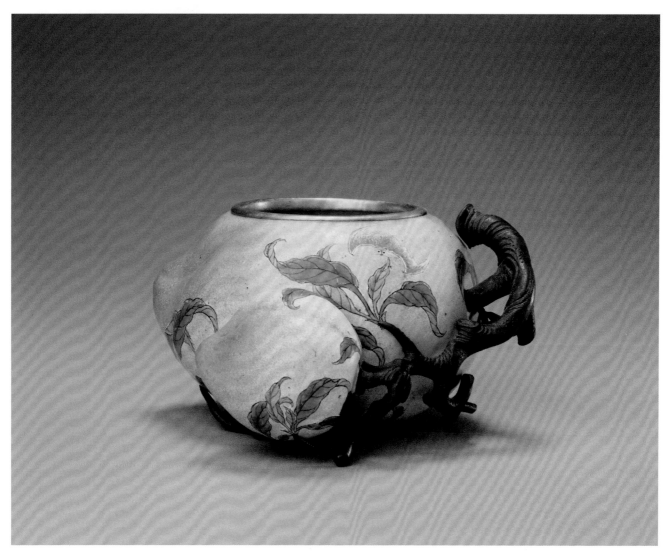

222

Painted enamel fan-shaped ewer
with designs of peonies

Qing Dynasty Qianlong period

Overall Height 9 cm
Diameter of Mouth 6.1 x 5 cm
Diameter of Foot 6 x 5 cm
Qing court collection

The ewer has a rectangular mouth, a short neck, a slanting shoulder, a fan-shaped belly, and a curved base. On the two symmetrical sides of the body are a spout and a curved handle. The ewer has a fitting rectangular lid with a knob. The body is layered with yellow enamel as the ground, and the four sides of the body are painted with peonies in red and blue enamels. The shoulder, spout, and handle are decorated with flowers and leaf scrolls. The lid is decorated with a red holly-hock in pink with the knob shaped like a flower bud. The base is glazed in white and written with a four-character mark of Qianlong (Qianlongnian zhi) in regular script within a double-line square in red.

The ewer is modeled with a declicate form, and the designs are rendered extravagantly. The bright yellow enamel is the typical colour enamel that characterizes the ware produced by the Imperial Workshops of court with royal attribute.

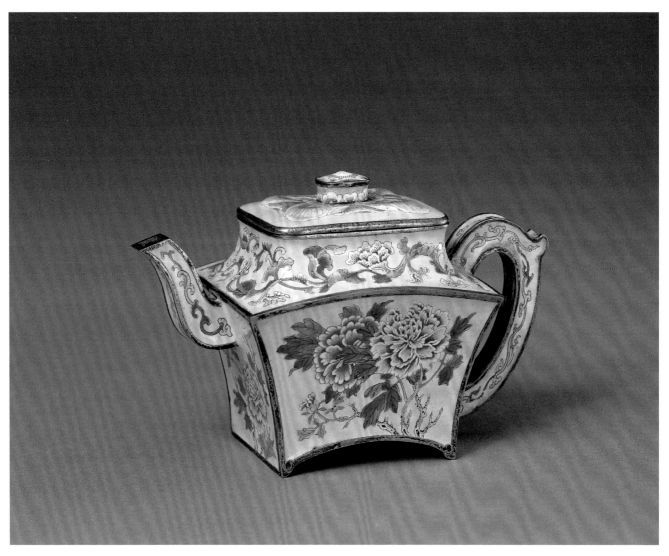

223

Eight lobed painted enamel teapot

with an overhead handle and designs of landscapes, flowers, and birds in panels

Qing Dynasty Qianlong period

Overall Height 37.8 cm
Diameter of Mouth 8.8 cm
Diameter of Foot 13.3 cm
Qing court collection

The eight lobed teapot has a short neck, a globular belly, and a ring foot. It has a fitting round lid with a knob. The teapot has a gilt and aventurine overhead handle, and on the side of the belly is a curved spout in gilt. The leg is supported by an S-shaped gilt bronze stand, in which is a small painted enamel box with chrysanthemum designs. The box is for storing burning oil and can be lit for heating the teapot. The lid and the neck are layered with yellow enamel as the ground and decorated with lotus sprays in colour enamels. Eight panels decorate the eight lobes of the belly, in which four are painted with landscapes and four are painted with birds and flowers alternatively. The base of the teapot and the oil box has a four-character mark of Qianlong (Qianlongnian *zhi*) in Song script style.

In making this teapot, techniques of metal, enamel treatment, and inlay are utilized. The form carries distinctive features of ware from the west, but the decorations are traditional Chinese landscapes, flowers, and birds painted meticulously with a touch of lyricism, which should have been painted by court painters. This work is a remarkable piece that blends both Chinese and Western cultural elements and fully illustrates the distinctive accomplishment in the production of enamel ware in the Qianlong period.

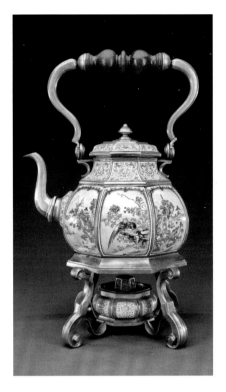

224

Painted enamel vase
in the shape of a begonia
with designs of panels of
landscapes on a hundred
flowers brocade ground

Qing Dynasty Qianlong period

Height 50.5 cm
Diameter of Mouth 16 cm
Diameter of Foot 14 cm
Qing court collection

The vase is in the shape of a begonia with a floral petal-shaped mouth and foot, a contracted neck, a wide shoulder, a belly tapering downwards, and a slim elongated body. Both sides of the shoulder are decorated with two copper animal masks holding rings. The body is decorated with hammered and embossed designs of flowers in the Rococo style and painted in thick gold, which is further complemented by painted enamel designs of a hundred flowers. Both sides of the belly have panels painted with designs of landscapes and figures in western style. The base is glazed in white and inscribed with a six-character mark of Qianlong (Daqing Qianlongnian *zhi*) in seal script within a double-line square in blue.

The decorative designs of spreading foliage floral patterns, western buildings, landscapes, ladies with child showed the style of Guangzhou (Canton) painted enamel ware. This piece was tailor-made in Guangzhou as a tributary object to the imperial court. The emergence and development of this type of enamel ware was strongly influenced by European painted enamel ware and oil painting, which had significant impact on the production of enamel ware in China at that time.

Rococo art originated in the 18th century in France, which was a popular art trend that crossed over Europe with notable features of refreshing, graceful, delicate, and elegant charm. The style had been significantly adopted in the arts of architecture, interior design, painting, literature, sculpture, music, etc.

225

Painted enamel gold cup and saucer
with designs of western young ladies

Qing Dynasty Qianlong period

Overall Height 15.8 cm Diameter of Cup 4.5 cm
Diameter of Saucer 14 cm

Qing court collection

The cup and saucer are in a set. The cup has an everted mouth rim, a curved belly, and a ring foot. Each of the two sides of the cup has a gold ear decorated with foliage scrolls. The saucer is in the shape of a water chestnut with a relief border at the centre as a supporting ring. The cup and plate saucer are decorated with champlevé enamel designs in gilt, with the recessed areas filled with green enamel. The exterior of the cup has two panels painted with western young ladies in colour enamels. The rim of the saucer has eight panels painted with western landscapes in rouge red. The interior of the base has four panels decorated with western young ladies painted in colour enamels. The bases of the cup and saucer are layered with lake blue enamel with the centre in gilt and engraved with a four-character mark of Qianlong (Qianlongnian *zhi*) in regular script.

The designs and colours of the cup reflect typical European decorative style, and this set of ware is a fine example revealing that the imperial ware in the Qianlong period had absorbed western influence for the production of enamel ware.

226

Painted enamel gold snuff bottle
with a design of a peacock fanning out feathers

Qing Dynasty Qianlong period

Overall Height 4.6 cm Diameter of Belly 3.7 cm

Qing court collection

The ovoid snuff bottle has a recessed base. The body is modeled in the shape of a peacock fanning out its feathers. Both sides of the body are decorated with the tail of a peacock fanning out its feathers. The sides of the bottle and the neck are decorated with red flowers on a yellow ground. The base has a round panel inscribed with a four-character mark of Qianlong (Qianlongnian *zhi*) in regular script in blue. The snuff bottle has a gilt bronze stopper with engraved designs and an ivory spoon.

Gold is utilized to make this snuff bottle. The number of gold snuff bottles produced is very limited, and this work thus represents a rare snuff bottle of its type in the Qing Dynasty.

227

Painted enamel snuff bottle
with designs of quails, chrysanthemums, and rocks

Qing Dynasty Qianlong period

Overall Height 5.5 cm Diameter of Belly 3.9 cm

Qing court collection

The ovoid snuff bottle has an oval ring foot. Both sides of the body have two symmetrical panels decorated with two quails either looking up to the sky, with the head turning back, or bowing the head looking for food. Surrounding them are designs of rocks, wild chrysanthemums, flowers, and leaves. Quails symbolize peace, chrysanthemums are a homonym for a comfortable home, and leaves are a homonym for livelihood, thus the designs are suggestive of living in a comfortable home with a prosperous career. The sides of the bottle are decorated with floral designs, and the neck is decorated with key-fret patterns in blue. The base is glazed in white, and the centre is inscribed with a four-character mark of Qianlong (Qianlongnian *zhi*) in regular script within a double-line square in blue. The snuff bottle has a gilt bronze stopper with carved designs and an ivory spoon.

The bottle is decorated with gracefully painted designs, and the designs on its sides are rendered with layered enamels in relief, which represents a rather rare technique in the production of painted enamel ware.

228

Painted enamel snuff bottle
with designs of a mother and a child listening to music

Qing Dynasty Qianlong period

Overall Height 6.1 cm Diameter of Belly 3.5 cm
Qing court collection

The snuff bottle is in the shape of a jar and has a ring foot. The body is decorated with a continuous scene of a mother and her child listening to music. At the side of the river is a boy playing a flute while across the river is a mother holding a baby in her arms listening. At their sides are rocks and clusters of flowers and grasses. The base is glazed in white, and the centre is inscribed with a four-character mark of Qianlong (Qianlongnian *zhi*) in regular script in blue. The snuff bottle has a gilt bronze stopper with carved designs and an ivory spoon.

The painted designs on the snuff bottle are vividly rendered and represent a new creative decorative type of snuff bottles by the Imperial Workshops of the Qing court.

229

Painted enamel snuff bottle
with designs of foreign mothers and children

Qing Dynasty Qianlong period

Overall Height 5.5 cm Diameter of Belly 3.7 cm
Qing court collection

The ovoid snuff bottle has an oval ring foot. Both sides of the body have a panel decorated with a mother and a child of foreign origin with the pictorial treatment almost identical. The mothers are holding their children with a merciful and peaceful appearance in a setting with clusters of trees, flowers, grasses, and western buildings. The space outside the panels are layered with green enamel as the ground and decorated with engraved gilt designs of foliage scrolls. The shoulder and the foot are decorated with foliage scrolls in pink on a white ground. The base is glazed in white, and the centre is inscribed with a four-character mark of Qianlong (Qianlongnian *zhi*) in regular script in blue. The snuff bottle has a glass stopper and an ivory spoon.

Designs of foreign figures and buildings had become popular on the enamel ware of the Qianlong period because a number of western priests subsequently came to China to preach, and they were also directly involved in the artistic creation of imperial ware.

Dynastic Chronology of Chinese History

Xia Dynasty	Around 2070 B.C.—1600 B.C.
Shang Dynasty	1600 B.C.—1046 B.C.
Zhou Dynasty	
Western Zhou Dynasty	1046 B.C.—771 B.C.
Eastern Zhou Dynasty	770 B.C.—256 B.C.
Spring and Autumn Period	770—476 B.C.
Warring States Period	475 B.C.—221 B.C.
Qin Dynasty	221 B.C.—206 B.C.
Han Dynasty	
Western Han Dynasty	206 B.C.—23A.D.
Eastern Han Dynasty	25—220
Three Kingdoms	
Kingdom of Wei	220—265
Kingdom of Shu	221—263
Kingdom of Wu	222—280
Western Jin Dynasty	265—316
Eastern Jin Dynasty Sixteen States	
Eastern Jin Dynasty	317—420
Sixteen States Periods	304—439
Southern and Northern Dynasties	
Southern Dynasties	
Song Dynasty	420—479
Qi Dynasty	479—502
Liang Dynasty	502—557
Chen Dynasty	557—589
Northern Dynasties	
Northern Wei Dynasty	386—534
Eastern Wei Dynasty	534—550
Northern Qi Dynasty	550—577
Western Wei Dynasty	535—556
Northern Zhou Dynasty	557—581
Sui Dynasty	581—618
Tang Dynasty	618—907
Five Dynasties Ten States Periods	
Later Liang Dynasty	907—923
Later Tang Dynasty	923—936
Later Jin Dynasty	936—947
Later Han Dynasty	947—950
Later Zhou Dynasty	951—960
Ten States Periods	902—979
Song Dynasty	
Northern Song Dynasty	960—1127
Southern Song Dynasty	1127—1279
Liao Dynasty	907—1125
Western Xia Dynasty	1038—1227
Jin Dynasty	1115—1234
Yuan Dynasty	1206—1368
Ming Dynasty	1368—1644
Qing Dynasty	1616—1911
Republic of China	1912—1949
Founding of the People's Republic of China on October 1, 1949	